FREDERIC CHURCH, WINSLOW HOMER, AND THOMAS MORAN: TOURISM AND THE AMERICAN LANDSCAPE

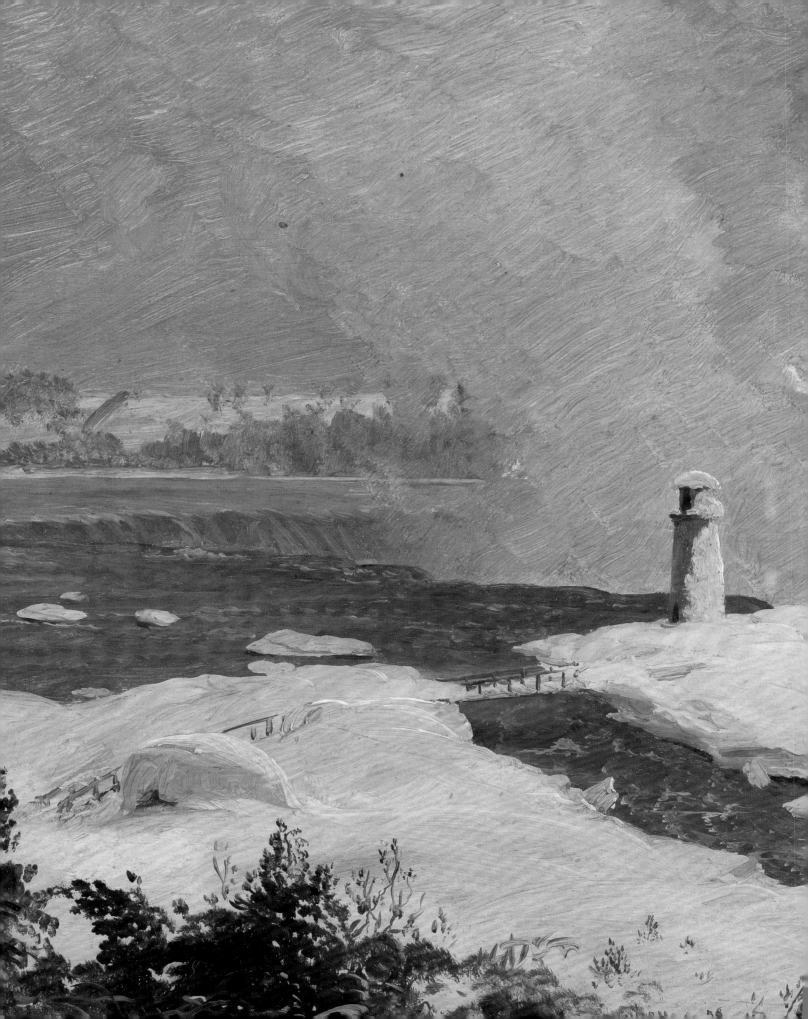

FREDERIC CHURCH
WINSLOW HOMER
AND THOMAS MORAN

TOURISM AND THE AMERICAN LANDSCAPE

Dr. Gail S. Davidson

Floramae McCarron-Cates

Dr. Barbara Bloemink

Dr. Sarah Burns

Dr. Karal Ann Marling

Smithsonian
Cooper-Hewitt, National Design Museum

Bulfinch Press
NEW YORK • BOSTON

Bulfinch Press

Time Warner Book Group
1271 Avenue of the Americas, New York, NY 10020
Visit our Web site at www.bulfinchpress.com

Published on the occasion of the exhibition
Frederic Church, Winslow Homer, and Thomas Moran:
Tourism and the American Landscape
at Cooper-Hewitt, National Design Museum
Smithsonian Institution
2 East 91st Street
New York, NY 10128
May 19–October 29, 2006

The *Frederic Church, Winslow Homer, and Thomas Moran:*
Tourism and the American Landscape exhibition is made possible
in part by Enid and Lester Morse and public funds from the New
York State Council on the Arts, a State agency. Additional support
is provided by Stephen McKay, Inc., Mr. and Mrs. Frederic A.
Scharf, and Larry and Janet Larose.

First Edition: April 2006

Library of Congress Cataloging-in-Publication Data

Cooper-Hewitt Museum.
Frederic Church, Winslow Homer, and Thomas Moran : tourism
and the American landscape / Barbara Bloemink . . . [et al.] —
1st ed.
 p. cm.
Includes bibliographical references.
ISBN-13: 978-0-8212-5786-9
ISBN-10: 0-8212-5786-2
 1. United States — In art — Exhibitions. 2. Landscape in art
— Exhibitions. 3. Church, Frederic Edwin, 1826–1900 —
Exhibitions. 4. Homer, Winslow, 1836–1910 — Exhibitions.
5. Moran, Thomas, 1837–1926 — Exhibitions. 6. Tourism and art
— United States — Exhibitions. 7. National characteristics,
American, in art — Exhibitions. 8. Art — New York (State) —
New York — Exhibitions. 9. Cooper-Hewitt Museum —
Exhibitions. I. Bloemink, Barbara J. II. Church, Frederic
Edwin, 1826–1900. III. Homer, Winslow, 1836–1910.
IV. Moran, Thomas, 1837–1926. V. Title.
N8214.5.U6C66 2006
758'.17309730747471—daa2 2005025749

Design by Tsang Seymour Design, Inc., New York.

PRINTED IN SINGAPORE

OPPOSITE TITLE PAGE: Frederic Edwin Church, *Niagara from Goat Island* (detail), March 1856. Brush and oil paint, traces of graphite on paperboard

PHOTO CREDITS

We are grateful to the individuals and organizations listed below for their permission to reproduce the images in this book. Every effort has been made to trace and contact the copyright holders of the images reproduced; any errors or omissions shall be corrected in subsequent editions. All images refer to figure numbers unless otherwise stated.

INTRODUCTION
All photos © Smithsonian Institution, photo by Matt Flynn; except: 4: The New York Public Library.

LANDSCAPE ICONS, TOURISM, AND LAND DEVELOPMENT IN THE NORTHEAST
All photos © Smithsonian Institution, photo by Matt Flynn; except: The Metropolitan Museum of Art: 1, 28; Smithsonian Institution Libraries: 2, 3, 29; Andalusia Foundation, photo by Will Brown: 4; Heckscher Museum of Art: 5; Olana State Historic Site, New York Office of Parks, Recreation and Historic Preservation: 6, 20, 22, 80, 83; Archives Center, National Museum of American History, Behring Center, Smithsonian Institution: 8, 24, 61; The New-York Historical Society: 10, 27; Corcoran Art Gallery: 16; National Gallery of Scotland: 21; The New York Public Library: 25, 55; Vose Galleries of Boston: 26; Vedder Memorial Library, Greene County Historical Society, photos by Matt Flynn: 32, 33; Bronck Museum, Greene County Historical Society, photo by Matt Flynn: 35; The Adirondack Museum: 38; American Antiquarian Society: 43; National Gallery of Art, Washington, D.C.: 45; Bryant F. Tolles, Jr.: 46, 47, 50, 56, 58; Sterling and Francis Clark Art Institute: 51; The Art Institute of Chicago: 52, 68, 70; Private Collection: 59; Maine Historic Preservation Commission: 62, 63; Bowdoin College Museum of Art: 65; Philadelphia Art Museum: 67; Memorial Art Gallery of the University of Rochester: 72; Wadsworth Atheneum Museum of Art: 76; Yale University Art Gallery: 78; Portland Museum of Art, photo by meyersphoto.com: 85.

THE BEST POSSIBLE VIEW
All photos © Smithsonian Institution, photo by Matt Flynn; except: Smithsonian Institution Libraries, photo by Matt Flynn: 6; Archives Center, National Museum of American History, Behring Center, Smithsonian Institution: 14; The New York Public Library: 29.

THE PASTORAL IDEAL
All photos © Smithsonian Institution, photo by Matt Flynn; except: The New York Public Library: 1, 6; Museum of Fine Arts, Boston: 3; The Brooklyn Museum: 9; The Lilly Library, Indiana University, Bloomington, IN: 10; Heckscher Museum of Art: 12; The Metropolitan Museum of Art: 13; Lyman Allyn Art Museum: 14; University of Delaware Library, Newark, Delaware: 15.

AMERICA INSIDE OUT
All photos © Smithsonian Institution, photo by Matt Flynn; except: Smithsonian Institution Libraries, photo by Matt Flynn: 3; The Metropolitan Museum of Art: 5 photo by Schecter Lee, 12; Library of Congress: 14.

All other photos: © Smithsonian Institution, photo by Matt Flynn.

CONTENTS

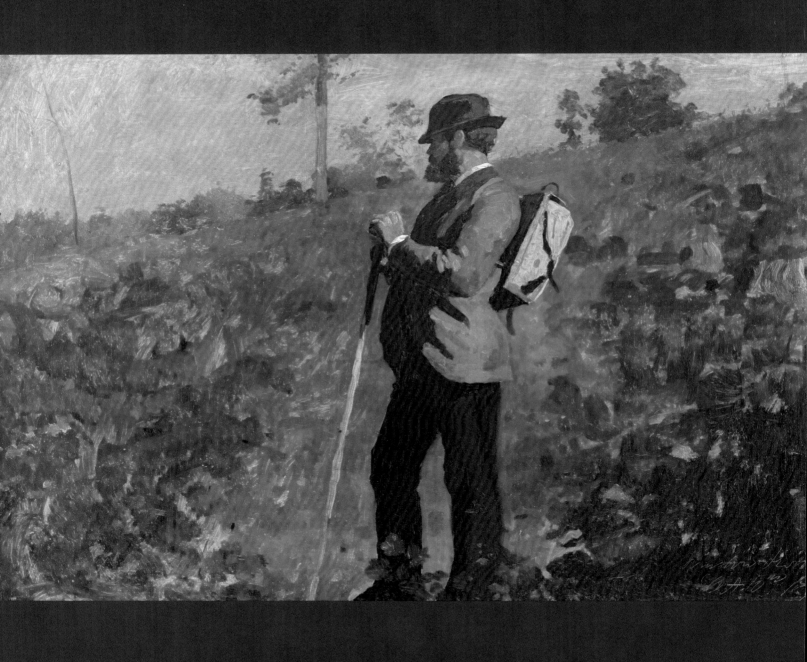

FOREWORD

PAUL WARWICK THOMPSON, DIRECTOR

Among the quarter million objects in the permanent collection of the Smithsonian's Cooper-Hewitt, National Design Museum are surprisingly large holdings of American art. Cooper-Hewitt—like its British counterpart, the Victoria and Albert Museum in London, with its extensive collection of British oil paintings, watercolors, pastels, and portrait miniatures; and the Musée des Arts Décoratifs in Paris, which possesses artworks by such artists as Paul Cézanne and Paul Gauguin—was founded with the mission to provide future designers, teachers, and artists with a knowledge of the arts and the principles of design. The Museum's principal founders, Eleanor and Sarah Hewitt—granddaughters of industrialist Peter Cooper, founder of The Cooper Union for the Advancement of Science and Art—endeavored to provide a museum resource for Cooper Union design students and to instruct the general public in the decorative arts. To do so, they felt it was imperative to make available not only the "best work in decoration," but also works of fine art which would inspire and foster aesthetic appreciation, so as to encourage students to discover "the beautiful in the useful."

Cooper-Hewitt's art collection includes over more than two thousand oil sketches and drawings by Frederic Edwin Church and over more than three hundred paintings and drawings by Winslow Homer—the largest gathering of works by these artists anywhere in the world—as well as approximately eighty works by Thomas Moran. Perhaps

more significant than the sheer number of works by these great American painters is the depth of their range, from initial sketches and studies in graphite and charcoal to finished masterpieces. The works, considered together, provide a detailed view of the artistic process—a characteristic that served well to inspire the designers and artists the school sought to train.

Over the course of their careers, Church, Homer, and Moran shared a common achievement: Together, they, along with other American landscape painters, helped promote the idea of America as a land of purity and beauty. Their breathtaking landscapes and pastoral paintings of Niagara, the Catskills and Adirondacks, New England, and the Western frontiers stirred our notions of national identity and fed our seemingly insatiable wanderlust. Literally millions of Americans followed in their footsteps to discover the glorious views our nation offered, and many millions more "traveled" to these places from the comfort of their own homes, as their iconic scenes were reproduced in stereoviews, periodicals, books, and decorative-arts objects.

The *Frederic Church, Winslow Homer, and Thomas Moran: Tourism and the American Landscape* exhibition and book aim to shed new light on the development of our far-reaching national identity, as well as the relationship between artist, conservationist, cartographer, photographer, and the growth

Winslow Homer. *Man with Knapsack*, October 1873. Brush and oil paint on canvas.

of mass tourism in America in the second half of the nineteenth century. The link between art and the development of the tourist industry has been the subject of European art history and of exhibitions of individual artists or separate geographical areas, but has remained a facet of American art that has not been examined as a whole — until now.

I wish to thank Dr. Gail S. Davidson and Floramae McCarron-Cates, Curator and Associate Curator of Cooper-Hewitt's Drawings, Prints, and Graphic Design department — and the guardians of our impressive American art collection — as well as Dr. Barbara Bloemink, Cooper-Hewitt's Curatorial Director, for conceiving and executing this extraordinary exhibition. Moreover, I would like to express my gratitude to Cooper-Hewitt's trustees, in particular Chairman Dinny Morse and Chairman Emeritus Harvey Krueger, who exhorted Barbara and me to present these remarkable paintings to the public, so rightly commenting that they have lain for too long in the vaults of the institution.

This exhibition would not have been possible without the generous support of Enid and Lester Morse, the New York State Council on the Arts, a state agency, Stephen McKay, Inc., Mr. and Mrs. Frederic A. Sharf, and Larry and Janet Larose. Many thanks also to Leven Betts for a beautiful exhibition design; Tsang Seymour Design for its thoughtful exhibition graphics and design of the catalogue; and Karyn Gerhard, Editor, and her colleagues at Bulfinch Press for their patience and cooperation in giving us exactly the book we desired. At Cooper-Hewitt, I thank Jocelyn Groom, Head of Exhibitions, and Mathew Weaver, Exhibitions; Mick O'Shea, Head of Installations; Chul R. Kim, Head of Publications; Steven Langehough, Registrar; Perry Choe, Conservation; Jill Bloomer and Annie Chambers, Image Rights and Reproduction; Athena Preston, Alumni Fellow, Cooper-Hewitt/Parsons Program; and Carolyn Kelly, Smithsonian Research Fellow.

INTRODUCTION

BARBARA BLOEMINK

Why are there major collections of art by some of the most significant American artists of the late nineteenth century in the permanent collection of the Smithsonian's Cooper-Hewitt, National Design Museum? The Museum owns more than ten thousand American paintings, drawings, prints, and photographs. The process of their acquisition is noteworthy not just because of the identities of the artists, but because of how the works were obtained and used to foster the future of American design. The largest portion of these collections comprises more than two thousand works by Frederic Edwin Church—making the museum the owner of the largest collection of works by Church in the world—and is accompanied by more than three hundred drawings, sketches, prints, oil sketches, and wood engravings by Winslow Homer, covering virtually every phase of his career; and more than eighty watercolors and drawings by Thomas Moran.

The original Cooper Union Museum for the Arts of Decoration, the progenitor of today's Cooper-Hewitt, National Design Museum, was founded in 1897 by sisters Sarah Cooper Hewitt (1858–1930), Eleanor Garnier Hewitt (1864–1924), and Amelia Hewitt (1856–1922) as a teaching museum affiliated directly with The Cooper Union for the Advancement of Science and Art. The latter was founded by their grandfather, Peter Cooper, in 1859 in order to provide practical courses for the education and self-improvement of the working class, particularly in the trades of engineering, illustration,

industrial design, architectural drawing, ornamental drawing, mechanical drawing, and painting. Initially, the school included night classes so that working men could attend. When founding The Cooper Union, Peter Cooper also incorporated an existing art school for women in order to provide female students with the practical skills to become self-supporting designers and art teachers [FIG. 1].

The Cooper Union art faculty included a number of distinguished contemporary artists, including Julian Alden Weir (1852–1919), Walter Shirlaw (1838–1909), and John Henry Twachtman (1853–1902), who taught drawing classes from life and from plaster casts after antique sculptures. For the painting classes, the teachers would often borrow paintings from their colleagues, from which the students worked. As a result, they were very keen to acquire works that could serve as models for their teaching. In a 1903 report, the Director of the Art School, Robert Swain Gifford (1840–1905), suggested that the school purchase figure studies to hang in the classroom instead of continually borrowing works from artists. The next year, an artists' committee, including Gifford, John George Brown (1831–1913), John La Farge (1835–1910), and Frederick Dielman (1847–1935), acquired drawings by contemporary artists James Wells Champney (1843–1903) and Robert Frederick Blum (1857–1903) for the school, to be used for teaching purposes, and which later became part of the collections of the Hewitt sisters' museum.[1]

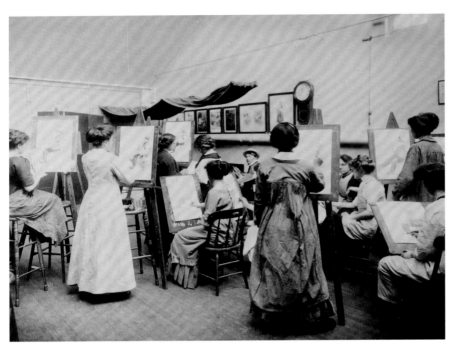

1. Unknown. Students in a life-drawing class at Cooper Union Women's Art School, ca. 1900. Photograph.

Peter Cooper had initially intended to establish a teaching museum affiliated with his university, but this was not realized until fifteen years after his death by his granddaughters. His idea, combined with the general call after the Civil War for America to develop its own national identity in art and design, led his granddaughters to found the first design and decorative-arts museum in the United States.[2] The sisters had a mission to make the finest examples of decorative arts accessible to future American designers in order to educate, encourage fine craftsmanship, and inspire innovation. As Eleanor Hewitt noted at the founding of the Museum, "For the worker, the source of inspiration is frequently found in the sight of an unexpected object, possibly one of an entirely different trade."[3]

This notion of teaching and inspiration lay at the heart of all of the Hewitt sisters' collecting. On their many trips to Europe, the young ladies began to amass decorative arts pieces as the foundation for the Museum. The Hewitts wanted to emulate the relatively new Museé des Arts Décoratifs in Paris, which, along with London's Victoria and Albert Museum, was dedicated to promoting and collecting fine decorative arts to inspire their national industries and trades. Many of the objects the sisters acquired were unusual and eclectic, reflecting an enormous range of works, from matchsafes and birdcages to wallpaper and fine lace. The items were then sent back to New York for the collections of the Museum that opened at Astor Place, the location of The Cooper Union.[4]

In 1907, in support of the new museum, the American businessman George Hearn founded the Museum Council, whose original members included Louis Comfort Tiffany (1848–1933), Daniel Chester French (1850–1931), J. Carroll Beckwith (1852–1917), and Edwin Howland Blashfield (1848–1936), all noted artists of their time, in addition to various collectors, lawyers, and other "men of property." Over the next two and a half decades, the Council acted as a quasi-Board of Directors, guiding the Museum's programming, making acquisitions, and assisting with fundraising.

In the second decade of the twentieth century, the Hewitt sisters started acquiring American figurative works and landscapes, including the works of Homer, Church, and Moran. Although nineteenth-century American art was not a particular interest of the Hewitt sisters, who favored European decorative arts, they viewed these works as important as "inspiration" and training in the creative process for future designers. As Eleanor Hewitt noted in 1919: "As quickly as they can be acquired, leaves from the note and sketch books of artists of the last half of the nineteenth century, and of the present day, are being placed (on the walls of the corridors and staircases). Distinguished men, namely, Frederick [sic] E. Church, Winslow Homer, Robert Blum, many other Americans . . . are already represented. The first conception of numerous well-known pictures, perhaps dotted down merely on an envelope, box cover, or chance scrap of paper, are there to inspire and illuminate students and laymen."[5]

Between 1916 and 1920, artist Eliot Clark assisted the Hewitt sisters in finding and acquiring drawings,[6] often in conjunction with Charles W. Gould, a prominent New York attorney and

member of the Cooper Union Board and Museum Council. Gould, who also served as a trustee at the Metropolitan Museum of Art, had a sizable group of works by Winslow Homer, including his acclaimed painting, *The Herring Net*. In 1916, Gould donated two drawings by Homer and began working with Clark to secure several key collections for the Museum. In 1917, they orchestrated the gift of 2,035 works by America's leading landscape painter, Frederic Church, which included 514 oil sketches and 1,521 graphite drawings in forty-seven sketchbooks and 492 loose sheets. According to Clark's account, he initially wrote Church's son, Louis Palmer Church, to ask whether he would consider giving his father's pieces that remained at Olana to the Cooper Union Museum. Clark and Gould then visited Church for two days and reviewed the extant works.

Clark and Gould chose very few of Church's early works, instead concentrating on work from the 1850s and 1860s, when the artist was fully mature. Once Clark and Gould made their choices, these works were sent to New York, where several were exhibited at an April 1917 reception for the Museum Council held at the Hewitt sisters' home. The sisters then sent a letter to Louis Palmer Church, acknowledging the gift and inviting him to visit the Museum where his donated works would now reside. Church replied, "I am only too glad that the sketches are to be in such good hands and are to be preserved in such an institution. And the fact that they will help others adds so much to it."[7]

Original records from the Registrar's office specify that "the [Church] collection was acquired in 1917 by the Misses Sarah and Eleanor Hewitt." At that time, Church was almost a forgotten painter. The sisters were eager to acquire what were considered minor works shunned by other museums and ended up taking nearly two-thirds of the materials at Olana.[8] The sisters were very vocal about their intention to use the works less as fine-art works than specifically as "teaching tools." The unfinished qualities of most of these works which prevented them from selling on the market were exactly what drew the Hewitts to acquire them.

2. Winslow Homer. *Study for "The Herring Net,"* 1884. Black, brown, and white chalk, white gouache on green laid paper.

We have far less detailed information on the Museum acquisition of the Winslow Homer works. Legend has it that Homer's elder brother and heir, Charles Savage Homer, Jr., and his wife Mattie played bridge with the Hewitt sisters, perhaps leading to the latter's inquiring about the artist's remaining works. Moreover, Charles Gould and Eliot Clark may have already been negotiating with Charles Homer for these works while working on the Church gift. In any event, in 1912, the Cooper Union Museum was given more than three hundred Homer drawings and watercolors by the artist's brother. In 1915, Charles Homer gave one Homer oil sketch to the Museum; two years later he donated another nine; and at his death, his widow added twelve more oils to the Museum's Homer collection. Supplementing this, in 1916, Gould donated two Homer drawings, including the most "finished" graphite study for *The Herring Net* [FIG. 2], and Eliot Clark gave fourteen Winslow Homer woodcuts from *Harper's Weekly* magazine.

In 1917, Clark also facilitated the third major American gift to the collection: eighty-three drawings and water-

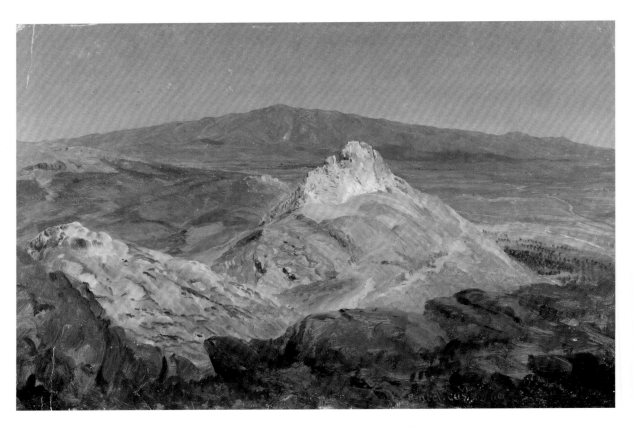

3. Frederic Edwin Church. *Mount Pentelicus, Greece*, 1869. Oil over graphite traces on cardboard.

colors, two retouched photographs, and four prints by Thomas Moran. According to Clark, he used the Homer gift to convince Moran to donate his works to the Museum. Decades later, Clark donated his own Frederic Church oil sketch, *Mount Pentelicus*, to the Hewitt sisters' museum [FIG. 3]. By 1927, the American drawings and paintings collection at the Cooper Union Museum was noted in an article written by Clark for *Art in America*.[9] Eliot emphasized that the collections were unique in that they contained many preparatory works by the three artists, thus providing particular information on the artists' creative process as well as a significant educational function for students. In crafting an exhibition at the National Design Museum, curators Gail Davidson and Floramae McCarron-Cates have remained true to the Hewitt sisters' usage and viewing intention of the Homer, Church, and Moran works. Although each artist has been written about extensively in monographs and histories of art, there has been little discussion of their landscape work relative to America's burgeoning tourism and land development. Church and Moran chose to depict the American landscape as

pristine and largely untouched by the realities of railroads, growing urbanization, manufacturing, and building expansion. Instead, as Davidson and Sarah Burns describe in their essays, their decision to depict unsullied and agrarian landscapes was a nostalgic "construction" of a landscape that was rapidly disappearing. Ironically, while their works reflected a pristine American landscape, the artists also helped to further the economic development that contributed to its demise.

This exhibition and book are a celebration of the American paintings, watercolors, and drawings being returned to Cooper-Hewitt, National Design Museum after being on loan, with many on public view for the first time in nearly half a century.[10] Seen in the context of the changing American landscape design, each artist's creative choices and processes are revealed. As the Hewitt sisters had intended to present these works as valuable teaching tools by demonstrating alternate views and creative processes from decorative arts, it is good to have them back in the Cooper-Hewitt collection.

Thomas Moran Sketching at
Grand Canyon
of Arizona

A large painting of the Grand Canyon of Arizona, by Thomas Moran, N. A., hangs in the National Capitol at Washington, D. C.

Mr. Moran was the first American artist of note to visit this world's wonder. He still frequently goes there to get new impressions. In his summer home at Easthampton or in his New York City studio, usually may be seen several canyon canvases under way.

Quoting from Chas. F. Lummis, in a recent issue of *Out West* magazine: "He (Moran) has come nearer to doing the Impossible than any other meddler with paint and canvas in the Southwest."

Other eminent artists also have visited the titan of chasms. They all admit it to be "the despair of the painter."

You, too, may view this scenic marvel as a side trip on the luxurious and newly-equipped

California Limited

en route to or from sunshiny California this winter.

Only **two** days from Chicago, three days from New York, and one day from Los Angeles. A $250,000 hotel, El Tovar, managed by Fred Harvey, will care for you in country-club style. Round-trip side ride from Williams, Ariz., $6.50.

Yosemite also can be reached in winter from Merced, Cal., nearly all the way by rail.

Write for our illustrated booklets: "Titan of Chasms" and "El Tovar."

W. J. Black, Passenger Traffic Manager
A. T. & S. F. Ry. System
111 Railway Exchange, Chicago

4. Santa Fe Railroad advertisement, in *Fine Arts Journal*, January 1909. Photomechanical reproduction on white wove paper.

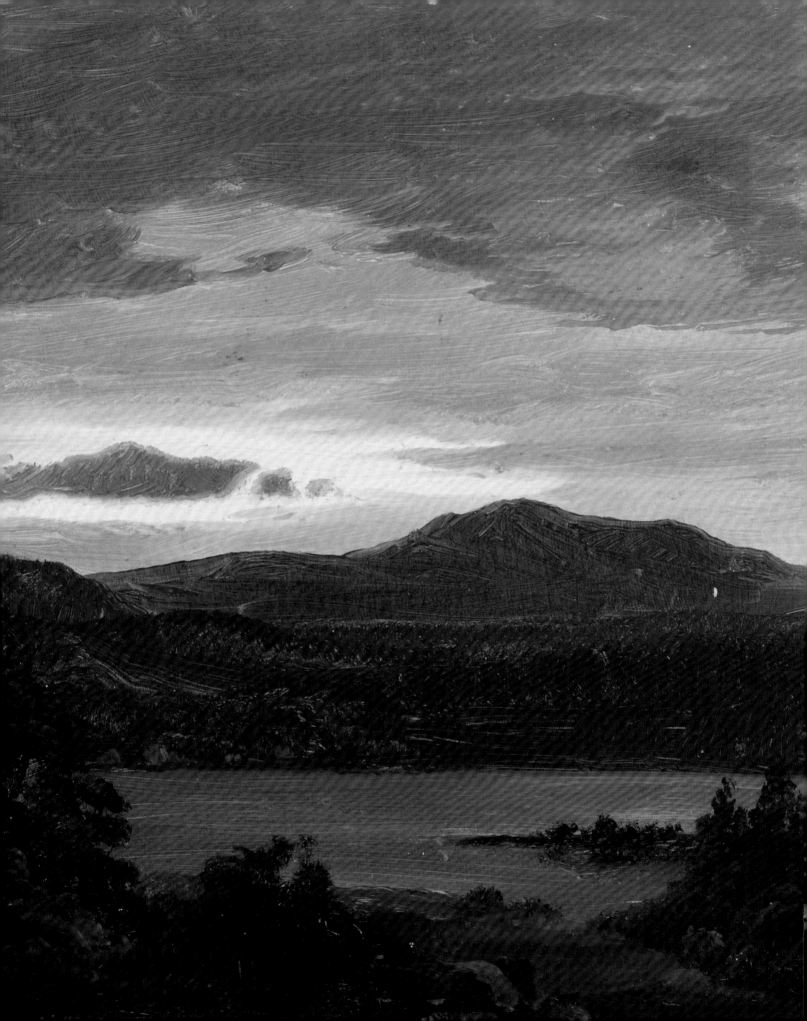

Landscape Icons, Tourism, and Land Development in the Northeast

Gail S. Davidson

In 1883, the admired and influential editor of *The Nation*, Edwin Lawrence Godkin, published a satirical essay entitled "The Evolution of the Summer Resort," on the birth and development of vacation spots.[1] According to Godkin, the resort phenomenon occurred in three phases: In the first phase, artists searching for subject matter, or families seeking an informal, healthy and inexpensive place to stay, appeal to a farmer to let them board at his house. The farmer, though first unwilling, agrees to take them in. When he realizes how much money he is making, the farmer initiates the second phase by expanding his business venture through advertising, getting endorsements from respected clergy, enlarging the house, and hiring a cook. The neighbors, who want to share in the good fortune, follow the farmer's example. Over time, the farmhouses and inns grow into larger hotels, catering to a permanent group of summer visitors. In the final phase, some of the boarders become so enamored of the scenery that they purchase lots and build private cottages. The hotel boarders, who have now become second-class citizens, are driven away to seek newer resorts; and the cycle begins again.

Though primarily intended as a witty critique of the wealthy elite "cottagers" on Mount Desert Island, Maine, like the Ogdens and the Kennedys, Godkin's analysis seemingly struck many people as truthful. More than fifty years later, the cultural historian Hans Huth, in his 1957 book, *Nature and the American: Three Centuries of Changing Attitudes*, also articulated a three-phase development of resorts, which starts with artists and writers exploring a place and locals creating boarding houses to serve them. In the second phase, the boarding house becomes a rustic hotel filled initially by cultured and refined visitors, then by more economically diverse vacationers. In the final phase, the elite clientele, seeking refuge from the larger community of resorters, builds their own cottages with privately owned beaches, thereby establishing class divisions within the resort community.[2] Godkin and Huth's analyses provide the framework for a more complex and nuanced account, visually supported by the works of Frederic Edwin Church (1826–1900), Winslow Homer (1836–1910), and Thomas Moran (1837–1926) in the collection of Cooper-Hewitt, National Design Museum, of the interaction of artists and business entrepreneurs in the development of tourism in the second half of the nineteenth century.

NIAGARA

During the nineteenth century, landscape painters pioneered the quest for "sublime" sights, seeking to convey on paper and canvas a divine presence in the marvels of nature.[3] As both Europe and America transformed from rural to industrial, urban societies, a culture of landscape developed, with writers and artists leading the search, in virgin wilderness areas, for an imagined Virgilian "picturesque" world of pastoral beauty and virtuous simplicity.[4]

FRONTISPIECE Frederic Edwin Church. *Mount Katahdin from Lake Katahdin* (detail), ca. 1853. Brush and oil on thin paperboard.

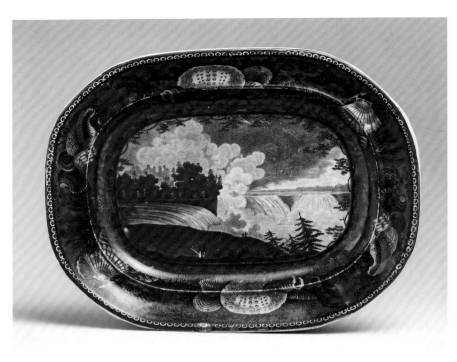

1. Enoch Wood & Sons. Platter: *View of Niagara Falls from New York*, ca. 1828–46. Transfer-printed earthenware.

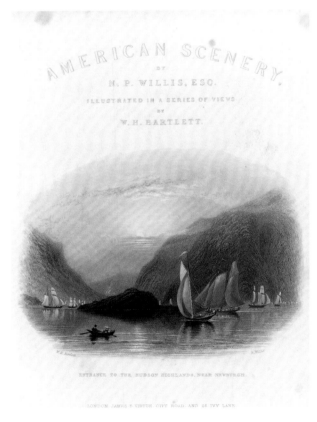

2. After William Henry Bartlett. Title page: *American Scenery*, 1840. Steel engraving on white wove paper.

The first artists to portray the American landscape through this romantic lens were British or Irish. One image of Niagara Falls from the French publication *Itinéraire Pittoresque du Fleuve Hudson* (1828–29) was reproduced on transfer-printed earthenware manufactured in Staffordshire, England for the American market by Enoch Wood [FIG. 1]. About ten years later, the topographic draftsman William Henry Bartlett (1809–1854) provided the illustrations [FIG. 2] to the 1840 book *American Scenery* by the well-known American journalist Nathaniel P. Willis.[5] Bartlett traveled to the United States in late 1836 and 1837, making watercolor drawings of notable Eastern landscapes and city views in New York State, from the Hudson Valley west to Niagara; in the New England states; and in the South as far as Virginia. One hundred seventeen engraved full-plate views, two of which were after Thomas Doughty (1793–1856), helped establish the canonical iconography of American vistas, which would be copied throughout the nineteenth century by European and American painters and printmakers, including Currier and Ives,[6] and appear on transfer-printed earthenware.[7] While most of this pottery was crude, inexpensive, souvenir-type earthenware, printed in blue, red, and brown, some manufacturers fabricated more upscale editions. An exceptional example is a painted porcelain dessert service with Rococo revival gilded decoration, produced between 1840 and 1844 by a Staffordshire manufacturer, probably Ridgway or Alcock, which included thirty-seven views after Bartlett [FIGS. 3, 4]. The large-scale production of the cheaper wares, in addition to the printed images, not only helped implant the American landscape in the minds of the public during the pre-Civil War years, but also encouraged scenic touring.

By the second half of the century, as incomes grew and working people had more leisure hours, scenic touring became accessible to middle-class as well as wealthy Americans, increasing the market for such souvenirs. Vacationers, inspired by the enduring images of Niagara Falls, the Hudson River Valley, the Adirondacks, the White Mountains, the

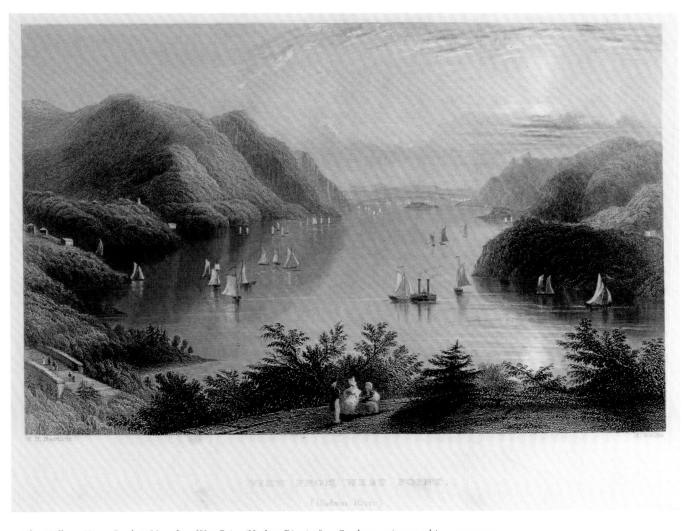

3. After William Henry Bartlett. *View from West Point (Hudson River)*, 1840. Steel engraving on white wove paper.

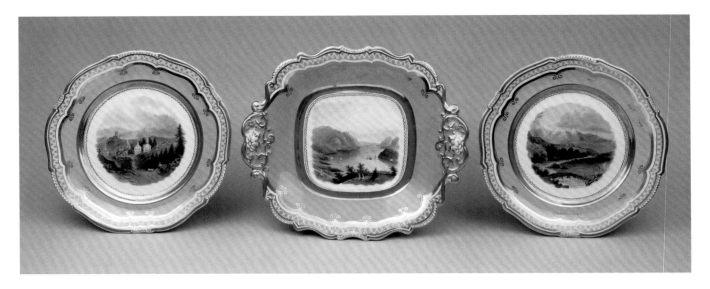

4. Attributed to Ridgway or Alcock. Platter: *View from West Point*; plate: *The Village of Catskill*; plate: *Mount Washington and the White Mountains*, ca. 1840–44. Transfer-printed, painted, and gilded porcelain.

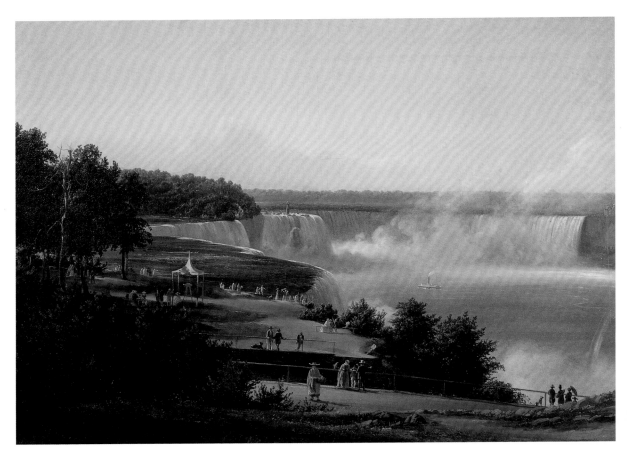

5. Ferdinand Reichardt. *Niagara*, ca. 1855. Oil on canvas.

rugged Maine coast, the Grand Canyon, Yellowstone, and Yosemite, followed in the artists' footsteps. Painters recorded, romanticized, edited, and sometimes embellished iconic views that dove-tailed with the nationalistic currents of the time, such as manifest destiny, abolition, pastoral nostalgia, and anti-urbanism. Their drawings and paintings, disseminated via exhibitions, reproductive prints, illustrated publications, and deluxe "coffee table" guidebooks, stimulated the burgeoning tourist industry, created a national market for landscapes, and established artists' careers.

Niagara Falls and the Catskills were two early vacation destinations drawing people from New York, Philadelphia, Boston, Chicago, down the Mississippi as far as New Orleans, and even Europe. Niagara had been considered America's greatest natural wonder since the eighteenth century, attracting, as early as 1838, around 20,000 visitors per year.[8] Well before its most famous

6. Attributed to Platt D. Babbitt. *View from Prospect Point*, ca. 1855. Daguerreotype (shown reversed).

interpreter, Frederic Church, arrived in the mid-1850s, many artists had attempted to convey its magnificence, including John Trumbull (1756–1843), Alvan Fisher (1792–1863), John Vanderlyn (1775–1852), Thomas Cole (1801–1848),

7. Langenheim Brothers. *Winter Niagara Falls, Terrapin Tower, Goat Island*, 1854. Glass plate stereoview.

Jasper Francis Cropsey (1823–1900), and John Frederick Kensett (1816–1872).⁹ By the mid-nineteenth century, the awe-inspiring cataract, or waterfall, was showing signs of physical wear and tourist overpopulation. In June 1850, a large portion of Table Rock, the viewing ledge suspended over the gorge on the Canadian side, fell. In 1852, large portions of rock broke off into the river beneath Prospect Point, the American side's main viewing area, and a very large rock broke away on Goat Island, the small island between the American Falls and the Canadian Horseshoe Falls.¹⁰

By 1850, somewhere between 50,000 and 60,000 tourists, out of a total resident U.S. population of 23 million, visited Niagara annually. One *New-York Daily Times* travel reporter expressed his frustration with the commercialism and general tackiness of the place: "Niagara . . . is overrun with savages of the bore kind . . . [who] pursue you relentless from the moment your eager foot descends from the [railroad] car."¹¹ Ferdinand Reichardt (1819–1895) rendered, in perhaps a more benign and pleasant light, the texture of Niagara tourism in the 1850s in his painting *Niagara Falls from Prospect Point* [FIG. 5], from a series of paintings he executed on this site.

The daguerreotypist Platt D. Babbitt (1822–1879), who was described in the above article as "that gen-

tleman with an elephantine camera," and whose pagoda-like pavilion could be seen in Reichardt's painting, had maintained a photography stand in Prospect Park as early as June 1852.¹² Daguerreotypes and glass-plate stereographs of Niagara visitors at Prospect Point caught by Babbitt's camera can be found in many photography collections; Church owned at least three early daguerreotypes attributed to Babbitt, one showing tourists gazing at the majestic cataracts from the edge of Prospect Point [FIG. 6].

In addition to Babbitt's photography enterprise, other tourist concessions were created by American and Canadian hotel operators and real-estate entrepreneurs, who owned the land on both shores and therefore controlled access to the view. Over the years they were able to stretch the visitor's experience of Niagara from hours to days by building a variety of viewing stations, such as the Terrapin Tower, transportation facilities, and other attractions, each of which cost a separate fee [FIG. 7]. Niagara's business entrepreneurs, like the Porter and Whitney families on the American side and the Forsyth family on the Canadian side, saw no contradiction between industrial development and the romantic appreciation of the natural spectacle, and optimistically promoted Niagara Falls as a divine wonder as well as a thriving mill town gener-

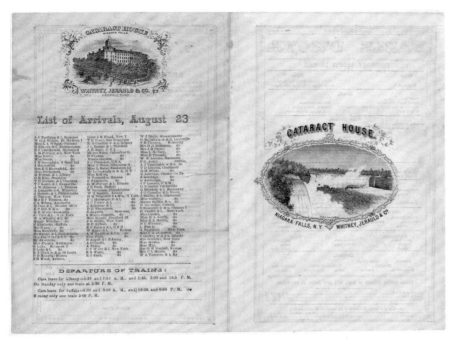

8. Cataract House menu, August 23, 1865. Wood engraving.

1855 of John Roebling's railroad suspension bridge over the Niagara river, some distance from the Falls,[14] must have made Church aware of increased development there [FIG. 10]. He likely sensed that the site would soon never be the same; moreover, the heightened profile of the cataracts offered an opportunity for the artist to capture clients who would jump at the chance to purchase a Niagara picture.

In the early 1850s, Church, his fellow artists, and tourists coming from New York would have reached Niagara by boat up the Hudson and along the Erie Canal, or via the Erie Railroad, touted as the best way to travel because tourists did not have to transfer trains five or six times. This route took passengers through the Delaware and Susquehanna valleys to Buffalo with only one transfer, and from there by carriage or horse-drawn train to Niagara. As of 1853, tourists could also take the New York Central Railroad, with a change of trains at Albany, all the way to Buffalo; in Buffalo, travelers could take a train to Niagara.

Church arrived in Niagara by March 19, 1856, and most likely stayed at the Cataract House Hotel, where he stayed the following July. Perhaps because he was based on the American side, the artist's early Niagara studies are located on this eastern side of the Falls, specifically on Goat Island, between the American and Canadian cataracts. The sunset on March 20th especially captivated Church, and after making initial graphite drawings in situ, he painted two exceptional oil sketches, in the Cooper-Hewitt collection, of Niagara Falls and Terrapin Tower from Goat Island on this theme. The smaller of the two [FIG. 11] may have been painted on the spot, since the tack holes in the corners suggest Church executed the sketch in the cover of his paint box, which was his normal working practice for plein-air oil sketches.[15] Working quickly from a high spot on Goat Island, close to the water's edge, Church focused on Terrapin Tower and its fragile wooden approach bridge enveloped in snow. Behind these structures, the turquoise water rushes towards and over the cascade, while a salmon-colored mist rises from the base of the cataract into the sky, dissolving into the purple-gray clouds.

ated by the powerful waters that they presumably held sacred.[13] Through tourist attractions and concessions and continual renovations of grand hotels like the Cataract House and Clifton Hotel, where Church stayed, Niagara was transformed from a sublime experience of natural beauty to an object of commerce parceled out and consumed by acquisitive visitors, whose numbers reached close to one million annually by 1900 [FIGS. 8, 9].

But if Niagara was overrun with tourists, you would never have known it by looking at Frederic Church's Niagara paintings or oil sketches. The earliest surviving Church sketches of the Falls date from March 19, 20, and 21, 1856. His artist friends Kensett and Cropsey had already made their pilgrimage to this landscape icon; Kensett drew and painted plein-air oil sketches in 1851, 1852, and 1857; and Cropsey in August 1852 and September 1855. For most of these years, Church sought less frequented turf in Maine, on Mount Desert Island and Mount Katahdin, and particularly in South America, where he spent six months in 1853. In 1854, he was preoccupied with painting and exhibiting his paintings of *Cotopaxi* and the *Andes of Ecuador*. However, the press coverage in March

9. Langenheim Brothers. *Clifton Hotel*, ca. 1855. Glass plate stereoview.

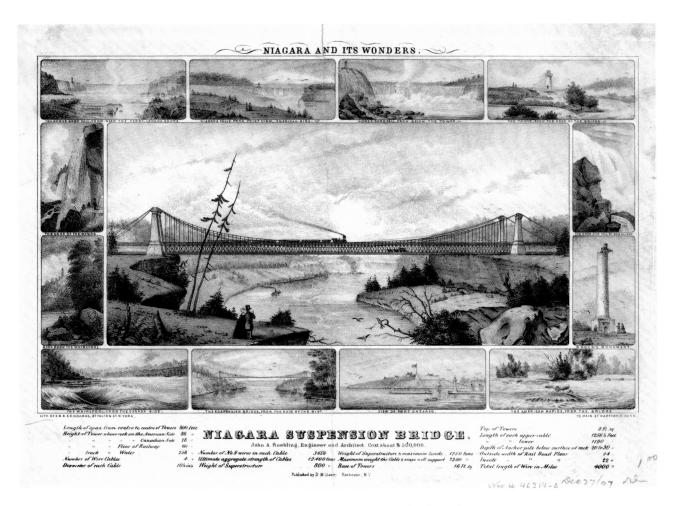

10. E. B. and E. C. Kellogg. *Niagra and Its Wonders: Niagara Suspension Bridge*, not dated. Lithograph on wove paper.

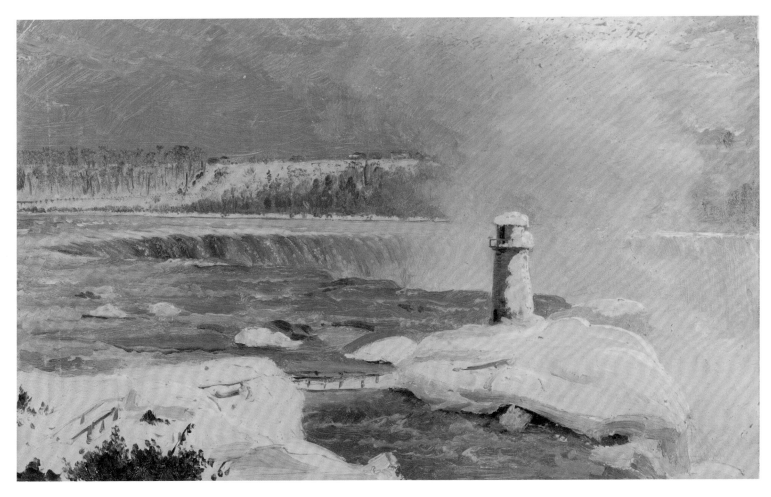

11. Frederic Edwin Church. *Niagara River and Falls in Snow*, March 1856. Brush and oil paint, graphite on paperboard.

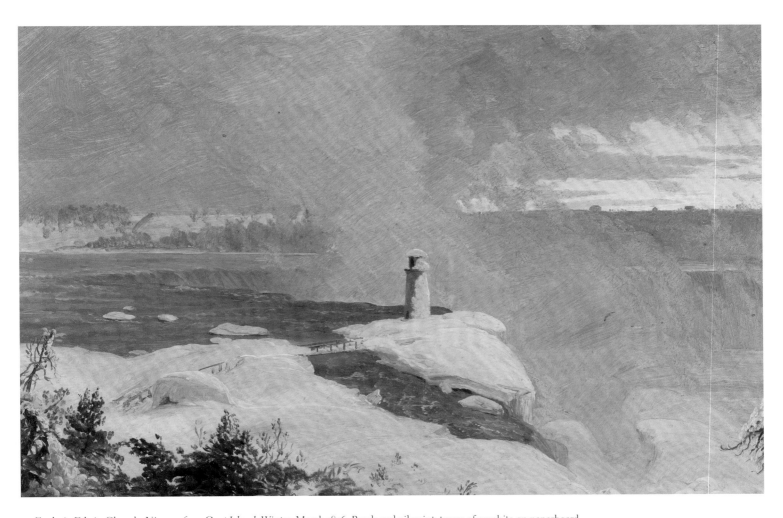

12. Frederic Edwin Church. *Niagara from Goat Island, Winter*, March 1856. Brush and oil paint, traces of graphite on paperboard.

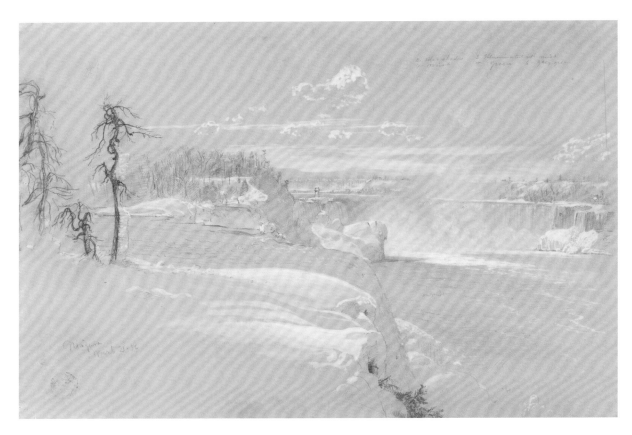

13. Frederic Edwin Church. *Niagara Falls in Winter*, March 21, 1856. Graphite, brush, and white gouache on grey buff paper.

This small sketch dashed off at the end of a cold day became a point of departure, with additional graphite studies for a larger, more highly finished studio sketch [FIG. 12]. In this work, the artist moved back and further to the right, shifting the Tower toward the middle of the composition. He also focused on a later, more dramatic moment of the sunset, when the bright, back-lit sky shined through the hot-orange tinged mist and clouds. These more complicated lighting and color effects requiring an additional effort on the artist's part, which Church acknowledged by his signature, suggest, as Eleanor Harvey noted, that the artist may have intended to exhibit the larger sketch at one of the National Academy exhibitions.[16]

From the Falls' southern side, Church seems to have generally worked his way north along the edge of the gorge and over to the western Canadian side, finally focusing on the view behind Canada's Horseshoe Falls for his first "Great Picture" of Niagara. By March 21, he had moved farther up-river, probably to Prospect Park on the edge of the American Falls, and in a drawing in graphite on grey buff paper [FIG. 13] captured a broader view of the American and Canadian Falls. Terrapin Tower sits again in the center of the composition, but is much smaller, and no longer functions as the organizational focus. Instead, dark, skeletal cedars on a snow-covered bank in the left middle ground capture the eye and form a foil behind which one looks over the American Falls to Luna and Goat islands with large ice- and snow-covered rocks beneath, to the Tower, the Horseshoe Falls, and to Table Rock with the Pavilion Hotel just visible at the right edge.

Church returned to Niagara in July, and again in October, 1856, to continue his search for the perfect Niagara view. In October, he worked more frequently on the Canadian side.

Based on sketches made during the fall trip, Church initiated, but never completed, a carefully detailed studio oil sketch of the view from the

water's edge on the Canadian side looking up and into the Falls [FIG. 14]. Another previously published study from his fall 1856 visit was painted on the spot. This is a beautiful and mysterious view, either late in the day or by moonlight, of the Canadian Falls [FIG. 15]. Quickly painted, with a slightly dry brush, this unusual sketch of Niagara might have rivaled any of the known Niagara-by-moonlight scenes had it been developed into a finished oil painting for an exhibition.[17]

Ultimately, when selecting the vantage point for his "Great Picture," *Niagara* [FIG. 16], Church rejected all of the above examples, and chose instead a more dramatic perspective from behind the Canadian Falls, where the visitor could stand on level ground with the cataract itself. In fact, Church went one step further, offering an unmediated encounter with Niagara's tremendous energy, and giving the viewer the disorienting sensation of teetering on the water's edge—a sublime experience executed to perfection. The origin of this picture can be traced in three graphite sketches in the Cooper-Hewitt collection. A graphite and white chalk sketch on tan paper from the Canadian bank, with stones and some plant matter in the foreground, looks out over the U-shaped edge of the Horseshoe Falls back to the Tower and Goat Island, to the American Falls and shore in the left distance [FIG. 17].

In this sketch, Church altered the perspective to fit what was a very broad view into an eleven-by-eighteen-inch format, and he may have opted at this time to try a panoramic view, more ideally suited to the scale of the real site. An unfinished and unpublished panoramic study on three sheets of paper [FIG. 18] and an oil sketch based on it probably preceded a small thumbnail sketch [FIG. 19] focusing on the elongated C-shaped contour of the cataracts going from the American Falls in the left distance around in a clockwise direction through the U-shaped Horseshoe Falls into the left foreground. These concept sketches were next developed in the final preparatory sketch at Olana, which directly preceded the "Great Picture."

If Church ignored in his pictures the tourists and tourist traps that had invaded the cataract, he cer-

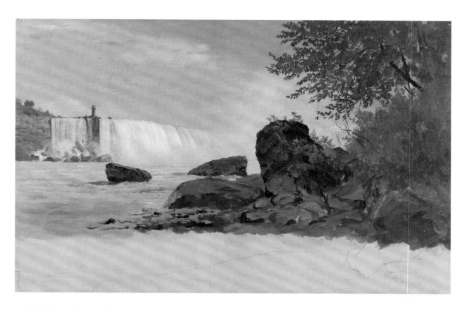

14. Frederic Edwin Church. *Niagara: View of the Canadian Falls and Goat Island*, September or October 1856. Brush and oil paint, graphite on paperboard.

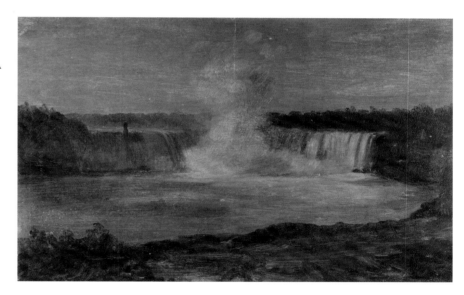

15. Frederic Edwin Church. *Niagara Falls in Evening Light*, September 1856. Brush and oil paint on paperboard.

tainly was not oblivious to collectors and the fine-arts audience who would have understood his intentions in painting his monumental canvas. In fact, Church's entrepreneurial savvy, like that of Winslow Homer and Thomas Moran, equaled the promotional skills of Niagara's real-estate and hotel developers. In an unprecedented venture, the artist, before completing the Corcoran picture, placed the Olana preparatory sketch with other Niagara oil

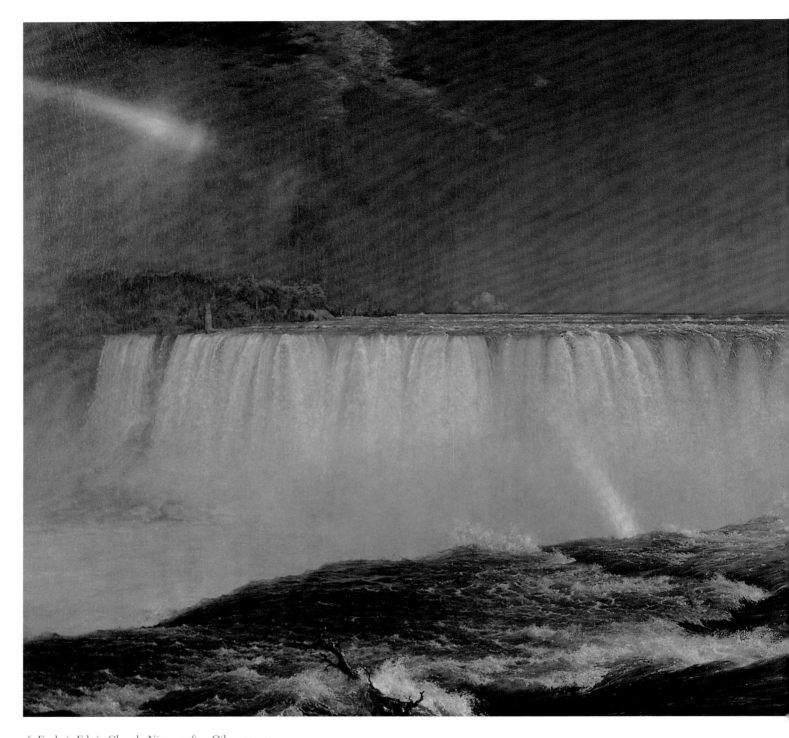

16. Frederic Edwin Church. *Niagara*, 1857. Oil on canvas.

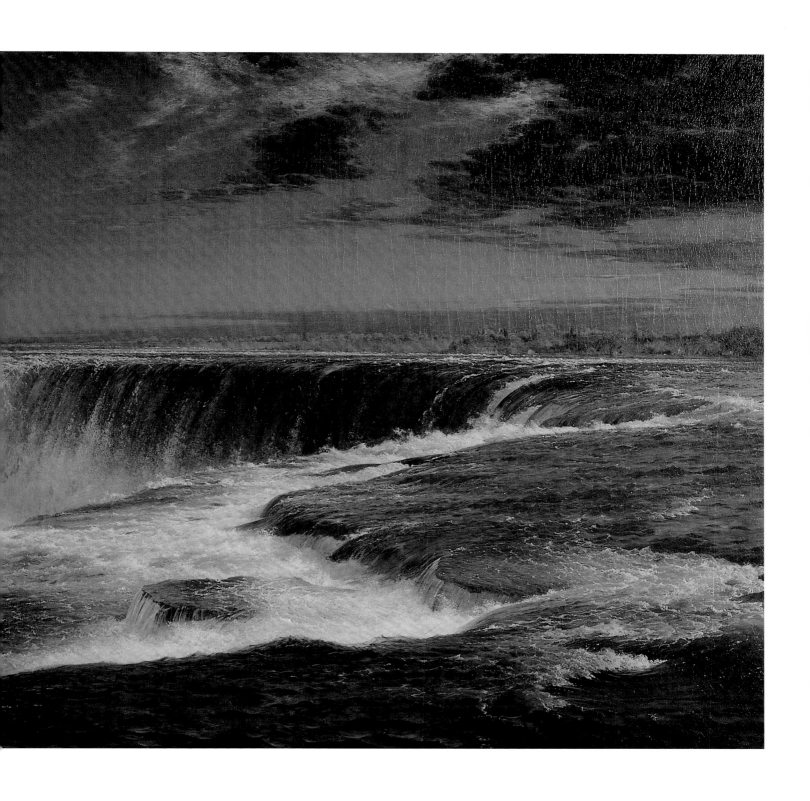

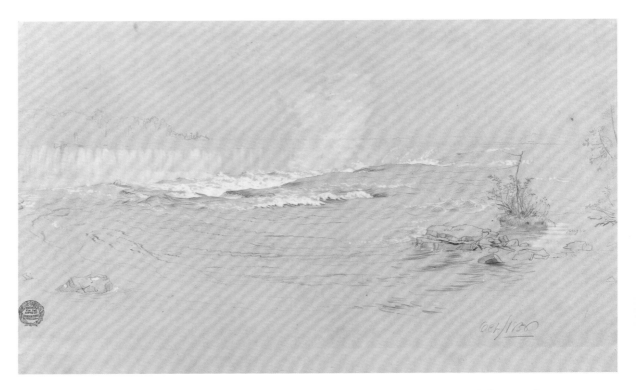

17. Frederic Edwin Church. *Niagara, Canadian Falls and Goat Island*, October 1856. Graphite, brush, and white gouache on tan paper.

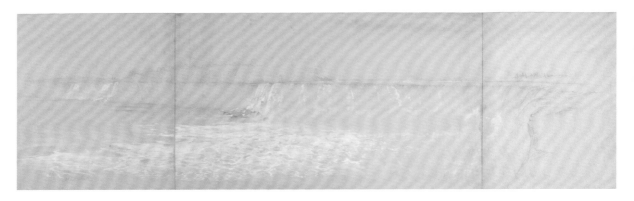

18. Frederic Edwin Church. *Niagara Falls Panorama*, ca. 1857. Graphite on paper.

sketches on view in his studio in the Tenth Street building in December 1856 to induce press coverage for his project and whet the appetite of potential buyers. Subsequently, instead of following the usual procedure of exhibiting a major work at the National Academy, he chose a more newsworthy route by selling the painting along with the publication rights directly to the New York dealers Williams, Stevens, and Williams. Skillfully marketing the picture between 1858 and 1859 in U.S. and British exhibitions, the gallery also commissioned a chromolithograph from London printmakers Day & Son to be sold along the tour [FIG. 20]. Public response to the seven-foot-long, three-and-a-half-foot-high panorama of Horseshoe Falls was explosive. For the thousands of viewers and print purchasers in England and in U.S. cities from New York to New Orleans, Church's *Niagara* supplanted Niagara itself as the symbol of America, and helped establish the artist's reputation as the greatest living landscapist.[18] At the last minute, the 1857 picture was included in the American display in the Paris

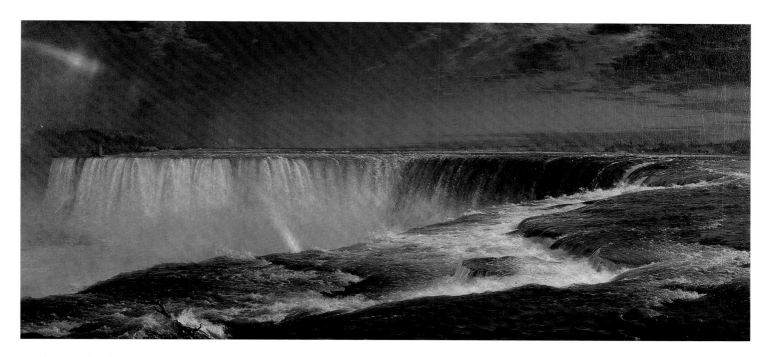

20. Charles Risdon after Frederic Edwin Church. *Niagara*, 1857. Chromolithograph.

1867 *Exposition Universelle*, where its symbolism and virtuoso technique created a sensation.

The exhibition of the 1857 *Niagara* in Paris replaced an earlier plan to display a new epic Church Niagara picture that New York dealer Michael Knoedler commissioned in 1866 for $15,000.[19] Instead of preparing fresh on-site sketches, the artist based the new work on studies made more than ten years earlier. One of these studies derived from an albumin print that Church had acquired in October 1856, now in Cooper-Hewitt's collection, of a view from the gorge below Prospect Point looking across the cascading American Falls on the left toward the Horseshoe Fall in the right distance [SEE MCCARRON-CATES, FIG. 26]. Painting on the photograph, which provided the overall compositional scheme, Church envisioned the color palette for the new picture, especially the turquoise blue water falling over the precipice. This photographic image, and a tiny thumbnail graphite sketch also at Cooper-Hewitt, became the compositional inspiration for Church's second great extant Niagara picture, *Niagara Falls from the American Side*, 1867 [FIG. 21].

19. Frederic Edwin Church. *Study for a Painting of Niagara Falls*, 1857. Graphite on cardboard.

There was nothing especially novel about painters like Church using photographs as a shortcut in their artistic process. Thomas Moran would have been working with his brother John's photographs as aide-mémoire by this date. By 1856, daguerreotypes and full-plate photographs were available to painters as memory aids or for inspiration. Church owned two daguerreotypes he might have referred to for the 1867 picture, along with the retouched photo and miniature graphite sketch [FIG. 22]. Church also used two additional oil sketches as source material:

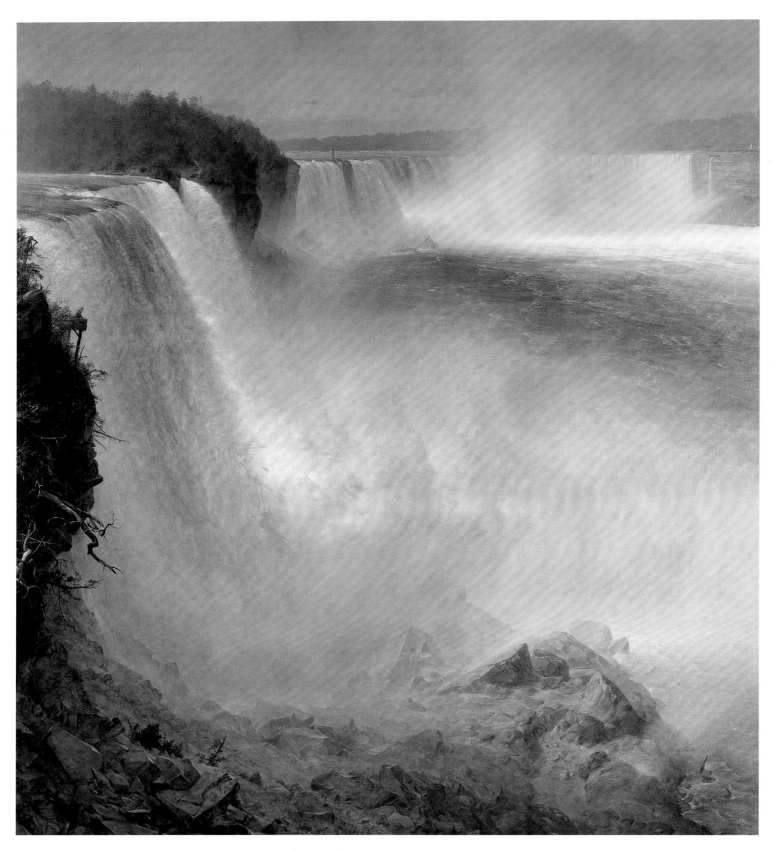

21. Frederic Edwin Church. *Niagara Falls from the American Side*, 1867. Oil on canvas.

a close-up view of the cascading waters at the foot of the American Falls; and a detailed study of the pyramidal rock formation, which appears in the lower right corner of the aforementioned sketch and in the large 1867 picture.[20] The finished painting includes three tiny figures, two of which stand on a viewing platform suspended over the steep escarpment, a device of scale which reinforces humanity's insignificance before the eternal spectacle. This is Church's only reference to the hordes of visitors who must have been climbing all over the landscape.[21]

As with his first iteration of Niagara, Church and his dealer skillfully choreographed the debut of his new painting. In 1867, Knoedler sent the picture to Paris, where it was chromolithographed, and on to London for exhibition at a commercial gallery to positive reviews, before being shown in Boston at the Williams Everett gallery. A brochure which accompanied the painting dramatically recounted Church's clinging to a treetop while preparing his sketches, and suggested that viewers examine the picture's individual elements through a tube in order to achieve a complete understanding of the falls. The pamphlet served a dual purpose, hyping the painting while promoting subscriptions for the reproductive chromolithograph.

Even though Niagara had long since lost its pristine character, having been polluted by industry and tourism, the notion of Niagara the beautiful — more than Niagara as primeval wilderness — found expression in paintings by Church's contemporaries John Frederick Kensett and Albert Bierstadt (1830–1902). Moran, who outlived all of his second-generation Hudson River School colleagues, was the last interpreter of the theatrical, symbolic Niagara. In 1881, he received a commission for fifteen designs of Niagara Falls to illustrate *Picturesque Canada*, modeled on the earlier volumes of *Picturesque America*, for which he had also executed illustrations.[22] Though the Canadian books were published between 1882 and 1884, the commission came from the New York engraving firm of Frederic Schell and Thomas Hogan, who executed the book's wood-engraved illustrations after drawings of many different artists. Moran also executed a number of paintings of the rapids above the falls and of the American Falls from

22. Attributed to Platt D. Babbitt. *American Fall*, ca. 1855. Daguerreotype (shown reversed).

below Goat Island. His etching of the Horseshoe Falls from the Canadian side portrays a romanticized view of the cataract, emphasizing the aesthetic quality of the etched line as well as Niagara's raw emotion and physical power [FIG. 23].

By the time Moran arrived at the falls in 1881, the national icon had become a national embarrassment, its banks and shores blighted by tourist buildings and factories which obscured the view from above and below. Hotel owners complained that middle- and upper-class cultured visitors had been replaced by a non-leisured class of excursionists who visited for the day and departed without spending the night.[23] Even honeymooners, who had been a significant percentage of Niagara's tourist population, chose other destinations.

About ten years earlier, Niagara's scarred state had served as an object lesson in the campaign to preserve Yellowstone. By the early 1880s, the successful creation of Yosemite as the first state preserve (1864) and Yellowstone as the first national park (1872) be-

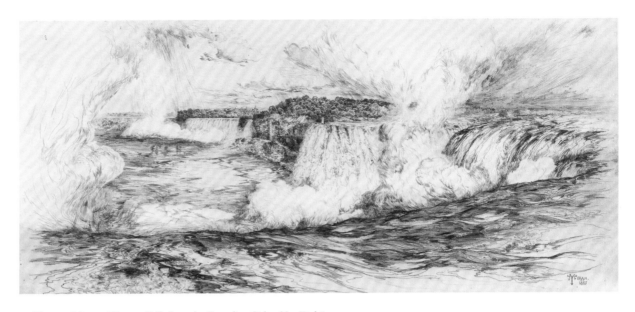

23. Thomas Moran. *Niagara Falls from the Canadian Side*, 1885. Etching on paper.

came the model for advocates of Niagara's restoration. The Free Niagara Movement, as the preservation impulse came to be called, was born officially at a meeting in the Cataract House on August 7, 1869 [FIG. 24]. Attendees included Frederick Law Olmsted (1822–1903), noted landscape architect and participant in the Yosemite preservation project; William Dorsheimer, a district attorney and Republican Party leader in Buffalo; and Dorsheimer's friend and architect Henry Hobson Richardson (1838–1886). A case could be made, however, that the unofficial birthplace of the movement was at the Century Club in New York City. All three men — Olmsted, Dorsheimer, and Richardson — were Club members, as was Frederic Church, who was known to have talked of the destruction of Niagara's scenery at the Club.[24]

While Olmsted, in an 1889 letter to Thomas V. Welsh, the first superintendent of Niagara Park, denied any direct contact with Church regarding the preservation of Niagara, and gave credit to the artist only begrudgingly in a report,[25] Church decidedly played a role in the preservation movement. In 1878, three years after a return visit to Niagara in 1875, Church spoke to William H. Hurlbert, an editor at the *New York World*, who met with Frederick Temple Blackwood (1826–1902, a.k.a. Lord Dufferin), Governor General of Canada,

urging Canada and New York State to hold joint discussions with the goal of creating a public park around the Falls. Hurlbert's visit encouraged Dufferin to speak to New York Governor Lucius Robinson, who appealed to the state legislature to support an international park at the Falls. The following year, the legislature authorized a report on the conditions of Niagara and what needed to be done to create a state reservation. The report, published in 1880, proposed that the state acquire the land around the cataract, restore it, and make it accessible free of charge to the public.

Meanwhile, all through the 1870s and into the early 1880s, unregulated private interests around the falls continued their development projects. The Porter family sold its riverfront property, including Prospect Point, to developers in 1872. The resulting Prospect Park Company, starting in 1873, made "improvements" to the park, which included establishing a store, fountains, an art gallery, several pavilions, a theater, and machinery for nighttime illumination of the falls, turning Niagara into a theme park *avant la lettre*. But the part of their plan that produced the most media flack was enclosing the park with a high board fence, thereby shutting out any view of the falls to any who did not pay an entry fee.[26] After the fence was installed, a subsequent writer in an article entitled "Extortions at

Niagara" tallied the charges at Niagara to be approximately $18.50 for a day's sojourn.[27] A cartoon by Arthur Lumley published in *Harper's Weekly* about this time, entitled *Niagara Seen with Different Eyes*, portrayed the variety of interests that had a stake in the struggle over Niagara: the tourists, the brides, the "practical businessman who runs the mills," the poets, the politicians, the American Indians, the artists, the geologists, the soldiers, and people who made their livelihood on the water [FIG. 25].

Increasingly, public opinion sided with government takeover and free access. The major hotels, like the Cataract House, the International on the American side, and the Clifton on the Canadian side also underwent extensive alterations, additions, or redecoration. Meanwhile, columnists noticed that the visiting population had largely become day-trippers who never used the hotels.[28] The preservation cause took on new urgency in 1883, when the Porters proposed to sell Goat Island to Cornelius Vanderbilt to build a palatial hotel with a permanent P. T. Barnum summer show. With this threat, socially prominent industrialists and writers formed the Niagara Falls Association to lobby for the reservation among the public, state legislators, local manufacturers, and hotel promoters. The pro-reservationists, who included Olmsted and Harvard art-history professor Charles Eliot Norton, argued the public park would be a win-win situation for everyone. For the working classes who had no second homes, suffering from the nervousness and alienation of city life, the reservation would offer a health-giving oasis; for business, it would bring visitors back to Niagara and thus boost tourism earnings; and for industry, it would raise property values and still allow the use of energy from the river and development of areas outside the reservation. In April 1885, the governor of New York state signed an appropriation bill to buy about one hundred acres of private property along the river for the reservation, and the New York State Reservation opened officially in July 1885. Two years later, Vaux and Olmsted received the contract to restore the grounds. They proposed judicious plantings to block the views and the noises of the city and the railroad, a series of carriage ways and trails to allow visitors to enjoy the

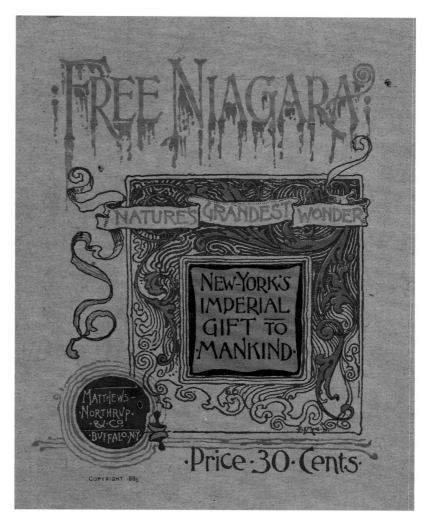

24. *Free Niagara, Nature's Greatest Wonder, New-York's Imperial Gift to Mankind*, 1885. Lithograph and photomechanical reproduction.

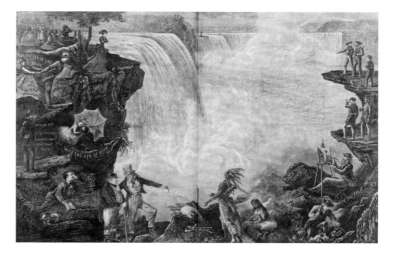

25. Arthur Lumley. *Niagara Seen with Different Eyes*, in *Harper's Weekly*, August 9, 1873. Wood engraving.

26. Thomas Cole. *View near the Falls of the Kauterskill, in the Catskill Mountains*, 1827. Oil on panel.

lush natural vegetation, and viewing stations limited to pedestrians.

In the final analysis, the preservation movement brought about one of those Faustian bargains typical of the American democratic process. In order to win votes for their plan, the reservation proponents gave the railroads, industrialists, and politicians clearance to develop Niagara's waterpower. Today, Niagara receives approximately twelve million visitors annually, many of whom are there for the Native-American casinos on the Canadian side. Despite Church's efforts and the New York State Reservation, American artists and middle-class tourists no longer flock to Niagara Falls; only the casinos are filled to the brim.[29]

THE CATSKILLS

If Niagara was the earliest of the country's tourist destinations in the nineteenth century, the Catskill Mountains, in New York State, ran a close second. By the mid-1820s, the Catskill Mountain House, the most celebrated of the Catskill resorts, had joined Niagara Falls and Saratoga Springs as an essential destination for sophisticated upper-middle-class travelers taking the fashionable American tour. The numbers of people visiting the Catskills grew exponentially in the following decades for various reasons: the region's proximity to New York City, the largest population center in the country; the increased availability of cheap steamboat travel up to Catskill Village, New York; and later, railroad accessibility.

Interest in the landscape, and Catskill scenery in particular, was also inspired by the contemporary literature of Washington Irving, James Fenimore Cooper, and William Cullen Bryant, all of whom based stories, novels, poetry, and newspaper reporting on their experiences in the Catskill Mountains.

In Cooper's immensely popular 1823 novel *The Pioneers*, the main character, Leatherstocking, describes the two most important sites, the view from the escarpment on South Mountain overlooking the Hudson River, and Kaaterskill Falls. Cooper's portrait of the area was commonly quoted in guidebooks, travel accounts, and essays through most of the century.[30]

While Irving, through his 1819 story "Rip Van Winkle" and *The Pioneers*, was arguably the most significant literary stimulus for Catskill tourism, the painter Thomas Cole was undoubtedly the leading visual interpreter of Catskill scenery from the 1820s through the 1840s. Just three years after he painted his first Catskill images in 1825, Cole's pictures were touted by James Kirke Paulding in *The New Mirror for Travellers; and Guide to the Springs* as more worthy of "gracing the drawings rooms of the wealthy" than British pictures or vulgar decorative arts objects. A. T. Goodrich even suggested that Cole, to a great extent, was responsible for making the Catskills a popular tourist spot.[31] Cole's 1827 painting *View near the Falls of the Kauterskill, in the Catskill Mountains*, commissioned for the main cabin of the steamship Albany, advertised the wild beauty of the falls to more people traveling on the Hudson River than any of his other pictures of this site [FIG. 26].[32]

Private collectors also played a role in the growth of Catskill landscape interest during the 1820s. Daniel Wadsworth, from one of Connecticut's wealthiest and most powerful families and a close friend of the painter John Trumbull, who had "discovered" Cole, commissioned a copy of Trumbull's 1826 Cole picture *Kaaterskill Falls* and became Cole's earliest patron; two decades later, he would become Frederic Church's early benefactor in the 1840s. Wadsworth's collection of American landscapes could be seen by the broader public in the fine-arts museum he founded in Hartford, the Wadsworth Atheneum. Through his support for Cole (it was Wadsworth who drew Cole's attention to the White Mountains) and Church and the establishment of a public museum featuring American landscape paintings, Wadsworth played a role, along with other wealthy, cosmopolitan land-

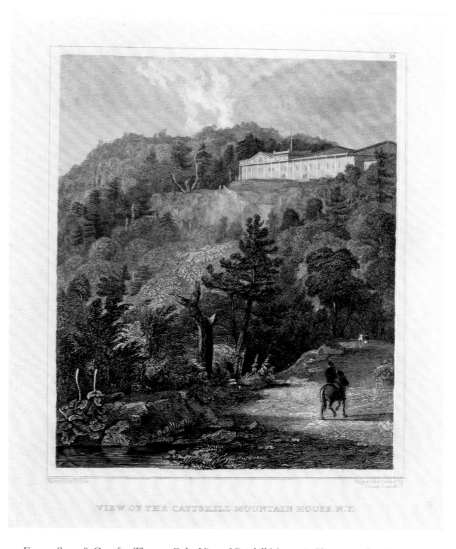

27. Fenner Sears & Co. after Thomas Cole. *View of Catskill Mountain House*, ca. 1831. Engraving.

scape collectors, in promoting an appreciation for American landscapes that had previously been considered inferior to those of Europe.[33]

By the time Cole arrived by sloop in the Catskills in 1825, entrepreneurs from the Catskills Mountain Association, looking to boost the local economy hitherto based solely on the tanning industry, had already constructed an elegant resort hotel on a rocky promontory overlooking the Hudson. A visitor to the hotel, known first as the Pine Orchard House and later as the Catskill Mountain House, described with astonishment, "After treading in the dark for two or three hours a perfect wilderness, without a trace save our narrow road, to burst thus

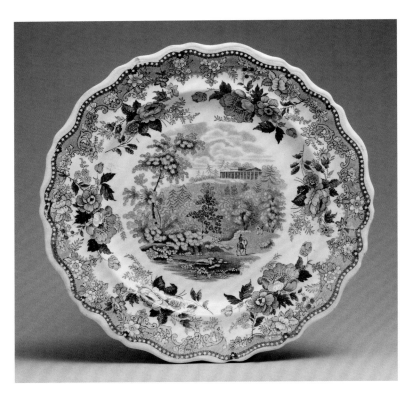

28. Job and John Jackson. Plate: *View of the Catskill Mountain House*, ca. 1831–35. Transfer-printed earthenware.

suddenly upon a splendid hotel and, glittering with lights, and noisy with the sound of the piano and the hum of gaiety—it was like enchantment."[34] Laudatory accounts of the Mountain House appeared in numerous newspapers, magazines, literary annuals, and travel books from the late 1820s through the 1840s.[35]

Visual counterparts to these written accounts during the first decade of the hotel's existence included an 1831 engraving, after a lost painting by Thomas Cole, showing the 140-foot-long Federal-style building with widow's walks on the roof, from the winding road below [FIG. 27]. Cole's print became one of the most popular images of the hotel, appearing on mass-produced English Staffordshire transfer ware by Job and John Jackson and others [FIG. 28]. Hundreds of these plates still survive in public and private collections, attesting to their popularity as tourist souvenirs for Mountain House visitors during the 1830s through the 1850s.

Another frequently illustrated hotel view was from the rocky escarpment to the south of the building,

as depicted in the engraving after William Henry Bartlett's *View from the Mountain House, on the Catskills* in American Scenery [FIG. 29]. Tourists traveling up the Hudson on steamboats could spot, some 2,800 feet above the valley floor, the white, four-story, classical-style edifice supported by eight columns, balanced on the ledge of a cliff on South Mountain, shining through the verdant forest. Cole loved the spectacular view, and depicted it in his paintings; Church also captured the Mountain House in a small oil sketch executed between 1844 and 1845, during his apprenticeship with Cole, from 1844 to 1846 [FIG. 30].[36]

In light of the prevailing transcendental interpretation of the landscape as the manifestation of divine handiwork, artists including Church, cosmopolitan collectors, and knowledgeable tourists considered the journey to, and the vista from, the Mountain House as a profound spiritual experience. The physical characteristics of the site, which forced the visitor to stand on a narrow and potentially dangerous ledge for the best perspective, provided the perfect stage for a "sublime" communion with nature. An anonymous *New York Times* account of a visit to the Mountain House in 1863 attempted to convey the feeling: "You seem to have left the earth, and to be gazing from some ethereal height down upon the world and its concerns. You see nothing above or around you; all is below; even the clouds wheel and roll in fleecy grandeur at your feet. Forests, meadows, harvest-fields, plains, mountains, rivers, lakes, cottages, villages and cities in every direction. A deep repose seems to have settled upon the world."[37]

The other major site that formed part of the ritual Mountain House visit was Kaaterskill Falls, a double cataract two-and-a-half to three miles to the west, "a mighty ravine amid heaven-shouldering mountains; a great curve of rock all crowned by trees and verdure-clad; a small stream of water dashing down a depth of 180 feet into the hollow below, thence to take another leap of 80 feet."[38]

During Church's apprenticeship with Cole, he retraced his mentor's sketching trips in the area of the Mountain House, Kaaterskill Falls, and Kaaterskill Clove. The graphite sketches of these sites from

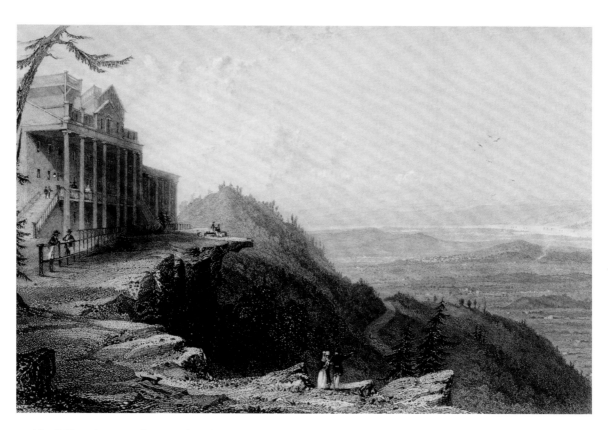

29. After William Henry Bartlett. *View from the Mountain House, on the Catskills*, 1840. Steel engraving.

30. Frederic Edwin Church. *View of the Catskills from the Hudson River Valley*, ca. 1844. Brush and oil paint, graphite on heavy paperboard.

31. Frederic Edwin Church. *View of the Catskill Mountain House*, July 1844. Graphite on white paper.

July and September 1844, in Cooper-Hewitt's collection and at Olana, were drawing and observation exercises which prepared him for his future evocations of the divine presence in nature [FIG. 31].

Church's drawing of the Mountain House from below shows the hotel just prior to its renovation by Charles L. Beach, a Catskill businessman who had built his fortune in stage transportation. Beach bought up most of the interest in the hotel in 1839, and gained full ownership by 1846. Under his regime, the Catskill Mountain House began its greatest phase, which lasted from the mid-1840s through the 1860s. Between 1845 and 1846, Beach renovated the structure by increasing the total building's length from 140 to about 200 feet, replacing the original eight columns with thirteen Corinthian columns, and changing the two staircases on the north and south ends of the piazza to a single set of stairs in the middle of the façade. The new edifice became the logo on a broadside advertising the Mountain House dating after 1851 and on the hotel invoices [FIG. 32]. During the 1850s, Church used

the Mountain House, along with the Cole family home, as a base of operations in the Catskills until he moved into his own house on the opposite side of the river. His name appears seven times in the Mountain House register beginning in 1854, with and without his friend Theodore Winthrop.

While there is no documentation concerning Church's method of travel between his studio in New York City and Catskill Village, he most likely came by steamboat, leaving New York in the morning and arriving at Catskill Landing by mid-afternoon. After debarking at Catskill, he would have taken one of the Beach family stages for the twelve-mile, four-hour trip up to the hotel for a charge of $1.00 to $2.00. An alternative method of travel after 1849 was the Hudson River Railroad, which originated at Chambers and Hudson streets, and by July 1850 reached Hudson (Oak Hill Station) on the east side of the river.[39] From there Church would have boarded one of Beach's ferries across to Catskill Landing, followed by a Beach stage to the Mountain House.

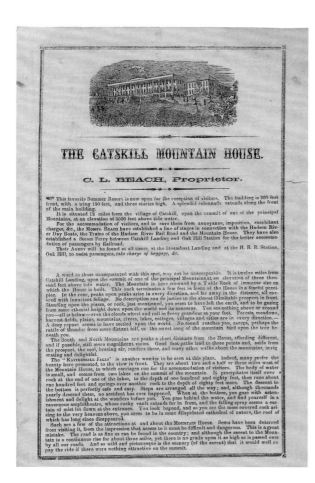

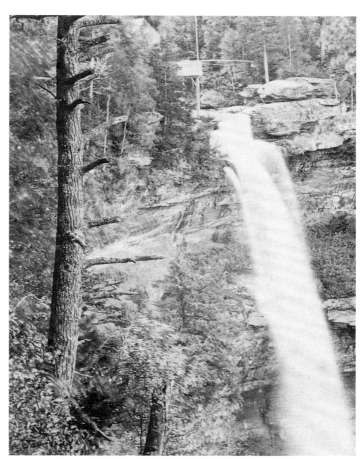

32. Advertising broadside, Catskill Mountain House, 1851. Wood engraving.

33. Stereoview of Kaaterskill Falls, 1871. Albumen silver print mounted on cardboard

During the 1850s and 1860s, life at the Mountain House and at its competitor, the Laurel House, constructed around 1852 at the top of Kaaterskill Falls, could be followed in popular magazines, newspaper columns, and cartoons of the period, whetting the appetites of many future Catskills visitors. The Mountain House was expensive — the daily charge up to the early 1860s of $2.50 equaled the rate of an upscale New York City hotel, and by 1869, it had increased to $4.00 a day. As the hotel invoices indicate, meals and any coach trips to falls were additional. Rates at the Laurel House were slightly more than half those of the Mountain House, and a boarding house considerably less.[40]

Guests at the Mountain House usually arose early to experience the "sunrising" ritual from the escarpment. After breakfast they visited the falls, which were owned and "operated" by the propri-

etor of the Laurel House, Peter Schutt. Schutt, much to people's horror, had dammed the river above the falls so he could charge twenty-five cents for turning the water on. He also installed a shack at the top of the falls, where hikers could buy a lunch lowered in a basket hanging from a long pole to a picnic spot on the path. This ingenious lunch/snack solution can be seen in almost all of the prints and stereo views of Kaaterskill Falls from the period [FIG. 33].

Another popular feature of the falls was the cavern behind the upper fall, where visitors could stand and watch the sheet of water falling in front of them. In the early 1870s, Winslow Homer painted a scene of two fashionable women standing while resting on their walking sticks under the expansive rocky overhang. Homer's reproduction of the picture as a wood engraving for the mass circulation

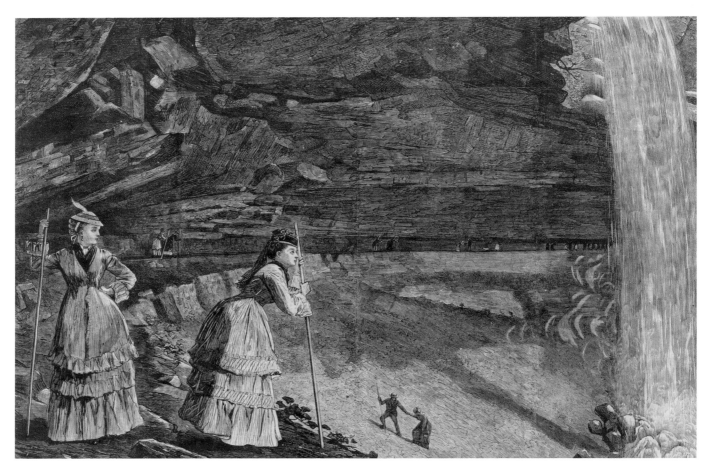

34. After Winslow Homer. *Under the Falls, Catskill Mountains*, in *Harper's Weekly*, September 14, 1872. Wood engraving.

Harper's Weekly, of September 14, 1872, doubtless piqued the curiosity of magazine subscribers for a Catskills visit [FIG. 34].

Following lunch, hikers could tramp through the Kaaterskill Clove to the village of Palenville—a favorite stopping place of Hudson River School artists Asher B. Durand (1796–1886), John Kensett, and John W. Casilear (1811–1893)[41]—or the men could go fishing while women read, or people could climb South or North Mountain. After T. Addison Richards's Catskills article in *Harper's Monthly*, July 1854, describing an overnight camp out on the top of North Mountain, such jaunts were reported in *New-York Daily Times* articles for the rest of the season. Indoor Mountain House activities included billiards and bowling, song fests, shows, and dances, with music supplied by bands and orchestras hired for the season by the hotel.[42]

Newspaper columns frequently alluded to the competition between the Mountain House and Laurel House for clientele. For Laurel House partisans, this hotel attracted those who "come to enjoy the mountain air, free and untrammeled by the ceremonies and etiquette of city life," while the Mountain House appealed particularly to the fashionable.[43] Poking fun at the guests and rituals of the Mountain House, Thomas Nast's *Sketches among the Catskill Mountains*, published in *Harper's Weekly*, July 21, 1866 [FIG. 35], shows, among other vignettes, the staff hauling the oversized trunk of one woman who has brought far too many dresses for the occasion; a child peering over the shoulder of an artist painting under an umbrella along with his colleagues scattered over the hillside around Kaaterskill Falls; and the staff waiting for tips from an exiting well-heeled gentleman, who was either too stingy or lacked pocket money due to the excessive hotel charges.

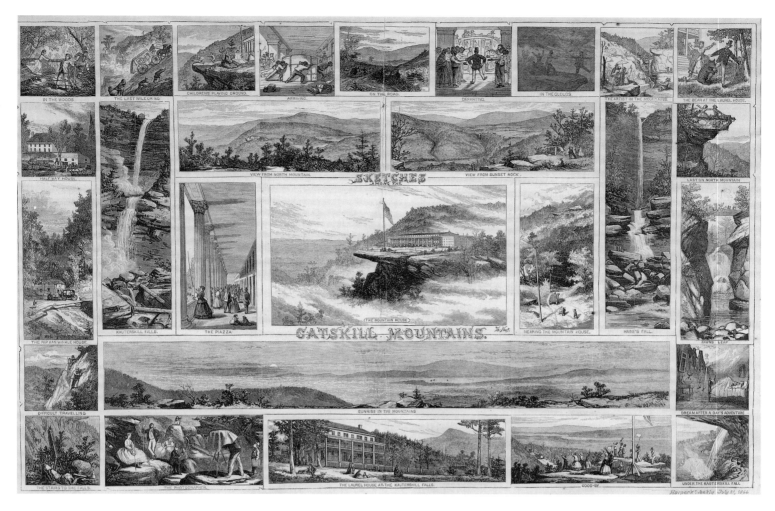

35. Thomas Nast. *Sketches among the Catskill Mountains*, in *Harper's Weekly*, July 21, 1866. Wood engraving.

As hotel life became too citified, and artists had more money due to commissions for Catskill landscapes from private collectors, many painters chose to build summer homes and studios in the area. A home on a mountainside in the Catskills had the advantages of easy accessibility to New York City and networking with clients, friends, and dealers, as well as providing marvelous views to portray on canvas. When Church purchased his property outside Hudson, New York, in March 1860, his teacher and colleagues had already constructed or renovated homes in the Catskills area. After marrying in 1836, Cole had established his Catskill residence in his wife's uncle's house, Cedar Grove; Samuel F. B. Morse (1791–1872), aided by the architect Alexander Jackson David (1803–1892), renovated his house, Locust Grove, near Poughkeepsie, between 1851 and 1852; Jervis McEntee (1828–1891) built his single room home and studio, designed by Calvert Vaux (1824–1895) in Rondout (Kingston), in 1853–54; Jasper Francis Cropsey constructed his twenty-nine room mansion, Alladin, on forty-five acres in Warwick, New York, in 1869; and Sanford Gifford (1823–1880) built his tower studio atop the family residence in Hudson, New York, in 1870. The grandest of all Hudson Valley "stately residences" was Albert Bierstadt's four-story château, at Malkasten (1865–66), in Irvington, New York, which was equipped with a studio with three large sliding doors opening to the surrounding landscape, so he could be closer to his animal subjects or view objects at a great distance.[44] Books and arti-

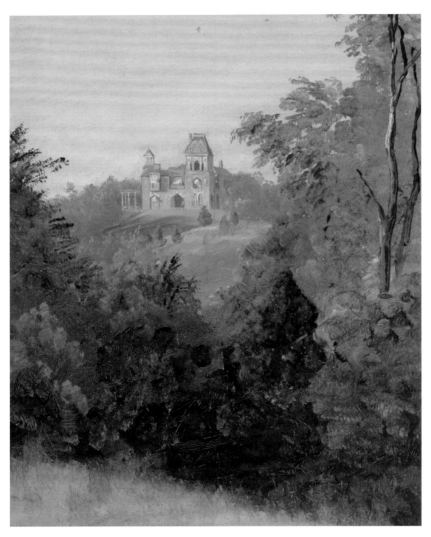

36. Frederic Edwin Church. *Olana from the Southwest*, ca. 1872. Brush and oil paint on thin paperboard.

his colleagues' example, purchased 126 acres of fields and woodlands on the east side of the Hudson River, on a hill that Cole first showed him opposite Catskill village. For the next thirty years, the artist, in between traveling to Maine, Jamaica, and South America, was thoroughly occupied with his successive homes, farm, and surrounding property. The Reverend Theodore Cuyler referred to Church's first, rather modest, house, called "Cozy Cottage," as "a patch of green . . . on which the painter Church is gathering materials for his nest."[47] Cuyler's analogy to Church as a bird building his nest was especially appropriate, since Church and his wife clearly believed that following the pastoral life, close to nature, was ideal for raising children.

After purchasing the remaining property on the hilltop above his farm in October 1867, Church immersed himself in designing and building his Persian fantasy showplace, Olana (1870–90), and to orchestrating the landscape on the extensive surrounding property.[48] A view of Olana in Cooper-Hewitt's collection, probably dating from the completion of the construction in 1872, shows the house like a pink confection on the crest of the hill amidst the surrounding greenery [FIG. 36].[49] Church had coveted the site on the summit of Long Hill since the early 1860s, as it offered perhaps the broadest panoramas of the Hudson River looking south toward West Point and of the Catskill range to the west and north.[50]

Executed in June 1870, *Sunset across the Hudson Valley* [FIG. 37] dates from what must have been a fulfilling period in Church's life. After the tragic deaths of his first two children to diphtheria, his son, Louis Palmer, who would later donate the Church collection to Cooper Union, was born on April 30 of that year; and the construction of his new villa on the Sienghenbergh summit was underway. Perhaps these joyful events explain to some extent this idyllic pastoral view, which looks southwest over carefully tended gently rolling meadows and intermittent tree lines toward the portion of the Hudson River called "the Bend in the River," about three miles south of the Olana site. The satisfaction Church expressed in owning what he called the "Center of the World" appears reflected in this

cles in contemporary magazines featuring these "show" homes and studios promoted the names and the personal success of their artist-owners, and presumably attracted curiosity seekers and visitors to the Catskill landscape.[45] These "statement" homes also inspired the development of the second-home market, which took off in the 1880s. Bierstadt, known for his marketing flair, had his own in-house publicity machine; his photographer brother Charles published full-plate photographs and stereo views of the grandiose studio attached to this palatial home.[46]

With his impending marriage to Isabel Mortimer Carnes in June 1860, Frederic Church, following

37. Frederic Edwin Church. *Sunset across the Hudson Valley*, June 1870. Brush and oil paint, graphite on paperboard.

perfectly balanced, fecund green-brown landscape and the creamy red-tinged clouds floating above in the turquoise sky.[51]

Church took great pride in his house and property on the Hudson, and was not unaware that his "feudal castle" was an asset to him financially and in terms of his career.[52] As the discussion of his Niagara pictures above shows, Church was not naive about the ways of the art market. His correspondence from the 1860s and 1870s concerning properties in the Catskills reveals his keen interest in the real-estate market in the vicinity of Olana and his delight in the growth of his investment.[53] While he never speculated in land, and was clearly

ambivalent about the Catskills becoming a resort of the rich or middle class, Church constantly urged his friends, acquaintances, and closest colleagues to invest in property nearby in an effort to surround himself with congenial, educated, socially compatible neighbors.[54] Church never managed to get his artist friends or his patrons to settle nearby, although the next generation of landscape tonalists in the 1880s created artist communities in the area.[55]

The hotel and second-home industry in the Catskills took off particularly after 1875, when the Ulster and Delaware Railroad penetrated the undeveloped western side of the Catskills. Towns along the railroad route, including Hobart, Stamford,

Margaretville, Pine Hill, and Phonecia, became re-sort centers with hotels and rental homes, each attracting about 1,000 people per summer from New York and Brooklyn.[56] To stimulate tourism and land development, an 1891 Catskill Mountains guide published by the Ulster and Delaware Railroad pointed out "several very attractive summer cottages . . . many of them [built] by artists."[57]

The creation of the Ulster and Delaware Railroad challenged the monopoly of Catskill Village as the point of entry into the mountains, and fewer people debarking at Catskill meant fewer tourists using Beach coaches to the Mountain House. Charles Beach responded to the threat by constructing the Catskill Mountain Railroad and then the Otis Elevating Railway in 1893, enabling tourists to travel from Philadelphia and New York to the Mountain House entirely by train. In 1880–81, Beach's Mountain House faced another challenge from the new Kaaterskill Hotel, built on the other side of South Mountain. With a guest capacity of seven hundred, it was purported to be the largest mountain hotel in the world.[58]

In the end, despite the growth of hotels and easy transportation, the Catskills lost its cachet as a tourist resort by the late 1870s. While Church, Cole, Durand, Gifford, Bierstadt, and McEntee played an informal role early on in developing Catskills tourism from the 1830s into the 1870s, many of the painters and writers abandoned the Catskills before the 1870s for newer wilderness areas in the Adirondacks, New Hampshire, Maine, the Grand Canyon, Yellowstone, and Yosemite. Short-term visitors and day-trippers of lower economic station now replaced full-season hotel boarders, who flocked to more exclusive resorts in New England or the West.

THE ADIRONDACKS

The Adirondack Mountains region, in northern New York State, was mapped only in the early 1830s, and about twenty years later, the popular press touted the area as the next unspoiled wilderness destination. According to one *New York Times* columnist, "No stage-coach, or rail-car, or steamboat, has penetrated it . . . this lake and forest region lies like an island, uninhabited and unlabored."[59] This early interest was stimulated by the publication in 1849 of Joel T. Headley's *Life in the Woods*, which described the author's fishing and hunting adventures in the northern woods in 1847 and 1848, but the great rush of vacationers came twenty years later, in the wake of William H. H. Murray's best-selling *Adventures in the Wilderness; or Camp-life in the Adirondacks*. "Adirondack Murray," as he came to be called, extolled the North Woods for its artistic merits, quoting a European visitor who maintained that no other locale "combined so many beauties in connection with such grandeur as the lakes, mountain, and forest of the Adirondack region presented to the gazer's eye." Murray also praised the area's "health-giving" benefits—even referencing one tubercular young man who entered the forest on the back of his guide and exited the woods healthy and carrying his own canoe—in addition to its hunting and fishing facilities and the opportunity for uninterrupted solitude.[60]

In reality, by the time Murray's book appeared, the lumber industry had penetrated the Adirondacks, denuding the forests of first- and second-growth trees for the production of wood-pulp paper. In 1850, New York State led the nation in lumber production, and was also a significant producer of Adirondack iron ore. Ironically, two years later, Winslow C. Watson predicted in an Essex County survey that the forests would soon approach depletion. Yet he, too, saw the region's potential as a tourist destination, asserting, "No climate is more salubrious, or better calculated to secure enjoyment and comfort to man."[61]

Five years after Murray's book, Seneca Ray Stoddard's (1843–1917) popular guidebook *The Adirondacks Illustrated* appeared, including hotel descriptions with images and prices.[62] From his base in Glens Falls, New York, Stoddard also produced stereoviews and single-plate images of the Adirondacks and its hotels, which could be purchased as souvenirs by visitors. At the time of these publications, the railroads, initially built for hauling lumber and iron ore, opened for passenger travel into the Adirondacks' interior. In 1864, Union

Pacific railroad entrepreneur Thomas Clark Durant acquired an existing rail line intending to extend it across the North Woods. In return for Durant's completing the line, New York State granted him the opportunity to purchase vast tracts of land, tax-exempt and at reduced cost. Durant consequently became the largest landowner in the state, and his family the state's most important land developers.[63]

By 1871, Durant's railroad ran from Saratoga, southeast of the Adirondacks, westward across the wilderness to the town of North Creek, in the central Adirondacks. In the mid-1870s and late 1880s, other railroad lines from Albany and Plattsburgh accessed the eastern corridor. Until then, vacationers made the arduous two-day trip from New York or Boston via Lake Champlain on several connecting trains, a steamboat, and stage coach.[64]

During the 1860s and 1870s, hotel accommodations grew to meet the rising interest of vacationers and sportsmen. In 1869, Murray had recommended five places to stay—the most important of which were Martin's hotel on Lower Saranac Lake, Bartlett's hotel on Round Lake, and Paul Smith's on St. Regis Lake; Stoddard, five years later, listed around 120 hotels and guest houses in the Adirondack region. The Prospect House, cited in later editions of Stoddard's guide, was the most spectacular of these resorts. Built between 1877 and 1879 by Frederic Durant, the nephew of Thomas Durant, this lavish hotel on Blue Mountain Lake boasted 300 rooms, each equipped with running water and steam-powered heat and electricity, along with bowling alleys and a wax museum.[65] Another Durant family member, Thomas's son William West Durant, completed after 1879 the first of the great Adirondack camps, Pine Knot. After selling the place to Collis P. Huntington, the developer constructed other camps on family land, which he then sold to wealthy urban industrialists, including J. P. Morgan and Alfred G. Vanderbilt.[66] These families played at pioneering on their own extravagant wilderness estates, with clusters of guest lodges, communal dining halls, blacksmith and carpentry shops, stables, gardens, and large attending staffs. These luxurious "camps" were a far cry from the simple log cabins inhabited by the early loggers and miners.

Painters were among the vanguard of visitors to the Adirondacks. Thomas Cole and Asher B. Durand painted at Lake George and Schroon Lake in the 1830s, and after Cole's death in 1848, Durand returned with artists John Frederick Kensett and John Casilear. In 1858, William James Stillman (1828–1901), landscape painter and co-editor of *The Crayon*, camped in the Adirondack wilderness with a group of Boston notables, including the poet Ralph Waldo Emerson and the scientist Louis Agassiz. Emerson's poem "The Adirondacks" commemorated this trip while promoting the area to future adventurers. Sanford Gifford sketched in the Adirondacks from the late 1840s; and William Trost Richards (1833–1905) and Homer Dodge Martin (1836–1897) were there in the 1850s and 1860s. Frederic Church and his friend Theodore Winthrop passed through the Adirondacks in 1856; finding the urban sportsmen pretentious and inept and the area overrun with artists, they plunged farther into the northern wilderness, toward Maine's Mount Katahdin.[67]

The popular haunt for landscape painters was the village of Keene Flats (today's Keene Valley), situated in the picturesque High Peaks region of the northeastern Adirondacks. The town's legendary guide turned business entrepreneur, Orson Phelps, maintained that artists had actually discovered the town, and were responsible for making it a tourist haven.[68] By 1872, more than 500 artists and tourists worked or vacationed in and around Keene Flats.[69] Of the painters based in Keene, Rosewell Morse Shurtleff (1838–1915) and John Lee Fitch (1836–1895) were friends of Winslow Homer. Homer and Shurtleff had begun their careers as illustrators in Boston in the mid-1850s; Fitch had sketched with Homer in the White Mountains during the summer of 1868.

Through the 1870s, Homer made three visits to Keene Flats, where he was photographed with a group of artists, including Shurtleff, on the banks of the Ausable River [FIG. 38]. Aside from these visits, Homer sojourned exclusively at the farm/boarding house owned by Thomas and Eunice Baker outside of Minerva, New York. Homer made twenty trips to the "clearing," as the farm was called, executing

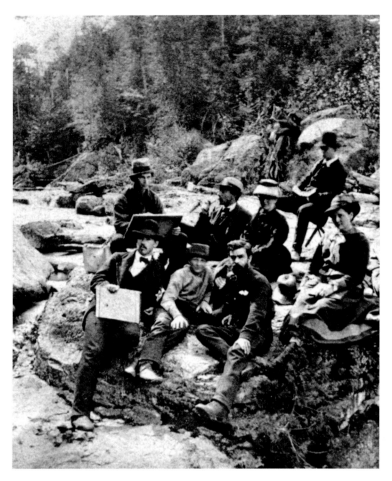

38. J. F. Murphy. *Artists at the Ausable River* (Homer with pipe in second row) 1874. Photograph.

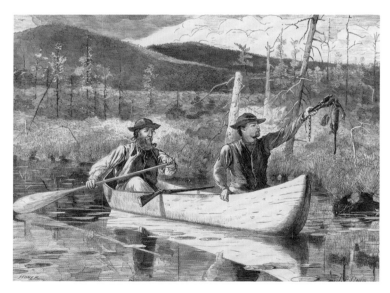

39. J. P. Davis after Winslow Homer. *Trapping in the Adirondacks*, in *Every Saturday*, December 24, 1870. Wood engraving.

around 100 watercolors as well as oil paintings and magazine illustrations over four decades, from 1870 through 1910. During these years, the Baker property was purchased by a group of business and professional men mostly from New York and established as a private sport club, under the title "Adirondack Preserve Association for the Encouragement of Social Pastimes and the Preservation of Game and Forests." In 1895, the club was renamed the North Woods Club. Although Homer was not among the association's founding members, he became a member in the club's second year.

This farm/club property of several thousand acres offered visually stimulating views and compelling subjects for Homer's artwork in addition to excellent fishing on its seven lakes and ponds. Homer, who excelled at fly-fishing, shared his passion with other active upper-middle-class men and women in the post–Civil War years. Different aspects of the fishing experience as well as hunting life became the predominant themes of the artist's Adirondack work. As all Homer scholars are quick to point out, however, the painter was not especially interested in the adventures of the well-heeled Adirondack sportsmen. Having come to the northern woods after trips to Long Branch, New Jersey, and Mount Washington, where he had concentrated on tourist diversions at the beach or in the mountains, Homer had another artistic agenda during his Adirondack visits. With a few exceptions, the artist explored the essential wilderness experience through images of the indigenous peoples, especially the guides who serviced the tourist population. He would later develop this artistic vision after 1883 in Prouts Neck, Maine.

Among Homer's earliest works depicting life at the clearing were two designs for magazine illustrations engraved on wood by other artists. *Trapping in the Adirondacks* shows two guides who also served also as handymen at the farm, Rufus Wallace and Charles Lancashire, pulling traps on Mink Pond under the shadow of Beaver Mountain [FIG. 39]. The same pair appears in *Deer-Stalking the Adirondacks in Winter* as two snowshoed hunters and their dog pursuing a deer mired in the snow [FIG. 40]. However, when the two prints were pub-

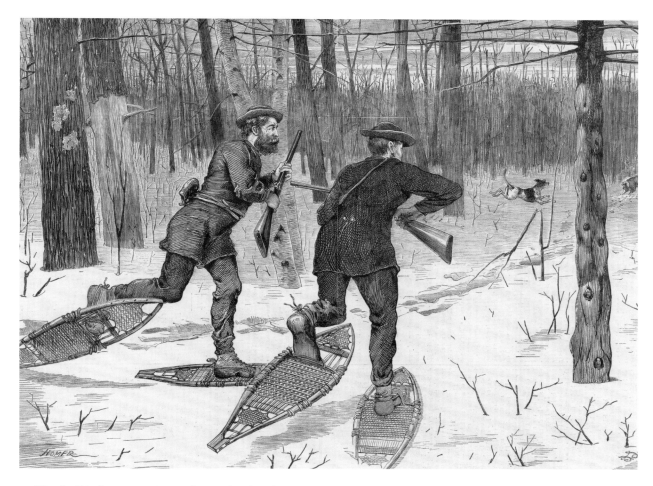

40. F.L. after Winslow Homer. *Deer-stalking in the Adirondacks in Winter*, in *Every Saturday*, January 21, 1871. Wood engraving.

lished in *Every Saturday* in 1870 and 1871, they were interpreted as images of vacationing urban sportsmen, indicating the popular press's role in promoting the Adirondacks and other spots as a destination for an out-of-doors, wilderness experience to their readership.[70] While Homer portrayed both scenes dispassionately, the deer-stalking scene alluded to a heated debate among the locals and summer sportsmen about the practice of hunting deer by "hounding." This method involved using dogs to drive deer into the water, where professional guides and their sportsmen clients waited in boats to shoot or club them. A series of Homer's watercolors depict the various stages of the hounding process, including the poignant *A Good Shot* of 1892, now in the Museum of Fine Arts, Boston.

While most of the artist's dazzling watercolors from 1889 to 1892 focused on the dark side of deer hunt-

ing, reflecting a Darwinian survival-of-the-fittest attitude, other watercolors projected an exultant image of the natural world. *Landscape with Deer in a Morning Haze*, dating from around 1892, shows a buck and two young fawns ambling innocently across a grassy meadow in front of deep green conifers enshrouded in early morning fog [FIG. 41]. This image of a harmonious and peaceful natural world is heightened by the overlapping layers of subtle blue-gray, green, and gold washes, and especially by the joyful splash of pink watercolor—a residue of the early morning sunrise—lifting above the haze. In this work, Homer came close to the spirit of Church and Moran's natural sublimeness.

If *Landscape with Deer* presented a constructed idyllic wilderness, Homer's watercolor *Valley and Hillside*, executed around the same time, expressed the ominous conflict between the natural world

41. Winslow Homer. *Landscape with Deer in a Morning Haze*, ca. 1892. Brush and watercolor, graphite on thick white wove watercolor paper.

and the humans who inhabit it [FIG. 42]. The sun-drenched autumn hillside in the background contrasts with a hillside, shaded by dense forest, of tree stumps in the foreground. A pentimento, which over time has come through the blue wash that the artist brushed over the foreground, of a logger carrying an axe-like implement over his shoulder, near the largest stump on the lower right, connects this work to a series of Homer watercolors that speak to the destruction of the wilderness by the lumber industry.[71] Contemporary articles in *Harper's Weekly* and elsewhere which came out against logging and the devastation of the Adirondack forest suggest that Homer, if not an ardent conservationist, was at least cognizant of the paradox of human settlement and scenic preservation.[72]

Conservation activists condemned the destruction of the wilderness and the watershed beginning in the 1850s, but it was only when New York businessmen became concerned with the state's canal system and its effect on industry that the conservation movement gained enough muscle to influence the state legislature. New York State established the Adirondack Forest Preserve, which comprised approximately 720,000 acres, in 1885. This act was followed by the creation in 1892 of Adirondack Park, which included the preserve, and an amendment to the state constitution two years later banning logging in the preserve.[73] While controversy over the destiny of the Adirondacks continues even today,[74] Winslow Homer's potent watercolors and oil paintings preserve an enduring vision of the Adirondacks from the last quarter of the nineteenth century.

NEW HAMPSHIRE AND THE WHITE MOUNTAINS

In 1854, a *New-York Daily Times* travel columnist writing from North Conway, New Hampshire, started his report with a revealing parable. After describing the peaceful and picturesque Conway landscape, he remarked everything would be perfect except for the noise of coaches carrying businessmen and other tourists packed inside—

42. Winslow Homer. *Valley and Hillside*, 1889–95. Brush and watercolor, graphite on off-white wove paper.

"fugitives" from the city, all focused on the White Hills ahead "as if their mighty peaks were capped with gold," oblivious to the landscape they were passing. But now and again, a stray artist, captivated by the local scenery, would extricate himself from under the trunks of fashionable clothes, to draw something of the landscape. Reluctantly, he returned to the city—perhaps Portland, Boston, or New York—where he sold the canvas for a paltry sum, maybe to the very businessman who rode by his side and saw nothing in the original landscape to attract a glance.[75]

Among the points to be drawn from this tale was the artist's role vis-à-vis the landscape and the tourist. The artist had to interpret the landscape, to emphasize those aspects which were important,

and teach the average layperson how to appreciate it. Without the visual clues provided by the artist, the average person would fly by, in search for "he knows not what." It was the artist's job to focus the untrained eye on the moral lessons to be drawn from the landscape.

For that correspondent, North Conway epitomized the quintessential "picturesque" landscape as it was defined by the landscape theorists of the time. He did not tout the awesome, dramatic precipices of the White Mountains, or the powerful force of Niagara's waters, but rather an "agrarian Arcadia" of both natural and manmade structures in which people lived peacefully and harmoniously with nature.[76] All of this beauty, he said, had eluded even the artists, with the exception of John Frederick

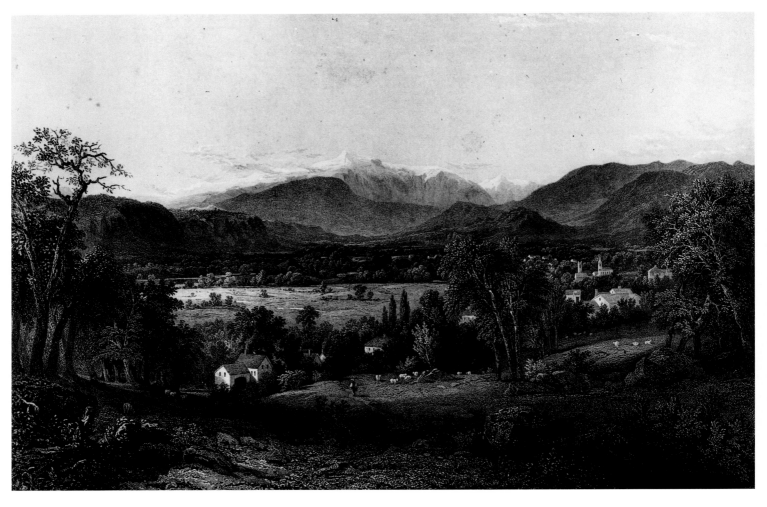

43. James Smillie after John Frederick Kensett. *Mt. Washington from the Valley of Conway*, 1851. Steel engraving.

Kensett from New York and Benjamin Champney (1817–1907), who had "discovered" North Conway. The celebrated Kensett picture the author alluded to was his 1851 *Mount Washington from the Valley of Conway*, which became famous through an engraving by James Smillie (1807–1885) that was sent to more than 13,000 members of the American Art Union [FIG. 43]. This painting of North Conway's village and sheep-filled pastures nestled in the Saco Valley beneath Mount Washington became even more widely known via the Currier and Ives lithographic transcription published nine years later.

The inclusion of Benjamin Champney's house, featured at the lower left of the print, alluded to his role in bringing painters to North Conway, transforming the town into New Hampshire's first art colony. Other artists mentioned in the 1854 *Times*

article, who were working in North Conway, were Daniel Huntington (1816–1906), Sanford Gifford, and Samuel Coleman (1832–1920). Huntington's dated sketch *Artists Sketching at Chocorua Pond* of 1854 [FIG. 44] documents the painters Thomas Edwards (1795–1856), John Wood Dodge (1807–1893), Alfred Ordway (1819–1897), and Benjamin Champney, plus the artist himself, drawing in the countryside southwest of the village. From the same 1854 sketching trip, Huntington drew a "picturesque" panorama of Mount Chocorua, in Cooper-Hewitt's collection, with trees and rocks in the foreground leading to a lake-filled meadow, spread out before a mountain in the middle distance. This skillful drawing may have been used by the artist as a preparatory study for the painting of Mount Chocorua (before 1861, New York Historical Society) which turned the peaceful

44. Daniel Huntington. *Artists Sketching at Chocorua Pond*, September 12, 1854. Graphite on cream paper.

scene into a much more romantic, "sublime" image of this legendary mountain.

Viewers of the time either would have known the engraving after Thomas Cole's *Chocorua's Curse* (1830), or could have read in their guidebooks the tale associated with the mountain. Chocorua was a Native American chief who was driven by his white pursuers to the edge of the mountain cliff and forced to jump to his death. This legend, repeated in different guidebooks of the period, helped bring tourists to the area. The guidebooks, like the artists' pictures, provided the contexts and associations connected to the scenery around which the traveler understood the local landscape.

Another romantic horror story, this one based on a real incident, was associated with Crawford Notch,

in the White Mountains. In this saga of 1826, the innkeeper Samuel Willey and his family fled from a rainstorm-induced landslide, which buried them but left their Crawford Notch boarding house intact. Just a year after the incident, ambitious artists and writers like Cole and Nathaniel Hawthorne began carving out their careers with views and narratives of the Willey tragedy. Cole's painting, *A View of the Mountain Pass Called the Notch of the White Mountains (Crawford Notch)*, 1839, dominated by a black storm cloud and blasted oaks, conveys the drama of death and destruction associated with the site [FIG. 45].

The visual and literary interpretations of the tale created a market for White Mountain scenery that was also advanced by the Crawfords, New Hampshire's most active and flamboyant family of

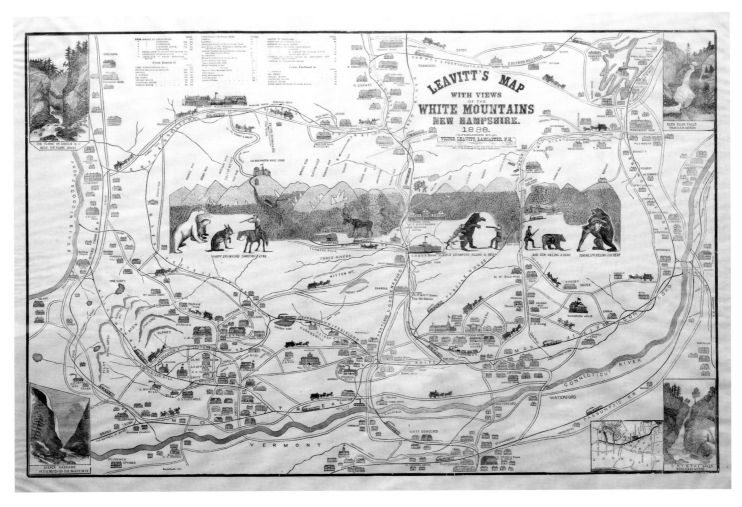

46. Franklin Leavitt. *Leavitt's Map with Views of the White Mountains, New Hampshire*, 1888. Wood engraving.

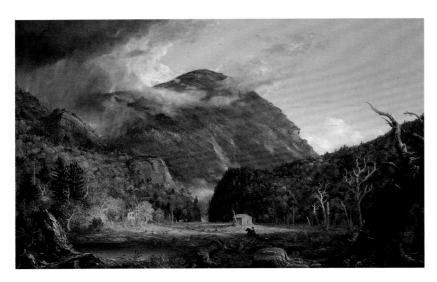

45. Thomas Cole. *A View of the Mountain Pass Called the Notch of the White Mountains (Crawford Notch)*, 1839. Oil on Canvas.

innkeepers. Ethan Allen Crawford was the "inventor, organizer, and driving force" behind the White Mountain tour.[77] During the 1820s and most of the 1830s, Crawford operated as a hotel owner, tour guide, road builder, and promoter for the area. Clearing the first footpath to the top of Mount Washington, and later improving it for horseback riders, he brought thousands of visitors to New Hampshire to climb what was then believed to be America's highest mountain, at 6,288 feet. By 1859, more than 5,000 people were reaching Mount Washington's summit each summer.

While Crawford may have been the initial force that got White Mountain tourism off the ground, later hotel entrepreneurs made important contributions to the development of New Hampshire's tourist industry. When Crawford was forced to give

up his debt-ridden property, the hotel was purchased and enlarged as the White Mountain House by Horace Fabyon, who also owned the Willey House for a short time. In North Conway, a shrewd businessman, Samuel Thompson, who ran Thompson's tavern (later Kearsarge House), created a stagecoach line passing through the town to bring travelers to his inn, and solicited artists to stay there. Thompson reputedly made an arrangement to board artists for the low price of $3.50 per week (the regular price was around $2.50 a day) and send lunch to their sketching grounds, if they agreed to annotate their sketches with a North Conway location.[78] If true, this story illustrates how hotel operators and painters could cooperate to advance their individual goals and build a tourist base in one region southeast of the White Mountains.[79] By 1853, some forty artists summered in North Conway along with other tourist "groupies" who had followed in their footsteps.[80]

Travel to the White Mountains was also promoted by map publishers such as George P. Bond, Franklin Leavitt [FIG. 46], and Harvey Boardman; stereographers, especially Benjamin West Kilburn of Littleton, New Hampshire; brochures, broadsides, and especially by the railroads which transported tourists (along with commercial products such as lumber) and in some cases built and operated hotels in the region. The Pemigewasset House in Plymouth, New Hampshire, was constructed, owned, and operated by the Boston, Concord, and Montreal Railroad, which had a stop right in front of the hotel, while the Atlantic and Saint Lawrence Railroad operated the Alpine House in Gorham, New Hampshire. Between 1850 and 1855, the railroads brought tourists to within eight miles of Mount Washington.[81] Coming from Boston, travelers could take the Eastern Railroad (Boston & Maine) to Portland and then the Grand Truck Railroad (formerly the Boston, Concord, and Montreal) to Gorham where they could take a stage to Crawford Notch. If tourists came from New York, they had the option of traveling to Boston, where they picked up the Boston and Maine to Portland, and from there taking a coach to the Profile House, the most well-known hotel in Franconia Notch.

47. Prospectus, Profile House, ca. 1880. Wood engraving.

The Profile House (formerly Lafayette House) [FIG. 47], owned and supervised in the 1860s by Richard Taft, Esq., who also owned the Flume House, took its name from the celebrated granite rock formation known as the "Old Man of the Mountain," which, until May 2003, existed above today's Highway 93. During the 1840s, and especially after 1850, when Nathaniel Hawthorne published "The Great Stone Face," the Old Man was transformed from a local curiosity to a symbol of the White Mountains, of New England, its people, and their political beliefs. (It became the official logo of New Hampshire in 1945.) Eastman's *White Mountain* guidebook described for the tourist the route from the hotel to

48. Francis Hopkinson Smith. *Old Man of the Mountain*, August 1876. Charcoal, black and white chalk on gray paper.

the Profile, and Thomas Starr King's *The White Hills* told visitors where to stand and the best time to view the rock formation.[82]

Francis Hopkinson Smith (1838–1915), a writer, fisherman, and artist, spent the summer of 1876 drawing in Franconia Notch. His skillful charcoal and chalk drawings, dating from August 1876, of *The Old Man of the Mountain*, *Echo Lake*, and *Fisherman on a Rock* (in the Flume) record the most important sites in and around Franconia Notch [FIGS. 48, 49]. Smith's use of dramatic contrasts of dark and light and sharp changes in scale between the objects of nature and the humans inhabiting nature suggest the artist attempted to fuse conventions of the "sublime" with aspects of tonalism derived from James McNeill Whistler (1834–1903) and French painters.

Winslow Homer, on the other hand, working in Crawford Notch during the late 1860s, created drawings and paintings that were entirely fresh. Homer went to the White Mountains on assignment from *Harper's Weekly* to prepare illustrations that would appeal to its fashionable female readers. The women in his White Mountain graphic design, and the pictures related to them, were different from those he would paint approximately ten years later in Houghton Farm. In both series, the women were affluent, but those in the White Mountains pictures were active and independent, engaged in sports like horseback riding or hiking. They represented the "early phase of the modern American woman."[83]

Homer visited the White Mountains during the summers of 1868 and 1869. While there is no record of where he stayed, David Tatham has posited that it must have been some place in Crawford Notch, whose fashionable and elegant hotels, like the second Crawford House or the Glen House, would have appealed to the well-dressed, cultured, and somewhat aristocratic artist. Homer arrived at the Notch at a propitious moment. In 1868, a cog railway which was begun in 1866 took its first paying customers from the base of Mount Washington to within five hundred feet of the summit. By July 1869, the "Railway to the

49. Francis Hopkinson Smith. *Fisherman on a Rock*, September 8, 1878. Charcoal, black and white chalk on gray paper.

Moon," as it was then called, was completed to the top of the mountain [FIG. 50]. Thus, in late August 1868, when Homer dated an early sketch for *The Bridle Path*, he could well have been among the first to try the new cog railway, which might explain why Homer seems to have situated both *The Bridle Path* and *Mount Washington* paintings on the side of the mountain where the railway could not be seen [FIGS. 51, 52]. Both pictures situated their subjects on a somewhat flat area, typically shrouded in fog, a few hundred feet from the summit. This misty background, particularly in the case of *The Bridle Path*, helped to silhouette the horse and rider so they appeared almost flat. This point was expressed by some of the critics when the picture was exhibited at the Century Association in November 1868 and at the National Academy in 1870.[84] There are other factors having to do with Homer's working methods that help explain how he composed the two Mount Washington pictures

50. Tradecard: Mount Washington Railway, 1879. Lithograph and photomechanical reproduction.

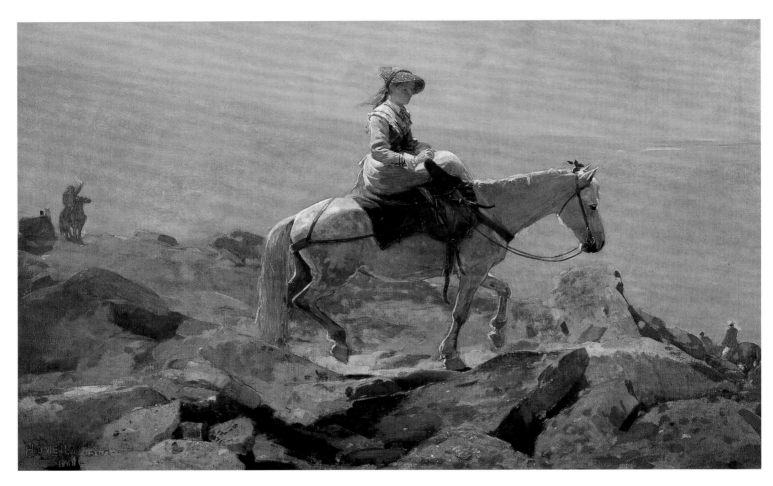

51. Winslow Homer. *The Bridle Path, White Mountains*, ca. 1868. Oil on canvas.

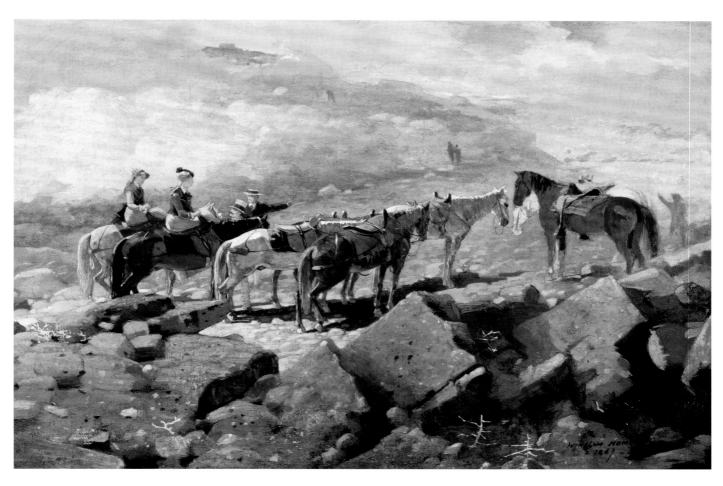

52. Winslow Homer. *Mount Washington*, 1869. Oil on canvas.

53. Winslow Homer. *Study for "The Bridle Path, White Mountains,"* August 24, 1868. Graphite on off-white wove paper.

54. Winslow Homer. *Study for "Mt. Washington" and "The Summit of Mt. Washington,"* 1869. Graphite on paper.

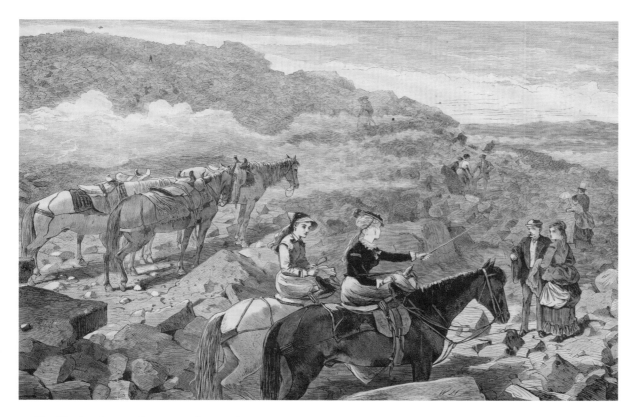

55. After Winslow Homer. *The Summit of Mt. Washington*, in *Harper's Weekly*, July 10, 1869. Wood engraving.

and, more important, how the pictures convey a new, more modern attitude about the landscape that separates Homer from the more traditional concepts of Frederic Church and Thomas Moran.

Cooper-Hewitt's collection includes preparatory drawings for each of the Mount Washington paintings and for the related wood engraving, *The Summit of Mountain Washington*, published in *Harper's Weekly* (July 10, 1869) [FIGS. 53–55]. A study of the horse, focusing especially on the saddle, in which the landscape and rider are barely indicated, suggests that Homer worked from individually studied motives, which he then assembled in the finished picture. This additive, somewhat mechanical manner of composing is especially understandable given Homer's training as an illustrator, where he could add or recycle elements in a scene as required. The artist's graphic background, which depended on meeting publication deadlines, also trained him to work efficiently and expediently. As long as he was combining two careers—as illustrator and painter—Homer learned to multi-task, using his drawings and paintings for both illustrations and independent exhibition pictures.[85] Moreover, Homer understood that wood engravings published in mass-market periodicals like *Harper's Weekly*, *Appleton's*, *Leslie's*, etc., could function as advertisements for his paintings, which were his most meaningful, and most remunerative, efforts. Thus the graphite sketch of four horses, which itself was probably assembled from studies of the individual horses (he recycled the single horse from *The Bridle Path*), was incorporated in the later 1869 Mount Washington painting, which shows a group of male and female tourists dismounting their horses in preparation for walking the remainder of the path to the summit, where the Tip Top House hotel appears through the patch of clouds in the upper left distance. This in turn was recycled, with some figural flipping, into the wood engraving titled *The Summit of Mount Washington*.

Another factor to be reckoned with in Homer's working method concerns his use of photography. Homer scholars have merely skimmed the surface

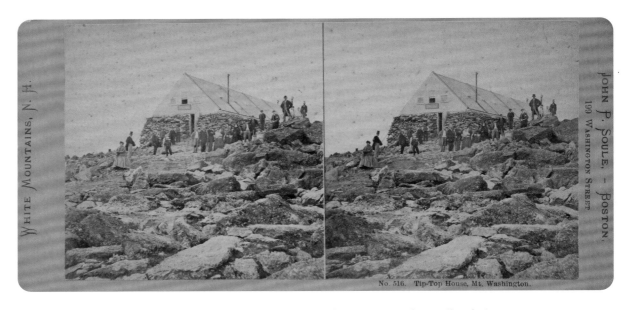

No. 516. Tip-Top House, Mt. Washington.

56. Anonymous. Tip Top House, Mt. Washington, not dated. Albumen silver print mounted on cardboard. 1850s.

of this subject, perhaps thinking it would minimize the artist's genius, or because not enough evidence has been assembled. Yet every artist, particularly someone as sophisticated as Homer, knew and used photographs at the close of the nineteenth century. In combing through mid-century stereographs of the White Mountains, one can find views which would have been available to Homer in the late 1860s, and are very similar to the landscape in his two large White Mountain paintings [FIG. 56]. There are also precedents for the small painting *White Mountain Wagon*, exhibited in 1870, which could have been lifted directly from a stereographic image [FIGS. 57, 58]. Homer's use of photography, "mechanical" working process, and study of Japanese prints help explain why his paintings, particularly the later pictures, can look so flat or planar. Even in the relatively early pictures, like *Mountain Climber Resting*, based on a Cooper-Hewitt drawing, the figure does not recline comfortably in the landscape setting, appearing to have been drawn inside the artist's studio and plugged into a landscape background, almost like a theater set [FIGS. 59, 60]. (The reclining man was also recycled in the 1870 wood engraving *The Coolest Spot in New England—Summit of Mount Washington*, which appeared in *Harper's Bazaar*, July 23, 1870.) This practice would also account for the artist's "lack of finish" in his paint application. Using short strokes of paint lying next to one another, rather than blended together, would help to give the sensation, if not the reality, of atmosphere moving around the figures. This kind of paint handling also tends to minimize the contours of forms, which the additive assembly process tends to emphasize.

All of this discussion begs the question of Homer's attitude toward the landscape as expressed in the White Mountain series of works, and as compared to landscape paintings by Church and Moran. Whereas Church and Moran venerated nature as a manifestation of divine creation, and Church, therefore, painted each element of nature with great specificity, Homer's landscape was completely secular. He saw nature as a place inhabited by humans. His people interacted with the landscape—they worked, talked, recreated, read, thought, and dreamed in the landscape. As Nicolai Cikovsky commented, "The landscape [Homer] experienced and the one he depicted, unlike the unpopulated wilderness landscape that once had served as the idealized version of American nationality, was intensely populated and socialized . . . It was also a thoroughly democratized landscape, one accessible no longer only to privileged admission and private communion, but one . . . easily available to large numbers of visitors of a wide social variety."[86]

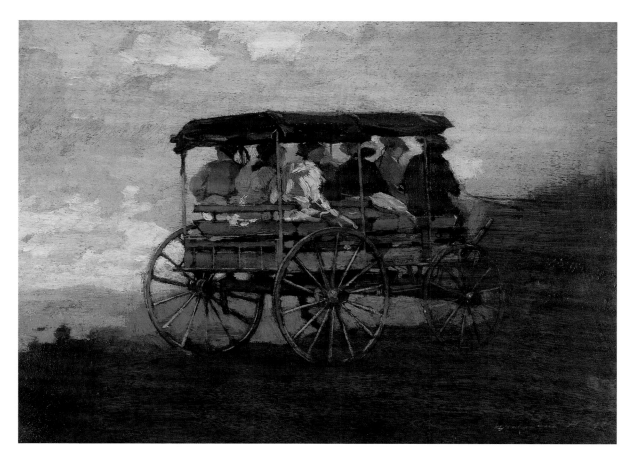

57. Winslow Homer. *White Mountain Wagon*, 1869. Oil on wood panel.

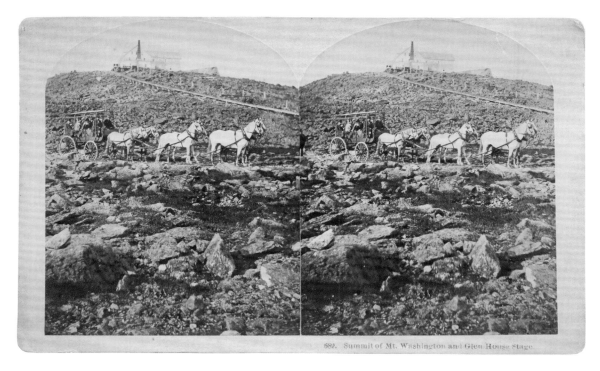

58. Anonymous. Summit of Mt. Washington and Glen House Stage, not dated. Albumen silver print mounted on cardboard.

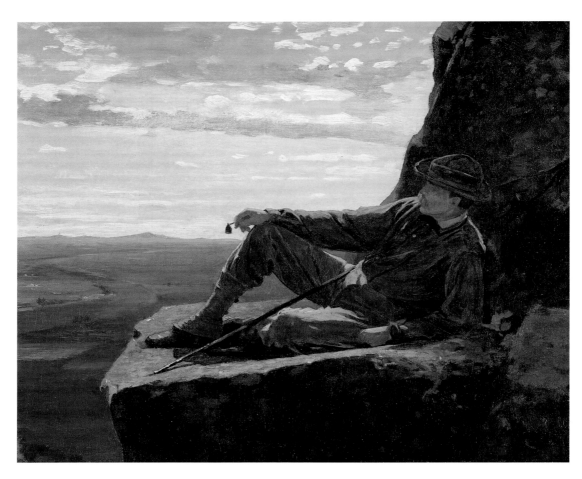

59. Winslow Homer. *Mountain Climber Resting*, 1869–70. Oil on canvas.

60. Winslow Homer. *Study for "Mountain Climber Resting,"* 1868–69. Black and white crayon on brown laid paper.

MAINE

In 1885, the state of Maine published a report assessing the agricultural, financial, commercial, and manufacturing health of the state, with special attention devoted to its position as a summer resort. The report observed that the state offered "not a single lake, but hundreds; not one famous beach, but a dozen; not a single island, but scores; not one mountain, but many—all easy of access by rail or boat . . . and all affording beautiful scenery, quiet, good fare, a cool invigorating summer atmosphere, and absolute freedom."[87] The report further emphasized, "Maine has the largest shore line of any State in the Union, Florida not excepted . . . Take this coast line from west to east, and it will be found dotted with summer resorts rapidly growing in popularity."[88] Among Maine's coastal resorts, Prouts Neck, a peninsula southeast of Portland, on the outskirts of Scarborough, acquired special significance at this time as the summer residence of Winslow Homer. The Portland newspapers during the 1880s, including the *Portland Daily Press*, followed closely Homer's arrival and departure schedule at the Neck as well as his exhibitions in Boston.[89]

It cannot be said that Homer "discovered" Prouts Neck, as an example of the first stage of the "resort-development" theory proposed by Edwin Godkin. By the time his family and he settled on the Neck, this area was already situated to become a prime vacation spot due to its historical associations, accessibility to transportation, and local entrepreneurial talent. According to Augustus F. Moulton, resident and local historian, Prouts Neck history dated back to the early seventeenth century, when the French and Native Americans fought with the English and Massachusetts Bay Colony settlers for control of the land. As Moulton pointed out, the remains of these wars were constant reminders to a tourist population, fascinated by anything colonial, that this area was historically interesting and worth cultivating.[90]

Furthermore, the local economy, which, in the early nineteenth century, was based on ocean and river fishing as well as clamming, was beginning to decline due to overfishing. The only commodities local farmers could sell, aside from their farm products, were the beautiful scenery and their land. In

1873, the Boston & Maine Railroad completed a double track line between Boston and Portland, enabling thousands of middle-class families from Boston, New York, Philadelphia, and Chicago to travel more expeditiously to scenic places along the Maine Coast [FIG. 61]. To reach Prouts Neck, tourists coming from New York or Pennsylvania could take the New York Central to Boston, where they would pick up the Boston & Maine Western Division to Scarborough Beach Station. Vacationers from points north or west could take the Grand Trunk Railway system or the Canadian Pacific and Maine Central Railroads to Portland, with a change of trains to Scarborough Beach Station. In the summer season, passengers from Montreal or New Hampshire could arrive via the Maine Central Railroad in a through car directly to Scarborough Beach. By 1904, there was also a through sleeping car train running from New York via Hartford and Worcester, Massachusetts, arriving in Portland the next morning and connecting with trains to Scarborough Beach. There was also an overnight steamer between New York, Boston, and Portland where vacationers could board a local train to Scarborough.

At Prouts Neck, the entrepreneurial Libby family was waiting to receive the city-weary travelers. By 1830, Captain Thomas Libby III had gained full possession of Prouts Neck, which he called Libby's Neck. During the fishing season, Libby ran an informal boarding house at his farm on the western highlands, known as the Prouts Neck House or Middle House, cleaning and cooking the catch for local fishermen, and offering them short-time lodging between their fishing expeditions. By the 1860s, Libby also provided food for the occasional picnickers who would come out for the day from Portland. As demand for lodgings grew, Libby's large family—including two sons, Silas and Beniah; a grandson; and two sons-in-law—built boarding houses or hotels near the Prouts Neck House. All of them were simple two- or three-storied clapboard buildings with gambrel, hipped, or mansard roofs and projecting covered piazzas on the water side. Undoubtedly the construction of several of these hotels was propelled by the 1873 scheduling of the Boston & Maine through train from Boston to Scarborough Beach.

61. Tradecard: Boston & Maine Depot; Boston and Maine Railroad, not dated. Lithograph.

Thomas Libby's son-in-law, Ira C. Foss, the most enterprising and innovative of the family, built the celebrated Checkley House in 1877 [FIG. 62].[91] He ferried new arrivals to and from the Neck with a fleet of horse-drawn stages that met every train at the station. Shortly after the Checkley House opened, Foss was already adding rooms and wings to the original structure, and, in 1895, he hired the prestigious Portland architect John Calvin Stevens (1855–1940), who designed the Homer family houses, the Ark and the Studio, to enlarge and re-model the facility. By 1896, the hotel brochure boasted that the Checkley "is furnished with all the comforts and convenience which make life not only endurable, but pleasurable." Also in 1896, Foss purchased the West Point House, which "had the same fine view of sea and shore, and is very com-fortably furnished." Its guests ate meals at the Checkley and were entitled to all the same privi-leges enjoyed by Checkley guests.[92] By 1904, the hotel had added electricity with electric bells and fire hoses on each floor connected to a tank hold-ing sixty-five gallons of water.[93]

An aggressive promoter, Foss had stiff competition from other hotels on or close to Prouts Neck. In 1890, Frank B. Libby built the Jocelyn House over-looking Scarborough Beach, on the eastern side of the Neck, which was also redesigned in 1898 with Victorian towers and trim by John Calvin Stevens. This majestic six-story hotel boasted an elevator, its own electric power, and eighty-one guest rooms holding approximately 175 people [FIG. 63]. Fortunately for Ira Foss, it burned down nineteen years after it opened.

In 1904, the rates at most of the hotels were gener-ally comparable, between $3.00 and $6.00 a day. The Checkley, however, remained slightly less at $2.50 to $3.00 a day, perhaps because of the com-petition from the Jocelyn Hotel. With all of the hotel capacity combined, there could have been between five hundred and one thousand people roaming around Prouts Neck on any given summer day, and this figure does not include private house owners, like the Homer family.

The Homers were among the first people to build vacation homes on Prouts Neck. As Patricia Junker showed in her informative essay, "Expressions of Art and Life in *The Artist's Studio in an Afternoon Fog*," [SEE P. 58] they were largely responsible for developing the area into an exclusive summer re-sort.[94] Their interest in Prouts Neck began in 1875 when Winslow Homer's younger brother Arthur and his wife Alice honeymooned at the Willows Hotel. The artist had his first view of the Neck when he visited with his brother and sister-in-law during their honeymoon. The Arthur Homers re-turned to the Willows for the following summers.

Meanwhile, during the summers of 1878 through 1880, Winslow visited Lawson Valentine's Houghton Farm in Mountainville, New York, where he was inspired to portray, in oil and water-color, very marketable bucolic fantasies of pastoral life. He had earlier visited York Harbor, Maine, where he painted the Revolutionary War garrison known as the Junkins House [FIG. 64], expecting to appeal to the colonial-revival tourist market in the greater Boston area. However, the opportunity to buy property on the Neck came about in 1879, after the death of Thomas Libby III, when his inheritors decided to cash in on the increased demand for va-cation property in Maine, and filed a subdivision plan.[95] According to the plan, the property was basi-

cally split into three sections running north-south for the heirs, leaving aside a portion of the property on the western highlands surrounding the family-owned hotels. The remaining land was divided up into 521 lots, with a marginal way, or easement, around the entire perimeter of the Neck to permit future homeowners and the public to access the view, the cliffs, and the seashore.

How the Homer family came to own nearly all of Prouts Neck can be followed in the Cumberland Country Record of Deeds from 1882 through 1910. First, Arthur Homer purchased lots set back from the ocean in the interior woodlands, and constructed his cottage, "El Rancho," in 1882. Early the next year, the Homers purchased fifty-nine lots in two transactions, giving them control of roughly one-third of the land in Prouts Neck.[96] The following year, Charles Savage Homer, Sr. purchased lots comprising the eastern division of the subdivision plan, which gave the family control of the entire shore on the eastern ocean side of the Neck.[97] By 1891, Charles Homer, Sr. purchased the remaining land in three transactions, giving them ownership of the southeastern shore of Prouts Neck.[98] Then, from 1888 through 1909, Charles Savage Homer, Jr., Winslow Homer, and Arthur Homer bought small individual properties from non-family members, thereby completing their ownership of the entire Neck, with the exception of the Libby and hotel properties.

With the purchase of Prouts Neck, the Homer family sought not only to build a family vacation compound at one of the most scenic spots along the Atlantic coast, but also sought to make money from the future sales of investment properties, and to control where and to whom these lots were sold. Such a sophisticated business plan probably came from Charles Savage Homer, Jr., who financed the real-estate purchases from the fortune he had made as a chemist for the Valentine Varnish Company. Both Charles and Winslow had experienced second-home resort life firsthand on the pastoral Hudson Valley property of Lawson Valentine. Charles would have been acutely aware of the investment potential for resort property to be shared by the senior Homers, the three Homer

62. Anonymous. Checkley House, before 1907. Chromolithograph.

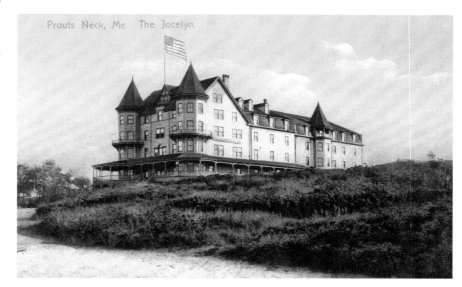

63. Anonymous. Jocelyn House, 1890s. Chromolithograph.

sons, and their descendants, and as a means of support for the future, which worked out exactly as he had planned.

The immediate family homes, particularly The Ark and Winslow Homer's studio, designed and redesigned by the Portland architect John Calvin Stevens, have been studied extensively [FIG. 65].[99] In addition to their own houses, the Homer brothers, between 1890 and 1908, built six houses for sale or rental, which Winslow, as the full-time Prouts

64. Winslow Homer. *Junkins House*, July 1875. Oil on canvas.

65. Unknown. Winslow Homer in the Gallery of His Studio, Prouts Neck, Maine, ca. 1884. Gelatin silver print.

Neck resident, managed for the family.[100] Both Charles and Winslow also contributed or sold land to construct both the Episcopal and Catholic churches as an attractive and necessary amenity to the resort,[101] as well as land for a golf club, for conservation (the Sanctuary), and to promote the market for their land and rental homes and contribute to the "welfare" of Prouts Neck.[102] With the same intentions, Winslow paid for the construction of

bathing cabanas on Scarborough Beach adjacent to Prouts Neck, which he gave to the Prouts Neck Association (the homeowners association created in 1887) two years before his death in 1910.

The house Winslow Homer built in 1904, on property that Charles had transferred to him above Kettle Cove, still stands. Designed by John Calvin Stevens, the six-bedroom, 19,000-square-foot, gambrel-roofed shingle-style cottage is monumental in comparison to the cramped artist's studio. While he never lived in the cottage, Homer involved himself completely in the design and construction process of the house, which lends support to the idea that Homer envisioned himself, like his brother, as a successful real-estate developer entitled to live quite comfortably in his old age.[103]

Other artists also made their trade-offs with land and railroad developers with the hope of furthering their careers. Thomas Moran's arrangement with the Santa Fe Railroad, along with William Trost Richards's investments in Newport and Eastman Johnson's activities on Nantucket, Massachusetts, are cases in point. [for Moran, see McCarron-Cates, p. 75]. Richards arrived in Newport in the 1870s in search of new subject matter after painting interior woodland scenes in his native Pennsylvania, the Catskills, the Adirondacks, and the White Mountains. He first rented, then later bought, a summer home, but by the early 1880s, his views had become obstructed by bigger and more fashionable homes. When a group of investors developing the Ocean Highlands on nearby Conanicut Island approached him with their plans, Richards was among the first to buy property on the island's southern shore. The artist's investment provided him with spectacular views over the Atlantic coast, which inspired new paintings and drawings [FIG. 66]. The developers also benefited because they used Richards's example to sell Conanicut property to other Philadelphians, including the financiers Joseph and Charles Wharton.[104] When Richards's house, Graycliff, was purchased and demolished by the government in 1899 to make room for a naval installation, the artist moved back into Newport proper to a house he had bought for winter use. Before his death,

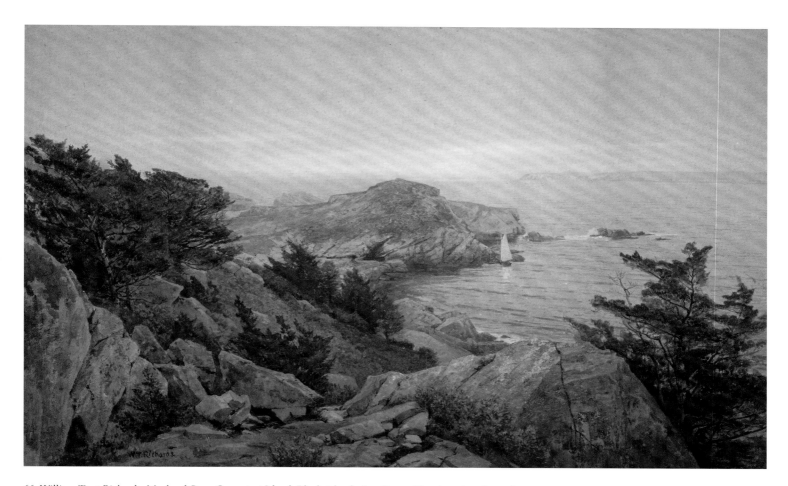

66. William Trost Richards. *Mackeral Cove, Conanicut Island, Rhode Island*, 1877. Pen and brush, watercolor on heavy, gray wove paper.

however, he purchased a tiny island off Conanicut in the mouth of Narragansett Bay and hired a local Rhode Island architect to construct a unique Arts and Crafts–style house either to sell on speculation or for his own use. Before he died, he sold the property and the house plans to a member of Wharton family for what he paid for it.[105]

As for Eastman Johnson (1824–1905), his studio residence on Nantucket was frequently cited in the press and helped raise the profile of the island to tourists. Johnson then attempted to cash in on the publicity by purchasing large tracts of land for future subdivision on speculation. His gamble did not end profitably, however.[106]

The business activities of Winslow Homer and his family, on the other hand, proved to be very successful. In addition to investing in rental homes, the Homer family also controlled the sale of their

building lots to people they wished as their future neighbors—mostly affluent, but not showy, social climbers. Among these were prominent clerics and theologians, industrialists, lawyers, and doctors, mostly from Philadelphia and Boston.[107] Photographs in the Homer collection at Bowdoin College indicate that the Homer family, the artist included, spent time with other cottagers as well as Scarborough locals. They also probably had occasion to mingle with the tourist population on Prouts Neck. The earliest extant Checkley House registers show that Homer and his family stayed on several occasions at the hotel, using it perhaps as an alternative residence while their cottages were under construction, or when their cottages were not ready to occupy at the beginning of the season; and possibly for meals. It would be fascinating to know if any of the well-to-do Checkley House guests ever wandered over to the painter's studio to gaze at his current work, and perhaps, if the some-

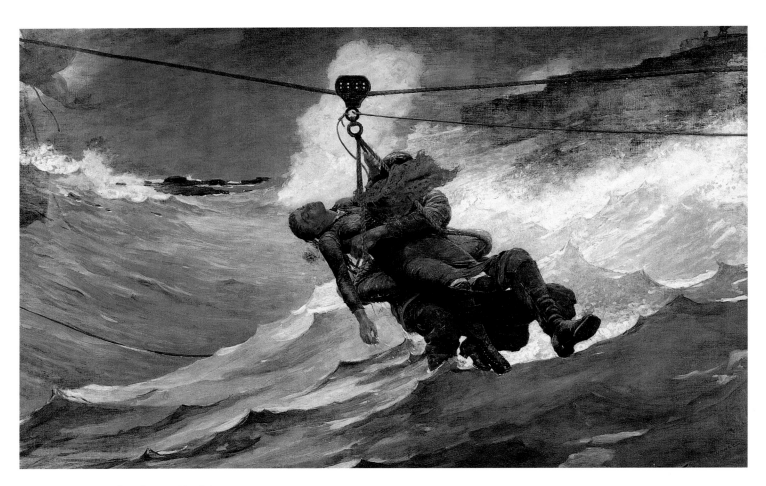

67. Winslow Homer. *The Life Line*, 1884. Oil on canvas.

what reclusive painter would let them in, purchase a watercolor of the local scenery for $175.[108]

Vacationers looking for a conventionally "pretty" landscape would not have found it among Homer's watercolors or oil paintings of the Prouts Neck coast. When he settled in Maine, Homer was no longer interested in appealing landscape backdrops for active tourists on holiday, as in his White Mountains images of the late 1860s; in pastoral landscapes of an imagined colonial past, as in the Houghton Farm works of 1878–80; or in sunny, life-affirming landscapes of the Gloucester shore. For as Homer and his family helped to change the face of Prouts Neck, so Prouts Neck indelibly altered the nature of Homer's landscapes and seascapes for the rest of his career. Living in his studio, surrounded by his family and homes, Homer was happier and more secure than he had ever been. With his expenses covered initially by his brother, and

later by property sales and home rentals in addition to the sales of paintings, he was free to develop aspects of his art that were most important to him — powerful narrative and cohesive form.

During the first few years after his move to the Neck, he painted a series of pictures inspired by the activities and people of the area, especially the fishing fleet which made its livelihood in the Atlantic waters off the Scarborough peninsula. These pictures include *The Life Line* of 1884, which depicts the dramatic rescue by a lifeguard of a drowning woman from a sinking ship, and *The Herring Net* of 1885, showing two fishermen hauling a net full of fish into their dory [FIGS. 67, 68]. Though based on quotidian events Homer is said to have witnessed or experienced firsthand, both pictures go beyond mere reportage to become, among other interpretations, powerful statements of the noble, and at times heroic, labor of

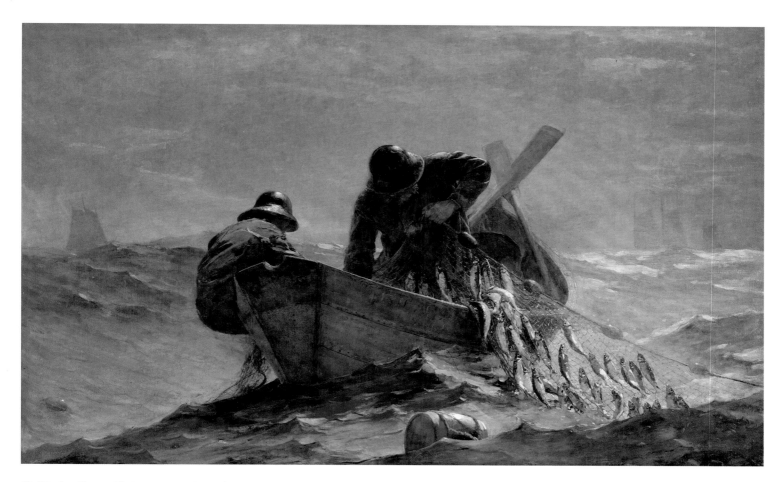

68. Winslow Homer. *The Herring Net*, 1885. Oil on canvas.

human beings amidst the uncontrollable forces of the natural world.[109] Carefully worked, potent studies for each of these pictures in Cooper-Hewitt's collection document the process by which Homer achieved these masterpieces [FIG. 69; see also p. 54].[110]

By the 1890s, however, Homer had eliminated any reference to traditional narrative, making the ocean and rocks the sole protagonists of his art, and concentrating mainly on formal elements of surface organization, texture, and value. These seascapes, tipped up to the front plane, incorporate his favorite diagonal construction, which he developed in his mid-1880s pictures, including *The Life Line* and *The Herring Net*. *The Coast of Maine* (1893) ranks as one of the most austere, and perhaps off-putting, of the 1890s paintings [FIG. 70]. Homer must have liked it, however, because he selected this work to exhibit with others at the 1900 Paris

Exposition Universelle. He based the picture on a series of charcoal and chalk drawings he had executed immediately after arriving in Prouts Neck of wind- and salt-stripped junipers clinging to the granite ledges along the marginal way near Kettle Cove [FIG. 71]. To achieve the final painting, he reorganized the elements of shrub, rock, and ocean along a more emphatic diagonal line derived from the oblique cliffs themselves. One of the anthropomorphic shrubs, whose wild limbs extend out over the ocean like one great scream, is silhouetted against the lighter toned misty ocean spray above.

While the peculiar, almost surreal characteristics of the *Coast of Maine* make this work unique within the artist's production, the silhouetted form unites it to another picture of equal dimensions from approximately the same time, *The Artist's Studio in an Afternoon Fog* of 1894 [FIG. 72].[111] In this most personal of Homer's pictorial essays, the two pre-

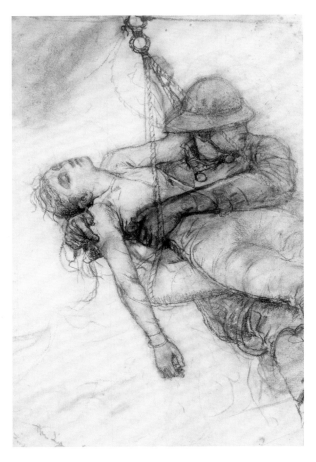

69. Winslow Homer. *Study for "The Life Line,"* 1882–83.
Black and white chalk on cream wove paper, lined in muslin.

eminently important buildings on Prouts Neck, his
brother's house (The Ark) and his own studio, ap-
pear on the cliff, silhouetted against the fog. Like a
haunting family portrait, this picture pays homage
to the "symbolic center" of Homer's world at
Prouts Neck.[112] In the larger context of this essay,
the painting also personifies the role that Homer
and his family played in transforming a bare penin-
sula of pastureland, conveniently situated between
Boston and Portland, into one of the premier sum-
mer resorts along the Atlantic Coast.

During the 1880s, tourist resorts up and down the
Atlantic coast were well into the "cottager phase"
of resort development, especially on the island of
Mount Desert, where cottager issues had become
national news. But the origins of this remote island
as a vacation destination actually date back twenty
years earlier than Prouts Neck, to before the Civil

War. Also, unlike the case of Prouts Neck, the
artists Thomas Doughty (1793–1856), Thomas
Cole, Fitz Hugh Lane (1804–1865), and Frederic
Church ranked among the discoverers of the spot.
Affirmed in the early accounts of the island, these
artists and their work helped to draw successive
waves of tourists and cottagers there.[113]

The feasibility of Mount Desert as a tourist destina-
tion was intimately tied to the general development
of Maine's transportation industry. When Church
first visited the island in 1850, he came by steam-
boat, sloop, and finally schooner. During the next
two decades, the steamboat became the most popu-
lar mode of transport, and to accommodate these
ships, two local hotel owners, Henry Clark in
Southwest Harbor in the 1850s and Tobias Richards
in Bar Harbor in 1868, constructed wharves in their
respective towns, which enabled large steamboats
filled with vacationers to commute to the island.

Church first came to Mount Desert in July 1850,
two years after the death of his teacher Thomas
Cole. Inspired by Cole's views of Mount Desert
(1844–45) as well as by coastal scenes by Lane and
Andreas Achenbach hanging in the 1849 annual ex-
hibition of the American Art Union, Church de-
cided to try his "pencil in a new field of art,"
marine painting.[114] He traveled with fellow artists
(perhaps Régis Genoux and Richard W. Hubbard)
from Franconia Notch, New Hampshire, where he
had been sketching, across Maine via the Maine
Central Railroad, and by steamer to the island.
That summer, John F. Kensett, Benjamin
Champney, and Lane were also working on Mount
Desert. According to an account of the trip, proba-
bly published by Church himself, the artist imme-
diately recognized the unusual natural and scenic
features that the island offered. "There is an im-
mense range of mountains running through the is-
land, one some two thousand feet high, of
admirably varied outline—in some places covered
with forest and broken with rocks and precipices
overhanging gems of lakes, and in others showing
nothing but bare rock from summit almost to
base." He also understood the island's potential as a
tourist Mecca: "What with trout fishing . . . and
deep-sea fishing, and deer and partridges, and an

70. Winslow Homer. *Coast of Maine*, 1893. Oil on canvas.

71. Winslow Homer. *Tree Roots on a Hillside, Prouts Neck*, 1883. Charcoal and white gouache on grey laid paper.

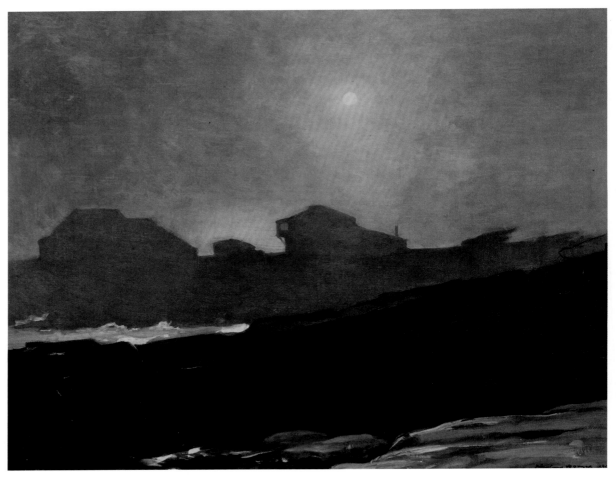

72. Winslow Homer. *The Artist's Studio in an Afternoon Fog*, 1894. Oil on canvas.

occasional 'bar' on the mountains, and riding and sailing, an air which cannot be surpassed for purity, sea and mountain both, and charms of scenery, composed likewise of both, it is surprising that some shrewd Bostonian has not erected some sort of hotel here."[115]

Though there were no hotels comparable to the Catskill Mountain House, there were farmhouses where artists and other travelers could board. Church most likely stayed at the Lynam Farm on Schooner Head, where Cole had resided six years earlier, and where Church's account in the *Bulletin of the American Art Union* suggests he stayed.[116] Church's graphite and oil sketches from this period record views around this section of the island. Though undated, his *Coast at Mount Desert Island (Sand Beach)* probably originates from this 1850 trip [FIG. 73]. Most likely executed indoors after on-site drawings, this unfinished sketch on a red ground reveals the artist's abiding attention to light, and particularly his almost scientific cataloguing of the color, structure, and texture of the rock formations. Characteristic of this part of the island, these jagged, gray, castellated rocks, frequently stained reddish-brown from the iron content, were produced by the glaciers that had scoured the surface of Mount Desert during the Ice Age. Church undoubtedly would have been aware of the geologic history of the island, and was also trained to make meticulously exact studies after nature by his teacher Cole and through the influence of John Ruskin (1819–1900), the preeminent theorist of "truth to nature."

Another sketch probably dating from the 1850 trip is the dramatic *Schoodic Peninsula from Mount Desert at Sunrise* [FIG. 74], which shows the view

73. Frederic Edwin Church. *Coast at Mount Desert (Sand Beach)*, ca. 1850. Brush and oil, graphite over red ground on grey paperboard.

across Frenchman's Bay from the area around Schooner Head. While this sketch itself was not developed into a larger canvas, the red and pink clouds, layered in horizontal bands against a golden, sun-tinged sky, prepared him to develop the similar sunrise/cloud theme in a larger picture intended for exhibition and sale, *Beacon, off Mount Desert Island* (1851, private collection).

After drawing and painting around Bar Harbor in August and September 1850, Church left Mount Desert to prepare paintings for exhibitions in New York and Philadelphia, but he returned six times between 1851 and 1862. In early July 1855, he traveled with John Kensett, and they stayed at the newly opened Agamont House, the first hotel in Bar Harbor. Constructed by the entrepreneurial Tobias L. Roberts, who ten years later built the wharf at the end of Main Street, the hotel's extant

register documents visits by many of the painters associated with the island, including Sanford Gifford, Jervis McEntee, Daniel Huntington, and William Stanley Haseltine. In August 1855, Church returned to Mount Desert with a large party of twenty-five people, including his sisters, his close friend Theodore Winthrop, Charles Tracy and his family, and others. Tracy, a lawyer for the railroads, and Winthrop's employer, kept a diary of the excursion (now at the Morgan Library in New York City) which documents Church's time on the island. The group traveled to Mount Desert by three different steamboats: from New York to Boston, where they were joined by the Churches; from Boston to Rockland, Maine; and from Rockland to Northwest Harbor. Based for the month of August in Somesville, at the island's earliest inn, the Mount Desert House, Church took many excursions by himself or with members of the party. On one of

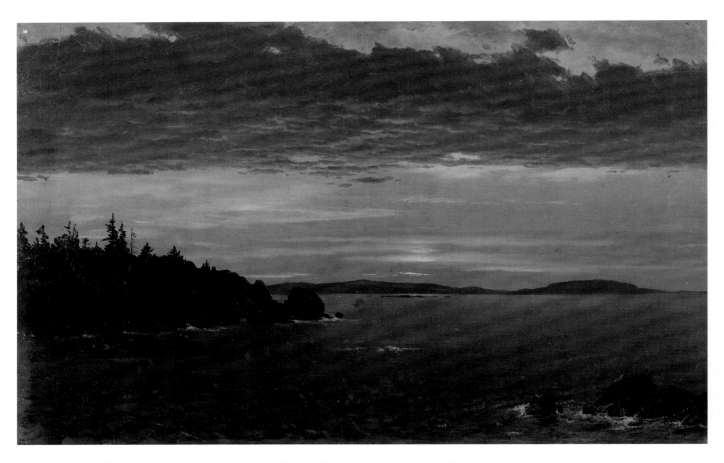

74. Frederic Edwin Church. *Schoodic Peninsula from Mount Desert at Sunrise*, 1850–55. Brush and oil paint on paperboard.

these trips, he went to Schooner Head during a storm to see "the ocean beating on the rocky shore."[117] Remembering his exhilaration upon viewing the scene, Church returned to this site in 1862, where he painted *Surf Pounding against the Rocky Maine Coast* [FIG. 75]. Based on the latter study, Church composed an exhibition canvas entitled *Coast Scene, Mount Desert*, 1863 [FIG. 76]. The finished painting converted the naturalistic study of the coast on an overcast day into a flamboyantly sublime image of divine redemption.[118] During the month, Church and the Tracy party also traveled to Bar Harbor (visiting the Lynam family along the way), where they are listed in the Agamont House register. Church loved the picturesque view of Bar Harbor and the Porcupine Islands, the three little "dumplings" just outside the harbor in Frenchman's Bay. One of his sketches shows the sun rising over the Porcupines on a foggy day [FIG. 77]. This image of a hazy sun shining through a steel-blue sky suggests more than color and light, it

also conveys the cool, moist air of Mount Desert itself—a mark of Church's observation and technical brilliance.

By 1857, the story of Church, the Tracys, and the dinner party they gave for eighty people before they left the island had become mythologized. A *New-York Daily Times* travel writer visiting the island reported hearing about the artist and the farewell party wherever he went.[119] Church was especially credited by George Ward Nichols, in *Harper's New Monthly Magazine*, with transferring the tourist center, originally at Southwest Harbor on the island's southern coast, to Bar Harbor on the eastern side. Nichols went so far as to formally acknowledge the important role Church and other artists played in transforming Bar Harbor into a tourist destination. "Cole was the pioneer here . . . and he had a host of followers . . . In the course of time Church's pictures of the scenery at Mount Desert were seen in the exhibitions of the National

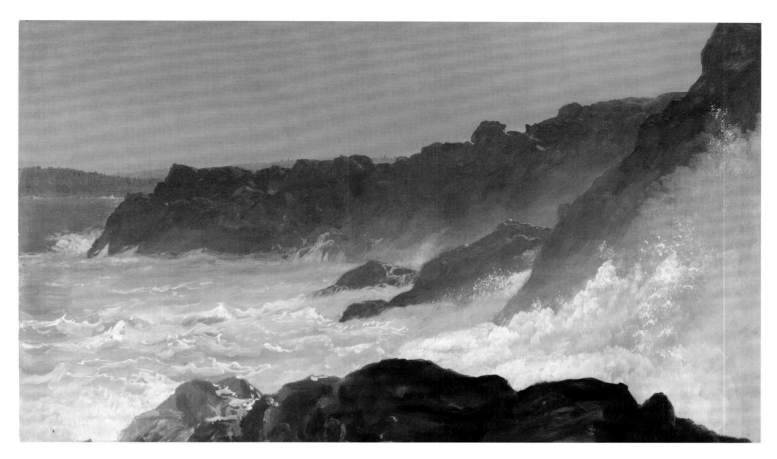

75. Frederic Edwin Church. *Surf Pounding against the Rocky Maine Coast*, ca. 1862. Brush and oil paint, graphite, on thin paperboard.

Academy and noted artists have followed . . . and it is chiefly by this means . . . that Mount Desert has become so popular as a watering place."[120]

In 1872, when this article appeared, Mount Desert was well into the second, or hotels, phase of resort development. The Eastern Railroad had bought the Agamont House from Tobias Roberts for the handsome sum of $30,000, and there were fourteen other hotels, the principal one being the Rodick House, which by 1882 accommodated around four hundred tourists.[121] Cottagers, who received the wrath of Edwin Godkin, had already begun building mansions. The first relatively modest 1869 house of Alpheus Hardy led the way for the increasingly elaborate million-dollar vacation homes of the Fords, Vanderbilts, Rockefellers, Carnegies, and Pulitzers.

Foreseeing as early as 1850 what lay ahead for the island, Church moved farther north, seeking a new wilderness experience. He found it two years later at Mount Katahdin (elevation 5,270 feet), already celebrated as the archetypal wilderness by Henry David Thoreau, who published an account of his mountain trek in an 1848 *Union Magazine* article. Once he found Katahdin, Church never looked elsewhere in the United States for primeval content. He made many more trips there, eventually purchasing a camp on Lake Millenocket, southeast of the mountain.

Very little survives from Church's earliest 1852 trip other than the heroic *Mount Ktaadn*, a work imbued with the myth of America's pastoral harmony, and which Church painted for the National Academy 1853 exhibition [FIG. 78].[122] Fortunately, a number of oil sketches detailing forest interiors can be linked with passages in Theodore Winthrop's account of his eight-day mountain trek with Church in 1856. Three oil sketches dating from the 1870s appear to have been the sources for

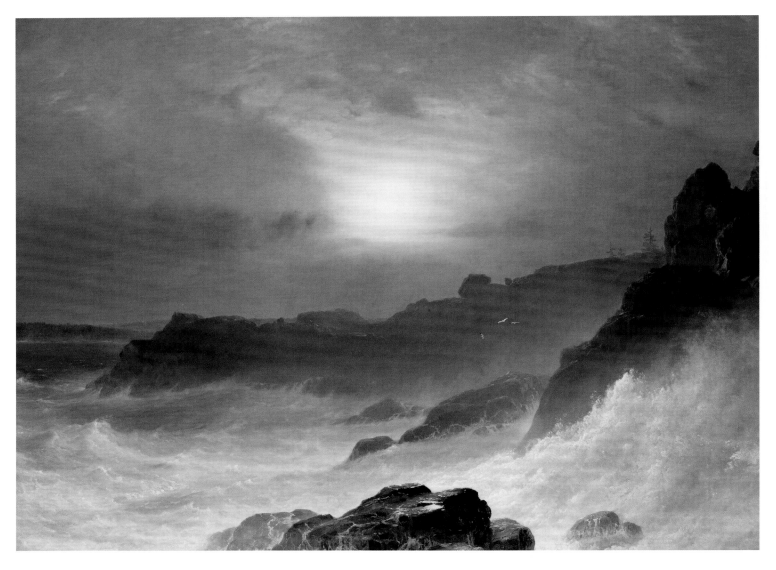

76. Frederic Edwin Church. *Coast Scene, Mount Desert (Sunrise off the Maine Coast)*, 1863. Oil on canvas.

the images accompanying writer A. L. Holly's illustrated record of an 1877 expedition that included Church, Lockwood de Forest II (1850–1932), Sanford Gifford, Horace W. Robbins (1842–1904), and Holly.[123] An unfinished sketch, *Mount Katahdin Rising over Katahdin Lake*, may well have been the model for the larger image, *Katahdin from the South Shore of the Lake*, incorporated in the headpiece of the "Camps and Tramps" article [FIGS. 79, 80], while two other detail sketches of the Great Basin, one view from far out in the lake and the other from closer up, appear to be conflated in another illustration, *A View in the Great Basin* [FIGS. 81–83]. Since the maga-

zine illustrations were designed by Thomas Moran, who included his monogram in the lower left and right corners of the two illustrations, it must be assumed that Moran studied Church's sketches still at Olana, or that Church sent his sketches to Moran in New York City. (In the process of translating Church's oil sketches into wood-engraved illustrations, Moran converted Church's rugged mountains into his own generic, fantastical cone-shaped peaks.) Finally, a dazzling oil sketch of Katahdin from 1852, with radiant sunset clouds casting a red glow on the lake below, served as the preparatory study for a small exhibition canvas, *Mount Katahdin* (1853) [FIGS. 84, 85].[124] Over the

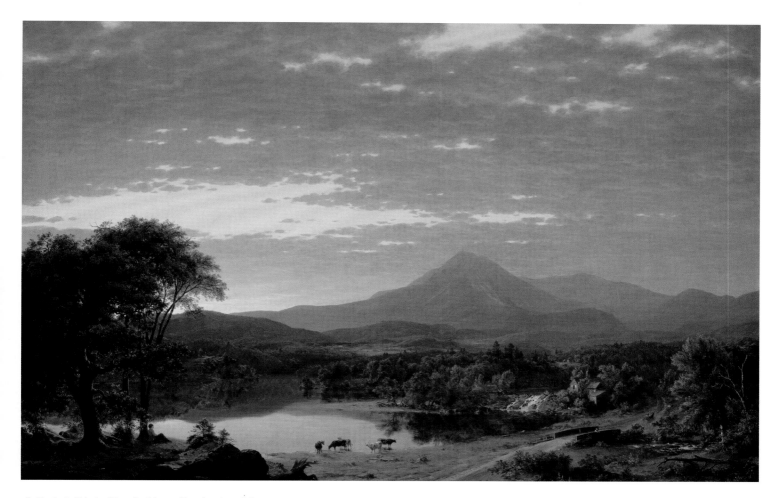

78. Frederic Edwin Church. *Mount Ktaadn*, 1853. Oil on canvas.

course of almost forty-five years, Church painted a nearly complete portrait of the colors, textures, and atmospheres of the noble mountain in all its moods and manners.

Church's trips into the wilderness must also be viewed in the light of the country's obsession with health, sports, and the outdoors in the years after the Civil War. The 1860s through the 1880s witnessed the introduction of a number of summer sports, from the relatively mild croquet to tennis, bicycling, and golf. During the 1860s and 1870s especially, a number of articles appeared in the *Atlantic Monthly, Scribner's Monthly*, and *The Nation* touting the virtues and pleasures of camping out. A. L. Holly's article "Camps and Tramps" was a camping "how-to" manual, complete with descriptions and diagrams of tent building, lists of essential supplies and foodstuffs, and a reckoning

of costs. The state of Maine in particular promoted itself as a destination for hunters and fishermen. The Boston & Maine Railroad, along with the Maine Central Railroad, which created the 1884 slogan "Maine, the Nation's Playground," were leaders in distributing sports-related brochures, maps, and guidebooks appealing to out-of-state sportsmen.

Throughout the years, there has understandably been a tug of war among sportsmen, conservationists, developers, and the lumber industry to protect the landscape so admired by Church and Homer while supporting the state's economy. After a wave of real-estate speculation on Mount Desert in the 1880s and 1890s challenged the lifestyle of the exclusive cottagers, Charles Elliot and George Dorr, with the financial support of bankers and railway executives, formed a corporation after 1900 to pur-

77. Frederic Edwin Church. *Sun Rising over Bar Harbor,* ca. 1860. Brush and oil paint on paperboard.

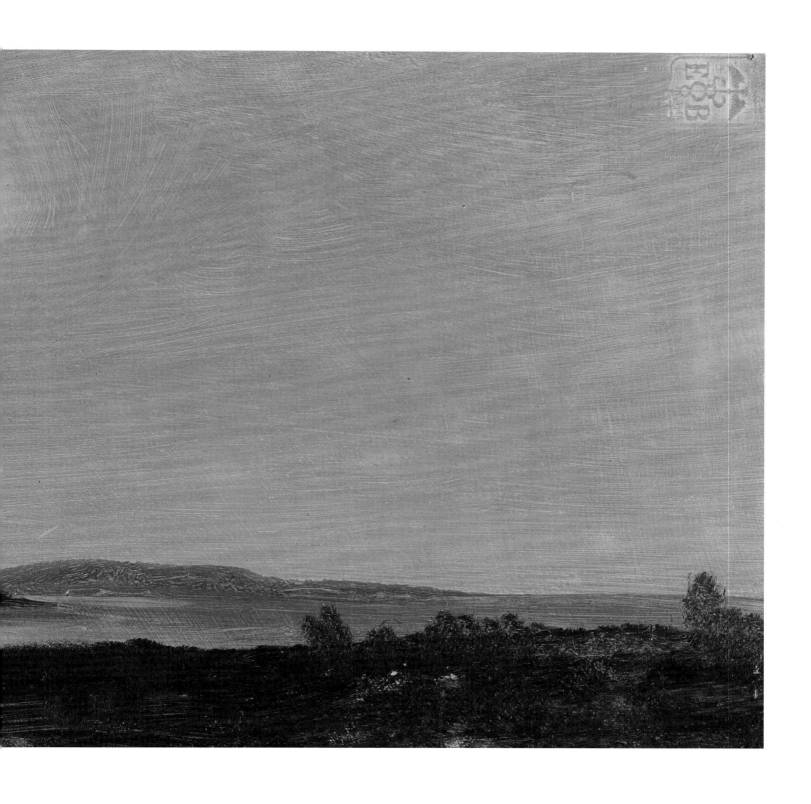

79. Frederic Edwin Church. *Mount Katahdin Rising over Katahdin Lake*, before 1878. Brush, oil and graphite on paperboard.

chase properties on the island to preserve undeveloped land for public enjoyment. This effort led to the creation of Lafayette National Park (now Acadia National Park) in 1919. Katahdin and the surrounding 6,000 acres were purchased by Maine's governor (1921–1925) Percival P. Baxter to form the nucleus of Baxter State Park, created in 1931, which today totals over 200,000 acres.

CONCLUSION

In an 1891 essay in *The Century* magazine entitled "Our Summer Migration, A Social Study," Edward Hungerford enumerated all the benefits of tourism to the "national spirit," regardless of class or region. According to Hungerford, vacationing not only rejuvenated men "to do more and better work" and "to prolong a working life or the working period of many lives"; more important, tourism brought revenue to transportation, local trades, construction, sports clothing and gear, and road building, emphasizing production and the national economy.[125] Coming at the close of the nineteenth century, his argument for tourism as the oil greasing the wheels of industrial capitalism was a long way from Thomas Cole's charge in 1836 to cultivate a taste

for scenery to "learn the laws by which the Eternal doth sublime and sanctify his works, that we may see the hidden glory veiled from vulgar eyes."[126]

These two opposing visions of the value of scenic appreciation—one secular and pragmatic, the other spiritual and personal—reflect the distinct approaches of Frederic Church, Thomas Moran, and Winslow Homer to the landscape. Both Church and Moran painted pristine landscapes in the tradition of Thomas Cole, revealing God's presence in nature and hailing America as the new Eden. Homer's landscapes, on the other hand, upheld a different set of national priorities. In the wake of the Civil War, when it was no longer viable for the nation to be defined by its untarnished land, artists like Homer sought to improve nature with human activity, purpose, individuality, and democratic values. In many of his works, Homer showed men working; children playing in the fields or on the seashore; and modern women recreating out-of-doors, reading, or absorbed in thought, independent, and self-assured. But Homer's landscapes, like Church's and Moran's, reflected a changing national agenda. Homer's paintings and drawings

of "fictitious" shepherds and shepherdesses exemplified a national nostalgia for a mythologized innocent, Arcadian past; while his late epic paintings of men and the sea referenced the Darwinian struggle for survival and the tough, courageous, persistent action that would be required of a new corporate America.[127]

Although their specific works may not have directly contributed to the growing summer migration,[128] the works by Church, Homer, and Moran in this book reflect how closely, at times, their choice of geographic subject matter paralleled the burgeoning tourist and land-development industries. By altering and "constructing" the perspectives they depicted of scenic American landscapes, all three of the artists, who were clearly aware of the popularity of their regional subjects, also enticed vacationers to these areas.

When Frederic Church arrived at Niagara, the site had already evolved into a tourist destination. His great *Niagara* of 1857, which was displayed in public exhibitions and reproduced in a chromolithograph and engraving, became a metaphor for America's unceasing forward motion westward to the Pacific Ocean and toward progress.[129] Indeed, Church's painting, as much or more than the cataract itself, remains fixed in the American imagination even today. Following in the footsteps of his teacher Thomas Cole, Church traveled to Vermont, the Catskills, and on through the Adirondacks and the White Mountains to Mount Desert. Both in the Catskills and Mount Desert, Church arrived fairly early in the resort-development process. His romanticized images, displayed in galleries and art institutions such as the National Academy of Design and the Century Club, or purchased by wealthy collectors or by the American Art Union, introduced these areas to a knowledgeable audience, which in turn sought out these landscapes and encouraged the larger public to follow. Furthermore, by establishing his home in the Catskills, Church, along with Bierstadt and

CAMPS AND TRAMPS ABOUT KTAADN.

KTAADN, FROM THE SOUTH SHORE OF THE LAKE.—FROM A STUDY BY F. E. CHURCH.

80. Thomas Moran after Frederic Edwin Church. *Katahdin from the South Shore of the Lake*, in *Scribner's Monthly*, May 1878. Wood engraving.

other artists who had summer homes/studios overlooking the Hudson River Valley, put his stamp of approval on the region as being worth visiting or investing in with a second home.

Like Church, Winslow Homer traveled to remote locations for his artwork, but he was searching less for divine confirmation than for a decent resort with enough amenities to be comfortable, and with good surrounding material for his artwork. Until his paintings brought him sufficient funds to live on, Homer provided images of fashionably dressed women and men on the cliffs at Long Branch, tourists on horseback or resting near the top of Mount Washington, men hunting deer, as well as

81. Frederic Edwin Church. *Great Basin, Mount Katahdin, Maine*, before 1878. Brush and oil paint on paperboard.

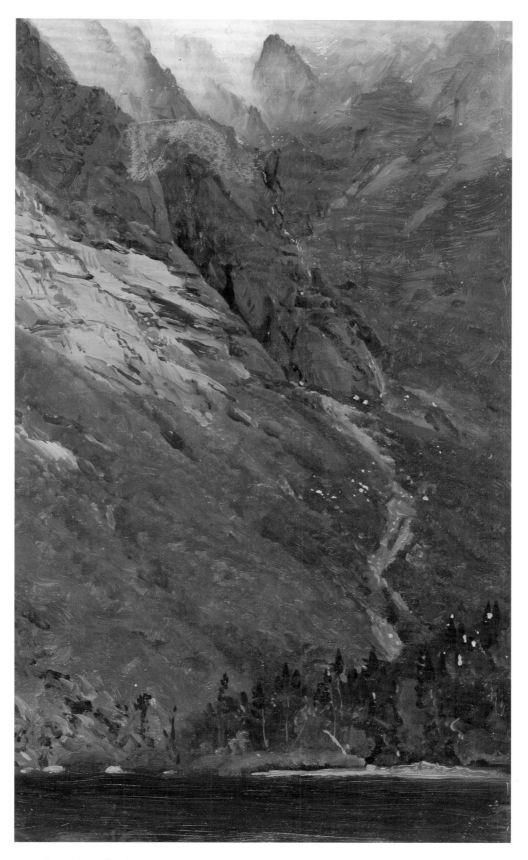

82. Frederic Edwin Church. *Mount Katahdin, Great Basin*, before 1878. Brush and oil paint on paperboard.

awoke, and rose up in the mirage, and bathed himself in the yellow light, till his crest was transmuted into gold, and his breast into leagues of pink coral, while every glory of the rainbow rolled down his gorgeous flanks, as morning broke upon the plain.

The Mount Turner party returned next day, and told their stories over the evening camp-fire,—stories of hard struggles over wind-falls and through tangled underwood, of a few spoonfuls of water apiece on the mountain top, and of compensation for their troubles in the rare beauty of a primeval forest,—singular growths, dead trunks tumbled picturesquely together by the wind, great trees wreathing their roots around big bowlders cushioned all over with mosses, and little rivulets running out below, all variegated with the glistening white birch and the great bronzed and many-tinted leaves of the moose-wood.

A VIEW IN THE GREAT BASIN.—FROM A STUDY BY F. E. CHURCH.

83. Thomas Moran after Frederic Edwin Church. *A View in the Great Basin*, in *Scribner's Monthly*, May 1878. Wood engraving.

children fishing in the Adirondacks or messing around the Gloucester shore. His images captured the eyes and imaginations of the independent and active readers of periodicals, guidebooks, journal articles, and accounts of resort areas. By the time the artist moved permanently to the Maine summer resort of Prouts Neck in the 1880s, Homer had matured as a painter and business entrepreneur. Taking a cue from his industrialist brothers, he invested in the vacation market, participating directly in the Maine resort and recreation industry.

Regardless of their individual motivations, these artists devoted their careers to creating landscapes and other images which stirred the imagination of vacationers across America. These pictures were profusely reproduced in numerous illustrated periodicals created in the 1850s. *Harper's Weekly, Frank Leslie's Illustrated Newspaper, Appleton's, Every Saturday, Scribner's Monthly* (later renamed *The Century*), and others commissioned designs for wood-engraved illustrations by Homer, Moran, and other artists. The celebrated deluxe publication edited by William Cullen Bryant, *Picturesque America* (1872–74), with essays on every scenic locale in the country, featured wood-engraved images by Moran of Yellowstone and the Grand Canyon, and these images came to be imprinted in the minds of travelers, potential travelers, and armchair travelers. Through the artwork that came to them in these pages and other publications, America's citizens learned to cherish their iconic landscapes.

Such images and illustrations inspired people to visit America's scenic sites, while it was the railroads that actually got them to their destinations. Between 1840 and 1896, the amount of track in the U.S. increased from 2,828 miles to 195,000 miles, making the wilderness of the Adirondacks, White Mountains, Vermont, Maine, and the Far West accessible to sportsmen and vacationers.[130] These new rail lines not only stimulated the growth of tourism, but also of resorts, some of which were built by the railroad companies themselves.

Today, summer—and winter—vacations are a time-honored ritual in the lives of many American workers and families, and many nineteenth-century American artists such as Church, Homer, and Moran contributed through their art to the growth and development of the young country's tourism and leisure pursuits.

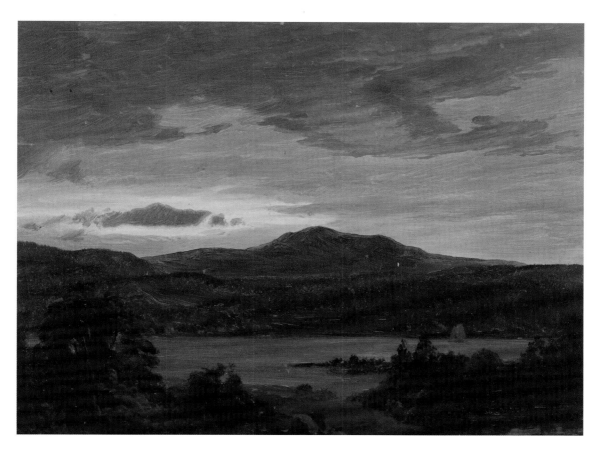

84. Frederic Edwin Church. *Mount Katahdin from Lake Katahdin*, ca. 1853. Brush and oil on thin paperboard.

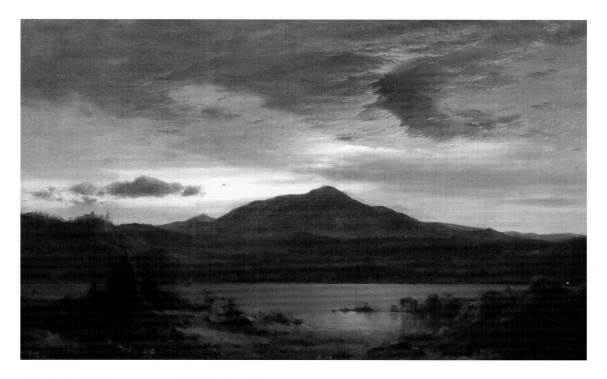

85. Frederic Edwin Church. *Mount Katahdin*, 1853. Oil on canvas.

The Best Possible View: Pictorial Representation in the American West

Floramae McCarron-Cates

Late nineteenth-century America witnessed the production of images of its iconic sites in tremendous numbers. Niagara Falls, Yellowstone, Yosemite Valley, the Grand Canyon, and various resort towns and mountain retreats were extensively memorialized via photography and wood engravings. This vocabulary of images registered deeply in the collective memory of Americans and served as surrogates for travel. While an increasing number of travelers crisscrossed the country in the years following the Civil War, many others journeyed vicariously through the printed medium and came to recognize panoramic sights unknown only a few years before.

The viewing of such iconic American places helped construct a sense of what it meant to be an American in the late nineteenth century. Hundreds of magazines, journals, weekly newspapers, picture books, and portfolios from the 1850s to 1910 published images that reinforced collective ownership of the land in the memories of Americans. What few realized, however, was that these images, which played such a convincing role in developing a national identity—separate from, yet equal to, the European identities that so many of the populace shed upon coming to America—were often edited, manipulated, and constructed expressly to stir national pride and instill a sense of belonging.

THE ARTIST AS RECORDER
Among the artists and photographers actively engaged in recording the American continent during

this period were some of the best-known artists, as well as a host of less familiar, but equally important, illustrators and regional photographers. In the mid-1860s, Carleton Watkins (1829–1916) photographed the magnificent views in California's Yosemite Valley [FIG. 1]; his images were instrumental in securing the area as a national park, and this earliest of portfolios of the "inviolate" wilderness became the basis for the concept that registered in the American public's conscience. In 1871, photographer William Henry Jackson (1843–1942) and painter Sanford Gifford (1823–1880) traveled to the Grand Canyon, and photographed and sketched its immense, steep canyon walls and unending views.

In 1873, artist Thomas Moran traveled with Jackson to the sulphur springs of Yellowstone, where the two sat side-by-side and recorded the exact same views, one with graphite and watercolor [FIG. 2], the other with large-format glass plates, stereo-cameras, and chemicals.

Winslow Homer, whose popular wood-engraved images of daily life published in *Harper's Weekly*, *Appleton's*, and *Frank Leslie's* in the 1860s and 1870s set the standard for the look of the well-heeled traveler to Long Branch, New Jersey, and Saratoga Springs, New York.

Thomas Moran and Winslow Homer shared similar artistic backgrounds. They were both self-taught, in the sense of having no formal art

FRONTISPIECE Thomas Moran. *Toltec Gorge*, 1881. Brush and black, brown, and blue ink washes, white gouache, graphite on tan wove paper.

1. Carleton E. Watkins. *Vernal Fall, 300 feet, Piwyac, Yosemite,* 1861–66. Albumen silver print.

training, as academies of art were few in America in the mid-nineteenth century; also, the two worked as illustrators, and were recognized as exceptional practitioners of the craft. Moreover, both artists later felt the need to progress beyond the limitations of illustrative rendering.

On the East coast, Frederic Church produced the most important nineteenth-century paintings of Niagara Falls, which were reproduced as color lithographs and widely disseminated. Church's crisp, detailed oil paintings, which brought him fame as a naturalist painter in the 1850s and 1860s, reveal an artist who believed that landscape painting

could, when coupled with a spiritual agenda, engender a moral code that guaranteed his popularity with the American public.

These artists were engaged in an identical pursuit: to record, document, and present "from the best possible view"[1] both the theoretically untrodden areas of the western United States and the well-trodden resort towns and watering holes to the American businessman, traveler, entrepreneur, and congressman. Their goal was to convince the public not only that the far-flung reaches of the country held promise and opportunity, but also that areas more familiar to the urban dweller were ideal

2. Thomas Moran. *Lower Fire Hole, Geyser Basin, Yellowstone*, 1892. Graphite on brown wove paper.

places to visit and spend their leisure hours. The precision with which all these documentarians recorded the views before them, with every frozen detail of tree and rock; and, in the case of Homer, the sophisticated, abstracted depiction of the upper-middle class, convinced the public of its right to both faraway territories and local resorts.

Photographs as well as sketches often served as the template from which artists and illustrators, employed by publishers of weekly journals, created their scenic illustrations, and they reinterpreted the documentary evidence as they reproduced it. The artists felt at liberty to add, eliminate, construct, and romanticize the template supplied by the photographic image while holding to the compositional structure. These images produced by Moran [FIGS. 3, 4] George Henry Smillie (1840–1921), Henry Fenn (1845–1911), and others working for *Appleton's*,

Frank Leslie's, *Scribner's*, *The Aldine*, and *The Century* magazines came to be imprinted in the minds of thousands of American readers and purchasers of albums, who came to feel as if they knew the places firsthand—unaware, in many cases, that what they saw was not necessarily what was there.

The sense of "being there" reached its apex with the popularity of the invention of the stereoscope—an optical instrument equipped with dual eyepieces used to impart a three-dimensional effect to two photographs, or stereographs, of the same scene taken at slightly different angles. The stereoscope brought urban armchair travelers deep into the remote wilderness, solidified the sense of an American place in the minds and memories of millions of people. The perceived realism of the photograph, its ability to record every branch and every stone, acted as a map, providing information as to light and tex-

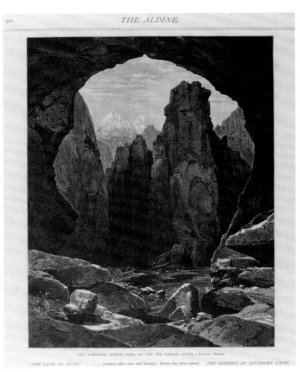

4. Thomas Moran. *The Narrows, North Fork of the Rio Virgin, Utah,* in *The Aldine,* vol. VII, No. 16, April, 1875. Wood engraving on off-white wove paper.

PALISADE CAÑON.

3. W. H. Morse after Thomas Moran. *Palisade Cañon,* in *Picturesque America,* vol. II, 1874. Wood engraving on off-white wove paper.

ture, but the stereoscope actually simulated arrival at a destination, allowing the viewer to absorb the scenery and experience a sensation akin to travel.

THE VIEW FROM THE PARLOR WINDOW

How better to evoke the sense of place than to attempt to virtually place the spectator in the scene at hand?[2] Photographs, wood engravings, and other graphic media could transport the viewer in ways

words alone could not. Single-image photographs and stereoviews carried two distinct responses to the landscape that can be considered objective and subjective, respectively. Wood engravings, used most frequently to illustrate texts by geologists, tour guides, storytellers, and essayists in nineteenth-century periodicals, instilled a romanticized subjectivity, a wistful mythologizing of the views. Coupled with descriptive text, the images were reinforced and amplified. The texts in turn were given an authority by the images—often of dramatic vistas, remote mountains, or pastoral meadows—and the viewer/reader was ultimately convinced of the authenticity of the narrative. The graphic black-and-white of the engravings conveyed the same invincibility as the authority of the black and white text, both produced and reproduced in identical fashion [FIG. 5].

In his reinterpretation of the development of Western painting from a sociocultural rather than an art-historical perspective, Jonathan Crary observed that photographic advances after 1839

influenced a reportorial change not only in the way images were made, but also in the way they were presented to the public. The impact of "the modernization of vision"[3] on information access, especially in the graphic arts, is evident in the proliferation of images executed by illustrators in the years from 1860 onward. Crary observed that the realism evident in late nineteenth-century painting and illustration and the advent of photography are better understood as the result "of a single social surface," rather than merely a formal comparison. Crary placed great emphasis on the impact of the stereoscope, pointing out that it was "a dominant form for the consumption of photographic imagery for over half a century," and, while it was intended to "formalize the physiological operation of binocular vision," it, and photography in general, "became an essential part of the shaping of the individual to the requirements of institutional power in the nineteenth century."[4]

In America, the nineteenth-century painters fell into two camps. The traditionalists, including Moran and Church, who looked to eighteenth- and nineteenth-century English and seventeenth-century French models for compositional strategies, and the modernists—Homer being an early American proponent—who recognized the fresh, abstract flatness of the photographic image and its possibilities as a new pictorial tool. In each case, the view was mediated: The traditionalists applied the compositional strategies of European landscape painters to iconic American vistas; modernists created a new, formal vocabulary based on the balance and arrangement of color on the picture plane. These two temperaments, which influenced the late nineteenth-century American landscape artist, reflected dualistic aspects of American culture of the period. On the one hand, there was a reportorial tendency to explain and describe with a precision that at times seemed hyper-real; on the other, there was also a strong romantic component. This duality reflected a strongly spiritual, yet practical, national character. For the publishers of the pictorials and the promoters of western tourism, this combination proved lucrative in the extreme. According to Harry C. Jones, writing for *The Quarterly Illustrator* in spring 1893, the four most

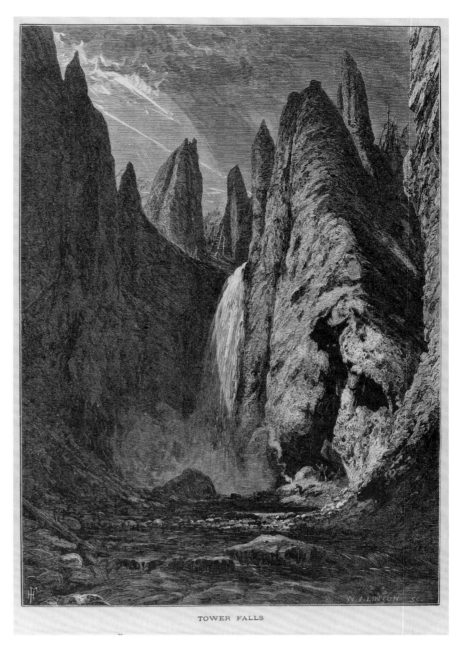

TOWER FALLS

5. William Linton after Henry Fenn. *Tower Falls, Yellowstone,* in *Picturesque America,* vol. II, 1872. Wood engraving on off-white wove paper.

important illustrated magazines of the time were *The Century, Harper's, Scribner's,* and *The Cosmopolitan,* and he notes that, in the months of September, October, and November 1892, these four periodicals published approximately 450 landscape and figure drawings and featured more than sixty artists.[5] These illustrations for fiction and essays provided a visual break, as well as anecdotal or moral reference points, from the printed text.

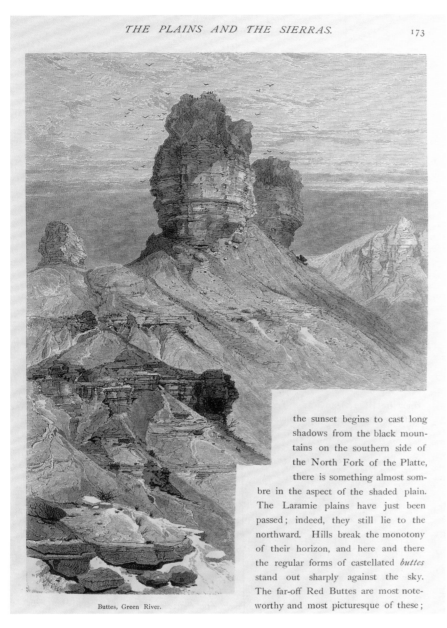

the sunset begins to cast long shadows from the black mountains on the southern side of the North Fork of the Platte, there is something almost sombre in the aspect of the shaded plain. The Laramie plains have just been passed; indeed, they still lie to the northward. Hills break the monotony of their horizon, and here and there the regular forms of castellated *buttes* stand out sharply against the sky. The far-off Red Buttes are most noteworthy and most picturesque of these;

Buttes, Green River.

6. Thomas Moran. *The Plains and the Sierras,* in *Picturesque America or The Land We Live In,* vol. II, p. 173, 1874. Wood engraving on off-white wove paper.

This reportorial yet romantic approach is evident in the field studies, watercolors, and wood engravings of Thomas Moran. Born in England and raised in Philadelphia, where he began his artistic career in 1853 as a wood engraver, Moran had been inspired by the writing of John Ruskin, and was introduced to the works of J. M. W. Turner (1778–1851) through the Philadelphia painter James Hamilton—at the time considered to be "the American Turner"— who encouraged the younger artist to study Turner's

Liber Studiorum [Book of Studies], a collection of engraved landscape compositions, grouped into categories: pastoral, mountainous, marine, etc., and was in essence a compositional reference book for any aspiring landscape painter.

Moran rendered mountain ridges, or the rim of the Grand Canyon [FIG. 6], in a sharp, unflinching line. Conversely, his wash drawings often emphasized vistas seen through a dramatic scrim of shadow and light playing on the precipitous rocky cliffs and solitary gorges [FIG. 7]. The wood engravings Moran produced for *Picturesque America* of Yellowstone [FIG. 8], the Sierras [FIG. 9], and the Grand Canyon [FIG. 10] vividly translated the panoramas into page-size views—vast, yet manageable, for the armchair traveler. Moran's first illustrations of Yellowstone for *Scribner's* magazine in the May–June 1871 issue accompanied N. P. Langford's article "The Wonders of Yellowstone," which documented the author's exploration of the region the year before. The images Moran supplied were a mixture of informed imagination pieced together from photographs provided by his publisher and his interpretation of Langford's text.

This same romantic reportage is evident in the oil sketches of Frederic Church, although his painterly application of color suggested variations of temperature and light. His descriptive use of color in a depiction of a Catskill sunset [FIGS. 11, 12] emphasized the dramatic and hinted at nostalgia. Travelers familiar with the New York countryside knew these views even if they had not actually had the privilege of viewing them from the vantage point of Church's home at Olana, in the Catskills.

Homer supplied a reportorial description while leaving the romantic agenda to the reader/viewer. His images of tourists in resort towns carried a lightly suggested narrative that was not always supplied by the accompanying text. Many of Homer's large illustrations were not linked to text but served as "stand-alone images."

As an example of romantic reportage, Moran's drawing entitled *Toltec Gorge,* from about 1881 [FIG. 13], and *Gorge and Tunnel,* his wood engrav-

7. Thomas Moran. *The Grand Cañon in the Rain*, 1873. Graphite on cream wove paper.

ing cut in 1880 [FIG. 14] and published in *Around the Circle through the Rocky Mountains* in 1890, seem almost identical except for the square format that eliminates two large rocks in the foreground. In both compositions, the treatment of light, details of the sky, and cluster of trees at center, as well as the splashing foam on the river as it churns among the rocks, are identical, despite the great variation in size. The wood engraving, produced under the auspices of the Denver and Rio Grande Railroads, was obviously intended as a promotional device to entice potential tourists. Another view of the same scene by Moran, *Toltec Gorge and Eva Cliff from the West, Denver and Rio Grande Railroad* [FIG. 15], dated 1892, repeats the sweeping parabola of

the steep sides of the gorge as they meet below. The same compositional strategy was used by Moran in 1874 in the wood engraving *Springville Canon, Utah* [FIG. 16], published in *The Aldine*, where the vista beyond the rocky outcropping allows us to peer down between steep cliffs into a narrow gorge. The repetition of this compositional device provided a sense of recognition and familiarity in the viewer that served to reinforce ownership of the landscape.

In her detailed and informative analysis of Moran, Joni Kinsey discussed how Moran artfully and compositionally rearranged the elements of the natural landscape that we recognize as the view from

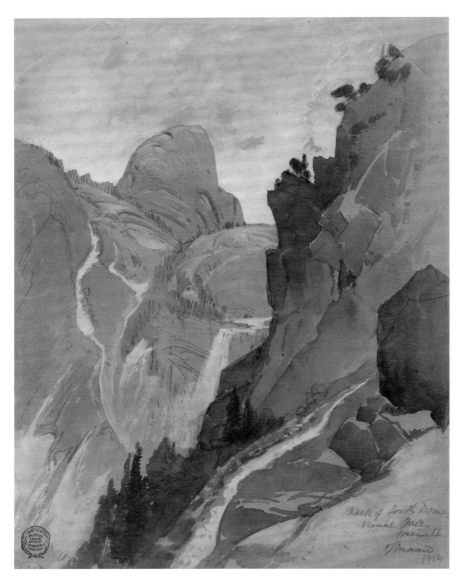

8. Thomas Moran. *Yosemite, Vernal Falls*, 1904. Brush and white gouache, graphite on blue gray wove paper.

SUMMIT OF THE SIERRAS.

9. Roberts after Thomas Moran. *Summit of the Sierras*, in *Picturesque America*, vol. II, 1874. Wood engraving on off-white wove paper.

Artist's Point.[6] In comparing the painting with Henry Jackson's photographs of the scene, it is clear that the photographic "truth" of the scene differs from the artist's perspective. Moran himself commented on his pictorial motives in composing his great painting *Grand Cañon of the Yellowstone* in George Sheldon's *American Painters*, published by D. Appleton in 1881: "Every form introduced into the picture is within view of a given point, but the relations of the separate parts to one another are not always presented . . . My aim was to bring before the public the character of that region." This compositional juggling to create a convincing equivalent of the scene, "the best possible view," was elucidated by Ernst Gombrich where he compared the photograph's "objective truth" to what an artist records:

Take the image on the artist's retina. It sounds scientific enough, but actually there never was *one* image which we could single out for comparison with either photograph or painting. What there was was an endless succession of innumerable images as the painter scanned the landscape in front of him and these images sent a complex pattern of impulses through the optic nerve to his brain.[7]

Gombrich ended this observation with the remark that an artist's interpretation of the myriad elements that constitute a painting, compared to what actually exists in nature, has the same relationship as a "poem bears to a police report."

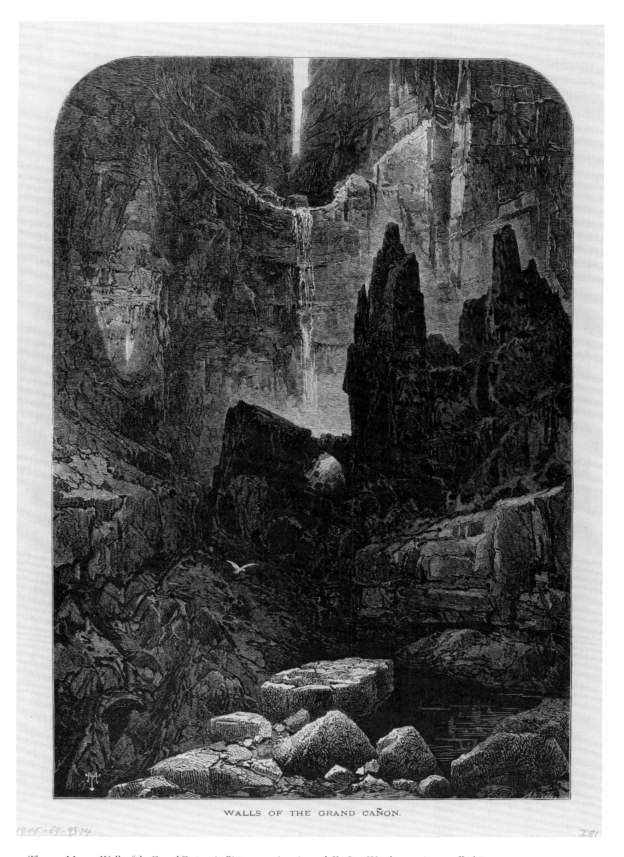

WALLS OF THE GRAND CAÑON.

10. Thomas Moran. *Walls of the Grand Cañon*, in *Picturesque America*, vol. II, 1874. Wood engraving on off-white wove paper.

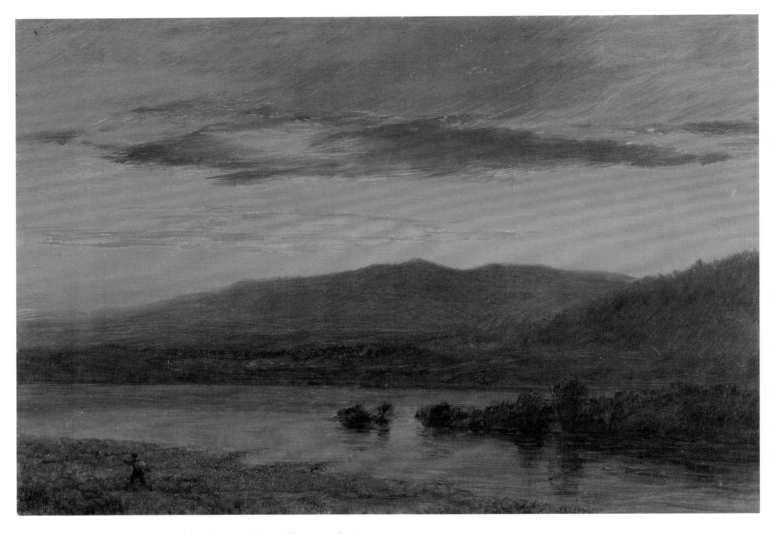

11. Frederic Edwin Church. *Sunset, Hudson, New York*, 1873. Oil on paper laminate.

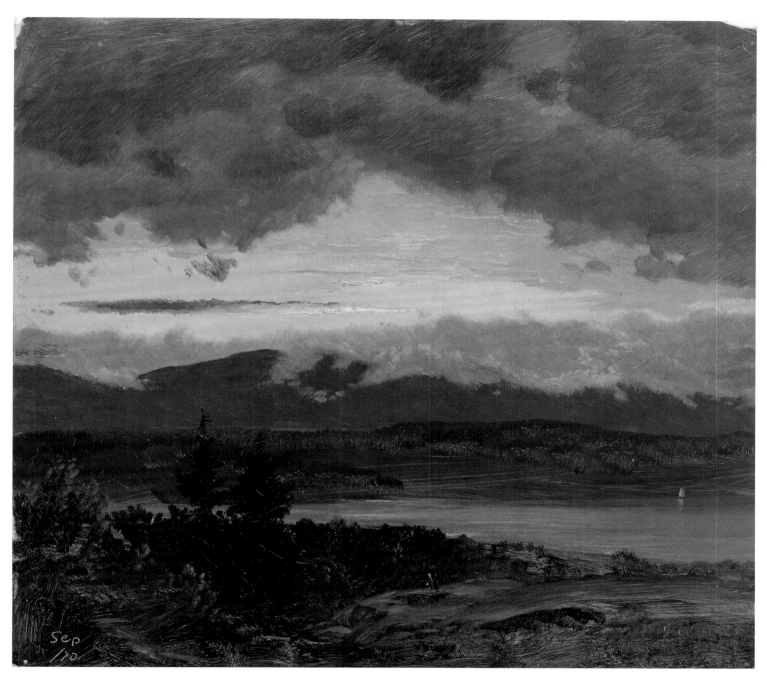

12. Frederic Edwin Church. *Sunset across the Hudson Valley*, 1870. Oil on paper laminate.

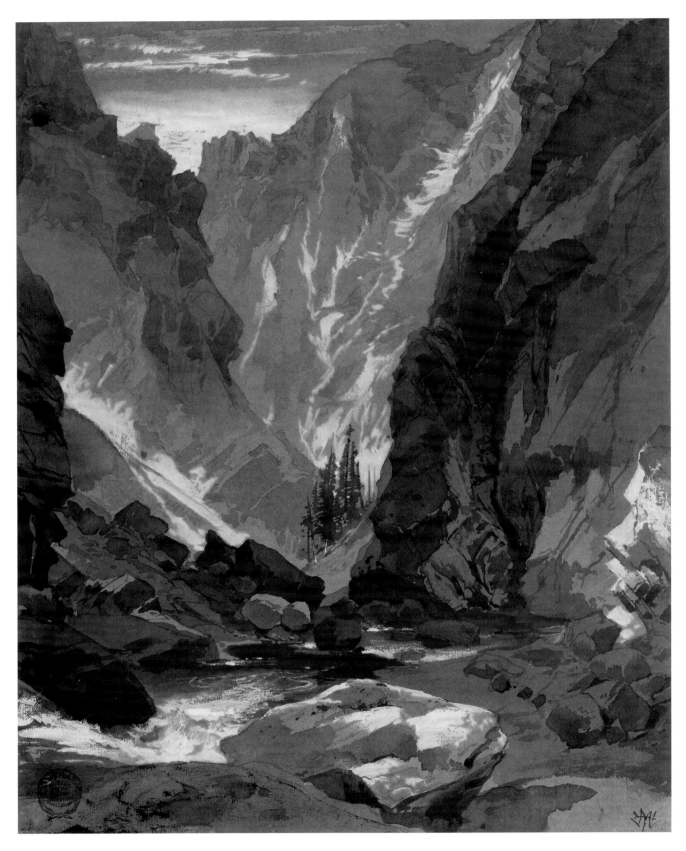

13. Thomas Moran. *Toltec Gorge,* 1881. Brush and black, brown, and blue ink washes, white gouache, graphite on tan wove paper.

14. Thomas Moran. *Gorge and Tunnel,* from *Around the Circle through the Rocky Mountains,* 1890. Wood engraving on off-white wove paper.

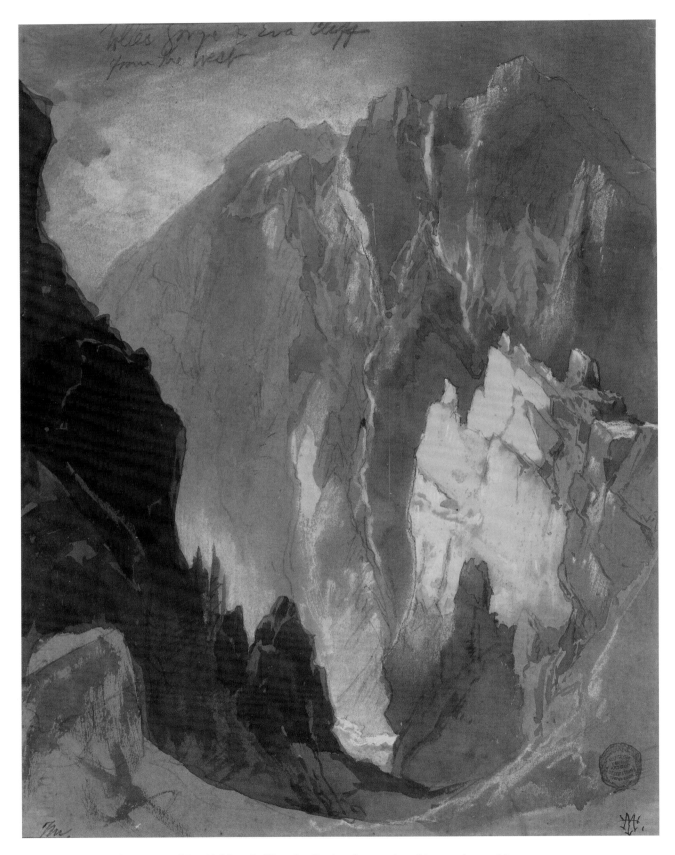

15. Thomas Moran. *Toltec Gorge and Eva Cliff from the West*, 1892. Brush and watercolor, white gouache, graphite on gray wove paper.

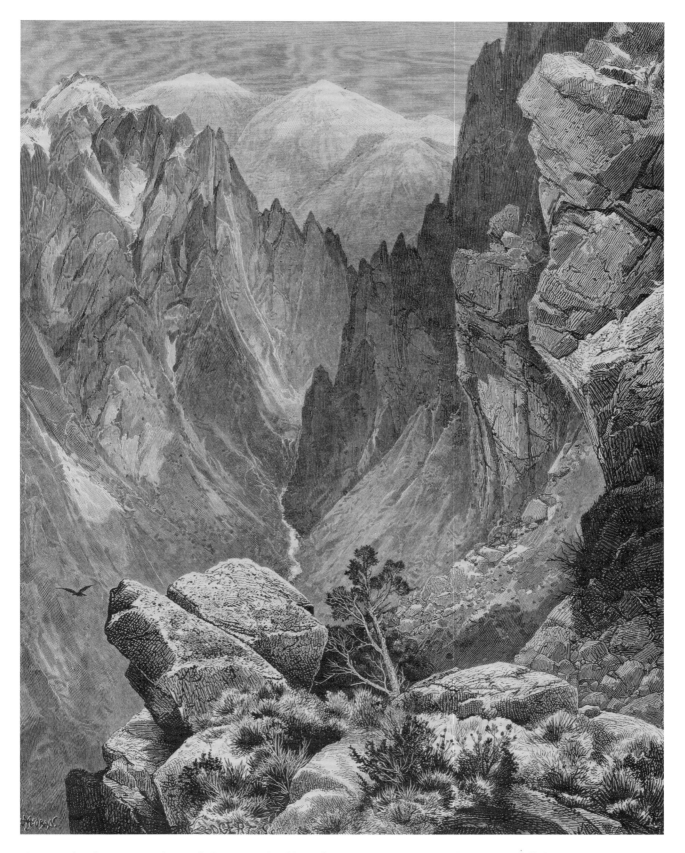

16. Bogert after Thomas Moran. *Springville Canyon*, in *The Aldine*, vol. VII, no. 1, January 1874. Wood engraving on off-white wove paper.

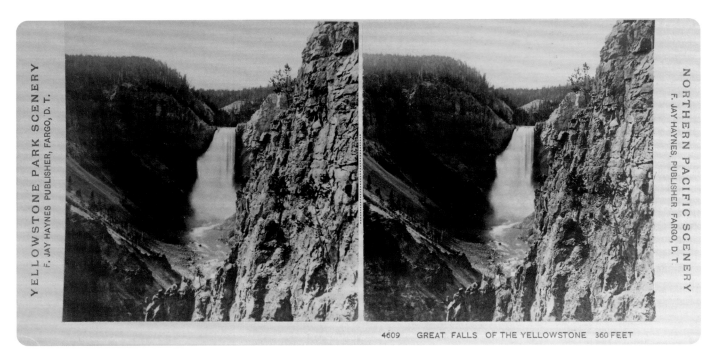

YELLOWSTONE PARK SCENERY
F. JAY HAYNES PUBLISHER, FARGO, D. T.

NORTHERN PACIFIC SCENERY
F. JAY HAYNES, PUBLISHER, FARGO, D. T.

4609 GREAT FALLS OF THE YELLOWSTONE 360 FEET

17. Frank Jay Haynes. *Great Falls of the Yellowstone*, number 4609 from the series *Thirty-six Selected Haynes Stereoscopic Views of the Yellowstone National Park*, 1881–88. Albumen silver prints mounted on cream paper laminate with printed text.

Moran was adapting what Gombrich called a "schema" or a blank—which resembles, in a general way, the salient features of a landscape in combination with topographical actualities. This, when presented in pictorial form, will convince the viewer of its authenticity, just as photographs of the immense vistas convince by detailing every possible nuance. Moran substituted his personal vision of rock, tree, mountain gorge, and stream, rendered in his signature style, to suggest what would best express "the character of that region." In fact, Jackson commented that Moran was as "interested as the photographer himself in selecting the view points . . . having in mind, perhaps, the good uses he could make of the photographs later in some of his compositions."[8]

That these same compositions, constructed from an assortment of combined elements from drawings and photographs, could be used repeatedly over several decades proves that the entrepreneurs of late nineteenth-century America, whether they be travel guides, railroad promoters, innkeepers, or publishers, depended on the ability of the consumer to recognize the same places over time.

Artists like Moran and, of course, photographers like Frank Jay Haynes (1853–1921) [FIGS. 17, 18], Watkins [FIGS. 19, 20], and John K. Hillers (1843–1925) [FIG. 21], who could be relied on to produce the "best possible view," were guaranteed success. Moran, like the stereoview photographers, relied on various tropes, or compositional devices, to ease the viewer into the scene. Many of Moran's wood engravings and drawings featured rock formations strategically placed in the "exaggerated foreground," providing an anchor of a sort for viewers to get their bearings [FIG. 22]. This was a variation of the photographer's trick of placing a branch or an artfully arranged grouping of rocks in the foreground to enhance the three-dimensional feel of the stereoscope. In both instances, the immediacy of the foreground enhanced the viewer's sense of actually being in the place.[9]

MEDIATION OF SCENIC VIEWS
In his 1859 essay "The Stereoscope and The Stereograph," published in *The Atlantic Monthly*, Oliver Wendell Holmes extolled the use of the new image-making techniques called daguerreotypes (unique photographic images) and "sun pictures"

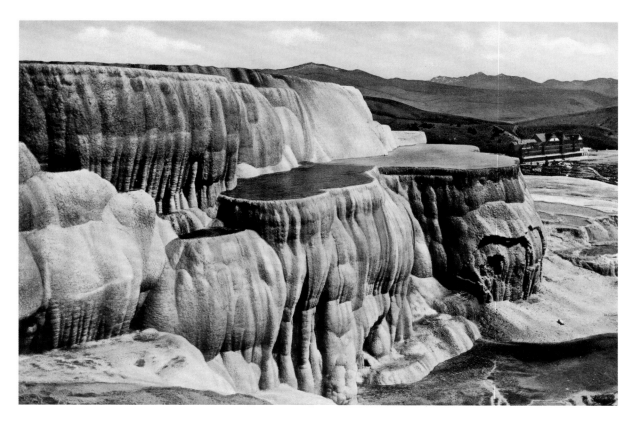

18. Frank Jay Haynes. *Mammoth Hot Springs–Yellowstone Park*, number 5 from the series *Yellowstone Park, Color Photogravures*, after 1889. Photolithograph on paper laminate.

(images made from a negative and that could be infinitely reproduced).[10] He praised the daguerreotype as being a "mirror with a memory," and stated that reproducible images would change how images were used; however, he reserved his most substantial praise for the stereographic process. As momentous as the physical presentation of the image itself was the almost magical three-dimensional nature of images viewed through a stereoscope [FIG. 23]. According to Holmes, it produced "a surprise such as no painting ever produced. The mind feels its way into the very depths of the picture." As the originator of the term "stereograph," Holmes conveyed the uncanny effect of studying the minutiae recorded by the photographer, and the sense of presence offered by the apparatus. He described examining a photograph under magnification of two people standing at Table Rock viewing the Niagara Falls, and how the degree of detail provided a sense of "knowing" and recognizing the individuals [FIG. 24]. The perfection of the image and the ability to place the viewer at the

scene were matched only by the captivating, almost overwhelming, detail that the stereograph provided.

More important than the details themselves was the impression that the viewer was actually at the scene. Holmes called "infinite volumes of poems" the views of exotic places that he visited with his "glass and pasteboard"—mountainous heights, winding streets, or "ever-moving stillness of Niagara." Holmes knew that in 1838 Charles Wheatstone[11] had published a description of stereo vision, explaining that when one looked at an image, say, of a fairly detailed and realistic painting, the viewer's two eyes sent the retinal image to the brain as one monocular experience. When, however, the visual information from a solid object was sent to the brain, the brain experienced the object from two opposing perspectives, and the impact of those two images, the left slightly different from the right, produced the three-dimensional image of the object at hand. This feeling of solidity gave stereography its impact.

19. Carleton E. Watkins. *Half Dome, 4967 Feet, Yosemite*, 1861–66. Albumen silver print.

The impact of the photograph, and the stereographic image in particular, on nineteenth-century landscape painters was considerable. Providing the most accurate aide-mémoire ever produced, while supporting the ideological agenda of "truth to Nature" advocated by progressive painters who followed the teachings of John Ruskin, the photograph simultaneously stimulated and threatened the traditional image makers. While painters could argue that photography could not compete with painting due to its inability to record color, they admitted the reportorial superiority of the new medium. The stereograph, early on considered merely a novelty, proved to be more instrumental in the popularization of scenic views than the photograph. Even the

most successful late nineteenth-century photographers in America, including Watkins, Eadweard Muybridge (1830–1904), and J. Loeffler, realized the commercial potential of the stereograph, and re-shot their iconic views with stereo cameras to satisfy their customers. [FIG. 25]

In 1867, Frederic Church began work on a monumental painting of one of North America's most spectacular scenic wonders, *Niagara Falls from the American Side* [see Davidson, p. 17]. Church, the first pupil of Thomas Cole (1801–1848), was a founding member of the Hudson River School of painters (so called for the subject matter of their landscape paintings), and considered by many crit-

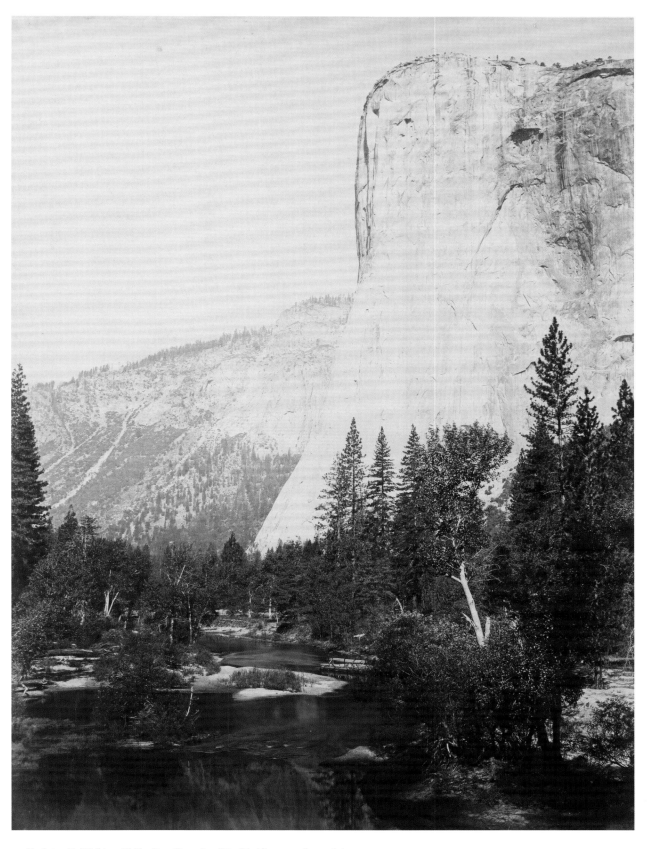

20. Carleton E. Watkins. *El Capitan, Yosemite,* 1861–66. Albumen silver print.

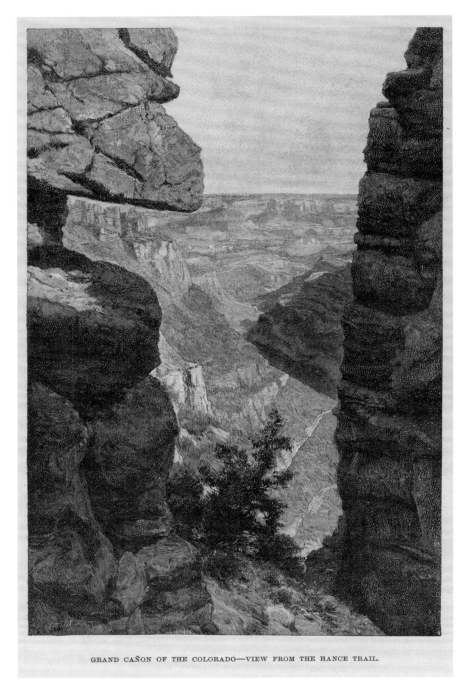

GRAND CAÑON OF THE COLORADO—VIEW FROM THE HANCE TRAIL.

21. F. Pettit after H. Bolton Jones from a photograph by John K. Hillers. *Grand Canyon of the Colorado, View from Hance Trail*, in *Harper's*, vol. LXXXII, Nov. 1890–Apr. 1891. Wood engraving on off-white wove paper.

DEVIL'S GATE, WEBER CAÑON.

22. John Filmer after Thomas Moran. *Weber River, Entrance to Echo Canyon*, in *Picturesque America*, vol. II, 1874. Wood engraving.

which he executed as early as 1856, he also relied on photographs, presumably to assist with correctly rendering the challenging perspective. Painting directly on a large-scale albumen print, taken by an anonymous photographer [FIG. 26]—one of literally dozens of landscape photographers who made a living selling images to tourists—Church placed a tiny, transparent triangle of aqua to convey the light striking the Canadian falls. He painted a line of trees in the distance and, with deft strokes, laid in the dark gray clouds and thin streak of blue sky that the photograph could not capture.

A comparison of the photo/oil sketch with the finished painting is revealing, as the photograph that serves as an under-painting in the traditional sense proves to be the structural basis for the considerably powerful composition, as well as for the details that convince us of our presence at the scene. The twisted trees that dangle on the left es-

ics as the best landscape painter in America. He had painted the Falls before, in 1857, and the enormous success of that painting in America and in England inspired him to prepare a second composition. While Church worked from graphite and white gouache preparatory drawings, many of

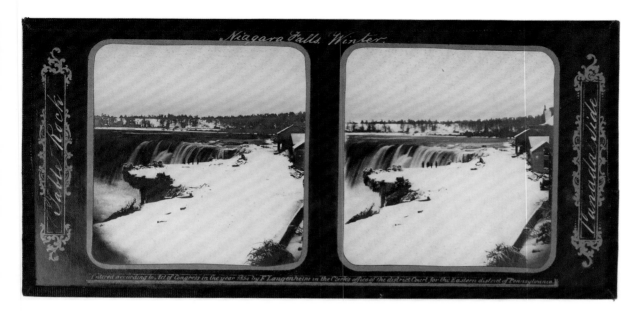

24. Frederick Langenheim. *Niagara Falls, Winter, Table Rock, Canadian Side*, 1854. Glass stereoview.

23. Underwood and Underwood. Stereoviewer, ca. 1901. Wood, aluminum, brass, and glass.

carpment in the painting owe their existence to the actual ones faithfully recorded in the photograph. Only the two minute figures standing on the viewing stand (figures that bear a resemblance to the two individuals observed by Holmes above in his description of the stereograph) are added from the imagination of the artist—or so we believe; the photograph from which Church worked was cropped all around, so the tourists in the painting may have been based on actual figures standing on the promenade of Prospect Point, surreptitiously captured by the photographer.

As the only known complete sketch for the large painting (highly finished working sketches for sections of the painting are in Cooper-Hewitt's collection, but none that so exactly correspond to the finished composition), the photograph/oil sketch provides information about Church's approach to beginning a major canvas. First, the image was cropped down to accentuate the most dramatic composition, and the sheet was glued down onto a laminated paper board, similar to the boards Church often used for oil sketches. Then, he obscured the intensity of the photographic detail with opaque wash; perhaps he felt the rich detail too distracting. At the center of the photograph, Church placed a point and, with ruled graphite lines, divided the image into sections. The lower right quadrant was marked off in intervals of one inch, measurements which correspond to similar markings running up the proper right edge on the back of the board. Curiously, the photograph was trimmed into an arc at the bottom, the corners of the sheet rounded off prior to being glued down. This preparatory object is one of the few extant examples of Church literally embracing a new technology and adapting it to his work. Debates often rage about whether certain artists "worked from photographs," and as corresponding images rarely survive, the speculation usually remains unresolved. In this case, Church was working directly on

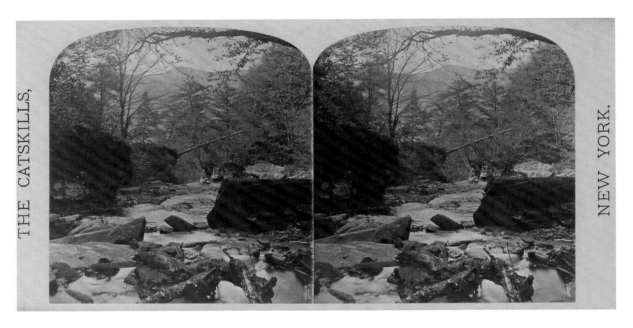

THE CATSKILLS,

NEW YORK.

25. J. Loeffler. *The Catskills*, ca. 1865. Albumen silver prints mounted on paper laminate with printed text.

the photograph, so he was obviously amenable to the use of photographs.[12] Church actively collected daguerreotypes, images on glass, and albumen prints of Niagara and many European and Middle Eastern sites which related to his paintings; among them were specific subjects like cloud studies, details of nature and camping scenes. Though he never journeyed to or painted the West, Church avidly collected the monumental images of Yosemite shot by Carleton Watkins.[13] Although Church collected many photographic works, there is no evidence that he ever made photographs himself, unlike his American contemporary Thomas Eakins. The photograph that serves as the study for *Niagara* does not bear a commercial photographer's stamp, and it has been suggested that Church may have hired a photographer to record specific details or compositions that best suited his needs.[14]

A comparison of the view itself with stereographic examples by the Philadelphia landscape photographers Frederick and William Langenheim (active Philadelphia 1840–74), who worked at Niagara in 1855, is instructive.[15] These examples are glass stereoviews in sepia, a process patented in 1854 in Philadelphia, a fact proudly noted on each slide. This image, *Winter Niagara Falls—General View from the American Side* [FIG. 27], shows a view of

the Falls that Church's judicious cropping denies us. The scene, taken from a higher vantage point and slightly to the left, clearly shows the lookout point favored by tourists, artists, and photographers for the "best possible view"—a term used by photographers until well into the twentieth century. A railing surrounds the precipitous drop, and the snow-shrouded, ogee-shaped pavilion used by Platt D. Babbitt, the most famous of the Niagara photographers, is clearly visible, an attraction in itself.

This scene of the falls in winter was one of the most dramatic that could be purchased as a souvenir. When viewed as intended in a stereoscope, the three-dimensional perspective of the falls, with the foreground railing appearing almost within arm's reach, and the point of the pavilion perched in the middle distance, is spectacular. The Canadian Falls in the background break into a rhythmic, semi-circular curve, appearing just behind the Terrapin Tower. Although no visitors are shown, probably due to the long exposure time needed to capture this magical scene, they are suggested by the pavilion and the railing. The absence of spectators seems odd; surely a view as dramatic as this must have had witnesses. But implied in the stereograph is a permanent spectator.

26. Frederic Edwin Church. *Niagara from the American Side*, 1858. Brush and oil over albumen silver print.

Thousands of these glass stereographs were sold beginning in 1854, the year the process was patented, into the 1870s, when the same images were reproduced as albumen prints mounted on heavy card stock and marketed as packaged sets of twenty-five or more. An example from the 1870s of Yellowstone taken by Haynes, a contemporary of Thomas Moran, shows a set of these cards in the sturdy cardboard box [FIG. 28], labeled and indexed with descriptions on the verso of each card detailing in poetic tones the sight before your eyes. The spectator, perhaps a visitor to the site or a friend or relative of the returning tourist, could stare indefinitely at the scene, and meditate on the sublime nature and the frightening energy of the foaming water, whether it was the falls of Niagara or the frozen cascades of Cleopatra's Pavilion in Yellowstone. As the image passed from hand to hand, a shared

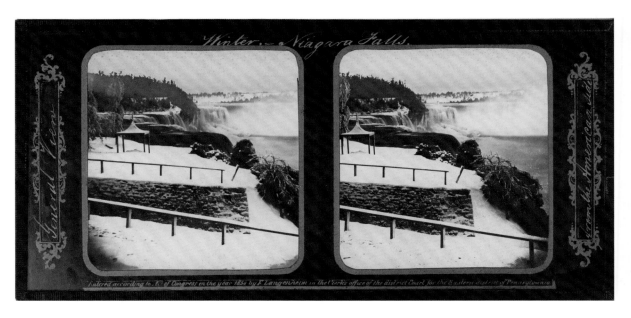

27. Frederick and William Langenheim. *Winter, Niagara Falls, General View from the American Side*, 1856. Glass stereoview.

knowledge of the place was formed. The retinal and intellectual impact of the stereoview of these iconic places on the viewer cannot be overstated. Holmes, writing in 1859, exclaimed, "By this instrument that effect [i.e., realism] is so heightened as to produce an appearance of reality which cheats the senses with its seeming truth."[16]

First presented in 1838 by Dr. Charles Wheatstone, the stereotype was originally a hand-drawn set of images, but soon became a vehicle for viewing both daguerreotypes and paper images. Whether they were daguerreotypes on polished copper or imprinted on glass, or albumen prints mounted on cardboard, these images gave the appearance of a third dimension. By the late 1850s, photographers recorded landscapes by using wet-collodian on glass, a process which, while laborious, produced results of startling clarity. The stereoscopic views of William and Frederick Langenheim were the result of a special camera which took two pictures simultaneously. Their special process for reproducing views on glass, which they called "hyalotypes," was also used to make slides for magic lanterns, another popular way of viewing transparencies. The Langenheims convinced a consortium of businessmen to finance a photographic excursion to produce stereoscopic views of American landscapes in 1855, traveling up from Philadelphia via the

28. Frank Jay Haynes. *Thirty-six Selected Haynes Stereoscopic Views of the Yellowstone National Park*, 1881–88. Albumen silver prints mounted on cream paper laminate with printed text. Boxed set of stereoscopic views.

Reading, Williamsport, and Elmira railroads to Niagara.[17] In 1862, on the occasion of Carleton Watkins's first exhibition at the Goupil Gallery in New York, the Reverend H. J. Morton, writing about the mammoth plate photographs of Yosemite Valley, proclaimed, "We are able to step from our study into the wonders of the wondrous valley, and gaze at our leisure on its amazing features."

The heightened realism of the wet-collodian on glass negatives, used by the photographers of the

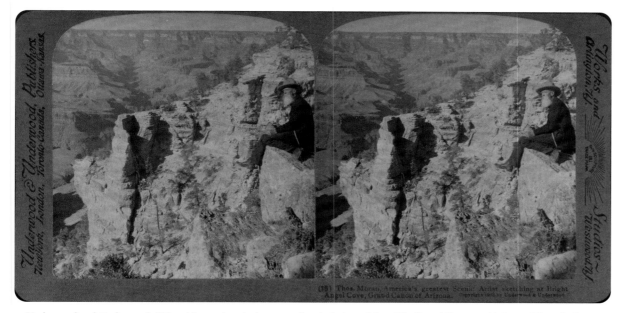

29. Underwood and Underwood. *"Thos. Moran, America's greatest Scenic Artist . . ." from The Grand Canyon of Arizona: Through the Stereoscope*, 1908. Albumen silver prints mounted on paper laminate with printed text.

1850s and 1860s to record Eastern as well as Western scenes, was real enough to dazzle as single photographs; but in stereo, they achieved a mesmerizing, almost surreal clarity. In addition, advances in steam-powered machinery used for producing stereoviews made thousands of images available by the early 1860s. Stereoviews were even beneficial to educating poor and immigrant families about the beauties of America. In a report published in the *Journal of the Franklin Institute* in September 1862, the machinery for mass-producing stereoviews inexpensively was considered essential in instructing "the humblest family where by their exquisite beauty and truthfulness they will engender a taste for the beautiful and in time entirely eradicate the cheap and disgustingly coarse lithographs, engravings and water-color daubs, which at present form so large a proportion of the pictures within reach of the poor."

In 1867, the third volume of Herman von Helmholtz's *Physiologischen Optik* published detailed observations about binocular vision. His descriptions of the sharpness and precision of the stereoview commented on the effect on memory the viewing of the images produced:

"These stereoscopic photographs are so true to nature and so life-like in their portrayals of material things, that after viewing a picture and recognizing in it some object . . . we get the impression, when we actually do see this object that we have already seen it before and are more or less familiar with it."[18]

By 1901, the firm of Underwood and Underwood had produced a boxed set of stereoviews of the Grand Canyon that included detailed descriptions of the explorations of the geological formations as well as a set of instructions for viewing the cards. The map placed the armchair traveler along the rim of the canyon (just as Thomas Moran is pictured here), from which the views were photographed, and explained the landmarks visible in each cone of vision [FIG. 29]. The instructions reminded the viewer to place the stereoscope close about the eyes in order to reduce the possibility of distraction by peripheral light and objects. The intention was to actually follow along in the footsteps of the photographer and experience the sensation of the view.

30. Thomas Moran. *Yosemite, Mirror Lake*, 1872. Brush and black wash, over graphite on light brown wove paper.

31. Thomas Moran. *The North Dome, Yosemite, California*, 1872. Brush and black wash, white gouache, over graphite on tan wove paper.

READING THE TEXT

A group of grisaille drawings executed in 1872 by Thomas Moran, *Yosemite, Mirror Lake* [FIG. 30], *The North Dome, Yosemite, California* [FIG. 31], *Half Dome, Yosemite* [FIG. 32], and *In the Yosemite Valley* [FIG. 33], all preliminary drawings for wood engravings, share certain characteristics.[19] In addition to the concentration on tonal variations, from deep blacks to whitened highlights, each drawing is presented in a vertical format, and shares a perspectival view which places the viewer precisely within the scenery. With the exception of the lack of color, the viewer can almost imagine standing on the trail in a valley filled with dramatic colors, with green conifers outlined against crystalline blue skies and startlingly white granite cliffs. The strategically placed boulders in the foreground of *The North Dome, Yosemite, California* and the river in *Falls of Yosemite* both encourage a sense of "being there." It is remarkable that the lack of local color and the substitution of carefully rendered gray washes hardly diminish the immediacy of the views. These drawings, produced in August/September 1872, while Moran and his wife Mollie were traveling on

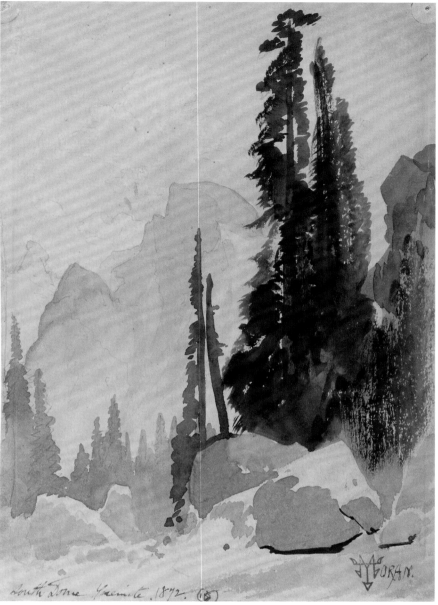

32. Thomas Moran. *Half Dome, Yosemite*, 1872. Brush and black wash, over graphite on tan wove paper.

commission by O. B. Bunce to produce illustrations for *Picturesque America*, attest to the power of the graphic mediums of wood engraving and photography, and how the consumers of these images integrated the information into their vocabulary.

Moran's tendency toward dramatic or romantic enhancement is evident in his images of the Yellowstone hot springs. In Louis Prang's 1875 *Yellowstone Park, and the Mountain Regions of Portions of Idaho, Nevada, Colorado, and Utah*, a

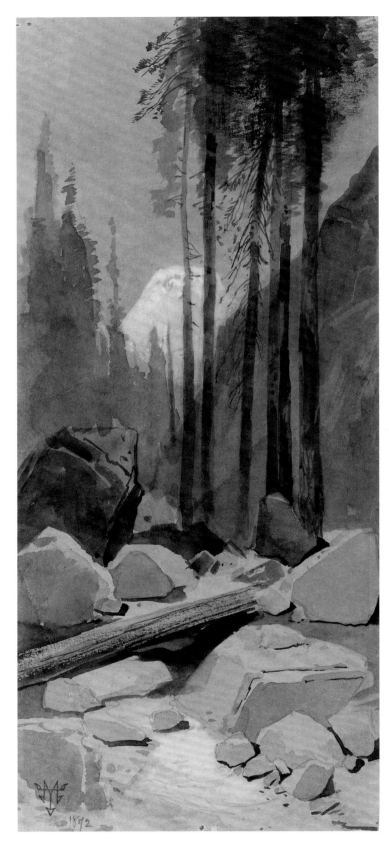

33. Thomas Moran. *In the Yosemite Valley*, 1872. Graphite, brush, and black ink and white gouache on cream wove paper.

lavishly illustrated account by F. V. Hayden of the exploration of the springs, Moran's chromolithograph *Castle Geyser, Upper Geyser Basin, Yellowstone* [FIG. 34], based on detailed sketches done on the spot, relied on fantastic cloud formations which echoed the sulfur and iron deposits of the foreground. The water spout is dramatically silhouetted by darkened sky, and the tiny spectators seem trapped between the overgrown mouth of the gaping pit and the boiling geyser. The allure is one of danger and awe — two emotions that could not be suggested by the starkly beautiful yet flat and monochromatic photographs taken at the same time by Jackson. In Powell's account of his *Exploration of the Colorado River of the West* of 1875, he preferred Moran's wood engravings over photographs, even though many of the engravings were based on the photographs of Hillers and Jackson. [20]

To understand how a monochromatic image came to be considered an accurate symbol for the land, and how viewing these images became the equivalent of experiencing these places firsthand, requires an understanding of the relationship of image to text. This in turn requires a definition of the term "reading" — whether of actual words or images — and how the originator of the "text" considered its impact on the person sitting in an East coast parlor, hoping to be carried away from an urban reality into an exciting and almost metaphysical experience.

It should be remembered that printed words were once not just published, but physically pressed onto the page prior to the invention of modern printing technology. Indeed, the page was never more a "living surface" than in the mid-nineteenth century, when Homer was at his peak as an illustrator. From a structuralist perspective, the configuration of lines, tones, and textures, combined with the graphic impact of Homer's pictorial interpretation of middle-class American life, was as convincing as any narrative. According to Roland Barthes, "Reading is: rewriting the text of the work within the text of our lives."[21] Homer's printed images were not only a means to convince the reader of cultural mores, proper attire, and deportment, but also provided a license for leisure, and a validation

to vacation that would become a staple in the American vocabulary.

In 1895, the eminent artist, critic, instructor, and author Joseph Pennell published a "Manual for the Use of Students" titled *The Illustration of Books*. This was a compilation of articles, some previously published in the *Art-Journal*, as well as lectures delivered to students at the Slade School of Art on "the various methods of making and reproducing drawings for book and newspaper illustrations." Pennell had been giving these lectures for three years prior to the publication of the manual, and he commented in the preface that "classes in drawings and engraving" for the purpose of providing illustrations for publication "have been started in almost all art schools." (Indeed, the copy referred to for this essay was in the library of the Cooper Union School of Art, founded in 1859, which was by the 1880s a major contributor to the proliferation of young illustrators, especially women.)[22] The publisher of this manual was W. Lewis Fraser, the art manager of *The Century* magazine at the time, and someone very much involved with the marketing of images.

Pennell considered illustration to be, in his words, "somewhat of a mechanical craft," and he refrained from including a discussion of art other than in the most cursory manner. His aim was to teach the student how to construct drawings that would be applicable to reproduction, and "what materials he should use, where he can get them, and how he should employ them."

Pennell devoted a lecture to "The Equipment of the Illustrator," and he stressed that the successful illustrator must understand the visual transition from drawing to reproduction, master tonal values in monochrome, and be able to visualize the appearance of the drawing after it is transferred to the wood block, engraved, and printed. He stressed that the illustrator must be able to present to the engraver an image that could be translated, tone for tone, into the language of the engraved relief line. In a subsequent chapter, Pennell discussed the types of black ink that a fine illustrator must use, and cautioned against using ink manufactured for

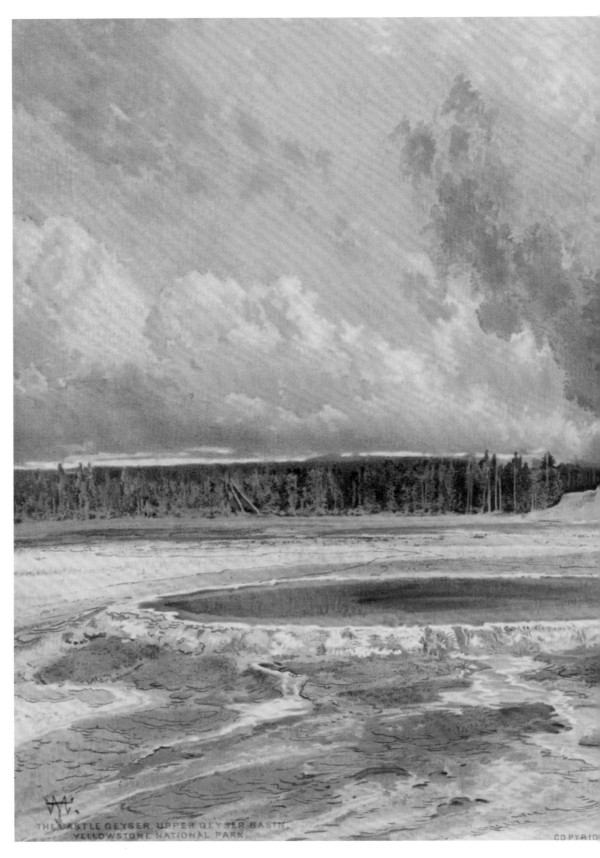

THE CASTLE GEYSER UPPER GEYSER BASIN,
YELLOWSTONE NATIONAL PARK.

COPYRI

34. Thomas Moran. *Castle Geyser, Upper Geyser Basin, Yellowstone*, 1876. Chromolithograph on white wove paper.

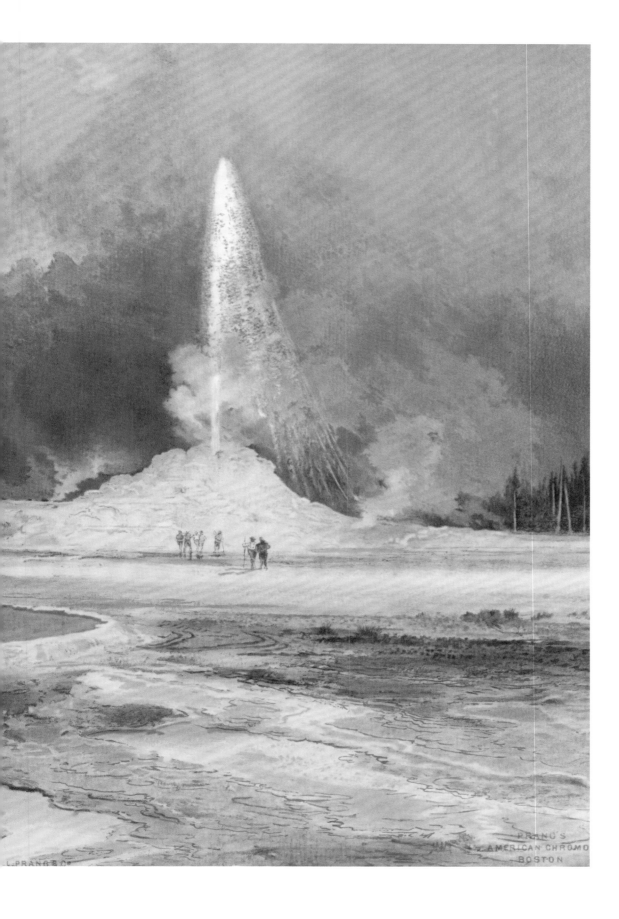

35. Winslow Homer. *Two Girls*, 1879. Graphite carbon tracing, retouched on white wove paper.

letter writing, as these inks contained a degree of blue pigment and thus were unsuitable to be photographed; in his day, photographic film was orthochromatic, meaning that the blue colors of the spectrum would not register.[23]

Throughout the essays, Pennell took for granted that the finished drawings would be photographed for transfer to the wood block to facilitate the engraving, and he warned against stray lines, fingerprints, or other marks, as they would reproduce as easily as the drawing itself. He also mentioned that the artists would be well advised to make the drawing larger than the size of the intended reproduction. Fine detail lines and hatchings, once reduced for photographic transfer, would become impossible to engrave, and the result would be unreadable.

Alternately, drawings enlarged for transfer often appeared "crude or clumsy."

In his discussion of transferring the drawn image into a wood engraving, Pennell explained the method of placing a transfer paper under the drawing and a tracing paper over the original, and then tracing out the top, allowing the artist to have both a tracing and a transfer while still retaining the original without additional markings. In many cases, it explains how both a wood engraving and an original drawing can remain intact; traditionally, the artist's original would be glued to the end grain side of the wood block as a guide for the engraver, thus being destroyed in the process.

Winslow Homer excelled in this most rudimentary of offset printing techniques. Many of his graphite drawings in the Cooper-Hewitt collection demonstrate his mastery of this method of transferring [FIG. 35], honed while supplying material to *Harper's Weekly*, *Appleton's*, and *Frank Leslie's*, and which served him well in the production of his later watercolors and paintings.

From about 1865, artists no longer lost their drawings in the engraving process, as direct photography onto the wood block became the prevailing technical method employed by publishers. Frances M. Benson remarked in the spring 1893 issue of the *Quarterly Illustrator* that Moran was so proficient at the newest technologies for publishing images that "there is not a process of photography, lithographing [*sic*] or etching, but he is familiar with it."[24]

In order for the public to absorb the massive number of iconic American views and recognize and identify each spot immediately, the images of these spaces had to conform to an established agenda. From Niagara to the White Mountains of New Hampshire, from the Maine Coast and the idyllic pastures of the Hudson River valley to the shore points of the mid-Atlantic coastal plain and the vast Western vistas that defined the grandeur and majesty of the United States, the same basic template of the "best possible view" was continually repeated, with romantic embellishments where needed in order to conform to the text.

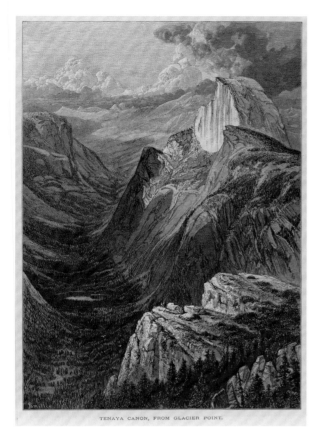

36. John Filmer after James D. Smillie. *Tenaya Canyon from Glacier Point, Yosemite*, in *Picturesque America*, 1874. Wood engraving on off-white wove paper.

THE MEDIATED VIEW AND THE CONSTRUCTION OF A NATIONAL VOCABULARY

Taken together, the paintings, drawings, and oil sketches of iconic scenery and views by Church, Homer, and Moran, along with the photographs and wood engravings of these same locations, reinforced the intellectual concept of a heritage shared by all Americans. In the Reconstruction period (1865–77) following the Civil War, it was imperative to reinforce the bond Americans felt to their land in order to strengthen the reunification efforts. As Western territories were added to the Union, and images of them produced by surveys proliferated in mass-produced journals and books, the vocabulary of iconic images became a primer for the new nation. Every schoolchild knew Moran's *Grand Canyon of the Yellow Stone* because it was hung in reproduction in nearly every classroom in America.[25] The beautiful wood engravings in the

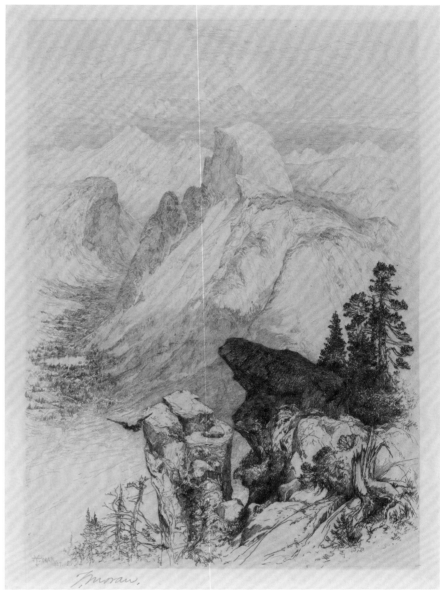

37. Thomas Moran. *The South Dome, Yosemite Valley (Half Dome)*, 1887. Etching on tan Japanese paper.

lavishly produced *Picturesque America* made far-flung sights part of America's collective visual memory. But were the scenes executed by Moran for the many publications exact depictions of the view, or did he deviate from the authority of the photographed image? As Eleanor Harvey noted, many people are perplexed when they arrive at the "very spot" on which the artist stood and the vista is not as they expected.[26] Comparing two famous images of Yosemite—a composition by James D. Smillie, *Tenaya Canyon, from Glacier Point,*

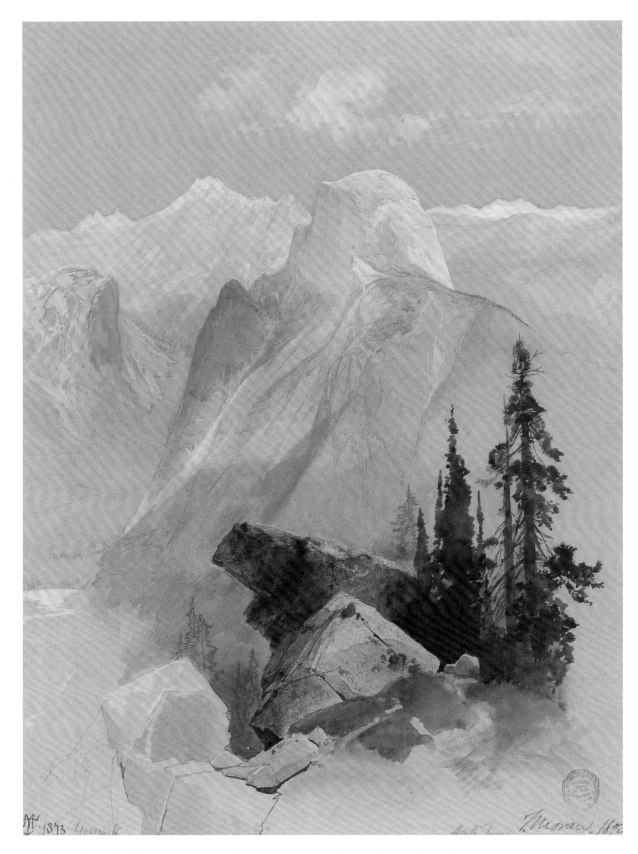

38. Thomas Moran. *Half Dome, Yosemite*, 1873. Brush and watercolor, white gouache, graphite on blue-gray wove paper.

Yosemite, engraved by John Filmer and published in *Picturesque America* in 1872 [FIG. 36], and Thomas Moran's etching of the same view, *The South Dome, Yosemite Valley (Half Dome)* [FIG. 37]—executed from the exact same vantage point underscores the importance of the constructed point of view to the artist. Smillie's is definitely what we know to be the "best possible view" of that landscape, looking up the valley with the light striking the face of the Half Dome on the right, and a long view of the valley floor from a dizzying height. Moran's etching, although executed in a medium better suited to express the aerial sensation of such a view, duplicated the exact composition point by point. The comparison of the two media is instructive, as the wood engraving, reproduced in a luxurious publication, and the etching, a fine-art print sold to collectors, played to the same consumer. One could say that the repeated "impression" of the view, whether published wood engravings or mammoth plate photographs, would induce a purchase of the etching for display, framed, in the parlor. Comparing these two images with the watercolor of the same view by Moran [FIG. 38], we see that he has again adopted the "best view," while the inclusion of opalescent colors gives an ethereal quality missing from the heavier treatment of the wood engraving by his contemporary, and only hinted at in the etching. But Moran's treatment of the scene feels constructed rather than observed, and the constructed quality undoubtedly came from the fact that this highly finished watercolor was executed in the studio from a combination of drawings by the artist, published photographs by others at the site, and the artist's own recollections. Additionally, the small trees at lower right seem out of scale with the immensity of the vista, almost as if Moran assumed the viewer needed to be reminded of the timberline in order to situate himself on the precipice. As in most of these artistic renderings, the accoutrements of civilization were edited out, leaving us with an unsullied and unobstructed view. This is what he remembered, and wanted us to remember.

A characteristic of many, if not all, of Homer's illustrations for the pictorials is the sense of detached immediacy to the scenes. There is no feeling of distance between the viewer and the participants portrayed. Rather, the viewer is encouraged to analyze those lucky individuals who have already arrived and experienced the East coast resort towns and watering holes—traveling among the men and women at a fishing party in the Catskills, or happening upon an artist at the height of the summer season in the White Mountains. Here, Homer shows us the best possible viewer, rather than the finest view, as he invites us to comment on the tilt of a woman's head or the style of her straw bonnet as she sits upon the bank of the small stream; and we notice the murmured conversation of the group of sprawled men behind her in their boater hats and cotton suits [FIGS. 39, 40]. These images also function as a "schema," but for the ideal American tourist rather than the ideal view. Homer and his publishers knew that the American tourist was as interested in the appearance of other tourists almost as much as they were interested in the views. This is underscored in images like *The Artist in the Country*, whose subject ostensibly is the view being painted, but we are offered the artist under his umbrella in the sun perched on the crest of a hillside in New Hampshire, with his young female companion peering over his shoulder [FIGS. 41, 42]. Homer showed us what an "artist painting in the outdoors" looks like and instructed the viewer in the proper way to unobtrusively participate in similar situations should that viewer happen upon an artist when next they toured the country.

Homer's wood engravings, so popular in the 1860s and 1870s, placed the viewer in the heart of the moment, as if turning your head to the left or right would result in seeing these groupings of couples, children, and hikers. This snapshot immediacy isolates the moment, captures it, and transforms it into a visual memory. Vividly outlined in strong black contours, the published wood engravings produced a series of indelible images, creating memories of holidays in the minds of the subscribers, who read the details of the images as well as the accompanying text.

The photographic teams that produced the stereoviews and photographic albums, E. T. Anthony, the Kilburn Brothers, Frank Jay Haynes, and others,

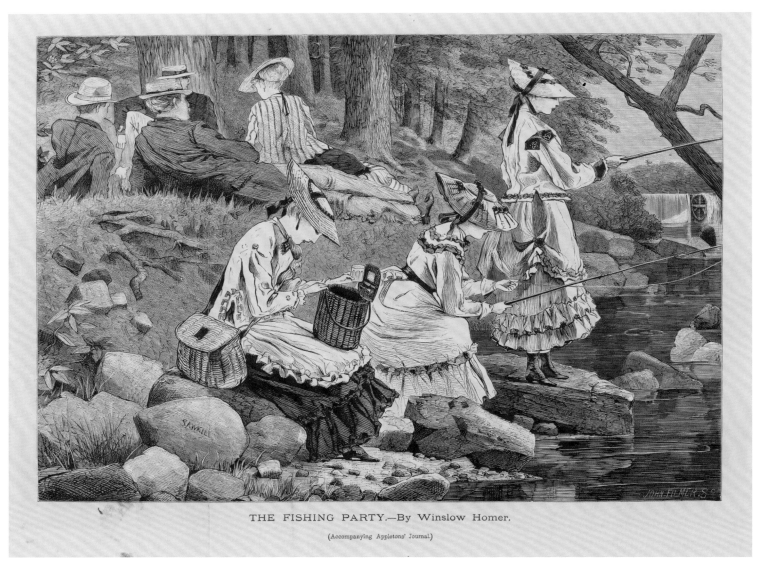

THE FISHING PARTY.—By Winslow Homer.

(Accompanying Appletons' Journal.)

39. Winslow Homer. *The Fishing Party*, in *Appletons' Journal of Literature, Science and Art*, October 2, 1869.

40. Winslow Homer. *Study for "The Fishing Party,"* ca. 1869. Graphite on tan wove paper.

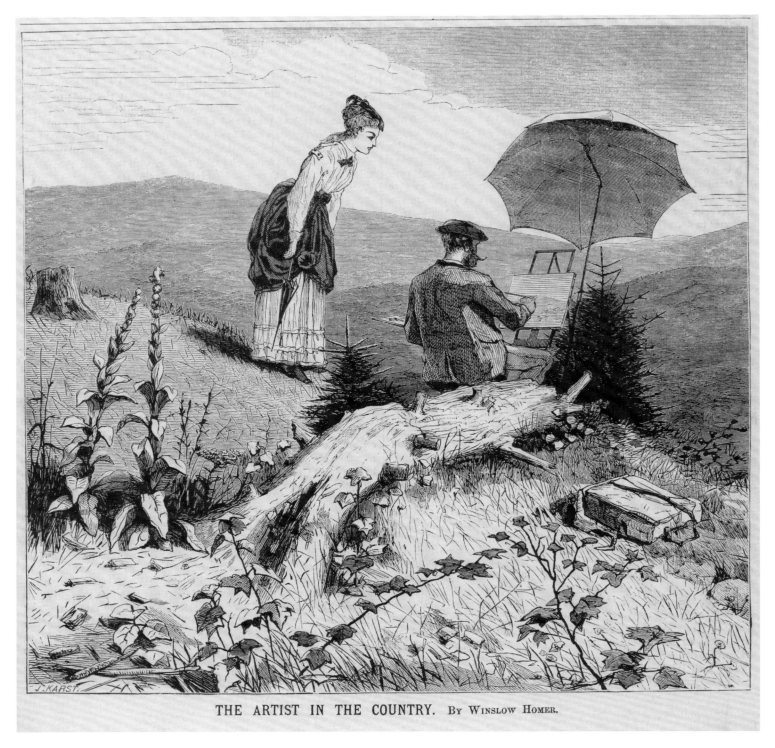

THE ARTIST IN THE COUNTRY. BY WINSLOW HOMER.

41. John Karst after Winslow Homer. *The Artist in the Country*, from *Appletons' Journal of Literature, Science and Art*, June 19, 1869. Wood engraving on white wove paper.

42. Winslow Homer. *Preliminary drawing for "The Artist in the Country" and "Artists Sketching in the White Mountains,"* 1868. Graphite on white wove paper, blackened on verso for tracing.

SUMMER IN THE COUNTRY.

43. Winslow Homer. *Summer in the Country*, in *Appletons' Journal of Literature, Science and Art*, vol. I, July 10, 1869. Wood engraving on off-white wove paper.

recorded specific locations from almost identical positions. For them, it was more important to record what would be the most recognizable impression for the tourist than to make images that captured a more unusual angle or attempted to introduce unfamiliar sights. In an era before the handheld camera, before tourists could record their own personal mementoes, professionally photographed stereoviews prepared them for the journey, showing them step-by-step the progression from landmark to landmark, or reminded them of their recent excursion. Throughout America, travelers and would-be travelers "knew" the iconic places, even if by proxy.[27]

It is a testament to Homer's creative genius that the general public preferred his sophisticated, convincing compositions to those of the many other artists working for the pictorials. Homer did not seem to have been influenced by the compositional strate-

gies of more traditional or academic artists, but rather, seemed more satisfied with a carefully delineated, almost mapped out, image. While others attempted three-dimensional illusions, sometimes fighting the abilities of the wood engravers employed to cut the blocks, Homer accepted the flat, graphic qualities of the medium, and worked with, rather than against, the process. The flatness of his wood engravings and of his paintings has been attributed to many influences, including Japonism and photography. The perceived lack of integration of figure and ground in images like *Summer in the Country*, a pleasant scene of young women playing croquet published in *Appletons' Journal of Literature, Science and Art* on July 10, 1869 [FIG. 43], and the abbreviated perspective of *Ship Building, Gloucester Harbor*, showing young boys at play at the seaside [FIG. 44], are evidence of Homer's awareness of both these stylistic and technological innovations. In the paintings *Gathering*

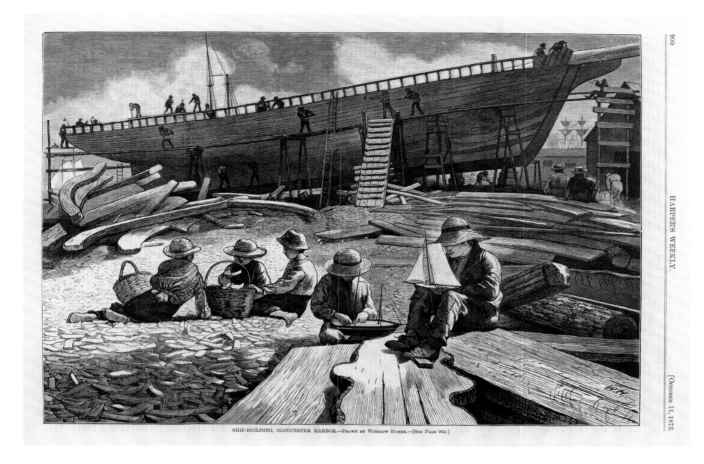

SHIP-BUILDING, GLOUCESTER HARBOR.—DRAWN BY WINSLOW HOMER.—[SEE PAGE 902.]

44. Winslow Homer. *Ship Building, Gloucester Harbor*, in *Harper's Weekly*, October 11, 1873. Wood engraving on white wove paper.

Autumn Leaves, dated about 1877 [FIG. 45], *The Yellow Jacket* of 1879 [FIG. 46], and others, it is almost as if a sheet of glass were held up between the viewer and the figures represented, pulling the background forward, and resulting in an abstracted arrangement of forms. The abstract relationship between figure and ground Homer employed in the paintings and in many of his woodcuts was identical to the effect recorded in photography, where the monocular nature of the single lens recorded all events, textures, and tones with a non-hierarchical objectivity.[28]

THE LANGUAGE OF THE BEST POSSIBLE VIEW

The virtual and the actual tourist in nineteenth-century America were united by the images they collected, not only in physical form—picture books, newspaper articles, photographs, and stereoviews—but in their memory as well. The iconic places and scenes, recognizable from repeatedly published images, registered in the collective consciousness of Americans, and those images created a visual vocabulary at the foundations of our pictorial American language. The wood engravings reproduced in the pictorial magazines, which owed their origin to the field images of the survey photographers; the duplication of those images in the lavish brochures published by hotel owners to entice visitors; and the impact of the stereograph on the would-be tourist all resonate in the shared memory as objective records of a place. As Gombrich stated, "Everything points to the conclusion that the phrase 'the language of art' is more than a loose metaphor, that even to describe the visible world in images we need a developed system of schemata."[29] The popularity of these images from the late 1860s well into the twentieth century shows the lasting currency of the American visual identity.

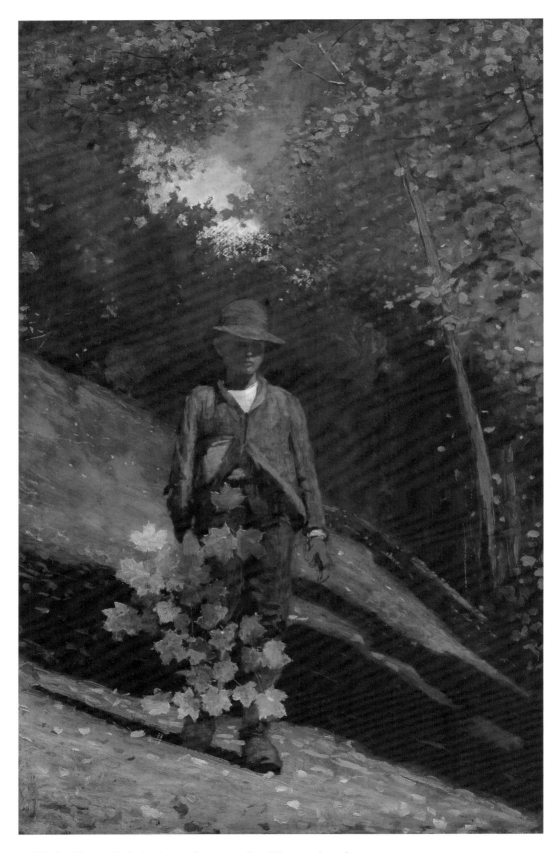

45. Winslow Homer. *Gathering Autumn Leaves*, ca. 1877. Oil on wood panel.

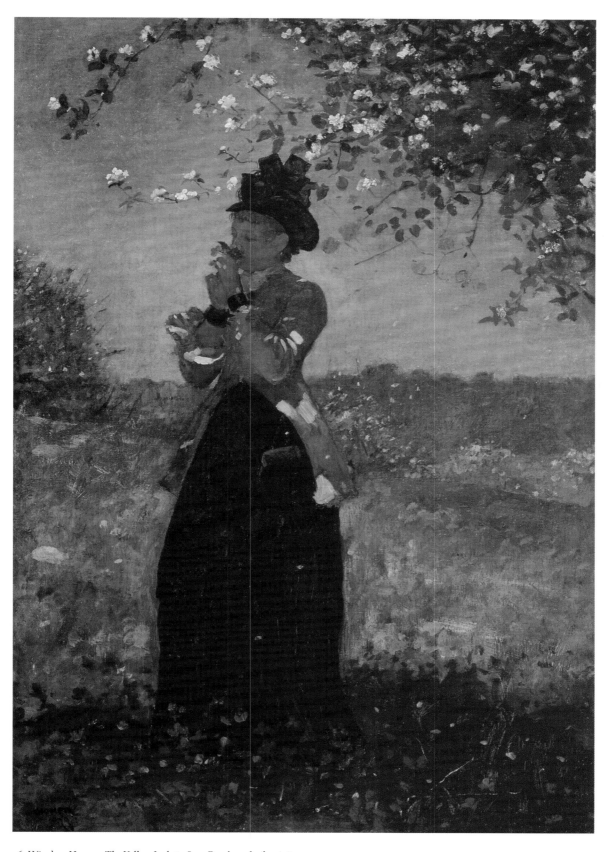

46. Winslow Homer. *The Yellow Jacket*, 1879. Brush and oil paint on canvas.

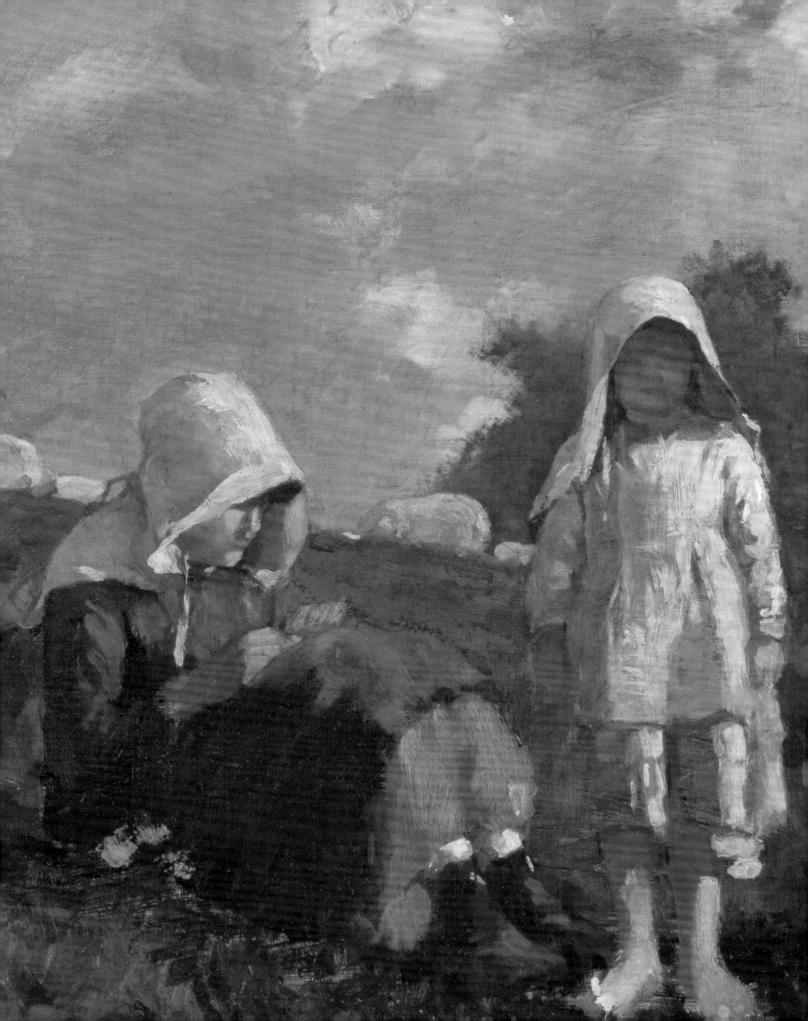

THE PASTORAL IDEAL: WINSLOW HOMER'S BUCOLIC AMERICA

SARAH BURNS

In the early 1870s, a decade when cosmopolitan styles were in ascendance and wealthy collectors lavished fortunes on modern European paintings, critics often disagreed vehemently about Winslow Homer's work. Some found his paintings sketchy and crude, while others lauded them as vigorous and truthful, although they all concurred that Homer's style made the artist stand out as uniquely and even defiantly American. Looking with refined distaste at Homer's rural idylls with their Yankee urchins in flannel shirts, flat-breasted maidens in calico sun-bonnets, and glaring, bald blue skies, Henry James marveled that Homer had the temerity to choose "the least pictorial features of the least pictorial range of scenery and civilization" and treat them "as if they were every bit as good as Capri or Tangiers." Another critic took the opposite tack, stating, "We like him most when he devotes his talent to georgic scenes—episode and incidents from agricultural life. . . . When he paints our American country scenes of farmer life, puts over them an American sky and around them an American atmosphere, he is at his best."[1]

By the end of the decade, however, artistic tastes had changed, and Homer now pleased everyone. Critics united in often rapturous praise of his drawings, watercolors, and oils featuring young girls, often in shepherdess guise, and the occasional swain roaming the orchards and meadows of his friend and patron Lawson Valentine's Houghton Farm. Not only were those rustic idylls a delight to the eye; more important, they unequivocally proclaimed their nationality. "The pleasure given by these pictures is large and wholesome, like their art," wrote the *New York Post*. "Here are the American shepherdesses which only Mr. Homer paints—self-possessed, serious, independent; not French peasants who till the soil; not Swiss slaves who watch cows, knitting stockings meanwhile with eyes downcast; not German *frauen*, who draw water and are shapeless, but free-born American women on free-soil farms."[2]

Common to Homer criticism, pro or con, was an acceptance of the artist as an unimpeachable witness, whose eye and hand reliably inscribed the literal truth—and only the truth—on paper or canvas. Taken at face value, Homer's imagery stood for something authentically and indelibly American. Indeed, to his credit was the actual "discovery" of the American shepherdess, whom he introduced to the public in studies that were "more essentially and distinctively pastoral than anything that any American artist has yet attempted." Charming and unaffected, his sketches and watercolors had an air of "happy naturalness and unpremeditated sincerity." Homer promoted himself in much the same terms. In an interview with the critic George W. Sheldon, Homer condemned the art of the fashionable French academician William Adolphe Bouguereau as false, waxy, and artificial. By contrast, the American asserted his preference "every time" for a "picture composed and painted out-doors . . . I couldn't even copy in a stu-

FRONTISPIECE Winslow Homer. *Two Girls with Sunbonnets in a Field* (detail), ca. 1877–78. Oil on canvas.

OUR ARTIST IN THE ADIRONDACKS.

1. Unknown. *Our Artist in the Adirondacks*, in *Appleton's Journal of Literature, Science and Art*, September 21, 1872. Wood engraving.

dio a picture made out-doors; I shouldn't know where the colors came from, nor how to reproduce them. I couldn't possibly do it."[3]

Yet despite such pronouncements, Homer was no ingenuous observer and recorder of facts: his idylls were highly selective constructions. Nor in many respects was his vision so purely national, as viewers assumed. Without question, Homer was aware of French Barbizon art, popular among American collectors and exemplified by the work of Jean-François Millet, who represented peasant life with romantic pathos and spiritual gravity. Less sentimental and decidedly more secular, Homer's rural scenes, referencing Millet, portrayed an uncorrupted, mythic American Arcadia, light-years removed from the modern world.[4] Keenly attuned to his market, Homer conceived, designed, and produced his American pastoral for urban consumption at a time of vigorous, and problematic, metropolitan expansion. Given their French connections and their patently fabricated makeup, what made those images so seductively authentic and compellingly American? How and why did viewers buy into Homer's fictions? What cultural needs and appetites did they satisfy?

The key to those questions lies in American modernity itself. The growth of the middle class, which enjoyed a surplus of both money and leisure, gave impetus to a burgeoning and highly profitable vacation culture. During and after the post–Civil War Reconstruction years, increasing numbers of Americans summered at newly built high-style or rustic resorts on the seacoast or in the mountains and hinterlands of New England, New York, and the mid-Atlantic states. Like many of his peers, Homer was a tourist in his own right, an artist who tracked, discovered, and packaged slices of rural Americana for urban consumption and sale. An important component of artist life, indeed, was the working "summer vacation," wherein painters undertook annual treks to far-flung beauty spots for the purpose of gathering the raw material of their art. From the mid-1860s until 1880, Homer was one of this band of summer pilgrims, traveling at different times to the White Mountains, the Catskills, Easthampton, Gloucester, and the Adirondacks, among other destinations, and returning to New York in the fall with a bulging portfolio of sketches that would serve as notes for paintings. According to the journalist Rebecca Harding Davis, the modern American artist was, more often than not, a tourist pioneer: "The history of all summering-places is alike. An adventurous artist usually ventures into a new field, and whispers his discovery to his friends. Scenery is well-nigh as popular a hobby just now as household decoration. After him come pell-mell the would-be aesthetics, and later the mere fashionables, as the flock follows the tinkle of the bell-wether, and up go the mammoth hotels as fast as mushrooms on a May morning on betramped sheep-walks."[5]

Appleton's spoofed that artistic quest in a full-page cartoon [FIG. 1], *Our Artist in the Adirondacks*, depicting that figure as a dapper urbanite "Going In," and a hardy woodsman "Coming Out," and in between a gallery of rustic types, including a "Belle" in lank calico dress and voluminous sunbonnet, much like so many of the country girls in Homer's meadows. The artist's job was to blaze the visual trail that hobbyists could later pursue—vicariously or otherwise—in their quest for local scenic beauty.

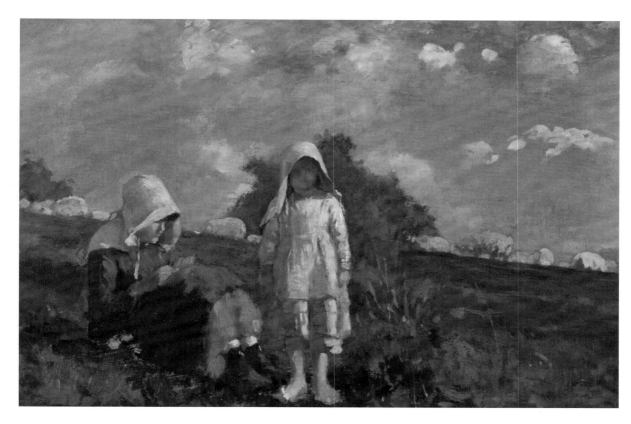

2. Winslow Homer. *Two Girls with Sunbonnets in a Field*, ca. 1877–78. Oil on canvas.

Homer's Houghton Farm drawings and paintings show girls and young women wearing either lank calico and floppy sunbonnets [FIG. 2], or fanciful white ruffled dresses, with tightly laced bodices and broad-brimmed straw hats with blue ribbons, in a style often described as *à la Watteau* or Bo-Peep [FIG. 3]. In this and other ways, such stylings represented Homer's radical re-envisioning of his friend's farm, which in every respect was a model of the latest in agricultural science. Lawson Valentine and his brother had known the Homer family since their childhood as neighbors in Cambridge, Massachusetts. A wealthy varnish manufacturer, Valentine employed Homer's older brother, Charles Savage Homer, Jr., as chief chemist in his firm, and became Winslow's loyal and munificent patron in the 1870s. Throughout that decade, Winslow Homer frequently visited the Lawson Valentines at their summer homes, first in Walden, New York, and, from 1876, at Houghton Farm near Mountainville, two hours from New York City, which Valentine acquired that year.[6]

After purchasing the estate, Lawson Valentine inaugurated a series of agricultural experiments involving crops in the field, animal feeding, and investigations of meteorology and soil temperatures, all conducted "in accordance with strictly scientific methods." In 1879, Valentine hired a director of experiments and later appointed a botanist and chemist. All operations on the farm were to be carried out "under the best possible organization and management, with a view of educating and enlightening others by furnishing valuable examples . . . in practical agriculture." Valentine's family and friends, meanwhile, could drive up the picturesque, winding route to the summer camp above the main residence, and climb a rustic tower for spectacular views of Newburgh Bay, the Hudson River, and the Catskill Mountains.[7]

Not one hint of this up-to-date, scientific farm run on modern business principles ever appeared in Homer's pastorals. Instead, Homer used its hills and meadows as a setting for an elaborate masquerade of archaic rusticity. The task of herding—or

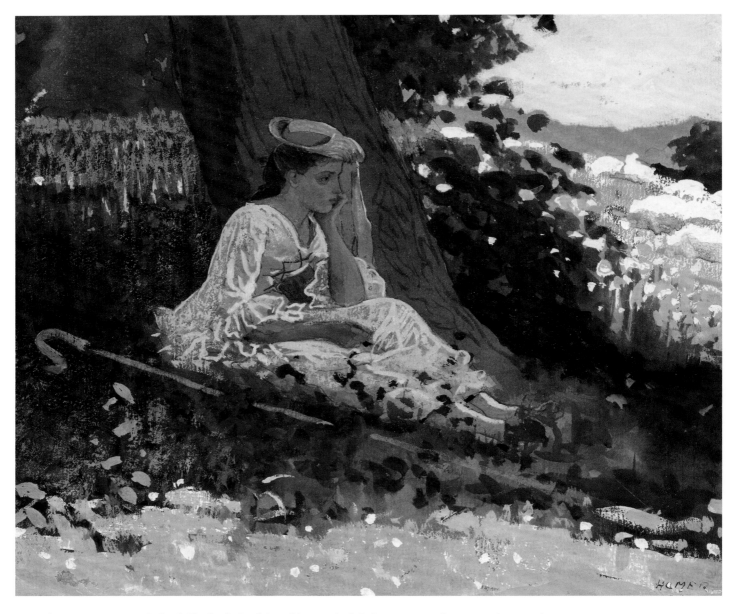

3. Winslow Homer. *Bo-Peep (Girl with Shepherd's Crook Seated by a Tree)*, 1878. Opaque watercolor over graphite pencil on paper.

playing at herding—the Southdown sheep was enacted by the Babcock children [FIG. 4], brother and sister from a family of squatters who lived high up on a mountain at the northwest boundary of Houghton Farm. As paid models, the children (and other unidentified locals, including a voluptuous young woman) posed in their own everyday dress or, in the young girl's case, occasionally donned the frilly costume supplied by Homer. Valentine family tradition had it that when Homer first asked the children to pose, they presented themselves in their "black Sunday best," whereupon the artist

sent them back up the mountain to change into more "picturesque working clothes."[8]

This detail alone is a telling sign of the class differences on which Homer based his rustic idylls. Appreciation of the pastoral almost invariably involved a lopsided balance of power, in which the middle- or upper-class consumer enjoyed a privileged glimpse into a simpler and implicitly more primitive way of life, set in what the historian Ann McClintock has termed "anachronistic space."[9] In his pastoral scenes, Homer deployed artistic sleight

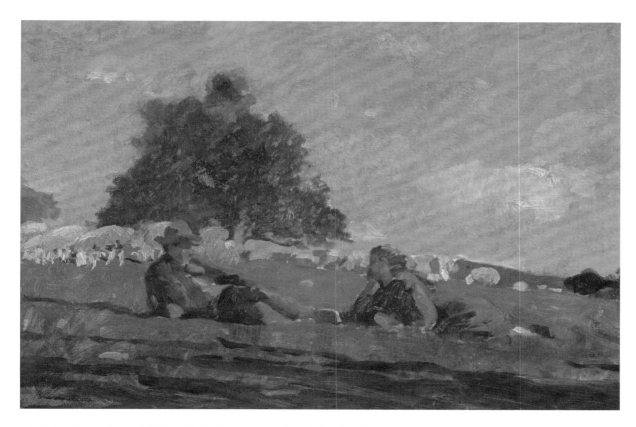

4. Winslow Homer. *Boy and Girl in a Field with Sheep*, ca. 1877–78. Brush and oil on canvas.

of hand to transform his young squatters into time-less Arcadians. Fresh and dexterous, his technique rendered fiction into fact: real, natural, and authentic. Whether or not his charming compositions were calculated to arouse nostalgic feelings is difficult to say, since they were, in a sense, false memories. Rather, Homer's idylls appealed to a powerful middle-class urge to seek refuge from the relentless pace of modernity which, by the 1870s, was radically reshaping the contours of American life. In Homer's countryside, we occasionally see fashionable young urbanites inhaling the heady aroma of apple blossoms [See McCarron-Cates, FIG. 46], or trail-riding in the mountains [FIG. 5]. Far more often, however, urban visitors were off-stage, invisible consumers of the artist's fantasy. Homer's imagery temporarily reversed the flow of time by inviting the beholder into an alternative reality, an anti-modern world split and sealed off from the present.[10]

The same cluster of sentiments and impulses animated contemporary popular literature on the sub-ject of the American countryside. Some journal articles realistically examined modern farm conditions in the Northeast, discussing the pressure of western competition, unremittingly hard work, economic stringencies, and ongoing migration of young people off the land and into towns and cities. "The young girls whom one now sees about railway stations in the most distant part of the country," wrote one reporter, "are dressed after the instructions of *Harper's Bazaar* and *Peterson's Magazine*. . . . They are certainly not to be blamed if they long for some vocation in which they can more freely indulge their growing desire for better dress and more interesting companionship." Nature writer John Burroughs, on the other hand, while recognizing the changing demographics and the impact of modernization, chose to turn aside and celebrate what remained of traditional ways: "It is unquestionably true that farm life and farm scenes in this country are less picturesque than they were fifty or one hundred years ago. . . . Still, the essential charm of the farm remains and always will remain; the care of crops and cattle, and of orchards,

5. Winslow Homer. *Bridle Path, White Mountains* (detail), August 24, 1868. Graphite on off-white wove paper.

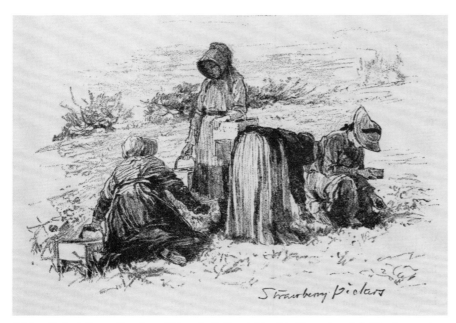

6. Mary Hallock Foote. *Strawberry Pickers*, in *Scribner's Monthly*, November 1878. Wood engraving.

ries in a field. Unlike the fashionably dressed farm girls longing for the excitement of travel and town life, these pickers, like Homer's shepherdesses, are frozen in mythic Arcadian-American time.[11]

As a working artist-tourist, Homer transported bits of local rustic color to the metropolis, where they appeared in exhibitions at the Century Club, the American Society of Painters in Watercolors, and the National Academy of Design, and other venues. Sealed off from any signs of agricultural progress, Homer's anti-modern Arcadia was also anti-urban. While this might seem on the surface too obvious to merit further discussion, in fact, the meaning of Homer's pastoral vision depended on a sustained and systematic opposition to the conditions of contemporary urban living. Most particularly, his country scenes stood for health and purity in antithesis to urban filth.

Expansion, the spread of slums housing the immigrant poor, and the ubiquity of horses in the streets made for a sanitation nightmare in post–Civil War New York. The presence of urban abattoirs further befouled the tainted air. In the Bowery, multi-story cattle markets and connected processing operations produced sickening stenches that wafted indiscriminately from poor neighborhoods to rich. When city health inspectors launched a comprehensive canvass of New York's poorer districts, they found blood and refuse from two hundred slaughterhouses flowing in the streets and stifling emanations from fat-boiling and entrail-cleaning establishments. Almost a decade later, there was little improvement to be seen — or smelled. Dr. Moreau Morris, a former sanitary inspector, wrote that an "almost incalculable" mass of decomposing filth was impregnating every particle of air that New Yorkers were compelled to inhale. He asked indignantly, "Of what use is it to ventilate our dwellings . . . when the very air which is sought is so laden with poison as to make it dangerous to breathe?"[12]

Such tales of suffocating metropolitan pollution cast a new light on artists' summer getaways. In his excursions, Homer almost invariably sought out subjects that emphasized physical vitality and sparkling, healthful atmosphere: frolicking school-

bees, and fowls . . . and the close acquaintance with the heart and virtue of the world." How "sweet and wholesome," he noted, "was the farmer's knowledge, culled from the book of nature." Significantly, Mary Hallock Foote's illustrations to Burroughs's article showed only the traditional, non-mechanized aspects of farm life, including one vignette [FIG. 6] of young farm girls in sunbonnets, picking strawber-

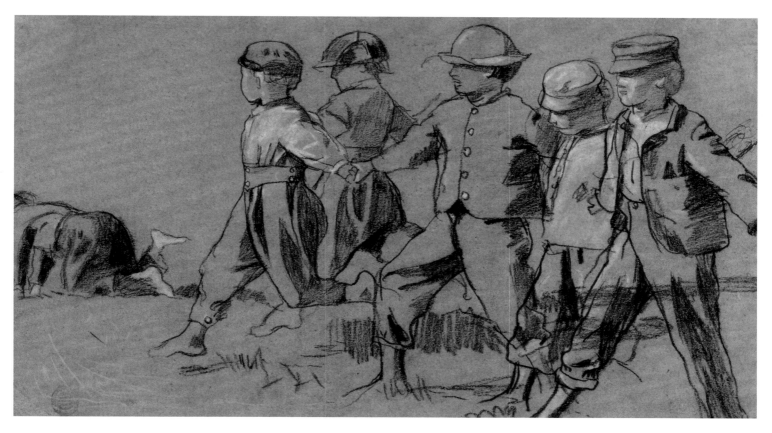

7. Winslow Homer. *Study for "Snap the Whip,"* 1872. Black and white chalk, touches of light orange chalk on green wove paper.

boys, milkmaids, harvesters, and berry-pickers of the early 1870s [FIG. 7] to the shepherdesses of 1878 and 1879 [FIG. 8]. When the latter came before the public, critics resoundingly declared them wholesome, natural, and salutary. *Fresh Air* [FIG. 9], in particular, struck many as a true picture of vibrant health. The young girl in that picture, wrote Susan Nichols Carter, "standing up against the light with her sheep around her, on the breezy hillside, is blown by the fragrant country wind, and the clinging folds of her gown and the bent leaves of the tree beside her are animated with life."

"The picture is well named 'Fresh Air,' " effused another, who found Homer's subject poised in the sun on a breezy hillside "a very wholesome home-bred article." For city dwellers who spent far too much time in their overstuffed, dusty parlors, clean air was as, if not more, potent a tonic as medicine. "It gives elasticity to the frame, imparts a ruddy glow to the cheeks, and drives the sluggish blood

even to the finger-tips," one health advisor wrote. Homer's fresh, natural compositions reminded urban viewers of an American countryside alive with cleansing zephyrs and impervious to metropolitan contamination—yet easily accessible by train for those with means and leisure. Even Homer's technique functioned metaphorically as antidote to murky and toxic metropolitan vapors.[13]

Yet for all their freshness and authentic native feeling, Homer's pastoral scenes were, in other ways, transparently artificial concoctions that the artist himself had conceived, dressed, and staged. Some writers registered these contradictions (and perhaps their own confusion) in their responses to the Houghton Farm sketches and watercolors. The *Sun*'s critic, for example, praised their happy naturalness and sincerity while simultaneously extolling their unnatural charms. Homer had apparently found a region "where there were shepherdesses not only as real as sheep and crooks could make them,

8. Winslow Homer. *Shepherdess Resting Under a Tree*, 1878. Graphite, brush, and white gouache on gray-green wove paper.

but possessed of all the daintiness of the true and original porcelain, distinctive in their own way as the shepherdesses of Watteau were in theirs, and full of the sort of character that would have led Hans Christian Andersen, had he known them, to bring them into close communion with his own particular fairies." Others also detected a quaint, vaguely French flavor in Homer's idylls: "Mr. Homer has a number of *bergeries* this year; he applies his frank, direct way of transcribing the immediate impression of nature to a set of themes that used to be generally embroidered on satin — Bo-peep and her sheep, Perrette and her *cruche*."[14] What could be further from "nature" than porcelain, embroidery, fairy tales, or the rococo fantasies of Watteau and his contemporaries?

Here again, Homer's shepherdesses and children had more to do with modern urban taste than contemporary country living. In particular, they traded on the antiquarian sentiment of the Colonial Revival, which generated a surge of patriotic identification with the country's revolutionary past. Among the most popular exhibits at the fundraising Sanitary Fairs during the Civil War were the recreations of Colonial life, especially the New England

kitchen-cum-restaurant, where costumed "dames" spun before a crackling hearth and "damsels with curious names and quaint attire" served as waitresses.[15] The *Philadelphia Centennial*, which gave fresh impetus to popular interest in the Colonial past, also featured a New England farmhouse complete with antique furniture and utensils and young women in ruffled costumes.

The fairs sparked a culture of parlor theatricals and other entertainments, such as Calico Parties, centering on eighteenth-century costumes and tableaux. As costume historian Beverly Gordon notes, the point of such entertainments was not to undertake a mimetic recreation of the past, but rather to recall, celebrate, and even gently poke fun at it. At once idealized and amusingly archaic, the Colonial past inspired patriotism and veneration while enabling the moderns to measure how far civilization had progressed. Slavish accuracy was of less importance than symbolic elements, and blurring of historical periods was the norm even in more scholarly works.[16]

The past, in other words, was generic and evocative rather than particular.

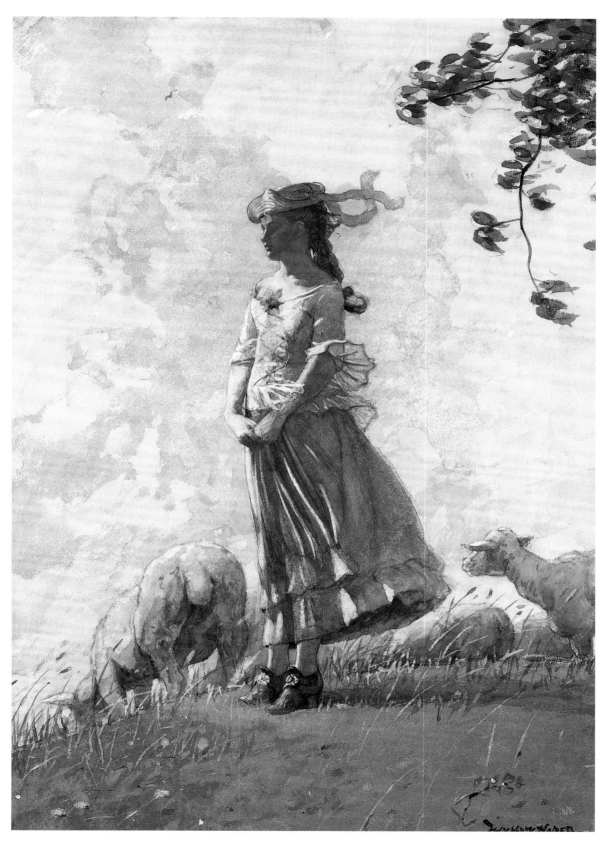

9. Winslow Homer. *Fresh Air*, 1878. Watercolor with opaque white highlights over charcoal on cream, moderately thick, rough-textured wove paper.

"Little Bo-peep she lost her sheep,
And did'nt know where to find them—
Let them alone, and they'll come home,

10. Unknown. *Little Bo-Peep She Lost Her Sheep*, in *The History of Little Bo-Peep the Shepherdess*, ca. 1852–58. Wood engraving.

Contemporary instructions for *tableaux vivants* and for masquerade balls bear this out. One book of parlor amusements, for example, specified calico dresses and white aprons for serving maids and old-fashioned maidens alike. Little Bo-Peep, similarly, was to wear "calico dress tucked over red petticoat," and hold a "crooked cane," while Charles Dickens's "Little Nell" sported a "calico dress, broad hat." In the early 1870s, according to one source, peasant costumes were exceedingly popular at private theatricals and fancy dress parties. Maud Muller, the rustic heroine of John Greenleaf Whittier's wistful ballad of 1867, represented the American version of the peasant type, and was to wear "a short skirt of pink cambric, with blouse-waist and apron of white muslin."[17]

Watteau shepherdess and Bo-peep costumes were similar, with different accessories: "A shepherdess dress for a girl of twelve is made of pearl-colored satin, with an over-skirt of blue silk striped with silver . . . Broad white shepherdess hat with blue ribbons. A crook wrapped with ribbon."[18] These costumes, in turn, were strikingly reminiscent of those in illustrations to the nursery rhyme "Little Bo-Peep," published in various English and American versions. While design and coloring differed, the costume invariably featured the same basic elements, including a short petticoat that exposed her ankles and calves, a looped-up overskirt, ruffled sleeves, tight-laced bodice, a broad-brimmed and ribboned straw hat, and of course a crook, sometimes embellished with ribbons as well, as in the illustration published in a so-called "Toy Book" in 1852 [FIG. 10]. Vaguely reminiscent of Watteau, such figures were equally indebted to the style of the Dresden china shepherdess, also a product of the eighteenth century and, according to one commentator, a ubiquitous fixture in "almost every house of wealth" in America. French, English, and American elements merged indiscriminately, together evoking a quaint and rustic past.[19]

In different combinations, nearly all of the elements making up the generic Bo-Peep appear on Homer's shepherdesses as well. Seen again and again in oils, watercolors, drawings, and tiles, that costume was most likely a ready-made outfit that Homer had acquired from one of the theatrical costumers who supplied fancy dress for parlor theatricals, masquerade balls, tableaux vivants, and the like.[20] The wind-blown young woman in *Fresh Air* wears a gauzy skirt with two flounces, a bodice laced with blue ribbon, ruffled sleeves, and a straw hat with the brim turned up in front and fluttering blue ribbons; on her feet are high-heeled black shoes with silver buckles, reminiscent of the eighteenth century. The more voluptuous figure seen in all of the shepherdess designs [FIGS. 11–13] Homer produced during his brief membership in the Tile Club wears the same costume, though with considerably shorter skirts and gaudier colors, and carries a long crook. Perhaps the most ubiquitous element is the straw hat with its ribbons and jaunty, turned-up brim: nearly all of the figures in Bo-Peep array sport this distinctive headgear.

11. Winslow Homer. *Shepherdess Resting*, ca. 1877. Charcoal on heavy wove paper.

12. Winslow Homer. *Resting Shepherdess*, 1878. Painted and glazed tiles.

14. Winslow Homer. Fireplace surround: *Shepherd and Shepherdess*, 1878. Painted and glazed tiles.

More than any of the other images, Homer's shepherdess tiles take anti-modern rusticity to a highly artificial extreme. The Tile Club, active from 1877 to 1887, was a loose association of New York artists who met in one another's studios to design tiles while indulging in good meals and high jinks. Inspired by the English Aesthetic movement, the Tile Club was an expression of "nostalgia for ancient methods of hand craftsmanship, directed against modern mass production and anonymous machine-made ornament."[21] Homer conceived his Bo-Peep tiles in the same spirit, rejecting modernity on one hand while on the other responding to an utterly modern vogue for new styles of ornament and design. Two-dimensional cousins of the Dresden shepherdess, Homer's Bo-Peeps were expressly intended to embellish contemporary urban interiors. The fireplace surround [FIG.14] designed for his affluent brother Charles shows the same voluptuous

13. Winslow Homer. *Shepherdess Tile*, 1878. Ceramic tile.

15. Wallace Nutting. *The Life of the Golden Age*, in *Wallace Nutting Pictures: Expansible Catalog…*, 1912. Photomechanical reproduction.

female model posing as an incongruously curva-ceous shepherd in jacket and breeches, and "his" buxom companion with her tight-laced bodice, provocatively short skirt, bows, and ruffles. It is a decorative exercise in pure pastoral make-believe.

A seamless pastiche, Homer's Americanized, rococo Arcadia tapped into fantasies of an unchanged and unchanging bucolic world, whose vague geography encompassed both rural New York and New England as quintessentially pastoral terrain.[22] Those viewing his idylls willingly suspended disbelief, accepting his breezy sketches and watercolors as "the diary of a few summer days of changing weather . . . the sultry closeness of the forest, or the free escape of a windy hill-top."[23] Dressing the present in the raiment of the past, Homer participated in producing the wide-spread illusion—or delusion—of an innocent America, fresh, clean, and whole.

A mature artist acutely aware of the complexities of modern life and the omnipresence—even in Arcadia—of mortality, Homer did not linger long in his sunny artificial paradise. Instead, he became the artist-tourist in ever more perilous and elemen-tal territory. Moving to Prouts Neck, Maine, in 1884, he turned his attention to dramas of the sea and shore, creating his ultimate vision of American nature as rugged, primitive, and infinitely powerful. Shepherdesses gave way to hardy fishermen and hunters, breezy meadows to crashing surf, silky

grass to jagged rocks. No longer pastoral, Homer's nature became the realm of therapeutic masculine adventure and revitalizing sport.[24]

The reassuring vision of an undying American pas-toral, however, lived on and lived long. In the early decades of the twentieth century, ex-minister Wallace Nutting (1861–1941) amassed fortune and fame as the purveyor of meticulously staged, hand-colored photographs purporting to represent domes-tic and pastoral life in early New England. Some of Nutting's popular subjects, notably his images of costumed young women in Colonial interiors, carry on the spirit of masquerade which had animated Homer's Bo-Peeps. Likewise, Nutting's landscapes, such as *The Life of the Golden Age* [FIG. 15] with its flock of torpid, wooly sheep, called upon the same fund of imagery that had given Homer's pictorial ex-cursions their charm. More sentimental and self-consciously poetic, Nutting's landscapes, like Homer's, traded on mythic symbols of an archaic, yet vividly present, Arcadian world where work was play and youth everlasting.[25] In this country, there were no factories, slums, immigrants, riots, war, or crime. There was no progress, no change, no history. In this avoidance of grim reality lay their instant and enduring appeal. Circulated endlessly in popular vi-sual culture and decorative arts, the Arcadian idyll came to stand for America, or at least one version of it, safely preserved under glass in all its wholesome, therapeutic, and everlasting freshness.

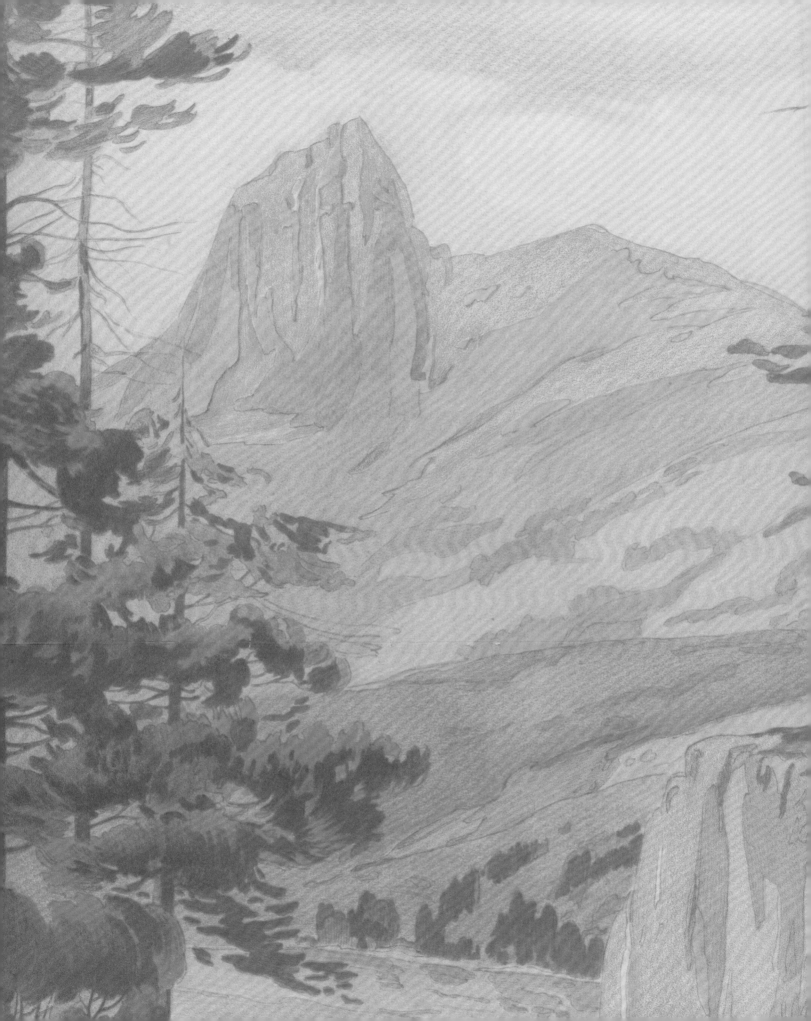

America Inside Out:
The View from the Parlor

KARAL ANN MARLING

When I was a little girl, living in that pretty swath of upstate New York between the old Erie Canal and the Finger Lakes, my grandmother once took me to visit her ancient Aunt Lib in rural Macedon. We had a living room at home, rarely used except when company came, and filled with all kinds of look-but-don't-touch items: a little brown vase that came all the way from China, albums of photographs taken on long-ago excursions to Canada, a blue Wedgwood ashtray with a tiny white goddess afloat in the middle. Grandma had a similar room, although a bit more austere. Hers featured a huge, hand-cranked Victrola, to be operated only by Grandpa, the complete novels of Richard Harding Davis in green cloth covers, and a huge seashell in which a very quiet child could hear the roar of the Pacific Ocean. But these treasures were nothing compared to the contents of Aunt Lib's dark, dank, and faintly dusty Victorian parlor.

Lib and her maiden daughter had once made a trip to Niagara Falls, or knew somebody who had done so. From a ladder of carved shelves in one corner of the room dangled a beautiful bag, a purse with a genuine silver frame, on which the Falls had been worked in tiny glass beads. There was a shell with a picture of the Rainbow Falls painted on one side; and a "pin tray," with a molded view of a soulful Indian maiden perched on the precipice, clouds of mist boiling around her, ready to leap into the river gorge below. And more: a lump of a minnie ball; an arrowhead; a stuffed crow; a belt buckle that

read "Chicago, 1893"; a hand-held stereoscope with a box of dog-eared cards: castles on the Rhine, the Parthenon, the Flatiron Building in New York City; and Niagara Falls, of course. I remember being told that if I didn't touch another thing, or say a single word, or move from the spot, I could look at the stereoviews on the granite-topped table. And so I did as I was told, until the old folks drifted out to the kitchen. Then, quiet as a mouse, I laid curious, reverential fingers gently on everything in the room—except for the black crow.

Aunt Lib's parlor was part *wunderkammer*, part souvenir stand, with a tourist brochure and a dash of history thrown in for good measure. It was, in short, the soul of America—the place where, even today, in similar relic rooms, we fumble our collective way toward a definition of who we are and who we were and who we aspire to be through an assemblage of precious, familiar, exotic objects that ought to be dusted a lot more often than they are. My living room is no exception. A little African basket. A little souvenir-of-Australia bowl made from recycled glass. A ceramic model of Mickey's House at Walt Disney World. A painting from the Minnesota State Fair. Pictures of my parents and grandparents. A reprint of the 1891 edition of Longfellow's *Song of Hiawatha* (with marginal illustrations by Frederick Remington), abandoned on a bit of fake peasant embroidery bought on sale at my local Target store.

FRONTISPIECE The Schmitz-Horning Company. Scenic panel: *Sierras*, 1913–14. Chromolithographed.

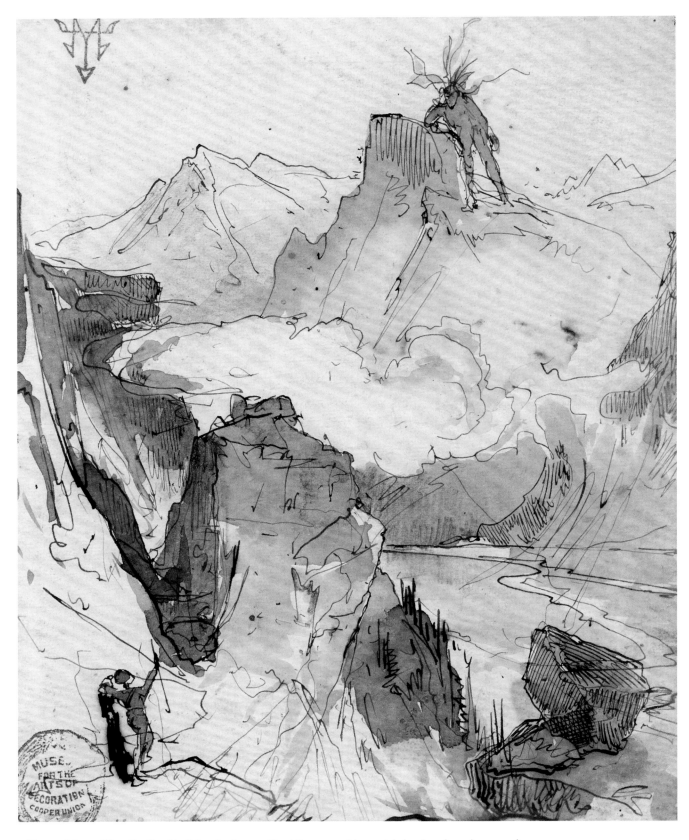

1. Thomas Moran. *Hiawatha Sees Mudiekeewis*, 1870–75. Graphite, pen, and brown ink, brush and gray-brown wash on paper.

When Longfellow's poem was first published in 1855, it had all the qualities to become the essential parlor book: It was an American epic, redolent of the past, but bright, too, with the promise of the new West [FIG. 1]. It had adventure, romance, and nostalgia for a nation without the railroads and the factories that helped create a hunger for the untouched picturesque—for the "shining Big-Sea Water" where Hiawatha still silently paddled his canoe.

In the twenty-first century, Longfellow is as much a part of Minnesota as its ten thousand lakes, although he never set foot in the state. There's a Longfellow neighborhood in Minneapolis, a Longfellow school, and a two-thirds-scale copy of his colonial house in Cambridge, Massachusetts, sitting near the Falls of Minnehaha Creek, where a bronze statue of Hiawatha and his love by the Norwegian immigrant Jacob Fjelde stands on a rocky crag above the stream. Longfellow got his Indian lore from Henry Schoolcraft's six-volume study of tribal history (1851–57), a daguerreotype of the falls taken by Alex Hesler of Chicago, and a book on the legends of the Dakota Sioux published in 1849 by Mrs. Mary H. Eastman. But he also created a resonant American place where there had once been only rushing water and sweet breezes.

By the 1870s (Custer went to his doom at Little Big Horn in 1876), European tourists were making their way to the upper Midwest, demanding to be taken to the spot where "the Falls of Minnehaha/ Flash and gleam among the oak-trees,/ Laugh and leap into the valley." Long, thin photographs of the falls, framed in a similar manner, joined the assemblage in a thousand parlors, where they signified nature's mysteries, an antiquity that a brash, young America seemed to lack, and the might-have-beens of a bloody westward expansion. Rookwood vases [FIG. 2] showing peaceful Indian encampments in the forest underscored the gap between what was, what was no more, and what ought to have been. From New York City to Minneapolis—and parts of Europe—the parlor reeked of lavender, wax, evasion, and moral sentiment.

Vases and plates and pitchers were ideal parlor items—fancy, gilded, richly colored, showy—and

2. Edward Timothy Hurley. Rookwood Pottery, *Indian Encampment*, 1909. Glazed stoneware.

the parlor was always a show of one's pieties, travels, and acquaintances. Permanent and pretty: far better even than the dull, worthy books of black-and-white renderings that inspired the china decorator's flights of fancy. It was a mark of honor to own *Picturesque America* (1872–74) [FIG. 3] in two massive volumes edited by William Cullen Bryant, America's most distinguished nature poet, with engravings after the works of Thomas Moran and many others. *Picturesque America, American Scenery, The White Hills*: portentous—even patriotic—endeavors, attempts to define what America was, in black and white. Lofty sentiments. The picturesque. Pictures of Yosemite and the Sierras. Tall mountains, deep gorges [see FRONTISPIECE, P. 132]. Gentlemen in suits and hats. Intrepid ladies in fashionable frocks, picking their way beneath

3. William Cullen Bryant. *Picturesque America, or The Land We Live In*, 1872–74.

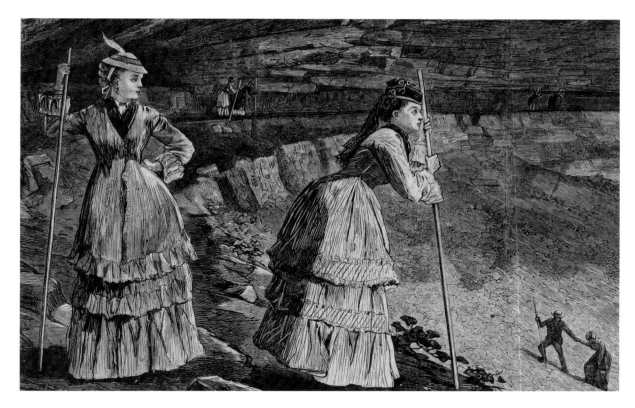

4. Winslow Homer. *Under the Falls* (detail), in *Harper's Weekly*, September 14, 1872. Wood engraving.

waterfalls [FIG. 4], blurring the distance between the parlor and the great wide world. Yet how much lovelier if the spectacular Falls of the Niagara, or the spread of the mighty Hudson River below West Point, came emblazoned or embossed on a fancy porcelain plate or platter, ready for display [see DAVIDSON, FIG. 5]. By such devices was the outside world domesticated and the wilderness made genteel, a part of daily life—our very own.

Thomas Moran's career as a tamer of the West began in earnest in the spring of 1871, with his first Yellowstone image for *Scribner's Monthly*. Like the images of Timothy O'Sullivan, William H. Jackson, and all the photographers and painters who joined the great Western expeditions during the decades after the Civil War, Moran's pictures represented a clean slate for America, a new arena for action, a dream of Manifest Destiny and endless possibility that thrilled those who looked at pictures in their parlors. Magazines, platters, poems, and pictures all told the same story. The Transcontinental Railroad [FIG. 5]. The freakish beauty of geysers, of canyons wider than a dozen Hudson Rivers. A geography fit

5. *Yellowstone Park*, Northern Pacific Railway, 1915. Photolithograph.

for the imagination of Titans, all right here on the granite-topped table [FIG. 6]. Already conquered by the railroad and the camera, the natural sublime became a kind of national icon in need of preservation from further impious assault. The new federal parks of the West were the parlor images of the East,

7. After Winslow Homer. *Winter – A Skating Scene*, 1868. Wood engraving.

on view in the form of rocks and waterfalls instead of chinaware and tiles.

In the second half of the nineteenth century, however, the new Western sublime was almost crowded out of the parlor by an older Eastern landscape redolent with human associations. The Civil War sent explorers to the Rockies, full of optimism and hope, but it also brought despair to much of New England. Farms failed, industries moved away. From New York to Maine, tourism filled the gap: summer visitors streamed north to board in quaint old farmhouses, and winter travelers exclaimed over ice skating and sugaring-off rituals of bygone times [FIG. 7]. Sarah Orne Jewett and Harriet Beecher Stowe and their sisters wrote popular novels praising the ancient virtues of New Englanders, the heirs of the Pilgrim Fathers. Novel-reading was a favorite parlor pastime.

In the summer of 1877, three young architects — the fledgling firm of McKim, Mead, and White — made a vacation tour of those Pilgrim haunts, and

6. United States Pottery Company. Pitcher, 1852–58. Parian.

8. Wallace Nutting. *At the Fender*, 1904. Hand-colored platinum print on cream wove paper.

returned to New York City to help launch a Colonial Revival. Suddenly, everything old was new again. Parlors erupted in a fever-blister of pewter candlesticks, tankards, locks of ancestral hair, souvenir booklets from Franconia Notch, commemorative spoons from witch-ridden Salem. A one-time clergyman named Wallace Nutting catered to the trade with hand-colored photographs of what appeared to be Colonial dames spinning their yarn in stately Colonial rooms full of what had suddenly become "antiques" [FIG. 8].

The very notion of taking pictures of America's long-dead colonists seems peculiar today, but Nutting's enterprise flourished. His "colonials" promoted New England, the search for antiques (often

in one's own attic), and the practice of colonializing the American parlor with painted woodwork and mantelpieces that served as repositories for significant autobiographical artifacts. Who was to say that the tallow-mold was not the property of some doughty ancestress? That a pillow stuffed with pine needles did not necessarily signify our delightful trip to New Hampshire (perhaps it was old Aunt Lib who spent the summer in the mountains and sent each of her relatives a box of rustic detritus)?

The Old East held other possibilities, too. It was still full of wild places—trout streams, rough terrain, mountain crags skipped over as the farmers of the post-Revolutionary period headed for the rich

9. Winslow Homer. *Camping Out in the Adirondacks*, in *Harper's Weekly*, November, 7, 1874. Wood engraving.

11. Matchsafe: *Fishing Basket*, late 19th century. Brass.

flatlands of the Genessee Valley to grow their wheat. The urban middle class of the late nineteenth century followed the rich to the still-untouched Adirondacks and the Catskills. A generation before the Boy Scouts of America were founded in 1910, city men were roughing it in hunting and fishing "camps" above the Mohawk Valley, along Lake George, and on the rugged coast of Maine. As work became sedentary, and conquests conceptual, the out-of-doors became an arena for recreational adventure [FIG. 9].

Out West, the wealthy made chairs and parlor tables out of the horns of animals they wrangled or shot [FIG. 10]. Back East, fishing creels turned up in the parlor in the form of elaborate matchsafes honoring the angler's avocation [FIG. 11]; and Winslow Homer's engravings in *Harper's Weekly* showed the outings of urbanites loose for a time in the natural world, fishing, picnicking, poking their thoroughly citified noses into uncivilized outdoor places. While Homer is hailed in our century as a painter and businessman who grasped the appeal of the dark, Darwinian contests between man and nature that became his specialty, his popular magazine illustrations more often reflected a lighter, parlor's-eye view of a Saturday's excursion into sunshine and fresh air.

Homer also introduced a third and final strain of parlor decor: the pastoral ideal. His fireplace tiles of Arcadian shepherds [FIG. 12] and their female

10. Attributed to Friedrich Wenzel. *Longhorn Armchair*, 1880–90. Horn, wood, leatherette, metal, glass, brass.

12. Winslow Homer. Fireplace surround: *Shepherd and Shepherdess* (detail), 1878. Painted and glazed tiles.

13. William Campbell Wallpaper Company, designed by Alfred Egli. Frieze: *The Oritani*, 1872. Machine printed, distempered colors.

counterparts serve as reminders of the agricultural communities most Americans came from. And there, in the mind's eye, perfection reigns. In imagination, handsome Native American braves paddle off into perfect sunsets [FIG. 13]. The Western sun always glows with the promise of a better life awaiting anyone with the courage to follow the light toward the horizon. The Old East betokens the nation's past, fragrant with legend. It is a place of deep serenity, broken only by sparkle of sun on water, of water on the scales of a leaping fish. All these Americas meet on the shelves of the parlor, in the heart of the home. Books, bibelots, pictures, souvenirs of places we once saw or want to see or have seen through the kindness of our wandering friends. Time. Memory. Desire. Reminders that the world is vast, but that everything, in the end, still fits within the compass of this one room. Our Great National Parlor.

That parlor, I would submit, is still a key element in the American home, under a variety of other names. The clutter—the wedding and graduation portraits, the snow-globes from last summer's vacation, the books of photos of our National Parks or the autumn foliage of New England—are all there, if not in the Great Room then surely in the family room, the living room, the media room. The Victorian *horror vacui,* or penchant for filling every piece of available space, still prevails in the domes-

tic spaces where we gather and spend time with friends. Some of our attachment to material things is through sheer habit or a deep-seated aversion to change. But some of it is surely a residual sense of parlor-ness. If the TV set in the corner is the twenty-first-century hearth, then the precious detritus that shows who we are, were, or aspire to be will always be found somewhere in the immediate vicinity of the new, flat-screen Sony.

In the peculiar sexual etiquette of domesticity that prevailed in the nineteenth century, the mantelpiece and, by extension, the fireplace belonged to the lady of the house, along with the rest of the "best room" designated as the parlor. In 1903, an article in the *Atlantic Monthly* gently regretted "The Passing of the Parlor," full of floral carpeting, wax flowers under dusty bell glass, antimacassars, and family portraits, "all so ugly, and so precious to grandmother!" Yet there was always more to parlors than grandmotherly fluff: There was the self-image of the family expressed through objects, which might range from miniature fishing creels to oilcloth lambrequins and murky Old Master reproductions in gilded frames [FIG. 14]. If the parlors of the 1830s and 1840s tended toward the formality of reception rooms with "suits" of matching furniture in correct, fashionable styles, the trend over the course of the century ran toward greater intimacy and self-expression on the part of family members.

14. Henry Charles Currier. Parlor of T. B. Winchester, Boston, MA. Photograph.

In a famous 1875 diatribe against parlors, tastemaker Clarence Cook declared his preference for the term "living room" because, in his view, parlors were places the rich "set apart for the pleasures of idleness," whereas the rising middle class should be actively doing things in the precious spaces of their homes: collecting artifacts that mattered to them; taking an interest in art and nature, in books, in the affairs of the world, and surely, in the physical and psychological expansion of the nation, bringing with it fresh beauties, challenges, and the imagery of adventure. As America expanded beyond its old Eastern borders, so, too, did the parlor change from a little-used and largely ceremonial chamber to the heart of the home.

But this change did not happen everywhere, nor did it happen at a uniform rate of speed. Although scholars have noted a growing disdain for parlors in rural America beginning in the 1840s—the waste of usable space and the urban pretentiousness of rooms reserved largely for receiving visitors were often criticized in progressive farm journals—my Aunt Lib's High Victorian front room is a tribute to the remarkable survival of the type. And one of the most famous literary evocations of the old-fashioned parlor came in 1920, in Sinclair Lewis's acidic portrayal of the small-town Midwest in *Main Street*. Born in 1885 in Sauk Centre, Minnesota, Lewis clearly drew on memories of his boyhood in describing the variegated parlors of the fictional hamlet of Gopher Prairie. Each of them defined a particular household: The parlor of Mrs. Lyman Cass, whose spouse owned the flour mill, thus "belonged to the crammed-Victorian school" of home decor, said Lewis, an aesthetic governed by two principles. First, he argued, everything had to look like something it was not; and second, every inch of the interior "must be filled with useless objects." His comic inventory of the latter included "burnt-wood portraits of Indian chiefs," Grant's memoirs, a popular novel, the family Bible, a plaque depicting the Exposition Building in Minneapolis, a polished seashell, a pin-cushion in the shape of a shoe stamped "Souvenir of Troy, N.Y.," and pennants from the colleges attended by the Casses' two sons. Nature, culture, personality, current events, souvenirs, the myth of the West.

By contrast, the parlor of Mrs. Luke Dawson, "wife of the richest man in town," was of the "bare-Victorian" type. This room was noteworthy for its evocations of nature in "its faded photograph of Minnehaha Falls in 1890, its 'colored enlargement' of Mr. Dawson, [and] its bulbous lamp painted with sepia cows and mountains and standing on a mortuary marble column." Nature, personality, a little culture, Longfellow, and all the rest. Satire or truth, Americans have proven stubbornly resistant to abandoning their parlors, along with their cows, Native Americans, the spectacular waterfalls of Niagara, and a dream of some fresh-air utopia visible only from the vantage point of the great indoors [FIG. 15].

15. Unidentified maker. Sidewall: *Japonaiserie*, 1883–85. Machine printed.

Selected Timeline

1826 Frederic Edwin Church is born in Hartford, Connecticut.

1832 Englishman Louis Braille invents the stereoscope.

1836 Winslow Homer is born in Boston, Massachusetts.

 Ralph Waldo Emerson's celebrated text, *Nature*, is published.

1837 Thomas Moran is born Lancashire, England.

1840 Nathaniel Parker Willis's two-volume set, *American Scenery, or Land, Lake and River illustrations of a Transatlantic Nature*, is published (London: G. Virtue). The text is illustrated with engravings made after drawings by W. H. Bartlett.

1842 Thomas Moran's family emigrates to the U.S. Thomas Moran, Sr., establishes a textile mill at Carrocksink, near Philadelphia, Pennsylvania.

 The American Art-Union is founded.

1843 English critic and social theorist John Ruskin publishes *Modern Painters I*, praising the Romantic landscapes of English painter J. W. Turner.

1844 Frederic Church moves to Catskill, New York, to study with Thomas Cole (1801–1848) for two years.

1845 Charles L. Beach purchases the Pine Orchard House, expands the building, and establishes Catskill Mountain House.

 Frederic Church sketches near the Catskill Mountain House.

1846 Henry David Thoreau travels to Mount Katahdin and publishes the first essay in his series, *The Maine Woods*.

1848 Thomas Cole dies in Catskill, New York.

 Michael Knoedler opens the first New York gallery for Paris dealer Goupil, Vobert, and Company. Before his death in 1878, Knoedler would exhibit numerous works by Frederic Church, Winslow Homer, and Thomas Moran.

1849 Frederic Church is elected a full member of the National Academy of Design.

1851 Frederic Church is elected to the Council of the National Academy of design for one year.

 Frederic Church travels to the American South—Virginia, North Carolina, Kentucky, and the upper Mississippi River region; the Catskills; Grand Manan Island and the Bay of Fundy, Canada; Mount Katahdin and Mount Desert, Maine; and possibly Niagara Falls, New York.

 The Erie Railroad is completed, linking the Hudson River to Lake Erie.

 The New-York Daily Times (later renamed *The New York Times*) begins publication.

1853 Frederic Church travels to South America for the first time, with Cyrus W. Field.

 Frederic Church completes *Mount Ktaadn* [Katahdin].

 Thomas Moran enters apprentice-ship with Scattergood and Telfer, a wood-engraving firm in Philadelphia.

 Thomas Moran completes *Catawassa Valley*, inscribed, "One of my earliest drawings on Wood. T. Moran 1853."

1854 Winslow Homer illustrates his first published work, a lithographed sheet-music cover for the Boston firm of John Bufford & Sons, where he apprentices for two years.

 Carleton Watkins establishes a "Daguerrian parlor" in San Francisco, and begins working as a photographer.

 Henry David Thoreau's *Walden* is published.

1855 Walt Whitman's *Leaves of Grass* is published.

 The Niagara Railway Suspension Bridge is completed. Designed by John August Roebling, the designer of the Brooklyn Bridge, it is the first of its kind in the world.

1856 In the spring, Frederic Church visits Niagara Falls, New York, and in late fall travels to Mount Katahdin, Maine, with Theodore Winthrop. A description of this journey would be published as *Life in the Open Air* in 1863.

 Winslow Homer begins illustrating work for *Ballou's Pictorial Drawing Room Companion*.

 Harper's Weekly begins publica-tion, helping to establish wood engravings—made from endgrain woodblocks carved in relief and easily printed with letterpress type—as the dominant form of visual media for the period.

 Western Union Telegraph Co. is established in Cleveland, Ohio.

1857 Church completes *Niagara*. The painting is first exhibited in April at the Gallery of Williams, Stevens, Williams, New York, to enthusiastic reviews. *Niagara* is exhibited in London in the summer, bringing Church to attention of influential critic John Ruskin (1819–1900).

 Winslow Homer illustrates his first commission for *Harper's Weekly*: five wood engravings on the subject of Harvard student life.

 George Pullman establishes the Pullman Sleeping Car for rail travel.

1858 *Niagara* is exhibited at the German Gallery in London and James McClure and Son in Glasgow, Scotland, and Manchester and Liverpool, England.

 The discovery of gold in Colorado leads to the "Pike's Peak Gold Rush."

1859 Frederic Church completes *Heart of the Andes*. The painting is purchased by William T. Blodgett for $10,000—the highest price ever for the work of a living American artist.

 Winslow Homer becomes a mem-ber of the National Academy of Design, and moves to New York City.

 Oliver Wendell Holmes publishes *The Stereoscope and the Stereograph* in *The Atlantic Monthly* (June 1859, 738–48).

 Boston Unitarian minister Thomas Starr King's *The White Hills: Their Legends, Landscape, and Poetry* is published (Boston: Crosby, Nichols, and Company, 1860).

1860 Thomas Starr King moves to California to be minister of the First Unitarian Church of San Francisco, and visits the Yosemite Valley.

 John Ruskin's *Modern Painters V*, which discusses allegorical interpre-tations of landscape through paint-ing, is published.

1861 *Harper's Weekly* publishes the first cover illustration by Winslow Homer, a portrait of "The Seceding Mississippi Delegation in Congress," depicting the start of the Civil War.

 Winslow Homer receives a com-mission to travel with the Union Army to provide illustrations for *Harper's Weekly*, and does so periodi-cally throughout the years 1861–65.

 Thomas Moran is elected an Academician of the Philadelphia Academy of Fine Arts.

 Carleton Watkins makes his first trip to Yosemite with one of his patrons, Trenor Park, entrepreneur of the Mariposa gold mine. The resulting thirty mammoth-plate photographs (22 x 18 in.) and 100 stereoviews are

among the first photographs taken of the Yosemite Valley.

1862 Frederic Church completes *Under Niagara* (reproduced as a chromolithograph).

Thomas Moran's illustrations of the Susquehanna River appear as illustrations for "Catawissa Railroad" in *Harper's Monthly*, June 1862.

Thomas Moran exhibits five oil paintings at the Philadelphia Academy of Fine Arts's annual exhibition.

1862 President Abraham Lincoln signs the Pacific Railway Act, authorizing construction of the first transcontinental railroad.

1863 Winslow Homer collaborates with Boston lithographer Louis Prang on a series of six lithographed plates illustrating serious and humorous incidents of Civil War life.

1864 Samuel Coffin Eastman publishes *The White Mountain Guide Book*, which includes two fold-out maps of the region (Concord, NH: E. C. Eastman; Boston: Lee & Shepard).

President Abraham Lincoln signs a bill granting Yosemite Valley and the Mariposa Grove of Giant Sequoias to the State of California as an inalienable public trust.

1865 Frederic Church's two young children, Herbert Edwin (b. 1862), and Emma Francis (b. 1864), die of diphtheria.

Thomas Moran goes on a sketching trip to Pike County, Pennsylvania, and visits the Delaware Valley Resort Cataract Region, sketching *Milford*, *Sawkill*, *Sawkill Fall*, and *Picnic Rock*.

The Confederacy falls, ending the Civil War.

1866 Winslow Homer exhibits his first well-known oil painting, *Prisoners from the Front*, at the National Academy of Design's annual exhibition.

Winslow Homer lives in Paris, France, for one year and becomes acquainted with Impressionist painting.

Frederic Church receives a commission of $15,000 from dealer Knoedler to paint a major canvas for inclusion in the 1867 Paris *Exposition Universelle*, resulting in *Niagara Falls from the American Side*. Winslow Homer would also exhibit a painting at the *Exposition Universelle*.

L. Prang and Company, the firm of Boston lithographer Louis Prang, establishes the process of chromolithography, allowing for the first mass reproduction of full-color images in the U.S.

Carleton Watkins photographs

Mount Starr King (named for Thomas Starr King in 1864), in Yosemite, California.

1867 Frederic Church spends February through September at Hudson, New York, and purchases eighteen acres on the forested summit of Long Hill above the farm, the future site of Olana.

1868 Winslow Homer travels to the White Mountains of New Hampshire, and makes sketches used as the basis for many paintings and engravings set in the area and produced as late as 1873.

Frederic Church's *Niagara Falls from the American Side* is exhibited in London and Boston, and is purchased by New York department-store owner A. T. Stewart.

Charles W. Sweetser's *Book of Summer Resorts, explaining where to find them, how to find them, and their especial advantages, with details of time tables and prices…is* published (New York: "Evening mail" office).

1869 Winslow Homer's *The Bridle Path* is first shown publicly at the Brooklyn Art Association.

Winslow Homer paints *Long Branch, New Jersey*, directly relating to a wood engraving made for *Harper's Weekly*.

"The Golden Spike" is hammered into place on May 10 at Promontory, Utah, linking the East and West coasts via the Transcontinental Railroad.

1870 The Adirondack Railroad is established.

Scribner's Monthly begins publication.

Winslow Homer makes his first visit to the Adirondack Mountains, staying at the summer home of painter Eliphalet Terry and family.

The Metropolitan Museum of Art in New York and the Museum of Fine Arts in Boston are founded by urban leaders to display art and promote art education to the public.

1870– Construction begins on Frederic
1872 Church's Olana atop the summit of Long Hill, in Hudson, New York. Architect Calvert Vaux replaces Richard Morris Hunt.

Frederic Church's *Niagara* (1857) is exhibited at Yale School of Fine Arts, New Haven, Connecticut.

1871 Winslow Homer visits the family of painter friend Lawson Valentine in Walden, New York, and begins regular summer visits to the countryside around Hurley, New York, for subjects for his work.

Thomas Moran completes arrange-

ments with the Northern Pacific Railroad Company for spending two months in "Yellowstone Country." The party arrives by train in Green River, Wyoming, via the Union Pacific Railroad, and Corrine, Utah, also by train. Moran travels through Montana by stagecoach and horseback, accompanies a geological expedition researching a report to Secretary of the Interior, and completes sketches in pencil and watercolor that form the basis of future oil paintings.

1872 Frederic Church occupies Olana for the first time with his family.

Winslow Homer completes several important works based on his sketches in Hurley, New York, including two versions of *Snap the Whip* in oil, and publishes a wood engraving of the same image in *Harper's Weekly*.

Winslow Homer makes a brief visit to the Catskill Mountains, resulting in a wood engraving, *Under the Falls, Catskill Mountains*, that appears in *Harper's Weekly* in September.

Scribner's Monthly publishes Isaac Bromley's "Wonders of the West" and Professor Ferdinand V. Hayden's "Wonders of the West II," both with illustrations by Thomas Moran.

President Ulysses S. Grant signs a bill to make Yellowstone the first National Park.

Thomas Moran completes *The Grand Cañon of the Yellowstone*. The painting is exhibited at his studio, in New York at Messrs. Leavett and Co., Clinton Hall, and the Goupil Gallery, in Boston at Blakeslee & Noyes Gallery, and the Great Hall of the Smithsonian Institution in Washington, DC. It is purchased by the U.S. Congress and permanently installed in the Capitol Building.

1873 Frederic Church's *Niagara* (1857) is exhibited at the *Cincinnati Industrial Exhibit* in Cincinnati, Ohio.

Winslow Homer spends the summer in Gloucester, Massachusetts, and begins working in watercolor.

The Aldine publishes "Yellowstone Region" with illustrations by Thomas Moran.

1874 Winslow Homer travels to East Hampton, Long Island, and sketches the beaches and surrounding farmland.

The Aldine publishes "Utah Scenery" with illustrations by Thomas Moran.

Thomas Moran completes *The Chasm of the Colorado*. The painting is exhibited at Upper Library Hall in Newark, New Jersey, in New York

at Messrs. Leavett and Co., and The Goupil Gallery, and in Washington, DC at the Corcoran Gallery of Art. The painting is purchased by the U.S. Library of Congress and hung as a companion piece to *The Grand Cañon of the Colorado*.

Picturesque America; or The Land We Live In, edited by William Cullen Bryant, and including illustrations by Frederic Church and Thomas Moran, is published as a two-volume set by Appleton and Company.

1876 Winslow Homer makes first visit to the Valentine family's newly acquired Houghton Farm in Mountainville, New York.

Boston Lithographer Louis Prang issues *Yellowstone National Park, and the Mountain Regions of portions of Idaho, Nevada, Colorado, and Utah*, described by Ferdinand V. Hayden and illustrated with fifteen chromolithographs by Thomas Moran.

The *Centennial Exhibition* is held in Philadelphia. Thomas Moran is awarded both a medal and a diploma, and exhibits several works, including *Mountain of the Holy Cross*. Winslow Homer's *Snap the Whip* (1872) is also exhibited. Frederic Church is also awarded a bronze medal and exhibits eight oil paintings, including *Niagara*.

1877 Thomas Edison invents the phonograph.

The first public telephones in the U.S. go into use.

The Tile Club is established.

Thomas Moran travels to Florida; sketches extensively around Fort George and Lake Isabel, later producing five illustrations for *Scribner's* "Island of the Sea."

American Art Association [later SAA] is founded; Thomas Moran is among founding members.

1876– Frederic Church spends fall months
1879 at Mount Katahdin, Maine.

1878 Winslow Homer shows twenty studies from Houghton Farm at the *Century Exhibition* in New York City.

Winslow Homer completes a ceramic tile fireplace surround depicting a shepherd and shepherdess.

Thomas Moran visits East Hampton, Long Island, staying at Gardner's Hotel as guests of the Tile Club, and sketches extensively.

Frederic Church purchases Millinocket Camp, near Mount Katahdin, Maine.

1879 Winslow Homer visits friend Joseph Foxcroft Cole in Winchester,

Massachusetts, and makes many sketches of his daughter Adelaide Cole and her friends, which figure into his Houghton Farm works.

Thomas Moran resigns from the Society of American Artists after his painting, *Scene in Florida*, is rejected from its annual exhibition.

1880 Thomas Moran sells *Mountain of the Holy Cross* to Dr. W. A. Bell, Vice President of the Denver and Rio Grande Railways, for $4,500. Bell made arrangements to buy the painting while his company's lawsuit against the Atchison, Topeka, and Santa Fe Railroad Co. for the possession of the Grand Canyon of Arizona was before the U.S. Supreme Court.

Thomas Moran spends the summer season sketching in East Hampton, Long Island.

New York City's streets are first lit by electric lamps.

1880– Frederic Church sketches and paints
1900 only sporadically, spending winters in Mexico and summers divided between Olana and Lake Millinocket, Maine.

1881 Winslow Homer exhibits watercolors from Gloucester, Massachusetts, at the Water Color Society's January exhibition.

Thomas Moran visits Niagara Falls to fulfill a commission for engraving firm Schell and Hogan of twelve views for *Picturesque Canada*.

1882 Winslow Homer returns to New York after spending two years working in Cullercoats, England.

Winslow Homer's younger brother Arthur B. Homer and his family build a house in the coastal town of Prouts Neck, Maine, where they had been summering since 1875.

Thomas Moran travels with J. G. Pangborn, engraver John Karst, and a railroad official through Maryland, Virginia, West Virginia, and Pennsylvania to fulfill a commission for *Picturesque B.&O.: Historical and Descriptive*, published in 1882.

1883 Winslow Homer's older brother Charles Savage Homer, Jr., and his family build a house in Prouts Neck Maine, known as The Ark, and Homer takes over the adjacent stables as his painting studio and living quarters.

The Northern Pacific railroad is completed at Gold Creek, Montana.

1884 Winslow Homer completes *The Life Line*, and an etching of the work is also published.

Construction is completed on Thomas Moran's studio cottage on Main Street in East Hampton, Long

Island, both based on sketches made in 1881. It is established as the family's summer residence.

1885 The Santa Fe Railroad is completed.

In his studio at Prouts Neck, Maine, Winslow Homer begins a series of oil paintings of seascapes of the Atlantic coastline.

1886 Following the death of A. T. Stewart, Frederic Church's *Niagara Falls From the American Side* (1867) is purchased by Scottish-American magnate John S. Kennedy and presented to the National Gallery of Scotland.

Thomas Moran exhibits *Niagara* and *Niagara Rapids* at the Century Club.

Thomas Moran exhibits sixty-four works at Ortiges & Co. Gallery preparatory to public auction.

Hydroelectric installations are begun at Niagara Falls, New York.

1888 Thomas Moran is elected to the hanging committee of the National Academy of Design.

George Eastman (1854–1932) invents the Kodak camera, small and light enough to be held in two hands, and using roll film.

1889 Winslow Homer spends a month with the Baker family in Minerva, New York, in the Adirondack Mountains, and returns to his studio to produce watercolors based on sketches made there.

Thomas Moran and Frederic Church, among others, choose not to exhibit their works at the Paris *International Exposition* as a protest against the perceived biases of the Committee on American Art organized for the exhibition.

1890 The Yosemite region is designated a National Park by the U.S. government.

Photographic images begin to supplant engravings based on hand-drawn illustrations in popular publications.

1892 Thomas Moran, his son Paul Moran, and William Henry Jackson spend the early summer months in the West, traveling via the Santa Fe Railroad, "with every comfort and convenience." The purpose of the trip was to create sketches of the Grand Canyon, Yellowstone, and the surrounding landscape which would be translated into oil paintings, then reproduced as lithographs used for advertising purposes for the Santa Fe Route.

1893 The World's *Columbian Exposition* in Chicago opens to mark the 400th

anniversary of Christopher Columbus's discovery of the Americas.

1894 *Century Magazine* publishes "Journey to the Devil's tower in Wyoming (Artists' Adventures)," written and illustrated by Thomas Moran, and an account of his trip to Yellowstone, the Tetons, and Big Horn Mountains with W. H. Jackson in 1892.

1896 Thomas Moran exhibits four oil paintings at the National Academy of Design *Autumn Exhibition*, and nine pen-and-ink drawings at the Pennsylvania Academy of Fine Arts annual exhibition.

The Niagara Falls hydroelectric plant opens.

1897 Thomas Moran exhibits four views of the West at the *Annual American Water Color Society Exhibition* at the National Academy of Design.

Amy, Eleanor, and Sarah Hewitt— granddaughters of industrialist Peter Cooper—found the Cooper Union Museum for the Arts of Decoration (Now Cooper-Hewitt, National Design Museum), as part of The Cooper Union for the Advancement of Science and Art.

1900 Frederic Church dies in New York City at age seventy-three.

Winslow Homer exhibits at the Paris *Exposition Universelle*.

Thomas and Ruth Moran travel West, visiting Shoshone Falls on the Snake River, Blue Lakes in Idaho, and Yellowstone—Moran's last trip to the park.

1901 Thomas Moran exhibits three oil paintings at the National Academy of Design *Annual Exhibition*, including *Yellowstone Canyon*.

Moran sells *Grand Cañon of the Yellowstone* to Antlers Hotel, Colorado Springs, Colorado, for display and sale, a practice he continues with other paintings.

1909 Thomas Moran visits the Grand Canyon and paints *Canyons of the Colorado, Zoraster*.

1910 Winslow Homer dies at Prouts Neck at age seventy-four. His funeral is held at Mount Auburn Cemetery in Cambridge, Massachusetts.

1911 The Metropolitan Museum of Art opens a memorial exhibition of the work of Winslow Homer.

1912 Charles Savage Homer, Jr., Winslow Homer's elder brother, gives a group of more than 300 drawings and a number of watercolors to the Cooper Union Museum for the Arts of Decoration.

1915 Thomas Moran exhibits at the *Society of Men Who Paint the Far West* exhibition at Macbeth Gallery, New York.

1915– Mrs. Charles Savage Homer, Jr.,
1918 Winslow Homer's sister-in-law, gives a group of twenty-two of the artist's oil paintings to the Cooper Union Museum for the Arts of Decoration.

1917 A group of more than 500 oil sketches made by Frederic Church are given to the Cooper Union Museum for the Arts of Decoration, by the artist's son, Louis P. Church.

Thomas Moran presents a large group of his landscape sketches as a gift to the Cooper Union Museum for the Arts of Decoration.

Thomas Moran and his daughter Ruth Moran establish a residence in Pasadena, California.

1924 Thomas Moran makes his last visit to the Grand Canyon with daughter Ruth Moran.

1926 Thomas Moran dies at his home in Santa Barbara, California, at the age of eighty-nine.

Timeline compiled and edited by Athena Preston

Notes

Introduction
Barbara Bloemink

1. The Art School's Director's Reports written during the years from 1902–09 reflect the faculty's overall disappointment with the basic grounding in elementary drawing techniques of even the senior students. See Gail S. Davidson, *Training the Hand and Eye: American Drawings from the Cooper-Hewitt Museum* (New York: Cooper Hewitt Museum, 1989), pp. 1–4, 16–19.

2. Eleanor Hewitt, pamphlet, privately printed, New York, 1896, p. 17.

3. In 1967, the Cooper Union Museum collections became part of the Smithsonian Institution, and in 1976, the Museum relocated to its current location in the Andrew Carnegie Mansion on Fifth Avenue and 91st Street, and changed its name to Cooper-Hewitt, National Design Museum, Smithsonian Institution.

4. At the Philadelphia *Centennial Exhibition* in 1876, the English designer Christopher Dresser gave three lectures. At one of them, he strongly recommended that America establish a design museum, like the Victoria and Albert Museum, to inspire new American design.

5. Eleanor Hewitt, "The Making of a Modern Museum," printed privately, New York, 1896, reprinted 1919.

6. I am grateful to Gail Davidson and her essay, "Eliot Clark and the American Drawings Collection at Cooper-Hewitt, National Design Museum," in *Archives of American Art Journal* 34, no. 4 (1994): pp. 2–15, for much of the information on the history of works of American art in the Cooper-Hewitt collection.

7. Ibid., pp. 7–8.

8. Dita Amory and Marilyn Symmes, *Nature Observed, Nature Interpreted: Nineteenth-century American Landscape Drawings & Watercolors from the National Academy of Design and Cooper-Hewitt, National Design Museum, Smithsonian Institution,* exhibition catalogue (New York: National Academy of Design, 1995), pp. 16–19.

9. Eliot Clark, "Studies by American Masters at Cooper Union," in *Art in America*, June 1927, pp. 180–88.

10. From 1968 through 2004, various Homer oil paintings were on loan to the Smithsonian's American Art Museum.

Landscape, Tourism, and Land Development in the Northeast
Gail S. Davidson

1. Edward Lawrence Godkin, "The Evolution of the Summer Resort," *The Nation* 37 (July–December 1883): pp. 47–48.

2. Hans Huth, *Nature and the American: Three Centuries of Changing Attitudes* (Berkeley: University of California Press; London: Cambridge University Press, 1957), pp. 124–25.

3. The term "sublime" refers to the aesthetics of the nineteenth-century philosophers Edmund Burke and Immanuel Kant, according to whom landscape (the natural world) evokes emotional responses in human beings ranging from terror/magnificence (sublime) to harmony/tranquility (beautiful/picturesque). In the United States, this concept blended with the transcendentalism of Ralph Waldo Emerson—in which God, the great designer of the natural world, reveals his presence through light (especially the sunrise and sunset)—and the notion of America as the new Eden. These convictions informed the landscapes of Frederic Church and Thomas Moran among other Hudson River School painters. See Andrew Wilton, "The Sublime in the Old World and the New," in Andrew Wilton and Tim Barringer, *American Sublime, Landscape Painting in the United States, 1820–1880,* exhibition catalogue (London: Tate Publishing, 2002), pp. 11–15.

4. Thomas Cole's "Essay on American Scenery," *American Monthly* 1 (January 1836), articulated the idea of the sublime, while Asher B. Durand's "Letters on Landscape Painting," published in *The Crayon* (1855), addressed the concept of the "picturesque," as well as "truth to nature," the meticulous description of nature derived from John Ruskin.

5. *American Scenery* was published in folios prior to 1840. See Eugene C. Worman, Jr., "*American Scenery* and the Dating of Its Bartlett Prints, Part 1," in *Imprint* 12, no. 2 (Autumn 1987): pp. 2–11; "Part 2," vol. 13, no. 1 (Spring 1988): pp. 22–27.

6. Ibid. Worman discusses the re-editions of *American Scenery* and Bartlett prints though 1876 as well editions in French, German, and Dutch.

7. An 1830s set of transfer-wares with images after the British naval officer Basil Hall preceded the series after Bartlett. See Jeremy Adamson, "Nature's Grandest Scene in Art," in *Niagara, Two Centuries of Changing Attitudes, 1697–1901,* exhibition catalogue (Washington, DC: The Corcoran Gallery of Art, 1985), pp. 37, 41, 157.

8. William Irwin, *The New Niagara: Tourism, Technology, and the Landscape of Niagara Falls, 1776–1917* (University Park, PA: The Pennsylvania State University Press, 1996), p. 17.

9. For an overview of the relevant paintings by these artists, see Adamson, *Niagara*, pp. 11–52; Elizabeth McKinsey, *Niagara Falls, Icon of the American Sublime* (Cambridge: Cambridge University Press, 1985), pp. 55ff.

10. G.L., "Niagara in June…," *New-York Daily Times*, Monday, June 14, 1852, p. 1.

11. "Niagara Falls," *New-York Daily Times*, July 2, 1852, p. 2.

12. On Babbitt and Niagara Falls, see Frank Henry Goodyear, *Constructing a National Landscape: Photography and Tourism in Nineteenth-century America*, Ph.D. dissertation, University of Texas at Austin, 1998 (Ann Arbor, MI: UMI Dissertation Services, 1999), pp. 22–60.

13. On the real-estate and industrial development of both the American and Canadian Niagaras, see Irwin, pp. 10ff.

14. "Niagara's Suspension Bridge," *New-York Daily Times*, March 12, 1855, p. 5, reporting from the *Buffalo Express*, March 10, 1855.

15. See Eleanor Jones Harvey, *The Painted*

Sketch, American Impressions from Nature 1830–1880, exhibition catalogue (Dallas, TX: Dallas Museum of Art; New York: Harry N. Abrams, 1998), pp. 120–121 on the generality of this working method in the nineteenth century and on Thomas Cole's sketch box in the Bronck Museum, Coxsackie, New York.

16. Ibid., p. 159.

17. See Adamson, *Niagara*, pp. 53–56.

18. For marketing Church's 1857 *Niagara*, see Jeremy Adamson, "Frederic Church's Niagara: The Sublime as Transcendence," Ph.D. dissertation, University of Michigan, 1981, 3 vols., vol. 1, pp. 16–58; "Nature's Grandest Scene," pp. 14–17; Harvey, pp. 67–68.

19. Between the 1857 and 1867 Niagara pictures, Church painted another exhibition canvas, now lost, entitled *Under Niagara* (1862), that is known from a sketch in the collection of Olana and a chromolithograph by Risdon & Day, see Gerald L. Carr, *Frederic Edwin Church: Catalogue Raisonné of Works of Art at Olana State Historic Site*, 2 vols. (London: Cambridge University Press, 1994), vol. 1: no. 388, pp. 249–251; vol. 2: pl. 18 and *Niagara*, no. 145, p. 151.

20. These are 1917-4-1353 and 1917-4-326-A, which are reproduced in Adamson, nos. 48 and 51, p. 135.

21. About the tourists, Church wrote to his friend Aaron C. Goodman on Sept. 2, 1858, from the Cataract House: "The cheap fares bring a great many queer people to the falls and as there is but a step from the sublime to the ridiculous I can readily bring myself from the contemplation of the awful cataract to the study of human character as developed in the persons of numerous verdants, who, full of greeners and conceit, swarm the hotels. I am somewhat annoyed too as they seem to think that the quarter which gives them admission to Goats [sic] Island also conveys the privilege of gaping over the shoulders of modest artists when engaged in studying the various effects about the Falls—." Citations from all of Church's correspondence are from transcriptions at Olana State Historic Site.

22. The number of drawings commissioned varies according to different accounts. Only ten were actually printed in the book. See Allan Pringle, "Thomas Moran: *Picturesque Canada* and the Quest for a Canadian National Landscape Theme," *Imprint* 14, no. 1 (Spring 1989): pp. 12–21; Joni L. Kinsey, "Moran and the Art of Publishing," in Nancy K. Andersen,

Thomas Moran, exhibition catalogue (Washington, DC: National Gallery of Art; New Haven: Yale University Press, 1997), p. 21; Thurman Wilkins, *Thomas Moran, Artist of the Mountains* (Norman, OK: University of Oklahoma Press, 1966), pp. 202–205.

23. Comments of John Bush, owner of the Clifton Hotel, and Frank R. Delano, part owner of the International Hotel, in the 1884 *Niagara Falls Gazette*, cited in Irwin, p. 243, n. 10.

24. For the participation of Olmsted, Dorsheimer, Richardson, and Church in the Niagara Preservation, see Frances R. Kowsky, "In Defense of Niagara: Frederick Law Olmsted and the Niagara Reservation," in *The Distinctive Charms of the Niagara Scenery: Frederick Law Olmsted and the Niagara Reservation*, exhibition catalogue (Niagara Falls, NY: Buscaglio-Castellani Art Gallery, Niagara University, 1985), online at the Preservation Coalition of Erie County, http://preserve.bfn.org/bam/kowsky/nf/.

25. The following account is based on a New York State survey, *Special Report of the New York State Survey on the preservation of the scenery of Niagara Falls…for the year 1879…*(Albany, NY: C. Van Benthuysen & Sons, 1880); Calvert Vaux, "A National Park at Niagara," in *New York Tribune* (September 28, 1878), p. 4; William H. Hurlbert, *New York World* (April 1, 1880); Frederick Law Olmsted, "Mr. Church and the Niagara Park," in *New York World* (April 6, 1880), p. 4; William H. Hurlbert, *New York World* (January 14, 1883); Charles M. Dow, *The State Reservation at Niagara: A History* (Albany, NY: J. B. Lyon Company Printers, 1914), pp. 9–38. Thanks to Gerald L. Carr for some of these bibliographic citations.

26. A writer for the *New-York Daily Times*, July 22, 1873, p. 4, commented, "Let them put down their flower-beds and their oleanders, therefore, with a nicely uniformed policeman to keep them in order, and then just dam up the cataract . . . so that it may be turned on with a key for the benefit of well-behaved visitors at say fifty cents or a dollar a head."

27. *New-York Daily Times*, Aug. 29, 1873, p. 4.

28. "Niagara Falls, Preparing for the Opening of the Season," *New-York Daily Times*, April 16, 1875, p. 8.

29. This section of the essay relies heavily on Irwin, pp. 63–95.

30. On the influence of *The Pioneers* in developing a taste for the Catskill landscape, see Kenneth Myers,

"The Catskills and the Creation of Landscape Taste in America," in *The Catskills, Painters, Writers, and Tourists in the Mountains, 1820–1895*, exhibition catalogue (Yonkers, NY: The Hudson River Museum of Westchester, 1987), pp. 34–36.

31. *North American Tourist*, 1839, p. 34, quoted in ibid., p. 49.

32. See Kenneth Myers, "Art and Commerce in Jacksonian America: The Steamboat Albany Collection," in *Art Bulletin* 82, no. 3 (September 2000): pp. 503–28; and Myers, "Catskills," p. 47.

33. Elizabeth Mankin Kornhauser, "Daniel Wadsworth and the Hudson River School," *Hog River Journal* 3, no. 1 (November 2004–January 2005): pp. 18–23.

34. *Boston Recorder and Telegraph*, October 6, 1826, published online at the Catskill Archive, http://www.catskillarchive.com.

35. Myers, "Catskills," pp. 50–51; and Roland Van Zandt, *The Catskill Mountain House* (New Brunswick, NJ: Rutgers University Press, 1966), pp. 24–42.

36. See Cole's *Catskill Creek*, 1845, in Carr, vol. 1, p. 57, fig. 23.

37. "The Catskills," *New York Times*, September 4, 1863, p. 5.

38. T.B.G., "The Catskills, Going to Catskill Falls for Recreation," *New-York Daily Times*, July 21, 1853, p. 2.

39. Rev. Charles Rockwell, *The Catskill Mountains and the Region Around* (New York: Taintor, 1867), Chapter 17, read online at the Catskill Archive, http://www.catskillarchive.com; Wendy Harris and Arnold Pickman, "Landscape, Land Use and the Iconography of Space in the Hudson River Valley: The Nineteenth and Early Twentieth Century," p. 13, paper presented at the New York Academy of Sciences, December 9, 1996, read online http://members.aol.com/cragscons/acsci.html; Bradbury and Guild, "The Hudson River and the Hudson River Railroad, 1851," p. 31, read online, http://www.catskillarchive.com.

40. See Van Zandt, pp. 343–345, for discussion of rates at the Mountain House and competing hotels.

41. Ibid., p. 175.

42. Ibid., pp. 62–63.

43. "The Catskills, Scenery and Attractions of the Catskill," *New-York Daily Times*, August 17, 1860, p. 2.

44. See discussion in William B. Rhoads, "The Artist's House and Studio in the Nineteenth-century Hudson Valley and Catskills," in Sandra S. Phillips

and Linda Weintraub, *Charmed Places, Hudson River Artists and Their Houses, Studios, and Vistas*, exhibition catalogue (New York: Edith C. Blum Art Institute, Bard College, and Vassar College Art Gallery in association with Harry N. Abrams, 1988), pp. 77–87.

45. On Cedar Grove and Malkasten, see Henry Tuckerman, *Book of the Artists: American Artist Life* (New York: G. P. Putnam & Sons, 1867); on Malkasten, Barry Gray (R. B. Coffin), "Homes on the Hudson VIII, Hawksrest. The Residence of Albert Bierstadt," *Home Journal* (1871); Martha J. Lamb, "The Homes of America," *The Art Journal* (1876), pt. 2, p. 45; on Alladin, see F.W., "Art-Home in the Hills," *Home Journal* (October 18, 1871); Martha J. Lamb, *The Homes of America* (New York: D. Appleton, 1879); for a general discussion on artists' summer studios/homes, see Lizzie Champney, "Summer Haunts of American Artists," *The Century Magazine* 30 (October 1885), pp. 845–860. On July 20, 1873, Church wrote to fellow artist Jervis McEntee, "Catskill is alive with strangers as usual — numbers drift over here including an occasional artist." He goes on to say, "It always gives me a peculiar sensation to see a young painter, stuck by the road side, doubled up over a box, under the shelter of a white umbrella." Written at a time when Church was falling out of favor, this comment may reflect the artist's nostalgia for his former youthful promise.

46. On Malkasten and Charles Bierstadt's stereoviews, see Linda Ferber, *Albert Bierstadt, Art and Enterprise* (New York: The Brooklyn Museum in Association with Hudson Hills Press, 1990), pp. 34–39.

47. "A Sabbath on the Catskills," in Rockwell, p. 260; originally published in *New York Independent*, August 23, 1860, p. 1.

48. Purchase confirmed in Church to Erastus Dow Palmer, October 22, 1867.

49. On the construction of Olana, see James Anthony Ryan, "Frederic Church's Olana: Architecture and Landscape as Art," in Franklin Kelly, ed., *Frederic Edwin Church*, exhibition catalogue (Washington, DC: National Gallery of Art, 1989), pp. 126–156; Olana was published in "Residence of Mr. Church, the Artist," *New York Art Journal* 2 (June 1876): pp. 247–48.

50. See Church's letter to his father, May 13, 1864.

51. Quote from Church to E. D. Palmer,

July 7, 1869.

52. This phrase used in Church to J. F. Weir, June 8, 1871.

53. See Church to E. D. Palmer, June 18, 1872.

54. Church to Ogden Rood, May 16, 1874; also see Church to Martin Johnson Heade, November 16, 1868; Church to E. D. Palmer, July 7, 1869; May 26, 1870; April 28, 1871; July 19, 1871.

55. See Rhoads, pp. 90–96.

56. See *New-York Daily Times*, May 21, 1893, p. 11; May 28, 1893, p. 11; July 22, 1894, p. 12; June 17, 1906.

57. *Catskill Mountains* (Rondout, NY: Ulster and Delaware Railroad, 1891), p. 40, quoted in Rhoads, p. 96.

58. See "Rival Mountain Houses, The New Hotel on the summit of the Catskills," *New-York Daily Times*, August 1, 1881, p. 5.

59. "The New York Hunting Ground," *New-York Daily Times*, September 2, 1857, p. 4.

60. William H. H. Murray, *Adventures in the Wilderness; or Camp-Life in the Adirondacks* (Boston: Fields, Osgood, & Co., 1869), pp. 11, 12–15, 17.

61. Winslow C. Watson, Esq., "A General View and Agricultural Survey of the County of Essex," in *Transactions of the N.Y. State Agricultural Society for 1852* (New York: The N.Y. State Agricultural Society, 1853), p. 813.

62. Seneca Ray Stoddard, *The Adirondacks Illustrated* (Albany: published by the author, 1874).

63. Craig Gilborn, *Durant, the Fortunes and Woodland Camps of a Family in the Adirondacks* (Sylvan Beach, NY: North Country Books; Blue Mountain Lake: The Adirondack Museum, 1981), pp. 8–11.

64. See Murray, pp. 40–44.

65. Theodore E. Stebbins Jr., "Winslow Homer, Time in the Adirondacks," in Patricia Junker and Sarah Burns, eds., *Winslow Homer, Artist and Angler*, exhibition catalogue (Fort Worth, TX: Amon Carter Museum; San Francisco: Fine Arts Museums of San Francisco, 2002), p. 109.

66. Gilborn, pp. 19–25.

67. "Life in the Open Air," *Atlantic Monthly* 10 (August 1862): pp. 203–204.

68. "With pencil (the artist) made pictures and sent them back to the cities, to be noticed in the drawing rooms and public halls. Visitors began to arrive. Each one brought three the next year." Quoted in Caroline W. Welsh, "A Wild Yet Pleasing Landscape," in Linda S. Ferber and Caroline M. Welsh, *In Search of a National Landscape, William Trost Richards and the Artists' Adirondacks,*

1850–1870, exhibition catalogue (Blue Mountain Lake, NY: The Adirondack Museum, 2002), p. 79.

69. Essex County Historical Society, "Keene, NY," online at http://www.adkhistorycenter.org/esco/tow/keene.html.

70. *Every Saturday*, December 24, 1870, p. 49, and January 21, 1871, p. 57.

71. See Helen A. Cooper, *Winslow Homer Watercolors*, exhibition catalogue (Washington, DC: National Gallery of Art; New Haven: Yale University Press, 1986), pp. 187–193.

72. See "The Adirondacks," *Harper's Weekly*, December 6, 1884, p. 805; "The Threatened Adirondack Forests," *Harper's Weekly*, June 17, 1891, p. 439.

73. "History of the Adirondack Park," New York State Adirondack Park Agency, http://www.apa.state.ny.us.

74. Anthony DePalma, "In Adirondacks, an Old Lion Still Bares Fangs," *New York Times*, March 14, 2005, pp. B1 & B6.

75. Lieton, "Summer Places: The Porch of the White Mountains," *New-York Daily Times*, August 18, 1854, p. 4.

76. See Donald D. Keyes, "Perceptions of the White Mountains: A General Survey," in *The White Mountains, Places and Perceptions* (Hanover, NH: University Press of New England, 1980), p. 43.

77. Donna Brown, *Inventing New England, Regional Tourism in the Nineteenth Century* (Washington, DC: Smithsonian Institution Press, 1995), p. 44.

78. Moses F. Sweetser, *Here and There in New England and Canada: Among the Mountains* (Boston: Boston and Maine Railroad, 1889), p. 20. On Thompson's role in promoting North Conway as a tourist spot and his deal with artists, see Barbara J. MacAdam, "A Proper Distance from the Hills: Nineteenth-century Landscape Painting in North Conway," in *A Sweet Foretaste of Heaven: Artists in the White Mountain 1830–1930*, exhibition catalogue (Hanover, NH: The Hood Museum, 1988), p. 22; and Brown, p. 67.

79. T. W. Higgenson, "A Day in the Carter Notch," *Putnam's Monthly* 2 (December 1853), p. 673, cited in Keyes, p. 44; and Brown, p. 67.

80. Brown, p. 67.

81. Brown, p. 49.

82. Brown, p. 69.

83. See David Tatham, "Winslow Homer in the Mountains," in *Appalachia* 36 (June 15, 1966), p. 75.

84. See critical comments quoted in

Nicolai Cikovsky, Jr., and Franklin Kelly, *Winslow Homer*, exhibition catalogue (Washington, DC: National Gallery of Art and New Haven: Yale University Press, 1995), p. 75.

85. Nicolai Cikovsky, Jr., has likened Homer's creative process to Eli Whitney's method of mechanical industrial production. See Nicolai Cikovsky, Jr., "Modern and National," in Cikovsky and Kelly, pp. 66–68.

86. Ibid., p. 72.

87. *Maine, Present Condition of the State, Its Agricultural, Financial, Commercial and Manufacturing Development. Advantages of the State as a Summer Resort* (Augusta, ME: Kennebec Journal Book Print, 1885), p. 32.

88. Ibid., p. 29.

89. For example, *Portland Daily Press*, March 3, 1883; July 2, 1883; January 2, 1884.

90. Augustus F. Moulton, "Scarborough," in John T. Hull, *Handbook, Portland, Old Orchard, Cape Elizabeth, and Casco Bay* (Portland, ME: John T. Hull, 1888), pp. 222–224.

91. Technically, Ira Foss was a son-in-law for one day only, as he and his wife, Annie Maria Libby, were married on August 21, 1876, and she died the next day. Foss's mother, Tryphena Foss, purchased the Point in December 1876 for $2,500, and Ira Foss presumably inherited it from her. I am indebted to Rodney Laughton of Scarborough, and Stephen Lowell of Portland, Maine, for their assistance with these details.

92. Hotel brochure: The Checkley and The West Point House, Prouts Neck, Maine, 1896, pp. 2–6.

93. Hotel brochure: The Checkley, Prouts Neck, Maine, 1904.

94. Patricia Junker, "Expressions of Art and Life in *The Artist's Studio in an Afternoon Fog*," in Philip C. Beam et al., *Winslow Homer in the 1890s: Prouts Neck Observed*, exhibition catalogue (New York: Hudson Hills Press in Association with the Memorial Art Gallery of the University of Rochester, 1990), p. 40.

95. See subdivision plan filed in Cumberland County Court House, October 22, 1879; and announcement of the lots for sale in *Portland Transcript*, November 29, 1879; also, Philip C. Beam, *Winslow Homer at Prouts Neck* (Boston: Little, Brown and Company, 1966), p. 29, suggests that the easement may have derived from the publicity about Mount Desert, where cottagers prevented public access to the water by fencing

their property down to the waterline.

96. See Junker, p. 63, n. 34, referencing Record of Deeds, 1883–1910, Cumberland Country Court House, January 23, 1883, Book 494, p. 168, grantor Augustus F. Moulton; February 5, 1883, Book 495, p. 118, grantor Hannah Louise Googins.

97. Ibid., November 26, 1884, Book 514, p. 241, grantor Hannah Louise Googins.

98. Ibid., June 26, 1891 Book 581, p. 267, grantor Eben Seavey; September 23, 1891, Book 578, p. 331, grantor Louisa Libby; October 23, 1891, Book 578, p. 340, grantor Seth L. Larrabee.

99. Junker, pp. 41–47; Earle Shettleworth, Jr., and John Calvin Stevens II, *John Calvin Stevens Domestic Architecture (1890–1930)* (Scarborough, ME: Harp Publications, 1990).

100. Junker, pp. 47–48.

101. Homer to Mattie, June 19, 1885: "The church is of great value to the property here — it is very pretty — is quite near my house."

102. While Charles and Winslow gave some of the property comprising the Sanctuary to the Prouts Neck Association, Mattie Homer, after Charles's death, sold property from 1919 to 1921 to the Association for $32,000. Prouts Neck Association, *Prouts Then and Now 1888–1970*, p. 52.

103. On the design and construction of Kettle Cove, see "A Residence at Prouts Neck, Maine," *Scientific American Building Monthly* (July 1904): p. 17; Earle G. Shettleworth, Jr., and William David Barry, "Brother Artists John Calvin Stevens and Winslow Homer," *Bowdoin Magazine* 61, no. 4 (Fall 1988): pp. 17–19; Junker, p. 47.

104. The deed is recorded in "Land Evidence Books," Jamestown, Rhode Island Town Hall, October 19, 1881, vol. 8, p. 328, and an announcement, "Mr. Richards' Villa," detailing the size, style, and cost of the house was reported in *The Newport Mercury*, October 22, 1881, p. 8; see also Rhode Island Historical Preservation and Heritage Commission, *Historic and Architectural Resources of Jamestown, Rhode Island*, 1995, pp. 18–19.

105. Purchase of land recorded in "Land Evidence Books," Jamestown, Rhode Island Town Hall, September 8, 1902, vol. 14, pp. 344–345. The announcement of Richards's sale of East Dumpling to Joseph Lovering Wharton, who would be following Richards's house plans, made national news ("Social and Travel Notes—Philadelphia," *Town and Country*, February 13, 1904, p. 9);

See also *Historic and Architectural Resources of Jamestown, Rhode Island*, p. 50.

106. Marc Simpson, "Taken with a Cranberry Fit, Eastman Johnson on Nantucket," in Marc Simpson, Sally Mills, Patricia Hills, *Eastman Johnson, The Cranberry Harvest, Island of Nantucket* (San Diego: Timken Art Gallery, 1990), p. 37.

107. Junker, pp. 52–53.

108. Homer quoted this price to a collector who wrote to him directly; see Arthur Hoeber, "Winslow Homer, A Painter of the Sea," *The World's Work* 21 (February 1911): p. 14009–14017.

109. See Cikovsky and Kelly, pp. 223–225, and citations therein for discussion of the psychosexual interpretation of *The Life Line*.

110. The same year that Homer executed *The Life Line*, he reworked the picture using the etching technique, which he had tried once before. This print represents the first of eight etchings that Homer prepared between 1884 and 1889 after Maine and Cullercoats paintings and one Adirondacks picture. Aside from the artistic fulfillment from experimenting with a new process, Homer also hoped to make money from the prints' sales as well as use them as advertisements for his oil paintings. This venture did not succeed, and the editions were not sold out before he died. See Lloyd Goodrich, *The Graphic Art of Winslow Homer* (New York: The Museum of Graphic Art, 1968), pp. 13–17.

111. Both Kelly, pp. 328–329, and Beam, pp. 119–124, relate the two pictures in their discussions.

112. Kelly, p. 329.

113. For a general account of these artists at Mount Desert, see John Wilmerding, *The Artist's Mount Desert, American Painters on the Maine Coast* (Princeton, NJ: Princeton University Press, 1994), pp. 17–43; 69–103.

114. On Achenbach's influence on Church, see Ibid., pp. 70–71.

115. Frederic E. Church, "Mountain Views and Coast Scenery, by a Landscape Painter," in *Bulletin of the American Art-Union* (November 1850): p. 131.

116. Ibid., p. 131, although Church calls it Lyman's Farm.

117. Anne Mazlish, ed., *The Tracy Log Book, 1855, A Month in Summer* (Bar Harbor, ME: Acadia Publishing Company, 1997), p. 69. In addition to positive comments from Frederic Church via Theodore Winthrop, the Tracy trip may have been inspired by a June 1855 article,

"Where Shall We Spend the Dog-Days?," in the *New York Tribune*, June 9, 1855, p. 4.

118. See discussion in Pamela J. Belanger, *Inventing Acadia, Artists and Tourists at Mount Desert*, exhibition catalogue (Rockland, ME: The Farnsworth Art Museum, 1999), pp. 80–87.

119. E.B.S., "A Visit to Mount Desert," *New-York Daily Times*, August 10, 1857, p. 2.

120. George Ward Nichols, "Mount Desert," *Harper's New Monthly Magazine* 45, no. 267 (August 1872), p. 324.

121. See "How Mount Desert Has Changed," *New-York Daily Times*, July 29, 1878, p. 8; and Belanger, p. 116.

122. See Kelly, 1988, for interpretation.

123. The 1856 expedition is documented in Theodore Winthrop's "Life in the Open Air," *Atlantic Monthly* (August, September, November, December 1862), and published in book form, *Life in the Open Air* (Boston: Ticknor and Fields, 1863); while the 1877 trip is described by Arbor Ilex (A. L. Holley), "Camps and Tramps about Ktaadn [*sic*]," *Scribner's Monthly Magazine* 16 (May 1878); pp. 33–47.

124. I am indebted to Gerald L. Carr for bringing the connection between these two works to my attention.

125. Edward Hungerford, "Our Summer Migration, A Social Study," *The Century* 42, no. 4 (August 1891): pp. 569–76.

126. Thomas Cole, "Essay on American Scenery," *American Monthly* 1 (January 1836): p. 12.

127. Tatham, *Homer in the Adirondacks*, pp. 81–82, 108–111; Cikovsky, pp. 251–253; Sarah Burns, "Revitalizing the 'Painted-Out' North, Winslow Homer, Manley Health and New England Regionalism in Turn-of-the-Century America," in *American Art* 9 no. 2 (Summer 1995): pp. 20–37.

128. Contemporary research has yielded the following tourism statistics: Between 1838 and 1900, Niagara grew from 20,000 to around one million visitors; Saratoga in the same years from about 8,000 to more than 200,000 visitors; the Catskills between 1829 and 1900 from about 600 to around 12,000 visitors; the White Mountains between 1850 and 1900 from 5,000 to 174,000 vacationers; Maine around 1900, about 500,000 visitors; the New Jersey shore between 1866 and 1900 from more than 50,000 to 700,000 tourists (including day-trippers). In the West, by comparison, Yellowstone between the early 1870s and 1900 went from 500 to about 17,189; Yosemite in approximately the same period from 3,000 to more than 7,000 tourists; and the Grand Canyon in 1900 had under 44,000 tourists. These statistics, by and large, from Thomas Weiss, "Tourism in America before World War II," *The Journal of Economic History* 64, no. 2 (June 2004): pp. 289–327; as well as http://yosemite.ca.us; and http://goamericanwest.com/Arizona/grandcanyon/ history.html.

129. This aspiration was expressed by G. W. Curtis in "Niagara Falls," in Charles A. Dana, ed., *The United States Illustrated in Views of City and Country*, 2 vols. (New York: Hermann J. Meyer, 1855), 1:13, 18; quoted in Adamson, *Niagara*, p. 67.

130. "The Migratory New Yorker and Where He Goes," in *The New York Times*, Sunday Magazine (July 3, 1910), p. 4.

THE BEST POSSIBLE VIEW
FLORAMAE MCCARRON-CATES

1. In an 1858 court case related to land development, Carleton Watkins referred to his landscape images as presenting the "best general view" that would be immediately recognized.

2. Roland Barthes, "Every photograph is a certificate of presence," in *Camera Lucida, Reflections on Photography*, translated by Richard Howard, p. 87.

3. Jonathan Crary, *Techniques of the Observer, On Vision and Modernity in the Nineteenth Century* (Cambridge, MA: MIT Press, 1992), p. 5.

4. Ibid., p. 16. The reference is to the concept of "normal" behavior in society as expressed in Foucault's *Discipline and Punishment*.

5. "Illustrator" and "artist" were not considered mutually exclusive terms in the nineteenth century. If an artist chose to report a subject accurately, with attention to detail, and executed it with a degree of verisimilitude that bordered on the clinical, even if the subject depicted was imaginary, the artist was considered no less important than one who produced expressive canvases for exhibition in the great salons. Joseph Pennell in *Modern Illustration* (a book owned by the Cooper-Union Art Day School and published in 1895) illustrates in reproduction the works of J. M. W. Turner, James McNeill Whistler, Childe Hassam, John Constable, Edward Burne-Jones, Frederic Remington, and even Francisco Goya, all recognized artists, side by side with the work of Sir John Tenniel, Boutet de Monvel, Kate Greenaway, Gavarni, Aubrey Beardsley, Edwin Austin Abbey, and many other contributors to *The Century Magazine, Scribner's*, or *The Illustrated London News*, who never produced an oil painting, but owed their reputations to the quality images they produced and had reproduced by process-block engravings.

6. Joni Kinsey, "Moran and the Art of Publishing," in Nancy K. Anderson, *Thomas Moran* (New Haven: Yale University Press, 1997), p. 312; and Nancy K. Anderson, *Thomas Moran and the Surveying of the American West* (Washington, DC: Smithsonian Institution Press, 1992), pp. 56–57.

7. Ernst H. Gombrich, *Art and Illusion*, 2nd ed. (London: Phaidon, 1962), p. 57.

8. William Henry Jackson, "With Moran in Yellowstone," in *Appalachia*, December 26, 1936, p. 154.

9. For a discussion of the Baroque origins of the "exaggerated foreground" and the different motives employed by artists to create a sense of immediacy in the viewer, see Heinrich Wölfflin, *Principles of Art History, The Problem of the Development of Style in Later Art* (New York: Dover reprint, 1976) pp. 84–85.

10. In 1856, Sir David Brewster published *The Stereograph*, the first publication to describe monocular and binocular vision.

11. *Contributions to the Physiology of Vision. — Part the First. On some remarkable, and hitherto unobserved, Phenomena of Binocular Vision.* by Charles Wheatstone, F.R.S., Professor of Experimental Philosophy in King's College, London. Received and Read June 21, 1838. http://www.stereoscopy.com/library/wheatstone-paper1838.html [5/2/2005].

12. Tim Barringer in entry 35, *American Sublime*, p.152, remarks on the novelty of this use of photography in Church's working methods.

13. The most recent publication discussing Church's photograph collection is the exhibition catalogue *Fire and Ice: Treasures from the Photographic Collection Frederic Church at Olana* by Thomas Weston Fels (New York: Dahesh Museum of Art and Ithaca: Cornell University Press, 1992). Many of the photographs in the collection at Olana, Frederic Church's home in Hudson, New York, have counterparts in the drawings and oil sketches at Cooper-Hewitt.

14. See Elizabeth Linquist-Cock, *The*

Influence of Photography on American Landscape Painting 1839–1880 (New York: Garland Publishing, 1977), pp. 116–117. Footnote 31 refers to an entry in Mrs. Church's diary recording their trip to Baalbek in 1868, where they were accompanied by a Mr. Berghem, photographer, who was included in their party to record views.

15. Frederick Langenheim was a German immigrant to Philadelphia who studied the process of stereography in Paris. His first daguerreotyped images of Niagara Falls were produced in 1855.

16. Oliver Wendell Holmes, "The Stereoscope and the Stereograph," 1859, reprinted in Beaumont Newhall, *Photography: Essays & Images* (New York: Museum of Modern Art, 1980), p. 56.

17. Peter Palmquist, *Carleton E. Watkins: Photographer of the American West* (Albuquerque, NM: University of New Mexico Press, 1983), p. 19.

18. Herman von Helmholtz, *Physiologischen Optik* (New York: Dover reprint, 1962), p. 303.

19. *Scribner's* published 339 wood engravings by Moran, *Harper's Monthly* published 41, *The Aldine* and *Picturesque America* published 39 and 23 wood engravings respectively, and this does not include the approximately 60 wood engravings by Moran that served as illustrations for both the Hayden and Powell and Dutton Survey reports.

20. Martha Sandweiss points out that Powell recognized that Moran's dramatically lit wood engraved compositions better fit his dramatic textural descriptions than the more analytic photographs that actually were done by photographers who accompanied him on the exploration of the Colorado. See *Print the Legend, Photography and the American West* (New Haven: Yale University Press, 2002), p. 296.

21. Barthes, p. 87.

22. Joseph Pennell, *The Illustration of Books: A manual for the use of students, notes for a course of lectures at the Slade School, University College* (New York: The Century Co., 1895).

23. Ibid., p. 52–53.

24. Frances Benson, "The Quarterly Illustrator," in *The Year's Art* (New York: Harry C. Jones, 1893), p. 78; originally published in *The Quarterly Illustrator*, vol. 1, no. 2, April–June 1893.

25. Due to the generosity of the Santa Fe Railroad. Moran was amenable to financial support from the railroad companies. In a letter to his wife dated July 26, 1892, written from Yellowstone, he wrote, "Altogether this trip will prove of great advantage to me I am sure . . . However, the trip will soon be over and I think I have opened the way to come out again whenever I want without paying R.R. fares." Quoted in Amy O. Bassford, ed., *Home-thoughts from Afar: Letters of Thomas Moran to Mary Nimmo Moran* (East Hampton, NY: East Hampton Free Library, 1967), p. 122.

26. Eleanor Harvey, *Thomas Moran and the Spirit of Place*, exhibition brochure, Dallas Museum of Art, 2001, p. 8.

27. The best published essay on stereoviews of the White Mountain region of New Hampshire remains Tom Southall's "White Mountain Stereographs and the Development of a Collective Vision," in Edward W. Earle and Nathan Lyons, *Points of View: The Stereograph in America – A Cultural History* (Rochester, NY: The Visual Studies Workshop, 1979).

28. For a description of depth of field as it pertains to photography, see Gordon Baldwin, *Looking at Photographs, A Guide to Technical Terms* (Malibu, CA: The J. Paul Getty Museum and the British Museum Press, 1991), p. 36.

29. Gombrich, p. 76.

THE PASTORAL IDEAL: WINSLOW HOMER'S BUCOLIC AMERICA
SARAH BURNS

1. Henry James, "On Some Pictures Lately Exhibited," *Galaxy* 20 (July, 1875): pp. 93–94; "Fine Arts: The Academy Exhibition," *New York Evening Mail*, April 23, 1877. For a comprehensive study of often conflicting responses to Homer's work during this period, see Margaret C. Conrads, *Winslow Homer and the Critics: Forging a National Art in the 1870s*, exhibition catalogue (Kansas City, MO: The Nelson-Atkins Museum of Art; and Princeton, NJ: Princeton University Press 2001).

2. "Fine Arts," *New York Evening Post*, Mar. 3, 1880. The author of this column was *Post* critic G. W. Sheldon, who praised Homer's shepherdesses in very similar language in his *Hours with Art and Artists* (New York: D. Appleton, 1882), pp. 139–40.

3. "The Water Color Exhibition," *The Sun*, Feb. 16, 1879; Sheldon, pp. 137–38.

4. On Homer's assimilation of Barbizon art, see Helen A. Cooper, *Winslow Homer Watercolors*, exhibition catalogue (Washington, DC: National Gallery of Art; and New Haven: Yale University Press, 1986), pp. 52–65; see also Peter Bermingham, *American Art in the Barbizon Mood*, exhibition catalogue (Washington, DC: National Collection of Fine Arts, Smithsonian Institution, 1975). See Kenneth Haltman, "Anti-Pastoralism in Early Winslow Homer," *Art Bulletin* 80 no. 1 (March 1898): pp. 93–112, for an opposing view on the question of the pastoral, or its refutation, in Homer's rustic scenes.

5. Rebecca Harding Davis, "By-Paths in the Mountains," *Harper's New Monthly Magazine* 61 (July 1880): p. 168. The newspapers regularly reported on the whereabouts of artists and the results of their summer sketching tours; see, for example, "The Return of the Artists," *New York Herald*, Oct. 19, 1872. Recent studies of tourism include Cindy S. Aron, *Working at Play: A History of Vacations in the United States* (New York: Oxford University Press, 1999), and Dona Brown, *Inventing New England: Regional Tourism in the Nineteenth Century* (Washington, DC: Smithsonian Institution Press, 1995).

6. An essential source on Homer, Houghton Farm, and the Valentines is John Wilmerding and Linda Ayres, *Winslow Homer in the 1870s: Selections from the Valentine-Pulsifer Collection*, exhibition catalogue (Princeton, NJ: The Art Museum, Princeton University, 1990); also see Lloyd Goodrich and Abigail Booth Gerdts, *Record of Works by Winslow Homer* (New York: Spanierman Gallery with City University of New York and the Whitney Museum of Art, 2005), 2 vols., vol. 2, pp. 16–17.

7. Henry E. Alvord, "Description of Houghton Farm," (Cambridge, MA: Riverside Press, 1882), pp. 3–5; the comment on "strictly scientific methods" is on p. 8 of the same publication, in Manly Miles, "Experiments with Indian Corn, 1880–81."

8. The story of the Babcock children was first narrated by Lawson Valentine Pulsifer in his "Notes on Winslow Homer's Connection with Harold Trowbridge Pulsifer and 'Houghton Farm,' " in the Harold T. Pulsifer Papers, Special Collections, Colby College, Waterville, Maine. I thank Madeline Douglas, Corporate Librarian, Valspar Corporation, for providing a copy of Pulsifer's "Notes" from the Valspar archives.

9. Anne McClintock, *Imperial Leather:*

Race, Gender, and Sexuality in the Colonial Contest (New York: Routledge, 1995), pp. 40–42.

10. The definitive study of the subject is Jackson Lears, *No Place of Grace: Antimodernism and the Transformation of American Culture 1880–1920* (New York: Pantheon, 1981).

11. George E. Waring, "Life and Work of the Eastern Farmer," *Atlantic Monthly* 39 (May, 1877): p. 590; John Burroughs, "Picturesque Aspects of Farm Life in New York," *Scribner's Monthly* 17, no. 1 (November 1878), pp. 42–43, 48.

12. Stephen Smith, *The City That Was* (New York: Frank Allaben, 1911), pp. 67–81; Dr. Moreau Morris, "City Sanitary Reform," *New-York Daily Times*, April 7, 1873.

13. Susan Nichols Carter, "The Water-Color Exhibition," *Art Journal* 5 (1879): p. 94; "The Water-Color Society," *New-York Daily Times*, February 1, 1879; "Air and Exercise for Ladies," *Harper's Bazaar* 1 (November 30, 1867): p. 66. There were many tourist attractions in the vicinity of Houghton Farm, including West Point; Storm King Mountain; "Idlewild," home of popular author Nathaniel Parker Willis; and numerous picturesque river towns including Newburgh and Fishkill. See *Appleton's Illustrated Hand-book of American Travel* (New York: D. Appleton & Co., 1857), pp. 128–133.

14. "The Water Color Exhibition," *The Sun*, Feb. 16, 1879; "Fine Arts: The American Water-Color Society's Exhibition," *The Nation*, February 6, 1879, p. 107.

15. Beverly Gordon, "Dressing the Colonial Past: Nineteenth-century New Englanders Look Back," in Patricia A. Cunningham and Susan Yoso Lab, *Dress in American Culture* (Bowling Green, OH: Bowling Green State University Popular Press, 1993), pp. 111, 115. I am indebted to Gordon, pp. 109–39, for my summary of New England-themed displays and entertainments during the Civil War and Reconstruction period.

16. Gordon, p. 128.

17. J. B. Bartlett, *Parlor Amusements for the Young Folks* (Boston: James Osgood & Co., 1875), pp. 20, 46; "New York Fashions: Fancy Costumes," *Harper's Bazaar*, February 25, 1871, p. 115.

18. "New York Fashions: Fancy Costumes," *Harper's Bazaar*, February 20, 1869, p. 115.

19. Henry J. Winser, "Dresden China. The Royal Saxon Porcelain Works at Meissen," *Scribner's Monthly* 15 (March, 1878): p. 693. For other Bo-Peep illustrations see, for example, *Little Bo-Peep and Henny-Penny* (New York: Hurd & Houghton, 1860); and *Ancient Illuminated Rhymes* (New York: McLoughlin Brothers, 1870). Walter Crane, *The Baby's Opera* (London: Routledge, 1877), also included an illustration of Bo-Peep, although in a style reminiscent less of the eighteenth century than of the contemporary Aesthetic Movement. Ronald Pisano, "The Tile Club, 1877-1887," *The Magazine Antiques* (February, 2000), p. 308, contends that Homer's shepherdesses are obviously similar to Crane's; however, the latter's shepherdess costume is quite different.

20. Cooper, p. 60, suggests that Homer had access to a ready-made Bo-Peep costume and also notes that during the 1870s, "Arcadian" elements began to appear in women's fashions as well, to be "swiftly adopted by American artists as subject matter."

21. Robert Wolterstoff, catalogue entry, in Wilmerding and Ayres, *Winslow Homer in the 1870s*, p. 62. On Homer's activities in the Tile Club, see Ronald Pisano, "The Tile Club, 1877-87," pp. 308–09, and on the Tile Club more generally, see Pisano, *The Tile Club and the Aesthetic Movement in America (1877–1887)*, exhibition catalogue (New London, CT: Lyman Allyn Art Museum, 2000).

22. Homer's Houghton Farm scenes were often identified with New England; see for example, "The Water-Color Society," *New-York Daily Times*, February 1, 1879.

23. "Fine Arts: The Growing School of American Water-Color Art," *The Nation* 28 (March 6, 1879): p. 171.

24. On Homer's later work and the culture of revitalizing masculine tourism, see Sarah Burns, "Revitalizing the 'Painted-Out' North: Winslow Homer, Manly Health, and New England Regionalism in Turn-of-the-Century America," *American Art* 9, no. 2 (Summer 1995): pp. 21-37.

25. See Thomas Andrew Denenberg, *Wallace Nutting and the Invention of Old America*, exhibition catalogue (Hartford, CT: Wadsworth Atheneum Museum; and New Haven: Yale University Press, 2003), for an informative history and analysis of Nutting's career. On the subject of art, myth, remembrance, and tourism more generally, see the essays in William Truettner and Roger B. Stein, eds., *Picturing Old New England: Image and Memory*, exhibition catalogue (Washington, DC: National Museum of American Art, Smithsonian Institution: New Haven and London: Yale University Press, 1999).

AMERICA INSIDE OUT: THE VIEW FROM THE PARLOR
KARAL ANN MARLING

1. Henry Wadsworth Longfellow, *The Song of Hiawatha* (Boston: David R. Godine, 2004).

2. "Minnehaha Falls and Longfellow's 'Hiawatha'," *Minnesota History* 8 (September 1927): pp. 281–82; 8 (December 1927): pp. 422–24.

3. The craze for commemorative spoons seems to date from 1890 when Gorham Silver produced a "Witch Spoon" as a souvenir of Salem, Massachusetts.

4. Karal Ann Marling, *George Washington Slept Here: Colonial Revivals and American Culture, 1887–1986* (Cambridge: Harvard University Press, 1988), pp. 88–89, 171–76.

5. For Homer the businessman, see Sarah Burns, *Inventing the Modern Artist: Art and Culture in Gilded Age America* (New Haven: Yale University Press, 1996), ch. 6.

6. See Cecilia Tichi, *The Electronic Hearth: Creating an American Television Culture* (New York: Oxford University Press, 1991).

7. Quoted in Sally McMurry, "City Parlor, Country Sitting Room: Rural Vernacular Design and the American Parlor, 1840–1900," *Winterthur Portfolio* 20 (Winter 1985): p. 267.

8. For a wide range of photographs of American parlors of the period, see William Seale, *The Tasteful Interlude: American Interiors Through the Camera's Eye, 1860–1917* (New York: Praeger Publishers, 1975). The swags of material are described in an 1883 issue of *Decorator and Furnisher* quoted in Marilyn Johnson, "The Artful Interior," *In Pursuit of Beauty* (New York: Metropolitan Museum of Art/Rizzoli, 1986), p. 136.

9. Clarence Cook, "Some Chapters on House-Furnishing," *Scribner's Monthly* 10 (June, 1875): p. 172.

10. McMurry, p. 270 and passim.

11. Sinclair Lewis, *Main Street* (New York: New American Library, 1961), pp. 135–36.

12. Lewis, p. 123.

REFERENCES

Adams, Celeste Marie, Franklin Kelly, and Ron Tyler. *America: Art and the West*, exhibition catalogue. New York: American-Australian Foundation for the Arts and International Cultural Corporation of Australia, 1986.

Adamson, Jeremy Elwell. *Niagara: Two Centuries of Changing Attitudes, 1697–1901*, exhibition catalogue. Washington, DC: The Corcoran Gallery of Art, 1985.

Adamson, Jeremy. "Frederic Church's Niagara: The Sublime as Transcendence." Ph.D. dissertation. University of Michigan, 1981.

Alvord, Henry E. *Description of Houghton Farm*. Cambridge, MA: Riverside Press, 1882.

Amory, Dita, and Marilyn Symmes. *Nature Observed, Nature Interpreted, Nineteenth-century American Landscape Drawings & Watercolors from the National Academy of Design and Cooper-Hewitt, National Design Museum, Smithsonian Institution*, exhibition catalogue. New York: National Academy of Design with Cooper-Hewitt, National Design Museum, Smithsonian Institution, 1995.

Anderson, Nancy K. *Thomas Moran*, exhibition catalogue. Washington, DC: National Gallery of Art; New Haven: Yale University Press, 1997.

Apostolos-Cappadona, Diane. *The Spirit and the Vision: The Influence of Christian Romanticism on the Development of Nineteenth-century American Art*. Atlanta: Scholars Press, 1995.

Atkinson, D. Scott. *Winslow Homer in Gloucester*, exhibition catalogue. Chicago: Terra Museum of American Art, 1990.

Avery, Myron H. "Artists and Katahdin," *In the Maine Woods*, Bangor, ME: Bangor and Aroostook Railroad Company, 1940, pp. 13–21.

Avery, Myron H. "Katahdin and Its Country," *Nature Magazine* 30, no. 4, October 1937, pp. 237–41.

Axelrod, Alex, ed. *The Colonial Revival*. New York: W. W. Norton, 1985.

B. Bradshaw & Co. *B. Bradshaw's ABC Dictionary to the United States, Canada, and Mexico*. London: Trübner, 1886.

Baldwin, Gordon. *Looking at Photographs: A Guide to Technical Terms*. Malibu, CA: The J. Paul Getty Museum and the British Museum Press, 1991.

Barthes, Roland. *Camera Lucida: Reflections on Photography*. Richard Howard, trans. New York: Hill and Wang, 1981.

Bartlett, J. B. *Parlor Amusements for the Young Folks*. Boston: James Osgood and Co., 1875.

Bassford, Amy O. *Home Thoughts from Afar: Letters of Thomas Moran to Mary Nimmo Moran*. East Hampton, NY: East Hampton Free Library, 1967.

Barron, Hal S. *Those Who Stayed Behind: Rural Society in Nineteenth-century New England*. Cambridge: Cambridge University Press, 1984.

Bayles, Richard M. *History of Newport County, Rhode Island, from the year 1638 to the year 1887, including the settlement of its towns, and their subsequent progress*. New York: L. E. Preston & Co., 1888.

Baumgartner, Eric W. *Our Own Bright Land: American Topographical Pictures, 1770–1930*, exhibition catalogue. New York: Hirschl & Adler Galleries, 1994.

Beal, Graham William John. *American Beauty: Paintings from the Detroit Institute of the Arts, 1770–1920*. London: Scala, 2002.

Beam, Philip C. *Winslow Homer at Prouts Neck*. Boston and Toronto: Little, Brown, and Company, 1966.

Beam, Philip C., et al. *Winslow Homer in the 1890s: Prouts Neck Observed*, exhibition catalogue. New York: Hudson Hills Press in association with the Memorial Art Gallery of the University of Rochester, 1990.

Becker, Howard, Thomas Sauthall, and Harvey Green. *Points of View: The Stereograph in America, a Cultural History*. Rochester, NY: The Visual Studies Workshop, 1979.

Beecher, Pamela. *American Landscape Painting and its Patrons in the Early Republic: Pastoral Ideology*. Ithaca, NY: Cornell University Press, 1996.

Belanger, Pamela J. *Inventing Acadia: Artists and Tourists at Mount Desert*, exhibition catalogue. Rockland, ME: Farnsworth Art Museum; distributed by University Press of New England, 1999.

Boime, Albert. *The Magisterial Gaze: Manifest Destiny and the American Landscape Painting, ca. 1830–1865*. Washington, DC: Smithsonian Institution Press, 1991.

Bolger, Doreen. *In Pursuit of Beauty: Americans and the Aesthetic Movement*, exhibition catalogue. New York: Rizzoli, for the Metropolitan Museum of Art, 1986.

Boorstin, Daniel J. *The Americans: The Democratic Experience*. New York: Random House, 1973.

Burroughs, John. "Picturesque Aspects of Farm Life in New York." *Scribner's Monthly* 17, no. 1 (November 1878): 41–55.

Bradbury and Guild, *The Hudson River and the Hudson River Railroad, 1851*. Boston: Bradbury & Guild, 1851. <www.catskillarchive.com/rrextra/abnyh.html>.

Braff, Phyllis. *Thomas Moran, a Search for the Scenic: His Landscape Paintings of the American West, East Hampton, and Venice*, exhibition catalogue. East Hampton, NY: Guild Hall Museum, 1980.

The Brooklyn Museum. *The American Renaissance, 1876–1917*, exhibition catalogue. Brooklyn, NY: Brooklyn Museum, Division of Publications and Marketing Services; exclusively distributed to the trade by Pantheon Books, 1979.

Brooks, Van Wyck. *The Flowering of New England, 1815–1865*. New York: E. P. Dutton & Co., Inc., 1936.

Brown, Dona. *Inventing New England: Regional Tourism in the Nineteenth Century*. Washington, DC: Smithsonian Institution Press, 1995.

Brown University Dept. of Art. *To Look on Nature: European and American landscape, 1800–1874*, exhibition catalogue. Providence, RI: Rhode Island School of Design Museum, 1972.

Bryant, William Cullen, ed. *Picturesque America; or, The land We Live In*. 2 vols. New York: D. Appleton and Co., 1874.

Buckley, Lauren. *Edmund CA. Tarbell: Poet of Domesticity*. New York: Hudson Hills Press, 2001.

Buell, Lawrence. *New England Literary Culture: From Revolution to Renaissance*. Cambridge: Cambridge University Press, 1986.

Burke, Margaret R. *Bowdoin College Museum of Art: Handbook of the Collections*. Brunswick, ME: Bowdoin College Museum of Art, 1981.

Burns, Sarah. *Inventing the Modern Artist: Art and Culture in Gilded Age America*. New Haven: Yale University Press, 1996.

Burns, Sarah. *Painting the Dark Side: Art and the Gothic Imagination*

in Nineteenth-century America.
Los Angeles: University of California
Press, 2004.

Burns, Sarah. *Pastoral Inventions: Rural
Life in Nineteenth-century American
Art and Culture.* Philadelphia:
Temple University Press, 1989.

Burns, Sarah. "Revitalizing the 'Painted-
Out' North: Winslow Homer,
Manly Health, and New England
Regionalism in Turn-of-the-Century
America." *American* 9, no. 2
(Summer 1995): 21–37.

Burnham, Patricia M., and Lucretia
Hoover Giese, eds. *Redefining
American History Painting.*
Cambridge: Cambridge University
Press, 1995.

Bermingham, Peter. *American Art in the
Barbizon Mood,* exhibition catalogue.
Washington, DC: National
Collection of Fine Arts,
Smithsonian Institution, 1975.

Buscaglio-Castellani Art Gallery of Niagara
University. *The Distinctive Charms
of Niagara Scenery: Frederick Law
Olmsted and the Niagara Reservation,*
exhibition catalogue. Niagara Falls,
NY: Niagara University, 1985.

Campbell, Catherine H. *The White
Mountains: Place and Perceptions.*
Hanover, NH: Published for the
University Art Galleries, University
of New Hampshire, Durham, by the
University Press of New England,
1980.

Carbone, Teresa A. *Eastman Johnson:
Painting America.* New York:
Brooklyn Museum of Art in associa-
tion with Rizzoli International
Publications, 1999.

Carbone, Teresa A. *Summers Abroad:
The European Watercolors of Francis
Hopkinson Smith,* exhibition cata-
logue. New York: The Jordan-Volpe
Gallery, 1985.

Carter, Robert. *Summer Cruise on the
Coast of New England.* Boston:
Crosby, 1864.

Carr, Gerald L. *In Search of the Promised
Land: Paintings by Frederic Edwin
Church.* New York: Berry-Hill
Galleries, Inc., 2000.

Carr, Gerald L. *Frederic Edwin Church:
Catalogue Raisonné of Works of Art
at Olana State Historic Site.* 2 vols.
London: Cambridge University Press,
1994.

Cameron, Katherine. *The Moran Family
Legacy,* exhibition catalogue.
East Hampton, NY: The Guild Hall
Museum, 1997.

Carbone, Teresa A., and Patricia Hills.
Eastman Johnson: Painting America.
New York: Brooklyn Museum of Art
and Rizzoli, 1999.

Chambers, Bruce W. *Selections from the
Robert: Coggins Collection of
American Painting.* Rochester, NY:
Memorial Art Gallery of the
University of Rochester, 1976.

Champney, Lizzie. "Summer Haunts
of American Artists." *The Century
Magazine* 30 (October 1885): 845–60.

Church, Frederic Edwin. "Mountain
Views and Coast Scenery, by a
Landscape Painter." *Bulletin of the
American Art Union*
(November 1850): 129–31.

Cikovsky, Nicolai, Jr., ed. *Winslow Homer:
A Symposium.* Washington, DC:
National Gallery of Art, 1990.

Cikovsky, Nicolai, Jr., and Franklin Kelly.
Winslow Homer, exhibition catalogue.
With contributions by Judith Walsh
and Charles Brock. Washington, DC:
National Gallery of Art; New Haven:
Yale University Press, ca. 1995.

Clark, Eliot. "Studies by American Masters
at Cooper Union." *Art in America*
(June 1927): 180–88.

Connolly, James B. *Book of the Gloucester
Fishermen.* New York: The John Day
Co., 1927.

Conrads, Margaret C. *American Painting
and Sculpture at the Sterling and
Francine Clark Art Institute.* New
York: Hudson Hills Press, 1990.

Conrads, Margaret C. *Winslow Homer
and the Critics: Forging a National
Art in the 1870s,* exhibition catalogue.
Princeton, NJ: Princeton University
Press in association with the Nelson-
Atkins Museum of Art, 2001.

Cooper, Helen A. *Winslow Homer
Watercolors,* exhibition catalogue.
New Haven and London: Yale
University Press for the National
Gallery of Art, 1986.

Cooper-Hewitt, National Design Museum,
Smithsonian Institution. *American
Art Pottery,* exhibition catalogue.
Seattle: University of Washington
Press for Cooper-Hewitt, National
Design Museum, 1987.

Cornell, Daniell. *Visual Culture as History:
American Accents: Masterworks from
the Fine Arts Museums of San
Francisco,* exhibition catalogue.
San Francisco: Fine Arts Museums
of San Francisco, 2002.

Crary, Jonathan. *Techniques of the
Observer: On Vision and Modernity
in the Nineteenth Century.*
Cambridge, MA: MIT Press, 1992.

Crompton, Arnold. *Thomas Starr King,
Apostle of Liberty.* Berkeley, CA:
Uniquest, 1975.

Cunningham, Patricia, and Susan Yoso
Lab. *Dress in American Culture.*
Bowling Green, OH: Bowling Green
State University Popular Press, 1993.

Curry, David Park. *American Dreams:
Paintings and Decorative Arts from
the Warner Collection,* exhibition
catalogue. Richmond, VA: Virginia
Museum of Fine Arts, 1997.

Curry, David Park. *Western Spirit:
Exploring New Territory in American
Art,* exhibition catalogue. Denver:
Denver Art Museum, 1989.

Curry, David Park. *Winslow Homer:
The Croquet Game,* exhibition cata-
logue. New Haven: Yale University
Art Gallery, 1984.

D. Appleton & Co. *Appleton's General
Guide to the United States and
Canada.* New York: D. Appleton,
1885.

D. Appleton & Co. *Appleton's Illustrated
Hand-Book of American Summer
Resorts: With Maps, and Tables of
Railway and Steamboat Fares.* New
York: D. Appleton & Co., 1896.

D. Appleton & Co. *Appleton's Illustrated
Hand-Book of American Winter
Resorts for Tourists and Invalids.*
New York: D. Appleton & Co., 1895.

Danbom, David B. *Resisted Revolution:
Urban America and their
Industrialization of Agriculture,
1900–1930.* Ames, IA: Iowa State
University Press, 1979.

Davidson, Gail S. "Eliot Clark and the
American Drawings Collection at
Cooper-Hewitt, National Design
Museum." *Archives of American Art
Journal* 34, no. 4 (1994): 2–15.

Davis, Rebecca Harding, "By-Paths in the
Mountains." *Harper's New Monthly
Magazine* 61 (July 1880): 167–85.

Dee, Elaine Evans. *To Embrace the
Universe: Drawings by Frederic Edwin
Church,* exhibition catalogue.
Yonkers, NY: Hudson River Museum,
1984.

Dee, Elaine Evans. *Nineteenth-Century
American Landscape Drawings
in the Collection of the Cooper-Hewitt
Museum.* Washington, DC:
Smithsonian Institution, 1982.

Dee, Elaine Evans, and Gail S. Davidson.
*Training the Hand and Eye: American
Drawings from the Cooper-Hewitt
Museum,* exhibition brochure.
Washington, DC: Smithsonian
Institution, 1989.

De Lisser, R. Lionel. *Picturesque Catskills:
Greene County.* Northampton, MA:
Picturesque Pub. Co., 1894.

Denenberg, Thomas Andrew. *Wallace
Nutting and the Invention of Old
America,* exhibition catalogue.
Hartford, CT: Wadsworth Atheneum
Museum; and New Haven: Yale
University Press, 2003.

De Weck, Ziba. *Winslow Homer and the
New England Coast,* exhibition cata-

logue. New York: Whitney Museum of American Art, 1984.

Donaldson, Gordon. *Niagara: The Eternal Circus.* Toronto: Doubleday Canada Ltd.; Garden City, NJ: Doubleday, 1979.

Dow, Charles M. *The State Reservation at Niagara: A History.* Albany, NY: J. B. Lyon Company Printers, 1914.

Downes, William Howe. *The Life and Works of Winslow Homer.* Boston: Houghton Mifflin, 1911.

Downing, Antoinette Forrester, *Early Homes of Rhode Island.* Richmond, VA: Garrett and Massie, Inc., 1937

Drake, Samuel Adams, *Historic Mansions and Highways around Boston.* Rutland, VT: C.E. Tuttle Co., 1971.

Drake, Samuel Adams. *Nooks and Corners of the New England Coast.* New York: Harper & Brothers, 1875.

Drake, Samuel Adams. *Pine-tree Coast.* Boston: Estes & Lauriat, 1891.

Earle, Edward W., ed. *Points of View: The Stereograph in America: A Cultural History,* exhibition catalogue. New York: The Visual Studies Workshop in collaboration with the Gallery Association of New York State, 1979.

Eastman, Samuel Coffin. *The White Mountain Guide Book.* Concord, NH: E. C. Eastman; Boston: Lee & Shepard, 1864.

Elliott, Susan Sipple. *Looking Down Yosemite Valley: Paintings by Albert Bierstadt.* Birmingham, AL: Birmingham Museum of Art, 1997.

Esten, John. *Childe Hassam: East Hampton Summers,* exhibition catalogue. East Hampton, NY: Guild Hall Museum, 1997.

Fels, Thomas Weston. *Fire and Ice: Treasures from the Photographic Collection, Frederic Church at Olana,* exhibition catalogue. New York: Dahesh Museum of Art and Cornell University Press, 1992.

Ferber, Linda S., and Caroline M. Welsh. *In Search of a National Landscape: William Trost Richards and the Artists' Adirondacks, 1850–1870,* exhibition catalogue. Blue Mountain Lake, NY: The Adirondack Museum, 2002.

Ferber, Linda. *Albert Bierstadt: Art and Enterprise.* New York: The Brooklyn Museum in Association with Hudson Hills Press, 1990.

Ferber, Linda S. *"Never at Fault": The Drawings of William Trost Richards,* exhibition catalogue. Yonkers, NY: The Hudson River Museum, 1986.

Ferber, Linda S. *Pastoral Interlude: William T. Richards in Chester County,* exhibition catalogue. Chadds Ford, PA: Brandywine River Museum, 2001.

Ferber, Linda S. *Tokens of Friendship:*

Miniature Watercolors by William T. Richards, exhibition catalogue. New York: Metropolitan Museum of Art, 1982.

Ferber, Linda S. *Watercolors by William Trost Richards,* exhibition catalogue. New York: Berry Hill Galleries, Inc., 1989.

Ferber, Linda S. *William Trost Richards: American Landscape & Marine Painter, 1833–1906,* exhibition catalogue. New York: The Brooklyn Museum, 1973.

Ferber, Linda S. *William Trost Richards: Rediscovered, Oils, Watercolors, and Drawings from the Artist's Family,* exhibition catalogue. New York: Beacon Hill Fine Arts, 1996.

Fifer, J. Valerie. *American Progress; The Growth of the Transport, Tourist, and Information Industries in the Nineteenth-century West, seem Through the life and Times of George A. Crofutt, Pioneer and Publicist of the Transcontinental Age.* Chester, CT: Globe Pequot Press, 1998.

Fosburgh, James W. *Winslow Homer in the Adirondacks: An Exhibition of Painting,* exhibition catalogue. Blue Mountain Lake, NY: Adirondack Museum, 1959.

Foster, Allen Evarts. *A Check List of Illustrations by Winslow Homer in Harper's Weekly and Other Periodicals.* New York: The New York Public Library, 1936.

Foster, N. Sherrill. *1630–1976, Life Styles East Hampton: A Bicentennial Exhibition,* exhibition catalogue. East Hampton, NY: Guild Hall Museum, 1976.

Fryxell, Fritiof. *Thomas Moran, Explorer in Search of Beauty.* East Hampton, NY: East Hampton Free Library, 1958.

Gardner, Albert Ten Eyck. *The Paintings of Winslow Homer from the Cooper Union Museums: A Benefit Exhibition for the Museum Acquisition Fund,* exhibition catalogue. New York: Ira Spanierman, 1966.

Gardner, Albert Ten Eyck. *Winslow Homer, American Artist: His World and His Work.* New York: Bramhall House, 1961.

Gardner, Albert Ten Eyck. *Winslow Homer: A Retrospective Exhibition,* exhibition catalogue. Washington, DC: National Gallery of Art, 1958.

Gardner, Albert Ten Eyck. *Winslow Homer: A Retrospective Exhibition,* exhibition catalogue. Boston: Museum of Fine Arts, 1959.

Gerdts, William H. *Thomas Moran, 1837–1926,* exhibition catalogue. Riverside, CA: The Picture Gallery, University of California, 1963.

Giffen, Sarah L., and Kevin D. Murphy, eds. *"A Noble and Dignified Stream": The Piscataqua Region in the Colonial Revival, 1860–1930.* York, PA: Old York Historical Society, 1992.

Gilborn, Craig. *Durant, the Fortunes and Woodland Camps of a Family in the Adirondacks.* Sylvan Beach, NY: North Country Books; Blue Mountain Lake, NY: Adirondack Museum, 1981.

Godfrey, Edward K. *The Island of Nantucket: What It Was and What It Is.* Boston: Lee and Shepard, 1882.

Godkin, Edward Lawrence. "The Evolution of the Summer Resort," *The Nation* 39 (July–December 1883): 47–48.

Gombrich, Ernst H. *Art and Illusion,* second ed. London: Phaidon Press, 1962.

Goodrich, Lloyd. *The Graphic Art of Winslow Homer,* exhibition catalogue. New York: The Museum of Graphic Arts, 1968.

Goodrich, Lloyd. *Winslow Homer,* exhibition catalogue. New York: Whitney Museum of American Art, 1973.

Goodrich, Lloyd. *Winslow Homer in New York State,* exhibition catalogue. New York: Storm King Art Center, 1963.

Goodrich, Lloyd, and Abigail Booth Gerdts. *Winslow Homer in Monochrome,* exhibition catalogue. New York: Knoedler, 1986.

Goodrich, Lloyd , edited and expanded by Abigail Booth Gerdts. *Record of Works by Winslow Homer,* vol. 1: 1846 through 1866, and vol. 2: 1867 through 1876. New York: Spanierman Gallery, 2005.

Goodyear, Frank Henry. "Constructing the National Landscape: Photography and Tourism in Nineteenth-Century America." Ph.D. dissertation, University of Texas at Austin, 1988. Ann Arbor, MI: UMI Dissertation Services, 1999.

Gould, Jean. *Winslow Homer.* New York: Dodd, Mead & Co., 1962.

Graff, Harvey. *Literacy and social development in the West: A Reader.* New York: Cambridge University Press, 1981.

Gruening, Ernest. *These United States: A Symposium.* New York: Boni and Liveright, ca. 1923–24.

Haltman, Kenneth. "Anti-pastoralism in Early Winslow Homer." *Art Bulletin* 80, no. 1 (March 1998): 93–112.

Harrison, Helen A., and Constance Ayers Denne. *Hamptons Bohemia Two Centuries of Artist and Writers on the Beach.* San Francisco: Chronicle Books, 2002.

Harvey, Eleanor Jones. *The Painted Sketch: American Impressions from Nature,*

1830–1880, exhibition catalogue. Dallas: Dallas Museum of Art in association with Harry N. Abrams, 1998.

Harvey, Eleanor Jones. _Thomas Moran and the Spirit of Place_, exhibition brochure. Dallas: Dallas Museum of Art, 2001.

Hassrick, Peter H. _The American West: Out of Myth, into Reality_, exhibition catalogue. Washington DC: Trust for Museum Exhibitions in association with the Mississippi Museum of Art, 2000.

Hendricks, Gordon. _The Life and Works of Winslow Homer_. New York: Harry N. Abrams, 1979.

Hills, Patricia. _The American Frontier: Images and Myths_, exhibition catalogue. New York: The Whitney Museum of Art, 1973.

Hills, Patricia. _Eastman Johnson_, exhibition catalogue. New York: Whitney Museum of Art, 1972.

Hills, Patricia. _The Painters' America: Rural and Urban Life, 1810–1910_. New York: Praeger Publishers, 1974.

Holland, Rupert Sargent. _Story of Prouts Neck_. Prouts Neck, ME: Prouts Neck Association, 1924.

Holly, A. L. "Camps and Tramps about Ktaadn [sic]," _Scribner's Monthly Magazine_, 16 (May 1878): 33–47.

Hooper, Marion. _Life along the Connecticut River_. Brattleboro, VT: Stephen Daye Press, 1939.

Hoopes, Donelson F. _The Beckoning Land; Nature and the American Artist: A Selection of Nineteenth-century Paintings_, exhibition catalogue. Atlanta: High Museum of Art, 1971.

Howat, John K., and John Wilmerding. _Nineteenth-century America: Painting and Sculpture; an Exhibition in Celebration of the Hundredth Anniversary of the Metropolitan Museum of Art, April 16 through September 7, 1970_, exhibition catalogue. New York: Metropolitan Museum of Art, 1970.

Hull, John T. _Handbook, Portland, Old Orchard, Cape Elizabeth, and Casco Bay_. Portland, ME: John T. Hull, 1888.

Hungerford, Edward. "Our Summer Migration, A Social Study," _The Century_, 42, no. 4 (August 1891): 569–76.

Huntington, David C. "Frederic Edwin Church, 1826–1900: Painter of the Adamic New World Myth." Ph.D. dissertation. Yale University, 1960.

Huntington, David C. _Frederic Edwin Church_, exhibition catalogue. Washington, DC: Smithsonian Institution, 1966.

Huntington, David, and Kathleen Pyne.

Quest for Unity: American Art between World's Fairs 1876–1893, exhibition catalogue. Detroit: Detroit Institute of Arts, 1983.

Huth, Hans. _Nature and the American: Three Centuries of Changing Attitudes_. Berkeley, CA: University of California Press, 1957.

Irwin, William. _New Niagara: Tourism, Technology and the Landscape of Niagara Falls, 1776–1917_. University Park, PA: Pennsylvania State University Press, 1996.

James, Henry. _The American Scene, Together with Three Essays from "Portraits of Places."_ New York: Charles Scribner's Sons, 1946.

James, Henry. "On Some Pictures Lately Exhibited." _Galaxy_ 20 (July 1875): 90–94.

Jenkins, Harold F. _Two Points of View: The History of the Parlor Stereoscope_. Uniontown, PA: E.G. Warman Pub., 1973.

Judd, Richard W., Edwin A. Churchill, and Joel W. Eastman, eds. _Maine: The Pine Tree State from Prehistory to the Present_. Orono, ME: University of Maine Press, 1995.

Judge, Mary A. _Winslow Homer_. New York: Crown Publishers, 1986.

Junker, Patricia, and Sarah Burns. _Winslow Homer: Artist and Angler_, exhibition catalogue. Fort Worth, TX: Amon Carter Museum, 2003.

Kelly, Franklin, Nicolai Cikovsky, Jr., Deborah Chotner, and John Davis. _American Paintings of the Nineteenth Century_, exhibition catalogue. Washington, DC: National Gallery of Art, 1996.

Kelly, Franklin, and Gerald L. Carr. _The Early Landscapes of Frederic Edwin Church, 1845–1854_, exhibition catalogue. Fort Worth, TX: Amon Carter Museum, 1987.

Kelly, Franklin, Stephen Jay Gould, James Anthony Ryan, and Debora Rindge. _Frederic Edwin Church_, exhibition catalogue. Washington, DC: National Gallery of Art, 1989.

Kelly, Franklin. _Frederic Edwin Church and the National Landscape_. Washington DC: Smithsonian Institution Press, 1988.

Keyes, Donald D. _The White Mountains: Place and Perceptions_, exhibition catalogue. Hanover, NH: University Press of New England for the University Art Galleries, University of New Hampshire, 1980.

King, Thomas Starr. _Vacation among the Sierras, Yosemite in 1860_. San Francisco: Book Club of California, 1962.

King, Thomas Starr. _The White Hills; Their Legends, Landscape, and Poetry_. Boston: Crosby, Nichols, Lee and Company, 1860.

Kirby, Thomas Ellis. _Catalogue of the A. T. Stewart Collection of Paintings, Sculptures, and Other Objects of Art_, auction catalogue. New York: American Art Association, 1887.

Koja, Stephan, ed. _America: The New World in Nineteenth-century Painting_, exhibition catalogue. Munich: Prestel Verlag, 1999.

Kornhauser, Elizabeth Mankin. _American Paintings before 1945 in the Wadsworth Athenaeum_, exhibition catalogue. New Haven: Yale University Press, 1996.

Kornhauser, Elizabeth Mankin. "Daniel Wadsworth and the Hudson River School," _Hog River Journal_ 1, no. 1 (November–January 2005): 18–23.

Kotik, Charlotta. _Spirit of Niagara: Selected views of Niagara Falls from Hekmian Bequest in the Permanent collection of the Albright-Knox Art Gallery: May 15–September 8, 1980_. Buffalo, New York: Buffalo Fine Arts Academy, 1980.

Kushner, Marilyn S., Barbara Dayer Gallati, and Linda S. Ferber. _Winslow Homer: Illustrating America_. New York: George Braziller in association with the Brooklyn Museum of Art, 2000.

Lamb, Martha J. _The Homes of America_. New York: D. Appleton, 1879.

Lane, Christopher W. _Impressions of Niagara: The Charles Rand Penney Collection of Prints of Niagara Falls and the Niagara River from the Sixteenth to the Early Twentieth Century_. Philadelphia: Philadelphia Print Shop, 1993.

Larsen, Ellouise Baker. _American Historical Views on Staffordshire China_. New York: Dover Publications, 1975.

Laughton, Rodney. _Scarborough_. Images of America. Portsmouth, NH: Arcadia, 1996.

Laughton, Rodney. _Scarborough in the Twentieth Century, Images of America_. Portsmouth, NH: Arcadia, 2004.

Lears, T. J. Jackson. _No Place of Grace: Antimodernism and the Transformation of American Culture, 1880–1920_. Chicago: University of Chicago Press, 1981.

Lindgren, James M. _Preserving Historic New England: Preservation, Progressivism, and the Remaking of Memory_. Oxford: Oxford University Press, 1995.

Maddox, Kenneth W. _In Search of the Picturesque: Nineteenth-century Images of Industry along the Hudson_

River Valley. Poughkeepsie, NY: Bard College, 1983.

Maine, Present Condition of the State, its Agricultural, Financial, Commercial, and Manufacturing Development. Advantages of the State as a Summer Resort. Augusta, ME: Kennebec Journal Book Print, 1885.

Mandel, Patricia C. F. *Fair Wilderness: American Paintings in the Collection of the Adirondack Museum,* exhibition catalogue. Blue Mountain Lake, NY: The Adirondack Museum, 1990.

Marling, Karal Ann. *George Washington Slept Here: Colonial Revivals and American Culture, 1876–1976.* Cambridge, MA: Harvard University Press, 1988.

Marx, Leo. *The Machine in the Garden: Technology and the Pastoral Ideal in America.* New York: Oxford University Press, 1964.

Matheson, Susan B. *Art for Yale: A History of the Yale University Art Gallery.* New Haven: Yale University Art Gallery, 2001.

Mayor, A. Hyatt, and Mark Davis. *American Art at the Century.* New York: The Century Association, 1977.

Mazlish, Anne, ed. *The Tracy Log Book, 1855, a Month in Summer.* Bar Harbor, ME: Acadia Publishing Company, 1997.

McClintock, Ann. *Imperial Leather: Race, Gender, and Sexuality in the Colonial Contest.* New York: Routledge, 1995.

McClinton, Katharine Morrison. *The Chromolithographs of Louis Prang.* New York: C. N. Potter; Distributed by Crown Publishers, 1973.

McGrath, Robert, and Barbara MacAdam. *"A Sweet Foretaste of Heaven": Artists in the White Mountains 1830–1930,* exhibition catalogue. Hanover, NH: The Hood Museum of Art, 1988.

McKinsey, Elizabeth R. *Niagara Falls: Icon of the American Sublime.* Cambridge, New York: Cambridge University Press, 1985.

McMurray, Sally. "City Parlor, Country Sitting Room: Rural Vernacular Design and the American Parlor, 1840–1900." *Winterthur Portfolio* 20 (Winter 1985): 261–88.

Meixner, Laura L. *French Realist Painting and the Critique of American Society, 1865–1900.* Cambridge and New York: Cambridge University Press, 1995.

Miller, Angela L. *The Empire of the Eye: Landscape Representation and American Cultural Politics, 1825–1875.* Ithaca, NY: Cornell University Press, 1993.

Morand, Anne. *Splendors of the American West: Thomas Moran's Art of the Grand Canyon and Yellowstone,* exhi-bition catalogue. Birmingham, AL: Birmingham Museum of Art; Seattle: distributed by the University of Washington Press, 1990.

Morand, Anne. *Thomas Moran, the Field Sketches, 1856–1923.* Norman, OK: University of Oklahoma Press, 1996.

Morrin, Peter, and Eric Zafran. *American Landscape Paintings: Selections from the High Museum of Art, Atlanta,* ex-hibition catalogue. Atlanta: High Museum of Art, 1981.

Moulton, Augustus Freedom. *Old Prouts Neck.* Portland, ME: Marks Printing House, 1924.

Murphy, Alexandra. *Winslow Homer in the Clark Collection,* exhibition catalogue. With contributions by Rafael Fernandez and Jennifer Gordon. Williamstown, MA: Sterling and Francine Clark Art Institute, 1986.

Murray, William H. H. *Adventures in the Wilderness: or Camp-Life in the Adirondacks.* Boston: Fields, Osgood, & Co., 1869.

Myers, Kenneth. "Art and Commerce in Jacksonian America: The Steamboat Albany Collection." *Art Bulletin* 82, no. 3 (September 2000): 503–28.

Myers, Kenneth. *The Catskills: Painters, Writers and Tourists in the Mountains 1820–1895.* Yonkers, NY: The Hudson River Museum of Westchester, 1897.

Nassau County Museum of Fine Art. *William Cullen Bryant and the Hudson River School of Landscape Painting,* exhibition catalogue. Roslyn, NY: Nassau County Museum of Fine Art, 1981.

Newhall, Beaumont. *Photography: Essays & Images.* New York: Museum of Modern Art, 1980.

Newhall, Nancy, ed. *Time in New England.* New York: Aperture, Inc., 1950.

New-York Historical Society. *American Landscape and Genre Paintings in the Collection of the New-York Historical Society: A Catalog of the Collection, Including Historical, Narrative, and Marine Art,* exhibition catalogue. Boston: G. K. Hall in association with the New-York Historical Society, 1982.

New York State Agricultural Society. *Transactions of the N.Y. State Agricultural Society for 1852.* New York: The Society, 1853.

New York (State). State Survey. *Special Report of New York State Survey on the Preservation of the Scenery of Niagara Falls, and Fourth Annual Report on the Triangulation of the State, for the Year 1879. James T. Gardner, Director.* Albany, NY: C. Van Benthuysen & Sons, 1880.

Nickel, Douglas R. *Carleton Watkins: The Art of Perception,* exhibition cata-logue. San Francisco: San Francisco Museum of Modern Art, 1999.

Nichols, George Ward. "Mount Desert," *Harper's New Monthly Magazine,* 45, no. 267 (August 1872): 321–41.

Nicoll, Jessica F. *The Allure of the Maine Coast: Robert Henri and His Circle, 1903–1918.* Portland, ME: Portland Museum of Art, 1995.

Novak, Barbara. *Nature and Culture: American Landscape, 1825–1865.* New York: Oxford University Press, 1980.

Nutting, Wallace. *Massachusetts Beautiful.* Framingham, MA: Old America Company Publishers, 1923.

Nylander, Jane C. *Our Own Snug Fireside.* New York: Alfred A. Knopf, 1999.

Palmquist, Peter. *Carleton E. Watkins: Photographer of the American West,* exhibition catalogue. Albuquerque, NM: published for the Amon Carter Museum by the University of New Mexico Press, 1983.

Parsons, Horatio A. *Book of Niagara Falls,* 3rd ed. Buffalo, NY: Oliver G. Steele, 1836.

Pennell, Joseph. *Modern Illustration.* London and New York: G. Bell & Sons, 1895.

Phillips, Sandra S., and Linda Weintraub. *Charmed Places: Hudson River Artists and Their Houses, Studios, and Vistas,* exhibition catalogue. New York: Edith C. Blum Art Institute, Bard College, and Vassar College Art Gallery in association with Harry N. Abrams, 1988.

Pisano, Ronald. *Idle Hours: Americans at Leisure 1865–1914.* Boston, Toronto, and London: Little, Brown, and Company, 1988.

Pisano, Ronald. *The Long Island Landscape, 1865–1914: The Halcyon Years,* exhibition catalogue. Southampton, NY: Parrish Art Museum, 1981.

Pisano, Ronald. *The Long Island Landscape, 1914–1946: The Transitional Years.* Southampton, NY: Parrish Art Museum, 1981.

Pisano, Ronald. *Long Island Landscape Painting, 1865–1920.* Boston, Toronto, and London: Little, Brown, and Company, 1985.

Pisano, Ronald. "The Tile Club, 1877–1887," *The Magazine Antiques* (February 2000): 306–13.

Pisano, Ronald. *The Tile Club and the Aesthetic Movement in America.* New York: Harry N. Abrams, Inc., 1999.

Poggioli, Renato. *Oaten Flute: Essays on Pastoral Poetry and the Pastoral Ideal.* Cambridge, MA: Harvard University Press, 1975.

Prevots, Naima. *American Pageantry: A*

Movement for Art and Democracy. Ann Arbor, MI: UMI Research Press, 1990.

Pringle, Allen. "Thomas Moran: Picturesque Canada and the Quest for a Canadian National Landscape Theme." *Imprint* 14, no. 1 (Spring 1989): 12–21.

Prouts Neck Association. *Century Loan Exhibition as a Memorial to Winslow Homer*, exhibition catalogue. Prouts Neck, ME: Prouts Neck Association, 1936.

Prouts Neck Association. *Prouts Then and Now, 1888-1970*. Prouts Neck, ME: Prouts Neck Association, 1971.

Pyne, Kathleen. *Art and the Higher Life: Painting and Evolutionary Thought in Late Nineteenth-century America*. Austin, TX: University of Texas Press, 1996.

Quinn, Vernon. *Beautiful America*. New York: Frederick A. Stokes Company, 1923.

Rainey, Sue. *Creating Picturesque America: Monument to the Natural and Cultural Landscape*. Nashville, TN: Vanderbilt University Press, 1994.

Rainey, Sue. *Shaping the Landscape Image, 1865–1910: John Douglas Woodward*, exhibition catalogue. Charlottesville, VA: Bayly Art Museum, University of Virginia, 1997.

"A Residence at Prouts Neck, Maine," *Scientific American Building Monthly* (July 1904): 17.

Revie, Linda L. *Niagara Companion: Explorers, Artists and Writers at the Falls, from Discovery through the Twentieth Century*. Waterloo, Ontario: Wilfrid Laurier University Press, 2003.

Reynolds, Jock, Susan C. Faxon, and Paul Metcalf. *Winslow Homer at the Addison*, exhibition catalogue. Andover, MA: Addison Gallery of American Art, 1990.

Rhode Island School of Design Museum of Art. *Selection VII: American Paintings from the Museum's Collection, ca. 1800–1930*, exhibition catalogue. Providence, RI: Museum of Art, Rhode Island School of Design, 1977.

Robinson, Christine T., and John R. Stilgoe, Ellwood C. Parry III, and Frances F. Dunwell. *Thomas Cole: Drawn to Nature*, exhibition catalogue. Albany, NY: Albany Institute of History and Art, 1993.

Robertson, Bruce. *Reckoning with Winslow Homer: His Late Paintings and Their Influence*. Cleveland, OH: The Cleveland Museum of Art, 1990.

Rockwell, Rev. Charles. *The Catskill Mountains and the Region Around.*

New York: Taintor, 1867.

Rossano, Geoffrey, ed. *Creating a Dignified Past: Museums and the Colonial Revival*. Cherry Hill, NJ: Rowman Publishers, Inc., 1991.

Rourke, Constance. *The Roots of American Culture, and Other Essays*. New York: Harcourt, Brace and Company, 1942.

Ryan, James Anthony. *Frederic Church's Olana: Architecture and Landscape as Art*. New York: Black Dome Press Corp., 2001.

Sandweiss, Martha A. *Print the Legend: Photography and the American West*. New Haven: Yale University Press, 2002.

Schlereth, Thomas J. *Victorian America: Transformations in Everyday Life*. New York: HarperCollins Publishers, 1991.

Scully, Vincent Joseph. *The Shingle Style and the Stick Style: Architectural Theory and Design from Downing to the Origins of Wright*. New Haven: Yale University Press, 1971.

Sears, John F. *Sacred Places: American Tourist Attractions in the Nineteenth Century*. New York: Oxford University Press, 1989.

Seale, William. *The Tasteful Interlude, American Interiors through the Camera's Eye, 1860–1917*. New York: Praeger Publications, 1975.

Seibel, George A. *Niagara Portage Road: A History of the Portage on the West Bank of the Niagara River*. Niagara Falls, Ontario: City of Niagara Falls, Canada, 1990.

Seibel, George A., project coordinator. *300 years since Father Hennepin: Niagara Falls in Art, 1678–1978*. Niagara Falls, Ontario: Niagara Falls Heritage Foundation, ca. 1978.

Sessions, Gene, ed. *Celebrating a Century of Granite Art*. Montpelier, VT: T. W. Wood Art Gallery, 1989.

Sheldon, G.W. *Hours with Art and Artists*. New York: D. Appleton, 1882.

Shettleworth, Earle G., Jr., and John Calvin Stevens II. *John Calvin Stevens Domestic Architecture, 1890–1930*. Scarborough, ME: Harp Publications, 1990.

Shettleworth, Earle G., Jr., and William Barry, "Brother Artists John Calvin Stevens and Winslow Homer, " *Bowdoin Magazine* 61, no. 4 (Fall 1988):16–19.

Shettleworth, Earle G., Jr., and Lydia B. Vandenbergh. *Images of America, Mount Desert Island, Somesville, Southwest Harbor, and Northeast Harbor*. Charleston, SC: Arcadia Publishing Co., 2001.

Shockley, Susan E., Sarah Burns, and Marie Louden-Hanes. *Winslow*

Homer, an American Genius at the Parthenon: The Move Towards Abstraction, exhibition catalogue. Nashville, TN: The Parthenon, 2000.

Simpson, Marc, Sally Mills, and Patricia Hills. *Eastman Johnson: The Cranberry Harvest, Island of Nantucket*, exhibition catalogue. San Diego: Timken Art Gallery, 1990.

Smith, Henry Nash, and William M. Gibson, eds. *Mark Twain-Howells Letters: The Correspondence of Samuel L. Clemens and William D. Howells, 1872–1910*. Cambridge, MA: Belknap Press of Harvard University Press, 1960.

Smith-Rosenberg, Carroll, *Disorderly Conduct: Visions of Gender in Victorian America*. New York: Alfred A. Knopf, 1985.

Springer, Haskell, ed. *America and the Sea: A Literary History*. Athens, GA: The University of Georgia Press, 1995.

Stebbins, Theodore E., Jr., and Galina Gorokhoff. *A Checklist of American Paintings at Yale University*. New Haven: Yale University Art Gallery, 1982.

Stebbins, Theodore E., Jr. *Close Observation: Selected Oil Sketches by Frederic E. Church, from the Collections of the Cooper-Hewitt Museum, the Smithsonian Institution's National Museum of Design*, exhibition catalogue. Washington, DC: Smithsonian Institution Press, 1978.

Stebbins, Theodore E., Jr. *Martin Johnson Heade*, exhibition catalogue. Boston: Museum of Fine Arts, 1999.

Stebbins, Theodore E., Jr. *The Life and Works of Martin Johnson Heade*. New Haven: Yale University Press, 1975.

Stebbins, Theodore E., Jr. *The Lure of Italy: American Artists and the Italian Experience, 1760–1914*, exhibition catalogue. New York: Harry N. Abrams, Inc., for the Museum of Fine Arts, Boston, 1992.

Stebbins, Theodore E., Jr., Carol Troyen, and Trevor J. Fairbrother. *A New World: Masterpieces of American Painting, 1760–1910*, exhibition catalogue. Boston: Museum of Fine Arts, 1983.

Stoddard, Seneca Ray. *The Adirondacks Illustrated*. Albany, NY: published by the author, 1874.

Sturges, Hollister, ed. *The Rural Vision: France and America in the Late Nineteenth Century*. Omaha, NE: Joslyn Art Museum, 1987.

Sutherland, Daniel E. *The Expansion of Everyday Life, 1860–1876*. New York: Harper & Row 1989.

Sweetser, Charles H. *Book of Summer*

Resorts. New York: *Evening Mail* office, 1868.

Sweetser, Moses F. *Here and There in New England and Canada: Among the Mountains.* Boston: Boston and Maine Railroad, 1889.

Tatham, David. *Winslow Homer Drawings, 1875–1885: Houghton Farm to Prouts Neck,* exhibition catalogue. Syracuse, NY: Joe and Emily Lowe Art Gallery, School of Art, College of the Visual and Performing Arts, Syracuse University, 1979.

Tatham, David. *Winslow Homer in the 1880s: Watercolors, Drawings, and Etchings,* exhibition catalogue. Syracuse, NY: Everson Museum of Art, 1983.

Tatham, David. *Winslow Homer in the Adirondacks.* Syracuse, NY: Syracuse University Press, 1996.

Tatham, David. *Winslow Homer and the Illustrated Book.* Syracuse, NY: Syracuse University Press, 1992.

Tatham, David. "Winslow Homer in the Mountains." *Appalachia* 36 (June 15, 1966): 73–90.

Tatham, David. "Winslow Homer at the North Woods Club," pp. 114-128 in Nicolai Cikovsky, Jr. editor. *Winslow Homer, a Symposium.* Washington, DC: National Gallery of Art; Hanover and London: University Press of New England, 1990.

Tatham, David. *Winslow Homer and the Pictorial Press.* Syracuse, NY: Syracuse University Press, 2003.

Tatham, David. *Winslow Homer Prints from Harper's Weekly,* exhibition catalogue. Hamilton, NY: Gallery Association of New York State, 1977–79.

Taylor, Joshua Charles. *America as Art.* Washington, DC: Smithsonian Institution Press, 1976.

Thaxter, Celia. *Among the Isles of Shoals.* Boston: J. R. Osgood and Co., 1873.

Thomas Gilcrease Institute of American History and Art. *The Gilcrease Comes to Scottsdale: Selections from the Permanent Collection of the Thomas Gilcrease Institute of American History and Art, Tulsa, Oklahoma.* Scottsdale, AZ: Fleischer Museum, 1990.

Tolles, Bryant F. *The Grand Resort Hotels of the White Mountains: A Vanishing Architectural Legacy.* Boston: David R. Godine, 1998.

Tolles, Bryant F. *Summer Cottages in the White Mountains: The Architecture of Leisure and Recreation, 1870–1930.* Hanover, NH, and London: University Press of New England, 2000.

Truettner, William H. *The West as America: Reinterpreting Images of the Frontier, 1820–1920,* exhibition catalogue.

Washington, DC: Smithsonian Institution Press for the National Museum of American Art, 1991.

Treuttner, William H. and Roger Stein. *Picturing Old New England, Image and Memory.* Washington, DC: National Museum of American Art, Smithsonian Institution; New Haven and London: Yale University Press, 1999.

Henry Tuckerman, *Book of the Artists: American Artist Life.* 2nd ed. New York: J. F. Carr, 1966 [1867].

United States Bureau of the Census. *Historical Statistics of the United States: Colonial Times to 1970.* Washington DC: The Bureau, U.S. Govt. Printing Office, 1976.

Van Zandt, Roland. *The Catskill Mountain House.* New Brunswick, NJ: Rutgers University Press, 1966.

Vanderbilt, Kermit. *Charles Eliot Norton: Apostle of Culture in a Democracy.* Cambridge, MA: The Belknap Press of Harvard University, 1959.

Von Helmholtz, Hermann. *Physiologischen Optik.* New York: Dover, reprint, 1962 [1867].

Voorsanger, Catherine Hoover, and Howat, John K. *Art and the Empire City: New York, 1825–1861.* New York: Metropolitan Museum of Art; New Haven: Yale University Press, 2000.

Waring, George E. "Life and Work of the Eastern Farmer," *Atlantic Monthly* 39 (May 1877): 584–95.

Warner, Charles Dudley. *Paintings by Frederic Edwin Church: Special Exhibition at the Metropolitan Museum of Art, May 28th to October 13th,* exhibition catalogue. New York: The Metropolitan Museum of Art, 1900.

Weber, Bruce, and William H. Gerdts. *In Nature's Ways: American Landscape Painting of the Late Nineteenth Century.* West Palm Beach, FL.: Norton Gallery of Art, 1987.

Weiss, Thomas, "Tourism in American before World War II," *The Journal of Economic History,* 64, no. 2 (June 2004): 289–327.

Wilkins, Thurman. *Thomas Moran, Artist of the Mountains.* Norman, OK: University of Oklahoma Press, 1966.

Williams, Chase & Co. *History of Penobscot County, Maine; with Illustrations and Biographical Sketches.* Cleveland: Williams, Chase & Co., 1882.

Willis, Nathaniel Parker. *American Scenery; or Land, Lake, and River Illustrations of a Transatlantic Nature.* 2 vols. London: George Virtue, 1840.

Wilmerding, John. *American Views: Essays on American Art.* Princeton, NJ:

Princeton University Press, 1991.

Wilmerding, John. *The Artist's Mount Desert, American Painters on the Maine Coast.* Princeton, NJ: Princeton University Press, 1994.

Wilmerding, John. *Winslow Homer.* New York: Praeger Publishers, 1972.

Wilmerding, John. *Winslow Homer: The Charles Shipman Payson Gift to the Portland Museum of Art, Portland, Maine,* exhibition catalogue. New York: Coe Kerr Gallery, 1981.

Wilmerding, John, and Elaine Evans Dee. *Winslow Homer, 1836–1910, A Selection from the Cooper-Hewitt Collection Smithsonian Institution,* exhibition catalogue. Washington, DC: Smithsonian Institution Press, 1972.

Wilmerding, John, and Linda Ayers. *Winslow Homer in the 1870s: Selections from the Valentine-Pulsifer Collection,* exhibition catalogue. Hanover, NH: The University Press of New England for the Art Museum, Princeton University, 1990.

Wilton, Andrew, and Tim Barringer. *American Sublime: Landscape Painting in the United States, 1820–1880,* exhibition catalogue. London: Tate, 2002.

Winthrop, Theodore. *Life in the Open Air.* Boston: Ticknor and Fields, 1863.

Worman, Eugene C., Jr. "American Scenery and the Dating of its Bartlett Prints, Part 1." *Imprint* 12, no. 2 (Autumn 1987): 2–11; "Part 2," 13, no. 1 (Spring 1988): 22–27.

Yale University Art Gallery. *A Private View: American Paintings from the Manoogian Collection,* exhibition catalogue. New Haven: Yale University Art Gallery; Detroit, MI: Detroit Institute of Arts, 1993.

PLATE LIST

Bequest of Mrs. Mary Mandeville
Johnston, 1914 (14.102.245)

FIGURE 29
After William Henry Bartlett
(British, 1809–1854)
*View from the Mountain House,
on the Catskills*, from N. P. Willis,
*American Scenery; or Land,
Lake, and River; Illustrations
of Transatlantic Nature*, 1840
Published by George Virtue,
London, England
Steel engraving on white wove paper
10½ x 8¼ in. (267 x 210 mm)
Courtesy of Smithsonian Institution
Libraries, Washington, DC

FIGURE 30
Frederic Edwin Church
(American, 1826–1900)
*View of the Catskills from
the Hudson River Valley*, ca. 1844
Brush and oil paint, graphite
on heavy paperboard
7 ¹⁵⁄₁₆ x 11⅞ in. (201 x 302 mm)
Cooper-Hewitt, National Design
Museum, Smithsonian Institution
Gift of Louis P. Church,
1917-4-333

FIGURE 31
Frederic Edwin Church
(American, 1826–1900)
View of the Catskill Mountain House,
July 1844
Graphite on white paper
10 ¹³⁄₁₆ x 15¼ in. (258 x 388 mm)
Cooper-Hewitt, National Design
Museum, Smithsonian Institution
Gift of Louis P. Church, 1917-4-1385

FIGURE 32
Advertising broadside,
Catskill Mountain House, 1851
Wood engraving on newsprint
9¾ x 6⅛ in. (246 x 156 mm)
Collection of Vedder Research
Library, Greene County Historical
Society

FIGURE 33
Stereoview of Kaaterskill Falls, 1871
Albumen silver print mounted
on cardboard
6 ¹³⁄₁₆ x 3¼ in. (173 x 83 mm)
Collection of Vedder Research
Library, Greene County Historical
Society

FIGURE 34
After Winslow Homer
(American, 1836–1910)
*Under the Falls, Catskill
Mountains*, in *Harper's Weekly*,
September 14, 1872
Wood engraving on paper
10¼ x 16 in. (260 x 406 mm)
Cooper-Hewitt, National Design
Museum, Smithsonian Institution
Gift of John Goldsmith Phillips, Jr.,
1947-4-18

FIGURE 35
Thomas Nast (American, 1840–1902)
Sketches among the Catskills,
in *Harper's Weekly*, July 21, 1866
Wood engraving on paper
13⅛ x 20¼ in. (346 x 527 mm)
Collection of Bronck Museum,
Greene County Historical Society

FIGURE 36
Frederic Edwin Church
(American, 1826–1900)
Olana from the Southwest, ca. 1872
Brush and oil paint on thin
paperboard
12¹⁄₁₆ x 9⁹⁄₁₆ in. (306 x 243 mm)
Cooper-Hewitt, National Design
Museum, Smithsonian Institution
Gift of Louis P. Church, 1917-4-666

FIGURE 37
Frederic Edwin Church
(American, 1826–1900)
Sunset across the Hudson Valley,
June 1870
Brush and oil paint,
graphite on paperboard
11⅛ x 15¼ in. (282 x 387 mm)
Cooper-Hewitt, National Design
Museum, Smithsonian Institution
Gift of Louis P. Church, 1917-4-582-a

FIGURE 38
J. F. Murphy
Artists at the Ausable River, 1874
Photograph
5 x 3 in. (127 x 76 mm)
Courtesy of The Adirondack Museum

FIGURE 39
J. P. Davis after Winslow Homer
(American 1836–1910)
Trapping in the Adirondacks,
in *Every Saturday*, December 24, 1870
Wood engraving
9¹³⁄₁₆ x 13⁷⁄₁₆ in. (250 x 342 mm)
Cooper-Hewitt, National Design
Museum, Smithsonian Institution
Museum purchase from Friends of
the Museum Fund, 1938-65-1

FIGURE 40
F.L. after Winslow Homer
(American, 1836–1910)
*Deer-stalking in the Adirondacks
in Winter*, in *Every Saturday*,
January 21, 1871
Wood engraving
10⁹⁄₁₆ x 14¼ in. (269 x 375 mm)
Cooper-Hewitt, National Design
Museum, Smithsonian Institution
Gift of Cora Wilson, 1939-70-1

FIGURE 41
Winslow Homer
(American, 1836–1910)
*Landscape with Deer in a Morning
Haze*, ca. 1892
Brush and watercolor, graphite
on thick white wove watercolor paper
14½ x 21¹⁄₁₆ in. (368 x 535 mm)
Cooper-Hewitt, National Design

Museum, Smithsonian Institution
Gift of Charles Savage Homer, Jr.,
1913-18-3

FIGURE 42
Winslow Homer
(American, 1836–1910)
Valley and Hillside, 1889–95
Brush and watercolor, graphite on off-
white wove paper
13¹⁵⁄₁₆ x 19¹⁵⁄₁₆ in. (354 x 507 mm)
Cooper-Hewitt, National Design
Museum, Smithsonian Institution
Gift of Charles Savage Homer, Jr.,
1912-12-185

FIGURE 43
James Smillie (American, 1807–1885)
after John Frederick Kensett
(American, 1816–1872)
*Mt. Washington from the Valley
of Conway*, 1851
Steel engraving
5 x 7 in. (127 x 178 mm)
Courtesy of American
Antiquarian Society

FIGURE 44
Daniel Huntington
(American, 1816–1906)
Artists Sketching at Chocorua Pond,
September 12, 1854
Graphite on cream paper
10³⁄₁₆ x 14 in. (259 x 355 mm)
Cooper-Hewitt, National Design
Museum, Smithsonian Institution
Bequest of Erskine Hewitt, 1942-50-161

FIGURE 45
Thomas Cole (American, 1801–1848)
*A View of the Mountain Pass
Called the Notch of the White
Mountains (Crawford Notch)*, 1839
Oil on canvas
40³⁄₁₆ x 61⁵⁄₁₆ in. (1020 x 1558 mm)
National Gallery of Art,
Washington, DC
Andrew W. Mellon Fund

FIGURE 46
Franklin Leavitt
*Leavitt's Map with Views
of the White Mountains,
New Hampshire*, 1888
Published by Victor Leavitt,
Lancaster, New Hampshire
Wood engraving on paper
24½ x 34½ in. (622 x 876 mm)
Courtesy of Bryant F. Tolles, Jr.

FIGURE 47
Prospectus, Profile House, ca. 1880
Wood engraving on paper
7 x 5 in. (178 x 127 mm)
Courtesy of Bryant F. Tolles, Jr.

FIGURE 48
Francis Hopkinson Smith
(American, 1838–1915)
Old Man of the Mountain,
August 1876
Charcoal, black and white
chalk on gray paper

22 7/16 x 13 3/16 in (570 x 335 mm)
Cooper-Hewitt, National Design
Museum, Smithsonian Institution
Gift of Mrs. F. Hopkinson Smith,
1923-41-1

FIGURE 49
Francis Hopkinson Smith
(American, 1838–1915)
Fisherman on a Rock,
September 8, 1878
Charcoal, black and white
chalk on gray paper
14 7/16 x 22 9/16 in. (366 x 573 mm)
Cooper-Hewitt, National Design
Museum, Smithsonian Institution
Gift of Mrs. F. Hopkinson Smith,
1923-41-3

FIGURE 50
Tradecard, Mount Washington
Railway, 1879
Lithograph and photomechanical
reproduction on heavy wove paper
3 x 5 in. (76 x 127 mm)
Courtesy of Bryant F. Tolles, Jr.

FIGURE 51
Winslow Homer
(American, 1836–1910)
The Bridle Path, White Mountains,
ca. 1868
Oil on canvas
24 1/8 x 38 in. (613 x 965 mm)
Sterling and Francine Clark
Art Institute, Williamstown,
Massachusetts

FIGURE 52
Winslow Homer
(American, 1836–1910)
Mount Washington, 1869
Oil on canvas
16 1/4 x 24 5/16 in. (413 x 618 mm)
The Art Institute of Chicago
Gift of Mrs. Richard E. Danielson
and Mrs. Chauncey McCormick,
1951.313

FIGURE 53
Winslow Homer
(American, 1836–1910)
*Study for "The Bridle Path,
White Mountains,"* August 24, 1868
Graphite on off-white wove paper
6 5/8 x 9 9/16 in. (168 x 243 mm)
Cooper-Hewitt, National Design
Museum, Smithsonian Institution
Gift of Charles Savage Homer, Jr.,
1912-12-221

FIGURE 54
Winslow Homer
(American, 1836–1910)
*Study for "Mount Washington"
and "The Summit of Mt. Washington,"*
1869
Graphite on paper
5 1/16 x 9 3/4 in. (129 x 248 mm)
Cooper-Hewitt, National
Design Museum, Smithsonian
Institution

Gift of Charles Savage Homer, Jr.,
1912-12-127

FIGURE 55
After Winslow Homer
(American, 1836–1910)
The Summit of Mt. Washington,
in *Harper's Weekly*, July 10, 1869
Wood engraving on white wove paper
9 x 13 3/4 in. (229 x 349 mm)
Print Collection, Miriam &
Ira D. Wallach Division of Art,
Prints & Photographs, The New York
Public Library, Astor, Lenox and
Tilden Foundations

FIGURE 56
Anonymous
Tip Top House, Mt. Washington,
not dated
Published by John P. Soule,
Boston, Massachusetts
Albumen silver print mounted
on cardboard
3 x 6 1/2 in. (76 x 165 mm)
Courtesy of Bryant F. Tolles, Jr.

FIGURE 57
Winslow Homer
(American, 1836–1910)
White Mountain Wagon, 1869
Oil on wood panel
11 3/4 x 15 13/16 in. (298 x 402 mm)
Cooper-Hewitt, National Design
Museum, Smithsonian Institution
Gift of Mrs. Charles Savage Homer,
Jr., 1918-20-9

FIGURE 58
Anonymous
Summit of Mt. Washington
and Glen House Stage, not dated
Published by B. W. Kilborn,
Littleton, New Hampshire
Albumen silver print mounted
on cardboard
3 x 6 1/2 in. (76 x 165 mm)
Courtesy of Bryant F. Tolles, Jr.

FIGURE 59
Winslow Homer
(American, 1836–1910)
Mountain Climber Resting, 1869–70
Oil on canvas
10 3/4 x 14 3/4 in. (273 x 375 mm)
Private Collection, Washington, DC

FIGURE 60
Winslow Homer
(American, 1836–1910)
*Study for "Mountain Climber
Resting,"* 1868–69
Black and white crayon on brown laid
paper
7 11/16 x 13 3/4 in. (195 x 350 mm)
Cooper-Hewitt, National Design
Museum, Smithsonian Institution
Gift of Charles Savage Homer, Jr.,
1912-12-98

FIGURE 61
Tradecard: Boston & Maine Depot;
Boston and Maine Railroad, not dated

Published by Forbes Co.,
Boston, Massachusetts
Lithograph on paper
3 5/16 x 4 9/16 in. (84 x 116 mm)
Warshaw Collection of Business
Americana—Railroads, Archives
Center, National Museum of
American History, Behring Center,
Smithsonian Institution

FIGURE 62
Anonymous
Checkley House, before 1907
Chromolithograph postcard
3 5/16 x 5 7/16 in. (84 x 138 mm)
Maine Historic Preservation
Commission

FIGURE 63
Anonymous
Jocelyn House, 1890s
Chromolithograph postcard
3 5/16 x 5 7/16 in. (84 x 138 mm)
Maine Historic Preservation
Commission

FIGURE 64
Winslow Homer
(American, 1836–1910)
Junkins House, July 1875
Oil on canvas
15 11/16 x 22 9/16 in. (398 x 573 mm)
Cooper-Hewitt, National
Design Museum, Smithsonian
Institution
Gift of Mrs. Charles Savage Homer,
Jr., 1918-20-11

FIGURE 65
Unknown
Winslow Homer on the
Gallery of his Studio,
Prouts Neck, Maine, ca. 1884
Gelatin silver print
4 7/16 x 6 1/16 in. (112 x 154 mm)
Bowdoin College Museum of Art,
Brunswick, Maine, Gift of the
Homer Family

FIGURE 66
William Trost Richards
(American, 1833–1905)
*Mackeral Cove, Conanicut Island,
Rhode Island*, 1877
Pen and brush, watercolor
on heavy, gray wove paper
31 3/4 x 41 3/4 in. (806 x 1060 mm)
Cooper-Hewitt, National
Design Museum, Smithsonian
Institution
Gift of The National Academy of
Design, 1953-179-1

FIGURE 67
Winslow Homer
(American, 1836–1910)
The Life Line, 1884
Oil on canvas
29 x 45 in. (737 x 1143 mm)
Philadelphia Art Museum,
George W. Elkins Collection,
1924

FIGURE 68
Winslow Homer
(American, 1836–1910)
The Herring Net, 1885
Oil on canvas
30⅛ x 48⅛ in. (765 x 1229 mm)
Art Institute of Chicago, Mr. and
Mrs. Martin A. Ryerson Collection,
1937.1039

FIGURE 69
Winslow Homer
(American, 1836–1910)
Study for "The Life Line," 1882–83
Black and white chalk on cream
wove paper, lined in muslin
17¹¹⁄₁₆ x 11 in. (449 x 280 mm)
Cooper-Hewitt, National Design
Museum, Smithsonian Institution
Gift of Charles Savage Homer Jr.,
1912-12-34

FIGURE 70
Winslow Homer
(American, 1836–1910)
Coast of Maine, 1893
Oil on canvas
24 x 30 in. (610 x 762 mm)
Art Institute of Chicago, The Arthur
Jerome Eddy Memorial Collection,
1931.505

FIGURE 71
Winslow Homer
(American, 1836–1910)
Tree Roots on a Hillside, Prouts Neck,
1883
Charcoal and white gouache
on grey laid paper
11¹¹⁄₁₆ x 23⅜ in. (297 x 593 mm)
Cooper-Hewitt, National Design
Museum, Smithsonian Institution
Gift of Charles Savage Homer, Jr.,
1912-12-91

FIGURE 72
Winslow Homer
(American, 1836–1910)
*The Artist's Studio in an Afternoon
Fog*, 1894
Oil on canvas
24 x 30¼ in. (610 x 768 mm)
Memorial Art Gallery of the
University of Rochester, R. T. Miller
Fund

FIGURE 73
Frederic Edwin Church
(American, 1826–1900)
Coast at Mount Desert (Sand Beach),
ca. 1850
Brush and oil, graphite over
red ground on grey paperboard
12 x 16¹⁄₁₆ in. (305 x 408 mm)
Cooper-Hewitt, National Design
Museum, Smithsonian Institution
Gift of Louis P. Church, 1917-4-645

FIGURE 74
Frederic Edwin Church
(American, 1826–1900)
Schoodic Peninsula from Mount

Desert at Sunrise, 1850–55
Brush and oil paint on paperboard
8¹⁵⁄₁₆ x 14 in. (227 x 355 mm)
Cooper-Hewitt, National Design
Museum, Smithsonian Institution
Gift of Louis P. Church, 1917-4-332

FIGURE 75
Frederic Edwin Church
(American, 1826–1900)
*Surf Pounding against the Rocky
Maine Coast*, ca. 1862
Brush and oil paint, graphite,
on thin paperboard
11¹³⁄₁₆ x 19¹⁵⁄₁₆ in. (300 x 507 mm)
Cooper-Hewitt, National Design
Museum, Smithsonian Institution
Gift of Louis P. Church, 1917-4-1324

FIGURE 76
Frederic Edwin Church
(American, 1826–1900)
*Coast Scene, Mount Desert
(Sunrise off the Maine Coast)*, 1863
Oil on canvas
36⅛ x 48 in. (918 x 1219 mm)
Wadsworth Atheneum Museum
of Art, Hartford, Connecticut
Bequest of Mrs. Clara Hinton Gould,
1948.178

FIGURE 77
Frederic Edwin Church
(American, 1826–1900)
Sun Rising over Bar Harbor, ca. 1860
Brush and oil paint on paperboard
5½ x 11⅞ in. (140 x 302 mm)
Cooper-Hewitt, National Design
Museum, Smithsonian Institution
Gift of Louis P. Church, 1917-4-1355

FIGURE 78
Frederic Edwin Church
(American, 1826–1900)
Mount Ktaadn, 1853
Oil on canvas
36¼ x 55¼ in. (921 x 1403 mm)
Yale University Art Gallery
Stanley B. Resor, B.A. 1901, Fund

FIGURE 79
Frederic Edwin Church
(American, 1826–1900)
*Mount Katahdin Rising over Katahdin
Lake*, before 1878
Brush, oil and graphite on paperboard
12¹⁄₁₆ x 20 in. (306 x 508 mm)
Cooper-Hewitt, National
Design Museum, Smithsonian
Institution
Gift of Louis P. Church, 1917-4-626

FIGURE 80
Thomas Moran
(American, 1837–1926)
after Frederic Edwin Church
(American, 1826–1900)
*Ktaadn from the South Shore of the
Lake*, in *Scribner's Monthly*, May 1878
Wood engraving on paper
9⁷⁄₁₆ x 6⁵⁄₁₆ in. (240 x 160 mm)
Olana State Historic Site, New York

State Office of Parks, Recreation and
Historic Preservation

FIGURE 81
Frederic Edwin Church
(American, 1826–1900)
*Great Basin, Mount Katahdin,
Maine*, before 1878
Brush and oil paint on paperboard
12 x 12¹⁵⁄₁₆ (305 x 329 mm)
Cooper-Hewitt, National Design
Museum, Smithsonian Institution
Gift of Louis P. Church, 1917-4-632

FIGURE 82
Frederic Edwin Church
(American, 1826–1900)
Mount Katahdin, Great Basin,
before 1878
Brush and oil paint on paperboard
14⁵⁄₁₆ x 8⅞ in. (363 x 225 mm)
Cooper-Hewitt, National Design
Museum, Smithsonian Institution
Gift of Louis P. Church, 1917-4-609-a

FIGURE 83
Thomas Moran
(American, 1837–1926),
after Frederic Edwin Church
(American, 1826–1900)
A View in the Great Basin,
in *Scribner's Monthly*, May 1878
Wood engraving on paper
9⁷⁄₁₆ x 6⁵⁄₁₆ in. (240 x 160 mm)
Olana State Historic Site, New York
State Office of Parks, Recreation and
Historic Preservation

FIGURE 84
Frederic Edwin Church
(American, 1826–1900)
*Mount Katahdin from
Lake Katahdin*, ca. 1853
Brush and oil on thin paperboard
8¹⁵⁄₁₆ x 11¹⁵⁄₁₆ in. (227 x 303 mm)
Cooper-Hewitt, National Design
Museum, Smithsonian Institution
Gift of Louis P. Church,
1917-4-323-c

FIGURE 85
Frederic Edwin Church
(American, 1826–1900)
Mount Katahdin, 1853
Oil on canvas
14 x 22 in. (335 x 558 mm)
Portland Museum of Art, Maine.
Private Collection, 1.1992

THE BEST POSSIBLE VIEW
FLORAMAE McCARRON-CATES

FRONTISPIECE
Thomas Moran
(American, 1837–1926)
Toltec Gorge (detail), 1881
Brush and black, brown and
blue ink washes, white gouache,
graphite on tan wove paper
12⁹⁄₁₆ x 9½ in. (319 x 241 mm)
Cooper-Hewitt, National

Design Museum, Smithsonian
Institution
Gift of Thomas Moran, 1917-17-68

FIGURE 1
Carleton E. Watkins
(American, 1829–1916)
Vernal Fall, 300 feet,
Piwyac, Yosemite, 1861–66
Albumen silver print
15 ⁹⁄₁₆ x 20 ⁹⁄₁₆ in. (397 x 523 mm)
Cooper-Hewitt, National Design
Museum, Smithsonian Institution
Gift of Unknown Donor, 1976-23-11

FIGURE 2
Thomas Moran
(American, 1837–1926)
Lower Fire Hole, Geyser Basin,
Yellowstone, 1892
Graphite on brown wove paper
9 ⁵⁄₁₆ x 12 in. (236 x 305 mm)
Cooper-Hewitt, National Design
Museum, Smithsonian Institution
Gift of Thomas Moran, 1917-17-52

FIGURE 3
W. H. Morse (American, active 1870s)
after Thomas Moran
(American, 1837–1926)
Palisade Cañon, in *Picturesque*
America or The Land We Live In,
vol. II, 1874
Published by D. Appleton & Co.,
New York, New York
Wood engraving on off-white
wove paper
8 ¹⁵⁄₁₆ x 6 ¼ in. (227 x 159 mm)
Cooper-Hewitt, National Design
Museum, Smithsonian Institution
Gift of Gilbert White Rose and
Henry Martin Rose II, 1945-69-9349

FIGURE 4
Thomas Moran
(American, 1837–1926)
The Narrows, North Fork of the
Rio Virgin, Utah, in *The Aldine,*
vol. VII, no. 16, April 1875
Wood engraving on off-white
wove paper
10 ⅛ x 7 ⁵⁄₁₆ in. (264 x 186 mm)
Cooper-Hewitt, National Design
Museum, Smithsonian Institution
Gift of Gilbert White Rose and
Henry Martin Rose II, 1945-69-9363

FIGURE 5
William Linton (British, 1791–1876)
after Henry Fenn
(American, 1845–1911)
Tower Falls, Yellowstone, in
Picturesque America or The Land
We Live In, vol. II, 1874
Published by D. Appleton & Co.,
New York, New York
Wood engraving on off-white wove
paper
9 ⅛ x 6 ¼ in. (232 x 159 mm)
Cooper-Hewitt, National
Design Museum, Smithsonian

Institution
Gift of Gilbert White Rose and
Henry Martin Rose II, 1945-69-9439

FIGURE 6
Thomas Moran
(American, 1837–1926)
The Plains and the Sierras,
in *Picturesque America, or The Land*
We Live In, vol. II, p. 173, 1874
Published by D. Appleton & Co.,
New York, New York
Wood engraving on off-white
wove paper
9 x 5 in. (229 x 127 mm)
Courtesy of Smithsonian Institution
Libraries, Washington, DC

FIGURE 7
Thomas Moran
(American, 1837–1926)
The Grand Cañon in the Rain, 1873
Graphite on cream wove paper
10 ¼ x 15 in. (244 x 380 mm)
Cooper-Hewitt, National Design
Museum, Smithsonian Institution
Gift of Thomas Moran,
1917-17-28

FIGURE 8
Thomas Moran
(American, 1837–1926)
Yosemite, Vernal Falls, 1904
Brush and white gouache,
graphite on blue gray wove paper
12 ¹⁵⁄₁₆ x 9 ¾ in. (328 x 248 mm)
Cooper-Hewitt, National Design
Museum, Smithsonian Institution
Gift of Thomas Moran, 1917-17-85

FIGURE 9
Roberts (American, active 1870s)
after Thomas Moran
(American, 1837–1926)
Summit of the Sierras, in *Picturesque*
America, or The Land We Live In,
vol. II, 1874
Published by D. Appleton & Co.,
New York, New York
Wood engraving on off-white
wove paper
9 x 6 ⅜ in. (229 x 162 mm)
Cooper-Hewitt, National Design
Museum, Smithsonian Institution
Gift of Gilbert White Rose and
Henry Martin Rose II, 1945-69-5193

FIGURE 10
Thomas Moran
(American, 1837–1926)
Walls of the Grand Cañon, in
Picturesque America, or The Land We
Live In, vol. II, 1874
Published by D. Appleton & Co.,
New York, New York
Wood engraving on off-white
wove paper
9 ¼ x 6 ¼ in. (235 x 159 mm)
Cooper-Hewitt, National
Design Museum, Smithsonian
Institution

Gift of Gilbert White Rose and
Henry Martin Rose II, 1945-69-9374

FIGURE 11
Frederic Edwin Church
(American, 1826–1900)
Sunset, Hudson, New York, 1873
8 ⁷⁄₁₆ x 12 ⁵⁄₁₆ in. (215 x 312 mm)
Oil on paper laminate
Cooper-Hewitt, National Design
Museum, Smithsonian Institution
Gift of Louis P. Church, 1917-4-1313

FIGURE 12
Frederic Edwin Church
(American, 1826–1900)
Sunset across the Hudson Valley, 1870
12 ¹¹⁄₁₆ x 13 ⅞ in. (322 x 352 mm)
Oil on paper laminate
Cooper-Hewitt, National Design
Museum, Smithsonian Institution
Gift of Louis P. Church, 1917-4-582-c

FIGURE 13
Thomas Moran
(American, 1837–1926)
Toltec Gorge, 1881
Brush and black, brown and
blue ink washes, white gouache,
graphite on tan wove paper
12 ⁹⁄₁₆ x 9 ½ in. (319 x 241 mm)
Cooper-Hewitt, National Design
Museum, Smithsonian Institution
Gift of Thomas Moran, 1917-17-68

FIGURE 14
Thomas Moran
(American, 1837–1926)
Gorge and Tunnel, in *Around the*
Circle, 1890
Published by Denver & Rio Grande
Railway
Wood engraving on off-white
wove paper
9 x 6 ¼ in. (229 x 159 mm)
Warshaw Collection of Business
Americana—Geographic, Archives
Center, National Museum of
American History, Behring Center,
Smithsonian Institution

FIGURE 15
Thomas Moran
(American, 1837–1926)
Toltec Gorge and Eva Cliff
from the West, 1892
Brush and watercolor, white gouache,
graphite on gray wove paper
12 ⁹⁄₁₆ x 9 ⁹⁄₁₆ in. (319 x 242 mm)
Cooper-Hewitt, National Design
Museum, Smithsonian Institution
Gift of Thomas Moran, 1917-17-31

FIGURE 16
Bogert (American, active 1870s)
after Thomas Moran
(American, 1837–1926)
Springville Canyon, in *The Aldine,*
vol. VII, no. 1, January 1874
Wood engraving on off-white
wove paper
10 ¼ x 8 ⅞ in. (260 x 225 mm)

Cooper-Hewitt, National Design
Museum, Smithsonian Institution
Gift of Gilbert White Rose and
Henry Martin Rose II,
1945-69-9340

FIGURE 17
Frank Jay Haynes
(American, 1853–1921)
Cleopatra's Terrace number 4512 from
the series *Thirty-six Selected Haynes
Stereoscopic Views of the Yellowstone
National Park*, 1881–88
Albumen silver prints mounted
on cream paper laminate with
printed text
3 1/2 x 7 in. (89 x 177 mm)
Cooper-Hewitt, National Design
Museum, Smithsonian Institution
Gift of Dr. Richard P. Wunder,
1962-156-1-1

FIGURE 18
Frank Jay Haynes
(American, 1853–1921)
*Mammoth Hot Springs–Yellowstone
Park*, number 5 from the series
Yellowstone Park, Color Photogravures,
Photolithograph on paper laminate,
after 1889
6 1/8 x 9 5/16 in.
(161 x 236 mm)
Cooper-Hewitt, National Design
Museum, Smithsonian Institution
Gift of Dr. Richard P. Wunder,
1962-156-1-2

FIGURE 19
Carleton E. Watkins
(American, 1829–1916)
Half Dome, 4967 Feet, Yosemite,
1861–66
Albumen silver print
15 3/8 x 20 13/16 in. (391 x 528 mm)
Cooper-Hewitt, National Design
Museum, Smithsonian Institution
Gift of Unknown Donor, 1976-23-6

FIGURE 20
Carleton E. Watkins
(American, 1829–1916)
El Capitan, Yosemite, 1861–66
Albumen silver print
20 1/4 x 15 7/16 in. (548 x 402 mm)
Cooper-Hewitt, National Design
Museum, Smithsonian Institution
Gift of Unknown Donor,
1976-23-22

FIGURE 21
F. Pettit (American, active 1870s)
after H. Bolton Jones (American,
1848–1927), from a photograph by
John K. Hillers (American, 1843–1925)
*Grand Canyon of the Colorado, View
from Hance Trail*, in *Harper's*, vol.
LXXXII, November 1890–April 1891
Wood engraving on off-white
wove paper
7 5/16 x 4 13/16 in. (186 x 122 mm)
Cooper-Hewitt, National Design

Museum, Smithsonian Institution
Gift of Gilbert White Rose and
Henry Martin Rose II, 1945-69-5689

FIGURE 22
John Filmer (American, active 1870s)
after Thomas Moran
(American, 1837–1926)
*Weber River, Entrance to Echo
Canyon*, in *Picturesque America
or The Land We Live In*, vol. II, 1874
Published by D. Appleton & Co.,
New York, New York
Wood engraving
9 1/16 x 6 5/16 in. (230 x 160 mm)
Cooper-Hewitt, National Design
Museum, Smithsonian Institution
Gift of Gilbert White Rose and
Henry Martin Rose II, 1945-69-9359

FIGURE 23
Underwood and Underwood,
New York (American Photography
Studio, 1882–ca. 1940)
Stereoviewer, ca. 1901
Wood, aluminum, brass, and glass
7 5/8 x 6 7/8 x 12 1/4 in.
(19.4 x 17.5 x 31.1 cm)
Cooper-Hewitt, National Design
Museum, Smithsonian Institution
Gift of Unknown Donor, s-e-307

FIGURE 24
Frederick and William Langenheim,
photographers (American, active
1840–1874)
*Niagara Falls, Winter, Table Rock,
Canadian Side*, 1854–55
Glass stereoview
3 1/4 x 6 3/4 in. (83 x 171mm)
Cooper-Hewitt, National Design
Museum, Smithsonian Institution
Gift of Norvin Hewitt Green,
1938-58-54

FIGURE 25
J. Loeffler
(American, active 1860s–1880s)
The Catskills, ca. 1865
Albumen silver prints mounted
on paper laminate with printed text
3 7/16 x 7 in. (87 x 178 mm)
Cooper-Hewitt, National Design
Museum, Smithsonian Institution
Gift of Eleanor and Sarah Hewitt,
1931-81-494

FIGURE 26
Frederic Edwin Church
(American, 1826–1900)
Niagara from the American Side, 1858
Brush and oil over albumen
silver print
12 7/8 x 11 5/8 in. (327 x 295 mm)
Cooper-Hewitt, National Design
Museum, Smithsonian Institution
Gift of Louis P. Church, 1917-4-1350

FIGURE 27
Frederick and William Langenheim,
photographers
(American, active, 1840–1874)

*Winter, Niagara Falls, General View
from the American Side*, 1855
Glass stereoview
3 1/4 x 6 3/4 in. (83 x 171 mm)
Cooper-Hewitt, National Design
Museum, Smithsonian Institution
Gift of Norvin Hewitt Green,
1938-58-53

FIGURE 28
Frank Jay Haynes
(American, 1853–1921)
*Thirty-six Selected Haynes Stereo-
scopic Views of the Yellowstone
National Park*, 1881–88
Albumen silver prints mounted on
cream paper laminate with printed
text; boxed set of stereoscopic views
7 1/4 x 3 3/4 x 2 in. (18.4 x 9.5 x 5.1 cm)
Cooper-Hewitt, National Design
Museum, Smithsonian Institution
Gift of Dr. Richard P. Wunder,
1962-156-1-√37

FIGURE 29
Underwood and Underwood,
photographers (active U.S., Canada,
England, 1880–1920)
*"Thos. Moran, America's
greatest Scenic Artist, sketching
at Bright Angel Cove, Grand
Canyon of Arizona,"* from
*The Grand Canyon of Arizona:
Through the Stereoscope*, 1908
Albumen silver prints mounted
on cardboard
3 5/8 x 4 13/16 (92 x 122 mm)
Robert N. Dennis Collection
of Stereoscopic Views, Miriam
& Ira D. Wallach Division of Art,
Prints & Photographs, The New York
Public Library, Astor, Lenox and
Tilden Foundations

FIGURE 30
Thomas Moran
(American, 1837–1926)
Yosemite, Mirror Lake, 1872
Brush and black wash, over
graphite on light brown wove paper
14 15/16 x 10 13/16 in. (379 x 274 mm)
Cooper-Hewitt, National Design
Museum, Smithsonian Institution
Gift of Thomas Moran,
1917-17-84

FIGURE 31
Thomas Moran
(American, 1837–1926)
*The North Dome, Yosemite,
California*, 1872
Brush and black wash, white
gouache, over graphite on tan wove
paper
6 5/8 x 5 1/2 in. (168 x 140 mm)
Cooper-Hewitt, National Design
Museum, Smithsonian Institution
Gift of Thomas Moran,
1917-17-14

FIGURE 32
Thomas Moran
(American, 1837–1926)
Half Dome, Yosemite, 1872
Brush and black wash, over graphite
on tan wove paper
7½ x 5¼ in. (191 x 133 mm)
Cooper-Hewitt, National Design
Museum, Smithsonian Institution
Gift of Thomas Moran, 1917-17-15

FIGURE 33
Thomas Moran
(American, 1837–1926)
In the Yosemite Valley, 1872
Graphite, brush, black ink, and white
gouache on cream wove paper
10½ x 4½ in. (267 x 115 mm)
Cooper-Hewitt, National Design
Museum, Smithsonian Institution
Gift of Thomas Moran, 1917-17-16

FIGURE 34
Thomas Moran
(American, 1837–1926)
*Castle Geyser, Upper Geyser Basin,
Yellowstone*, 1876
Chromolithograph on white
wove paper
9⅝ x 13⅞ in. (245 x 353 mm)
Cooper-Hewitt, National Design
Museum, Smithsonian Institution
Museum purchase through
gift of Louis R. Ehrich, 1941-9-1

FIGURE 35
Winslow Homer
(American, 1836–1910)
Two Girls, 1879
Graphite carbon tracing,
retouched on white wove paper
7⁷⁄₁₆ x 4⁷⁄₁₆ in. (189 x 112 mm)
Cooper-Hewitt, National Design
Museum, Smithsonian Institution
Gift of Charles Savage Homer, Jr.,
1912-12-71

FIGURE 36
John Filmer (American, active 1870s)
after James D. Smillie
(American, 1833–1909)
*Tenaya Canyon from Glacier Point,
Yosemite*, in *Picturesque America*, 1874
Wood engraving on off-white
wove paper
9 x 6¼ in. (229 x 159 mm)
Cooper-Hewitt, National Design
Museum, Smithsonian Institution
Gift of Gilbert White Rose and
Henry Martin Rose II, 1945-69-9468

FIGURE 37
Thomas Moran
(American, 1837–1926)
*The South Dome, Yosemite Valley
(Half Dome)*, 1887
Etching on tan Japanese paper
Plate mark: 12¹³⁄₁₆ x 9⁹⁄₁₆ in.
(325 x 230 mm)
Cooper-Hewitt, National Design
Museum, Smithsonian Institution

Museum purchase through gift
of Mrs. Gustav E. Kissel, 1949-102-2

FIGURE 38
Thomas Moran
(American, 1837–1926)
Half Dome, Yosemite, 1873
Brush and watercolor, white gouache,
graphite on blue-gray wove paper
19¼ x 15⅝ in. (502 x 397 mm)
Cooper-Hewitt, National Design
Museum, Smithsonian Institution
Gift of Thomas Moran, 1917-17-32

FIGURE 39
Winslow Homer
(American, 1836–1910)
The Fishing Party, in *Appletons'
Journal of Literature, Science and Art*,
October 2, 1869
Wood engraving on off-white wove
paper
10⅞ x 15¹⁄₁₆ in. (276 x 383 mm)
Cooper-Hewitt, National Design
Museum, Smithsonian Institution
Gift of Miss Edith Wetmore, 1936-43-2

FIGURE 40
Winslow Homer
(American, 1836–1910)
Study for "The Fishing Party," ca. 1869
Graphite on tan wove paper
6 x 8¹¹⁄₁₆ in. (153 x 220 mm)
Cooper-Hewitt, National Design
Museum, Smithsonian Institution
Gift of Charles Savage Homer, Jr.,
1912-12-265

FIGURE 41
John Karst (American, 1836–1922)
after Winslow Homer
(American, 1836–1910)
The Artist in the Country, in
*Appletons' Journal of Literature,
Science and Art*, June 19, 1869
Wood engraving on white wove paper
6¹³⁄₁₆ x 7³⁄₁₆ in. (176 x 183 mm)
Cooper-Hewitt, National Design
Museum, Smithsonian Institution
Museum purchase from Friends
of the Museum Fund, 1938-47-1

FIGURE 42
Winslow Homer
(American, 1836–1910)
*Preliminary drawing for "The Artist
in the Country" and "Artists Sketching
in the White Mountains,"* 1868
Graphite on white wove paper,
blackened on verso for tracing
8⁵⁄₁₆ x 5¹³⁄₁₆ in. (211 x 147 mm)
Cooper-Hewitt, National Design
Museum, Smithsonian Institution
Gift of Charles Savage Homer, Jr.,
1912-12-263

FIGURE 43
Winslow Homer
(American, 1836–1910)
Summer in the Country, in *Appletons'
Journal of Literature, Science, and Art*,
vol. I, July 10, 1869

Wood engraving on off-white
wove paper
4½ x 6⅝ in. (114 x 168 mm)
Cooper-Hewitt, National Design
Museum, Smithsonian Institution
Gift of John Goldsmith Phillips, Jr.,
1947-4-63

FIGURE 44
Winslow Homer
(American, 1836–1910)
Ship Building, Gloucester Harbor,
in *Harper's Weekly*, October 11, 1873
Wood engraving on white wove paper
9¼ x 13⁹⁄₁₆ in. (235 x 345 mm)
Cooper-Hewitt, National Design
Museum, Smithsonian Institution
Gift of Arthur B. Carlson, 1951-93-11

FIGURE 45
Winslow Homer
(American, 1836–1910)
Gathering Autumn Leaves, 1877
Brush and oil paint on wood panel
24¼ x 38¼ in. (616 x 972 mm)
Cooper-Hewitt, National Design
Museum, Smithsonian Institution
Gift of Charles Savage Homer, Jr.,
1917-14-3

FIGURE 46
Winslow Homer
(American, 1836–1910)
The Yellow Jacket, 1879
Brush and oil paint on canvas
22¹³⁄₁₆ x 15⅝ in. (579 x 397 mm)
Cooper-Hewitt, National Design
Museum, Smithsonian Institution
Gift of Charles Savage Homer, Jr.,
1917-14-4

THE PASTORAL IDEAL: WINSLOW
HOMER'S BUCOLIC AMERICA
SARAH BURNS

FRONTISPIECE
Winslow Homer
(American, 1836–1910)
Two Girls with Sunbonnets in a Field
(detail), ca. 1877–78
Oil on canvas
15⅝ x 22½ in. (397 x 572 mm)
Cooper-Hewitt, National Design
Museum, Smithsonian Institution
Gift of Mrs. Charles Savage Homer,
Jr., 1918-20-5

FIGURE 1
Unknown
Our Artist in the Adirondacks,
in *Appletons' Journal of Literature,
Science and Art*, September 21, 1872
Wood engraving on white wove paper
11¹⁄₁₆ x 7⁷⁄₁₆ in. (281 x 189 mm)
General Research Division,
The New York Public Library,
Astor, Lenox and Tilden Foundations

FIGURE 2
Winslow Homer
(American, 1836–1910)

Two Girls with Sunbonnets in a Field,
ca. 1877–78
Oil on canvas
15⅝ x 22½ in. (397 x 572 mm)
Cooper-Hewitt, National
Design Museum, Smithsonian
Institution
Gift of Mrs. Charles Savage Homer,
Jr., 1918-20-5

FIGURE 3
Winslow Homer
(American, 1836–1910)
*Bo-Peep (Girl with Shepherd's
Crook Seated by a Tree),* 1878
Opaque watercolor over graphite
pencil on paper
7 x 8¼ in. (178 x 210 mm)
Museum of Fine Arts, Boston
Bequest of John T. Spaulding, 48.724

FIGURE 4
Winslow Homer
(American, 1836–1910)
Boy and Girl in a Field with Sheep,
ca. 1877–78
Brush and oil on canvas
22⁹⁄₁₆ x 15⁷⁄₁₆ in. (573 x 392 mm)
Cooper-Hewitt, National Design
Museum, Smithsonian Institution
Gift of Mrs. Charles Savage Homer,
Jr., 1918-20-6

FIGURE 5
Winslow Homer
(American, 1836–1910)
Bridle Path, White Mountains
(detail), August 24, 1868
Graphite on off-white wove paper
6⅝ x 9⁹⁄₁₆ in. (168 x 243 mm)
Cooper-Hewitt, National Design
Museum, Smithsonian Institution
Gift of Charles Savage Homer, Jr.,
1912-12-221

FIGURE 6
Mary Hallock Foote
(American, 1847–1938)
Strawberry Pickers, in *Scribner's
Monthly,* November 1878
Wood engraving on white wove paper
9⁷⁄₁₆ x 6⁵⁄₁₆ in. (240 x 160 mm)
General Research Division,
The New York Public Library,
Astor, Lenox and Tilden
Foundations

FIGURE 7
Winslow Homer
(American, 1836–1910)
Study for "Snap the Whip," 1872
Black and white chalk,
touches of light orange chalk
on green wove paper
Verso: graphite, black and white
chalk on green wove paper
9¼ x 16⁹⁄₁₆ in. (235 x 420 mm)
Cooper-Hewitt, National Design
Museum, Smithsonian Institution
Gift of Charles Savage Homer, Jr.,
1912-12-82

FIGURE 8
Winslow Homer
(American, 1836–1910)
Shepherdess Resting under a Tree,
1878
Graphite, brush, and white gouache
on gray-green wove paper.
5¼ x 8⁹⁄₁₆ in. (133 x 218 mm)
Cooper-Hewitt, National Design
Museum, Smithsonian Institution
Gift of Charles Savage Homer, Jr.,
1912-12-88

FIGURE 9
Winslow Homer
(American, 1836–1910)
Fresh Air, 1878
Watercolor with opaque white high-
lights over charcoal on cream, moder-
ately thick, rough-textured wove paper
20¹⁄₁₆ x 14 in. (510 x 356 mm)
The Brooklyn Museum
Dick S. Ramsay Fund, 41.1087

FIGURE 10
Unknown
Little Bo-Peep She Lost Her Sheep,
in *The History of Little Bo-Peep
the Shepherdess,* ca. 1852–58
Published by Geo. Routledge & Co.,
London and New York
Wood engraving on white wove paper
7 x 5 in. (178 x 138 mm)
Courtesy of The Lilly Library, Indiana
University, Bloomington, IN

FIGURE 11
Winslow Homer
(American, 1836–1910)
Shepherdess Resting, ca. 1877
Charcoal on heavy wove paper
14¼ x 22¹⁄₁₆ in. (362 x 560 mm)
Cooper-Hewitt, National Design
Museum, Smithsonian Institution
Gift of Charles Savage Homer, Jr.,
1912-12-206

FIGURE 12
Winslow Homer
(American, 1836–1910)
Resting Shepherdess, 1878
Painted and glazed tiles
8 x 16 in. (20.3 x 40.6 cm);
two tiles, each 8 x 8 in. (20.3 x 20.3 cm)
Collection of the Heckscher Museum
of Art, Huntington, New York
Partial Gift of Karen H. Bechtel
in memory of Ronald G. Pisano
and Partial Museum Purchase with
funds from the Acquisition Fund,
the Eva Gatling Fund, and the
Baker/Pisano Fund

FIGURE 13
Winslow Homer
(American, 1836–1910)
Shepherdess Tile, 1878
Ceramic tile
7¾ x 7¾ in. (19.7 x 19.7 cm)
Lyman Allyn Art Museum,
New London, Connecticut
(1945.155)

FIGURE 14
Winslow Homer
(American, 1836–1910)
Fireplace surround: *Shepherd and
Shepherdess,* 1878
Painted and glazed tiles
36 x 49¼ in. (91.4 x 121.1 cm); twelve
tiles, each 8 x 8 in. (20.3 x 20.3 cm)
The Metropolitan Museum of Art,
Bequest of Arthur G. Altschul, 2002
(2003.140)

FIGURE 15
Wallace Nutting
(American, 1861–1942)
Life in the Golden Age, in *Wallace
Nutting Pictures: Expansible
Catalog . . . ,* 1912
Published by Wallace Nutting, Inc.,
Framingham, Massachusetts
Photomechanical reproduction
on white wove paper
10 x 7 in. (254 x 178 mm)
University of Delaware Library,
Newark, Delaware

AMERICA INSIDE OUT
KARAL ANN MARLING

FRONTISPIECE
The Schmitz-Horning Company
Scenic panel: *Sierras,* 1913–14
Chromolithographed
37¹³⁄₁₆ x 19⁹⁄₁₆ in. (96 x 49.7 cm)
Cooper-Hewitt, National Design
Museum, Smithsonian Institution
Gift of the Wallpaper Council, Inc.,
1960-163-14

FIGURE 1
Thomas Moran
Drawing: *Hiawatha sees Mudiekeewis,*
1870–75
Graphite, pen and brown ink,
brush and gray-brown wash on paper
5½ x 4⁵⁄₁₆ in. (14 x 11 cm)
Cooper-Hewitt, National Design
Museum, Smithsonian Institution
Gift of Thomas Moran, 1917-17-35

FIGURE 2
Edward Timothy Hurley
(American, 1869–1950)
Rookwood pottery, *Indian
Encampment,* 1909
Glazed stoneware
13¹¹⁄₁₆ x 6½ in. (34.7 x 16.5 cm)
Cooper-Hewitt, National Design
Museum, Smithsonian Institution
Gift of Marcia and William
Goodman, 1984-84-1

FIGURE 3
William Cullen Bryant
(American, 1794–1878)
*Picturesque America, or the Land We
Live In,* 1872–74
Published by D. Appleton & Co.,
New York, New York
Wood engraving on off-white
wove paper, leather, gilding

9 x 5 in. (229 x 127 mm)
Courtesy of Smithsonian Institution
Libraries, Washington, DC

FIGURE 4
Winslow Homer
(American, 1836–1910)
Under the Falls (detail),
in *Harper's Weekly*, September 14, 1872
Wood engraving on paper
15⅝ x 19¾ in. (397 x 502 mm)
Cooper-Hewitt, National Design
Museum, Smithsonian Institution
Gift of John Goldsmith Phillips, Jr.,
1947-4-18

FIGURE 5
Yellowstone Park,
Northern Pacific Railway, 1915
Offset photo lithograph on paper
9 x 10½ in. (225 x 269 mm)
Cooper-Hewitt, National Design
Museum, Smithsonian Institution
Gift of Unknown Doneor, s-e- 306

FIGURE 6
United States Pottery Company
(American, 1849-58)
Pitcher, 1852–58
Parian
8⅜6 in. (20.8 cm) high
The Metropolitan Museum of Art,
Gift of Dr. Charles W. Green, 1947
(47.90.15)

FIGURE 7
After Winslow Homer
(American, 1836–1910)
Winter—A Skating Scene, 1868
Wood engraving on paper
9⅜ x 13⅞ in. (238 x 352 mm)
Cooper-Hewitt, National Design
Museum, Smithsonian Institution
George A. Kubler Collection
#5737

FIGURE 8
Wallace Nutting (1861–1941)
At the Fender, 1904
Hand-colored platinum print
on cream wove paper
16 x 18 in. (406 x 457 mm)
Cooper-Hewitt, National Design
Museum, Smithsonian Institution
Gift of Mary M. Kenway, 1956-42-3

FIGURE 9
Winslow Homer
(American, 1836–1910)
Camping Out in the Adirondacks,
in *Harper's Weekly*, November 7, 1874
Wood engraving on paper
10⁵⁄₁₆ x 15¾ in. (259 x 400 mm)
Cooper-Hewitt, National Design
Museum, Smithsonian Institution
Gift of John Goldsmith Phillips, Jr.,
1947-4-24

FIGURE 10
Attributed to Friedrich Wenzel
(Bohemian, 1827–1902)
Longhorn Armchair, 1880–90
Horn, wood, leatherette,
metal, glass, brass
37¹³⁄₁₆ x 38⅜ x 34⅝ in.
(96 x 97.5 x 88 cm)
Cooper-Hewitt, National Design
Museum, Smithsonian Institution
Gift of Jack Lenor Larsen,
1986-39-1

FIGURE 11
Matchsafe: *Fishing Basket*,
late nineteenth century
Brass
1¹¹⁄₁₆ x 2⅜ x 1³⁄₁₆ in. (4.3 x 6 x 3 cm)
Cooper-Hewitt, National Design
Museum, Smithsonian Institution
Gift of Stephen W. Brener
and Carol B. Brener, 1978-146-162

FIGURE 12
Winslow Homer
(American, 1836–1910)
Fireplace surround: *Shepherd
and Shepherdess* (detail), 1878
Painted and glazed tiles
36 x 49¼ in. (91.4 x 121.1 cm);
twelve tiles, each 8 x 8 in.
(20.3 x 20.3 cm)
The Metropolitan Museum of Art,
Bequest of Arthur G. Altschul, 2002
(2003.140)

FIGURE 13
William Campbell Wallpaper
Company, designed by Alfred Egli
(Swiss)
Frieze: *The Oritani*, 1872
Machine printed,
distempered colors
37³⁄₁₆ x 19³⁄₁₆ in. (94.5 x 49 cm)
Cooper-Hewitt, National Design
Museum, Smithsonian Institution
Gift of Paul F. Franco,
1938-50-14-a,b

FIGURE 14
Henry Charles Currier (1851-1938)
Parlor of T. B. Winchester, 138
Beacon Street, Boston, MA, 1894
Copy photograph
Collections of the Library of
Congress, LC-C801-309

FIGURE 15
Sidewall: *Japonaiserie*, 1883–85
American
Machine printed
29⁵⁄₁₆ x 18½ in. (74.5 x 47 cm)
Cooper-Hewitt, National Design
Museum, Smithsonian Institution
Gift of Miss Grace Lincoln Temple,
1938-62-18

ACKNOWLEDGMENTS

Gail S. Davidson and Floramae McCarron-Cates, on behalf of Cooper-Hewitt, National Design Museum, would like to thank their colleagues, Elizabeth Broman, Sarah Coffin, Jennifer Cohlman, Lucy Commoner, Gregory Herringshaw, Mei Mah, Wendy Rogers, Larry Silver, Cynthia Trope, Stephen Van Dyk, and interns and volunteers Mary Catlett, Judith Bergoffen, Lillian Clagett, Anna Daley, Tara DeWitt, Meredith Furman, Susan Hermanos, Claire Howard, Alexandra Mann, Margery Masinter, Marilyn Symmes, Sung Won, as well as the following individuals and organizations, for their invaluable help and cooperation during the preparation of this exhibition and book.

Acadia National Park: Brook Childrey
The Adirondack Museum: Gerald Pepper, Laura S. Rice, Angela Donnelly
American Antiquarian Society: Georgia B. Barnhill, Jackie Donovan
Andalusia Foundation: James Biddle III, Connie Houchins
The Art Institute of Chicago: Judith Barter, Amy Berman
Konstanze Bachmann
Bar Harbor Historical Society: Deborah Dyer
Mr. and Mrs. Max Berry
Bowdoin College Museum of Art: Alison Ferris, Laura J. Latman
Alex Boyle
Brooklyn Museum: Barry Harwood, Ruth Janson
Bureau of Historic Sites, Peebles Island: Ann Cassidy, Marie Culver
Sarah Burns, University of Indiana
Gerald L. Carr
Cedar Grove, The Thomas Cole National Historic Site: Betsy Jacks
Nicolai Cikovsky, Jr.
The Charles Rand Penney Collection: Charles Rand Penney, Amy Sanderson
Matt Flynn
Linda and Peter Foss, Scarborough, Maine
George Eastman House: David Wooters
Judith Goldstein
Greene County Historical Society: Raymond Beecher, Steven Pec, Shelby A. Mattice, Linda Gentalen
Heckscher Museum of Art: Anne de Pietro, William Titus
Fred Hill
Hirschl & Adler Galleries, Inc.: M. P. Naud
The Huntington Library: Amy R. W. Meyers
Mrs. William S. Kilroy, Sr.
Rodney Laughton, Scarborough, Maine
The Library Company of Philadelphia: Jenny Ambrose, Charlene Peacock, Sarah Weatherwax
The Library of Congress: Marilyn Ibach
Lyman Allyn Art Museum: Nancy Stula, Linda Lavin, Kelly Stroup
Maine Historical Society: Nicholas Noyes, William D. Barry
Maine Historic Preservation Commission: Earle G. Shettleworth
Karal Ann Marling, University of Minnesota
Memorial Art Gallery of the University of Rochester: Susan Nurse

The Metropolitan Museum of Art: Kevin Avery, Alice Cooney Frelinghuysen, Deanna Cross
Mount Desert Island Historical Society: Charlotte Singleton
Mount Holyoke College: Patricia Albright
Museum of Fine Arts, Boston: Sue Welsh Reed, Erin Schleigh
The Museum of Fine Arts, Houston: Emily Neff
National Academy Museum: Mark Mitchell
National Gallery of Art: Barbara Goldstein Wood
National Museum of American History: John Fleckner, Kay Peterson, Susan Strange, Helena Wright
Newport Historical Society: Bertram Lippincott III, M. Joan Youngken
New-York Historical Society: Linda Ferber, Kristine Paulus, Jill Reichenbach
The New York Public Library: David Lowe, Roberta Waddell
New York State Council on the Arts
Northeast Harbor Library: Robert Pyle
Olana State Historic Site: Linda McLean, Evelyn Tribilcock, Valerie Balint
Philadelphia Museum of Art: Holly Frisbee
Portland Museum of Art: Stewart Hunter, Stephanie Doben, Kevin Eame
The Scarborough, Maine Historical Society and Museum: Becky Delaware, Anna Delaware, Shirley Corse
Seattle Art Museum: Patricia Junker
Smith College Museum of Art: Jessica Nicoll
Smithsonian American Art Museum: Elizabeth Broun, Eleanor Harvey, Melissa Kroning, Joann Moser, William Treuttner, Denise D. Wamaling
Smithsonian Institution Libraries: Susan Frampton, Eliza Gilligan
Ira Spanierman
Laura Sprague, Portland, Maine
Sterling and Francine Clark Art Institute: Merry Armata
The U.S. Department of the Interior Museum: Kim Robinson
University of Delaware: Shaun Mullen, Karen Pyle, Bryant Tolles
University of New Mexico: Michael Kelly
William Vareika
Charles Von Nostitz
Wadsworth Atheneum Museum of Art: Elizabeth Mankin Kornhauser, Adria Patterson
Deedee Wigmore

For more information on the museum and the exhibition, Cooper-Hewitt invites you to visit its Web site at www.cooperhewitt.org.

Index